IRISH CULTURE AND WARTIME EUROPE, 1938–48

IRISH CULTURE AND WARTIME EUROPE, 1938–48

Dorothea Depner and Guy Woodward

EDITORS

FOUR COURTS PRESS

Set in 10.5 on 13 point AGaramond for
FOUR COURTS PRESS LTD
7 Malpas Street, Dublin 8, Ireland
www.fourcourtspress.ie
and in North America by
FOUR COURTS PRESS
c/o ISBS, 920 N.E. 58th Avenue, Suite 300, Portland, OR 97213.

ISBN 978-1-84682-562-0

A catalogue record for this title
is available from the British Library.

Printed in England
by Antony Rowe Ltd, Chippenham, Wilts.

Contents

Notes on contributors

JULIE BATES was awarded her PhD by Trinity College Dublin in 2013. Her doctoral thesis charted Samuel Beckett's material imagination and evolving creative praxis through thirteen recurring objects in his fiction, drama and poetry, from the early 1930s to the late 1980s. Julie is currently revising her thesis for publication as a monograph with Cambridge University Press. She has contributed a chapter to the *Oxford Handbook of Modern Irish Theatre* (2015), and has presented her work in Ireland, Britain, Portugal, Colombia, Mexico and Turkey. Julie has lectured on modern European literature and art at universities in Dublin and Mexico, and currently works as a lecturer in Sarajevo.

GERALD DAWE has published eight collections of poetry with the Gallery Press, including *Mickey Finn's Air* (2014), as well as publishing several collections of essays. He has edited numerous anthologies of Irish poetry and criticism, most recently the ground-breaking *Earth Voices Whispering: An Anthology of Irish War Poetry, 1914–45* (2008). He is Professor of English and Fellow of Trinity College Dublin.

DOROTHEA DEPNER was awarded a doctorate by Trinity College Dublin in 2013. She has published articles on representations of the Second World War in Irish literature and on Irish-German literary connections. Dorothea co-edited and introduced a selection of wartime diary notes, letters and unpublished chapters for an omnibus edition of Christabel Bielenberg's memoirs, *The Past Is Myself* and *The Road Ahead*, published by Transworld in 2011.

CONOR LINNIE is an Irish Research Council Scholar and PhD candidate at the School of English, Trinity College Dublin. He is researching the life and work of Nevill Johnson in Ireland, 1934–58, and has recently worked as a research assistant in the re-publication of Johnson's writings by the Lilliput Press, *Nevill Johnson, 1911–1999: Artist, Writer, Photographer*, edited by Eoin O'Brien. Conor would like to thank the Irish Research Council for the generous support provided by their scholarship.

UTE ANNA MITTERMAIER teaches in the Department of Humanities at the University of Applied Sciences Technikum Vienna. She completed a PhD thesis on 'Images of Spain in Irish Literature, 1922–75' at Trinity College Dublin and has published essays on the representation of Spain and the Spanish Civil War in the works of Irish writers, including Kate O'Brien, Charles Donnelly, Peadar O'Donnell and Maura Laverty. Most recently, her essay 'In Search of Mr Love; or, The Internationalist Credentials of "Myles before Myles"' appeared in the collection *Flann O'Brien: Contesting Legacies* (2014).

EVE PATTEN is Professor of English at Trinity College Dublin, where she lectures in nineteenth- and twentieth-century British and Irish literature. Her books include *Samuel Ferguson and the Culture of Nineteenth-Century Ireland* (2004), *Literatures of War* (2008) and *Imperial Refugee: Olivia Manning's Fictions of War* (2012). She has edited several collections of essays including *Ireland, West to East: Irish Cultural Connections with Central and Eastern Europe* (2014), and *The Perils of Print Culture: Book, Print and Publishing History in Theory and Practice* (2014). She is currently working on a study of English writers and their Irish literary connections in the first half of the twentieth century.

ALEX RUNCHMAN lectures at Trinity College Dublin and the Irish Centre for Poetry Studies at the Mater Dei Institute, Dublin City University. He is the author of *Delmore Schwartz: A Critical Reassessment* (2014). Among his other publications are essays on modern revisions of the epic (*A Companion to Poetic Genre*), mid-twentieth-century American sonnets (*After Thirty Falls: New Essays on John Berryman*), and the Irish poet Pearse Hutchinson (*Reading Pearse Hutchinson*). He has also written reviews for *Poetry Ireland* and *The Stinging Fly*.

ANNE THOMPSON is a PhD candidate in the School of English at Trinity College Dublin. Her doctoral research is focused on the life of the British author Terence Hanbury White, and she is currently completing his literary biography. Her other research interests include Irish folklore, literature of the Second World War, and eighteenth-century Irish drama. Originally from Texas, she received her BA from New York University in 2011 and her MA from the National University of Ireland, Galway, in 2012.

TOM WALKER is the Ussher Assistant Professor of Irish Writing at Trinity College Dublin. He has published articles on several aspects of twentieth-century Irish literature and his monograph on the poetry of Louis MacNeice is forthcoming from Oxford University Press.

MAURICE WALSH is the author of *The News from Ireland: Foreign Correspondents and the Irish Revolution* (2008). He was Knight Wallace Fellow at the University of Michigan in 2001 and Alistair Horne Fellow at St Antony's College, Oxford, in 2010/11. As a foreign correspondent for the BBC he reported from Africa, Asia, Latin America, the United States and Europe. His essays, reviews and reportage have appeared in *Granta*, the *London Review of Books*, the *Dublin Review*, the *New Statesman* and many other newspapers in Ireland, the UK and the US. His book on the Irish revolution, *Bitter Freedom: Ireland in a Revolutionary World*, will be published by Faber in 2015. He teaches journalism at Kingston University, London.

KATHRYN WHITE is Lecturer in Irish Literature at the University of Ulster. She is co-editor of John Hewitt's autobiography *A North Light: Twenty-five Years in a Municipal Art Gallery* (2013) and author of *Beckett and Decay* (2009).

GUY WOODWARD was awarded a doctorate by Trinity College Dublin in 2012, and from 2012–13 held a Government of Ireland Postdoctoral Fellowship, awarded by the Irish Research Council. He has lectured at universities in Dublin and in Mexico. His book *Culture, Northern Ireland and the Second World War* is published by Oxford University Press in 2015.

SIMON WORKMAN is a Lecturer in Humanities at Carlow College, Carlow. His most recent publications include essays and reviews on twentieth-century Irish poetry, poetry and the auditory imagination, and on representations of London in Louis MacNeice's writing.

Acknowledgments

This book arose from the symposium 'Writing Home: Irish Culture and Wartime Europe, 1938–1948', held in the Trinity Long Room Hub, Trinity College Dublin, in June 2013. We would like to thank Jürgen Barkhoff, Caitriona Curtis and Sarah Dunne at the TLRH for helping to make the symposium a success.

At Trinity College we thank Eve Patten for her support and encouragement for both the symposium and this book. We also thank Nicholas Grene and Harry Clifton for their encouragement and involvement in the symposium.

We thank Professor Roy Foster for his advice and for his support for this book.

For generous financial assistance we thank the Patrick Kavanagh Bursary, Trinity College Dublin.

At Four Courts Press we thank Martin Fanning and Meghan Donaldson for all their help during the preparation of this book.

For their various assistance, generosity and forbearance during the research and preparation of this book we thank Deirdre Wildy, Frank Reynolds and Graham Long.

Finally, we thank all the participants at the original symposium, including Megan Kuster, Tzu-Ching Yeh and Frank Ferguson, whose talks on Elizabeth Bowen, Samuel Beckett and John Hewitt, respectively, were valuable explorations of the effects of the war on Irish writing. We also thank all our contributors for their patience while the book was prepared for publication.

PERMISSIONS

The editors would like to thank the following for permission to reproduce copyright material:

Harry Clifton for permission to quote from 'German War Dead, Glencree Cemetery'; Clare Hastings for permission to reproduce *Landscape with Figures – III* by Osbert Lancaster; David Higham Associates for permission to quote from unpublished material by Terence Hanbury White and the Harry Ransom Center, Austin, Texas, for allowing access to their archives; the Barbara Levy

Literary Agency for permission to quote from unpublished material by Siegfried Sassoon; Galway Johnson and the Down County Museum for permission to reproduce *Kilkeel Shipyard* by Nevill Johnson; the Trustees of the Estate of the late Katherine B. Kavanagh, through the Jonathan Williams Literary Agency, for permission to quote from 'Epic' by Patrick Kavanagh; the Glucksman Library, University of Limerick, for permission to quote from unpublished material in the Kate O'Brien papers; the Estate of Louis MacNeice and David Higham Associates for permission to quote from 'The Coming of War' and 'Neutrality'; the Deputy Keeper of the Records, Public Records Office of Northern Ireland for permission to quote from materials in the John Hewitt Papers; Special Collections and Archives at the McClay Library, Queen's University Belfast, for permission to quote from unpublished material by Stephen Gilbert and Forrest Reid in the Stephen Gilbert Collection; Finola Graham for permission to quote from unpublished material in the Francis Stuart papers at the University of Ulster, Coleraine; the Department of Early Printed Books & Special Collections, Trinity College Dublin, for permission to quote from materials in the Denis Johnston Collection.

All reasonable efforts have been made to contact the holders of copyright in materials reproduced in this book. The publisher will be happy to rectify any omissions in future printings.

Foreword

In a postscript to the first US edition of *The Demon Lover*, a collection of the short stories she wrote during the Second World War, the Anglo-Irish novelist Elizabeth Bowen reflected:

> Every writer during this time was aware of the personal cry of the individual. And he was aware of the passionate attachment of men and women to every object or image or place or love or fragment of memory with which his or her destiny seemed to be identified, and by which the destiny seemed to be assured [...] But through the particular, in wartime, I felt the high-voltage current of the general pass.[1]

Bowen spent the war in London, acting as an air-raid warden during the blitz, while periodically returning home to County Cork. Though she defended Éamon de Valera's policy of Irish neutrality, her own experience of war was British – that is to say, central, threatened, engaged. In her case, the intensified sense of life was reflected in the supercharged fiction she wrote during these years – much of it set in Ireland. For those living permanently in her native country during these years, the relation to world hostilities was always going to be different, but the psychological sense of displacement was also present. Nonetheless, the experience of war in Ireland would – at the time and since – be inevitably seen in apposition to the very different trials undergone by Britain. This dissonance is thoughtfully and suggestively explored by the essays in this book.

Inevitably, that implicit awkwardness makes for an uncomfortable subject. In his magisterial history *Ireland Since the Famine*, published in 1971, F.S.L. Lyons likened Ireland's experience of neutrality from 1939 to 1945 to living in Plato's Cave, facing into a world of refracted shadows with one's back turned to the clear light of reality.[2] This was instantly seen in some quarters as betraying an

1 'The Demon Lover' in Elizabeth Bowen, *The Mulberry Tree: Selected Writings of Elizabeth Bowen*, ed. Hermione Lee (London, 1986), pp 97, 99. 2 Lyons, *Ireland Since the Famine* (London, 1971), pp 557f.

offensively Anglocentric approach. Why should Irish neutrality be interpreted as opting for an absence from the main current of world history? What lay behind this rather edgy reaction was the sensitivity of the connections between Ireland and Britain at this point – a sensitivity reflected in the responses of Irish writers to the war.

It should be remembered that during the Second World War Ireland was still a member of the Commonwealth, and that this membership was not a matter of unequivocal commitment. The outcome of the Anglo-Irish treaty of 1921 had been a bitter civil war in Ireland, fought over the very question of allegiance to the British crown as the symbolic head of the British Commonwealth of Nations. Though the dissidents, led by de Valera, had lost that battle, when they entered constitutional politics as Fianna Fáil and gained power in 1932, they set themselves to distancing the Irish state from its Commonwealth ties. This was done by imposing a new Constitution as well as engaging in a long diplomatic campaign to assert effective independence of action in international politics. The embrace of neutrality was, in its way, a logical continuation of this. Withdrawal from the Commonwealth and the declaration of Republican status would follow in 1948–9.

Behind the gesture of neutrality lay a complex mesh of ambiguities within and outside the Department of External Affairs – stretching to the mingled and often conflicting loyalties felt, not only by Irish people of Protestant backgrounds and ex-unionist affinities, but by anyone who had a relative serving with the Allies – as many Irish people did. This could make for long-lived resentments, some only recently lulled to rest by the belated recognition that those who signed up to fight Hitler should not be seen as having betrayed Cathleen ni Houlihan (some of Cathleen's most vociferous followers were warmly supportive of the Führer, but that is another story). As the war went on, it became clear that the Irish government's approach to neutrality was decisively tilted in favour of Britain, but a certain ambivalence remained. This helps explain the angry tone of Louis MacNeice's poetry, pinpointed in this volume; from the other side, it is also reflected in the paranoid reaction in some old-style nationalist quarters to Elizabeth Bowen's reports to the Dominions Office on Irish wartime opinion, taking the form of overblown accusations that she was 'a spy'. This reflects a certain rankling Anglophobia, as well as, perhaps, a matter of uneasy conscience.

It has to be admitted, moreover, that – as many of the following essays make clear – the response of writers from an Irish Protestant background to the war (Bowen, MacNeice, Denis Johnston, Samuel Beckett, Hubert Butler) was more committed and less ambiguous than writers whose traditions were Catholic and nationalist. The exception is Francis Stuart, who spent his early life repudiating a Protestant and Unionist background, his middle years supporting (and living in) Nazi Germany, and his latter years obscuring his sinister allegiances and

presenting himself as some kind of existentialist puritan, nobly determined on ethical independence. These claims are convincingly exploded by Dorothea Depner in this book.

Yet as Simon Workman shows, MacNeice's own response to the war was deeply complex – far more so than might be inferred by taking some of the reflections in *Autumn Journal* and 'Neutrality' out of context. Responses to the war sharpened and focused issues of identity, subtly probed in Bowen's extraordinary war novel *The Heat of the Day*, published in 1949. Here, the themes of doubling, doppelgangers, betrayal and conflicts of loyalty and allegiance predominate – while in a rootless and shifting world, the solid centre of identity is an Irish house, which is to be inherited by an Anglo-Irish soldier. And the pro-Nazi spy at the centre of the book is not an Irish nationalist, but the impeccably British product of a Home Counties background.

It is not just in Ireland that a measured response to the implications of what happened in Europe under Nazi threat took some time to emerge, on the part of historians, writers and artists. The path was often shown by the post-war generation, coming to terms with the hidden world of their parents or grandparents – shown vividly in Germany by the epic artistic projects of Gerhard Richter and Anselm Kiefer from the 1960s. From the same era the rankling, half-suppressed memories of fascism and the ensuing war can be traced in a wide range of fictions (Günter Grass' *The Tin Drum*, William Maxwell's *The Chateau* and Giorgio Bassani's *The Garden of the Finzi-Continis* might be taken as indices, all published between 1959 and 1962). But Ireland's experience, yet again, set it at an angle to this European universe. Rather than the memory of conflict, dispossession, invasion, or totalitarian government, Irish writers who stayed at home had to consider the significance and effects of neutrality; Hubert Butler's penetrating essays addressed the question early on, and he returned to it for much of his life. Patrick Kavanagh's sense of the war – discussed, again, by Simon Workman – was as something deferred, a disturbing echo to the ascertainable realities of life around him. By contrast, those Irish people who experienced the war as combatants or first-hand observers brought their own perspective to it. One of the achievements of this collection is to bring back into focus the writings of Denis Johnston, explored by Maurice Walsh and Tom Walker, and to recover the interesting testimony of the soldier and novelist Stephen Gilbert through Guy Woodward's penetrating analysis. Samuel Beckett's experience of war, and his definitively Irish perspective upon it, has also come into increasing prominence (notably since the publication of his letters), and Julie Bates' essay here adds materially to the picture, suggestively counterpointing Beckett's sensibility with the writings of W.G. Sebald.

Above all, when looking at the significance of the Second World War for the Irish imagination, it must be remembered that the north-eastern part of the

island was formally at war, and thus lived through a definitively different experi-
ence – including bombing raids. But one of the striking conclusions of this
collection is to show that even for those based in Belfast the war could make
them feel, like John Hewitt, 'enclosed and segregated', inward-looking – despite
his strong consciousness of being from Planter stock and therefore presumably
committed to the British war effort. Similarly the essays dealing with Ulster
artists in this book suggest that their wartime experience was also one of
withdrawal, removal, a certain absence from reality. Plato's Cave might not be an
inapposite metaphor north of the border too, for the artistic conscience at least.
And Guy Woodward's analysis of the Northern Irishman Stephen Gilbert's novel
Bombardier, reflecting the most engaged experience of war imaginable, suggests
that it simultaneously conveys a sense of detachment, scepticism, and a refusal
to accept mythologies, however conveniently near to hand.

It is apposite that this book ends with the memories of those born in the
years just after the war, such as Gerald Dawe. I too was born in that era, and had
three Irish uncles who fought with the Allies; but it was not a record that was
much celebrated when they came home, and they all eventually emigrated. In
the last generation, the world of Irish people like them, for whom the war was a
defining experience, has begun to be reclaimed – in landmark books of social
history such as Clair Wills' *That Neutral Island* (2007), and research projects into
the record of Irish soldiers who fought with the Allies. The essays that follow
represent a suggestive exploration into an imaginative territory which has been
too long left uncharted. Through the worlds of literary imagination it also recap-
tures the instability and erosion of frontiers which Bowen, in that same
introduction to *The Demon Lover*, associated with the atmosphere of war.
'Sometime I hardly knew where I stopped, and somebody else began […] Walls
went down; and we felt, if not knew, each other. We all lived in a state of lucid
abnormality.'[3] Which is, perhaps, where writers aspire to be.

R.F. Foster
Carroll Professor of Irish History
Hertford College
University of Oxford

3 Bowen, 'The Demon Lover', p. 95.

Introduction

DOROTHEA DEPNER AND GUY WOODWARD

> There are twelve of you here, and much snow
> At a thousand feet, in the folded wings
> Of the European theatre, where time means nothing.
> I look at your graves. I see my own name written.
>
> Harry Clifton, 'German War Dead, Glencree Cemetery'

Glencree Cemetery, a former quarry in the Wicklow Mountains, is the remote final resting place of 134 German servicemen, the majority of whom drowned off the Irish coast or crashed on the island during the Second World War. Harry Clifton's encounter with their graves in the wintry Irish landscape prompts an imaginative act of excavation and remembrance. Mining this small, obscure plot, he removes layers of oblivion to reveal that the divisions which seem to separate past and present, self and other, are not set in stone: all it takes to step out of the shelter of 'the folded wings of the European theatre' is personal investment and the realization that Ireland was, and is, part of the historical events that reverberated across the entire continent. The authors of the essays in this collection engage in a similar endeavour, unearthing unfamiliar connections entertained by artists and writers, connections that anchor Irish culture firmly within the larger framework of European history.

This book has its genesis in a symposium entitled 'Writing Home: Irish Culture and Wartime Europe, 1938–1948', which was held at Trinity College Dublin in 2013 and was launched with an inspirational reading by Harry Clifton. It includes essays by participants in the original conference and some new reflections, all of which contribute to, and broaden, the debate on the impact of the Second World War on Irish literature and culture within a decade that encompasses both the eve and aftermath of the war. In contrast to the economic stagnation and political isolation that, according to conventional readings, defined Ireland during the 'Emergency', the contributions in this volume all testify to an uninterrupted dialogue and exchange with the Continent through the media of literature and art.

Creative engagements by individual writers and artists with the Second World War form part of the archive of Irish cultural memory, and exploring them critically is itself part of a dynamic process that does not merely reflect, but can also define and redefine the way Irish society conceives of itself. Aleida Assmann describes this dynamic interplay existing between 'functional memory' – where a society's highly selective recollection of the past serves to legitimize an official discourse and to distinguish the community involved in its memorial practices from others – and 'storage memory', which holds data regardless of its relevance to the present.[1] Invariably, functional memory neglects, and sometimes consciously suppresses, alternative versions of the past. Yet storage memory, fed by the arts, sciences, archives or museums already contains in its repository the elements for future functional memories, for it allows the critical distance necessary to assume a different perspective from the canonized version of the past and can subvert its scope by retrieving events and narratives that differ from those valorized at a given moment.

As we write this introduction, we are acutely aware of the weight placed on 2014 as a year of commemoration in Europe: one hundred years since the outbreak of the First World War, seventy-five years since the start of the Second. The vision of Europe as a space evolving from a divided past into a united future informs current official discourse, best epitomized perhaps in Herman Van Rompuy's 2012 Nobel Lecture, 'From War to Peace: A European Tale'.[2] Although Ireland, at first glance, seems to hold relatively little stake in an idea of shared European memory that centres on the Second World War as its unifying, inaugural event, in recent years the country has shown signs of adopting a memorial culture that includes commemorations of both world wars.[3] In May 2013, the state went one step further, granting an apology and pardon to some 5,000 Defence Forces personnel who deserted to fight with the Allies in the Second World War, paying respect to their contribution 'in the fight against tyranny'.[4] These changes in memorial practices exemplify not only what Ann

1 Aleida Assmann, *Cultural Memory and Western Civilization: Functions, Media, Archive* (Cambridge, 2011), chapter 6. Other scholars who have contributed towards developing a dynamic concept of cultural memory include Jan Assmann, Ann Rigney, Michael Rothberg and Astrid Erll. See J. Assmann, 'Collective Memory and Cultural Identity', *New German Critique*, 65 (1995), 125–33; A. Rigney, 'Plenitude, Scarcity and the Circulation of Cultural Memory', *Journal of European Studies*, 35 (2005), 11–28; M. Rothberg, *Multidirectional Memory: Remembering the Holocaust in the Age of Decolonization* (Stanford, 2009); Astrid Erll and Ann Rigney, 'Literature and the Production of Cultural Memory: Introduction', *European Journal of English Studies*, 10:2 (2006), 111–15. For an exploration of Irish cultural emblems, literary icons and historical landmarks, see Oona Frawley's series *Memory Ireland* (Syracuse, 2010–14). 2 Delivered on the occasion of receiving the Nobel Peace Prize on behalf of the European Union in Oslo on 10 Dec. 2012, http://www.nobelprize.org/nobel_prizes/peace/laureates/2012/eu-lecture_en.html, accessed 21 Aug. 2014. 3 In addition to official commemorations, two scholarly studies published in recent years highlight the fate of Irish participants in the Second World War: Bernard Kelly, *Returning Home: Irish Ex-Servicemen after the Second World War* (Dublin, 2012) and Steven O'Connor, *Irish Officers in the British Forces, 1922–45* (London, 2014). 4 Marie O'Halloran, 'Bill Granting Pardon

Rigney calls the 'copy-cat dimension to memorial culture',[5] but also the extent to which symbolic media (texts, images, rites or monuments) that mediate the past can travel beyond temporal and spatial boundaries to encourage identification and solidarity within 'imagined communities' far larger than the nation.[6]

And yet the key components of today's 'European Tale' can already be traced in Hubert Butler's 1941 essay, published in *The Bell*, against 'barriers' within and between European societies, in which he urges his fellow Irish to 'create some social organism to overcome the barriers between ourselves, so that it can extend its scope outside our island when peace returns.'[7] They are also present in Seán Ó Faoláin's essay 'One World', which appeared in the same publication three years later, in which he argued that Ireland's 'future is locked with the future of Europe.'[8] Of course, the urgency with which Ó Faoláin and the well-travelled Butler reminded Irish readers of the long tradition of cross-fertilization between Ireland and European cultures itself spoke volumes of the damage they feared isolationism was inflicting on Irish culture during the war. Decades passed before Ó Faoláin's view became accepted political currency, unlocking the unique potential of 'coming to terms with the past [...] in comparative contexts and via the circulation of memories linked to what are only apparently separate histories and national or ethnic constituencies'.[9]

In *The Irish Story*, R.F. Foster argues that history could be divested of its totalizing tendency 'by rereading it, and by realizing and accepting the fractured, divergent realities, and the complications and nuances behind the various Stories'.[10] The emphasis on multiple perspectives and nuances is important in order to avoid subordinating the past to contemporary political agendas. Doing so would result in 'a diminishing rather than a deepening of historical understanding',[11] as Diarmaid Ferriter warns in the context of reassessing Irish neutrality during the Second World War. If the idea of a shared past, rooted in the Second World War,[12] holds an undeniable appeal as a narrative of reconciliation and integration, an undifferentiated, emotional approach to these same events risks conflating present concerns with past events. Adopting a uniform narrative also risks establishing an essentialist collective memory which, as Ann Rigney points out, excludes those who do not share this past.[13]

for Deserters Passed', *Irish Times*, 8 May 2013. **5** Rigney, 'Plenitude', 24. **6** Astrid Erll, 'Travelling Memory', *Parallax*, 17:4 (2011), 4–18 at 15. **7** Hubert Butler, 'The Barriers', *The Bell*, 12:4 (1941), 40–5 at 45. **8** Seán Ó Faoláin, 'One World', *The Bell*, 7:5 (1944), 373–81 at 380. **9** Rothberg, *Multidirectional Memory*, p. 272. **10** R.F. Foster, *The Irish Story: Telling Tales and Making it up in Ireland* (London, 2001), p. 35. **11** Diarmaid Ferriter, 'Denigrating Neutrality during Second World War has Become Fashionable: Historical Understanding of the Emergency has Diminished', *Irish Times*, 11 May 2013. **12** See, for example, Dan Diner, 'Memory and Restitution: World War II as a Foundational Event in a Uniting Europe' in Dan Diner and Gotthart Wunberg (eds), *Restitution and Memory: Material Restoration in Europe* (New York, 2007), pp 9–23 at p. 9. **13** Ann Rigney, 'Transforming Memory and the European Project', *New Literary History*, 43:4 (2012), 607–28 at 616.

In order to acknowledge and preserve diverse historical experiences of this period, what is needed is a sustained, critical engagement coupled with 'an awareness of the alterity of the past *wie es eigentlich gewesen* ("as it actually happened") [...] as an antidote to complacency and temporal foreshortening.'[14] A number of Irish historians have researched the nuances of Irish neutrality, including Donal Ó Drisceoil, Brian Girvin, Geoffrey Roberts, Dermot Keogh and Mervyn O'Driscoll.[15] In 2007, Clair Wills published *That Neutral Island: A Cultural History of Ireland during the Second World War*, a multi-facetted, ground-breaking study of Irish experiences of the war outside the realms of politics and diplomacy. Wills examined a wealth of sources from the archive of Irish cultural memory, including the works and personal reflections of Irish writers.

The authors who have contributed to this collection continue in this vein, offering unfamiliar perspectives on Irish culture during the Second World War often deriving from their own archival research into contemporaneous sources such as diaries, letters, and manuscripts. Crucially, these sources allow us to see how events unfolding on the Continent were interpreted contemporaneously, rather than with the benefit of hindsight. In mining the prodigious archives of Denis Johnston to illuminate *Nine Rivers from Jordan*, his vast work of wartime reportage, Tom Walker demonstrates that 'an Irish cultural frame [offers] illuminating ways of seeing in relation to Europe's present'. Maurice Walsh, meanwhile, focuses on Johnston's role as a journalist and 'continuous, forensic, but imaginative exploration of his own role as a witness'. Johnston is perhaps best known for his work for the stage, but one of the guiding ambitions of this volume was to re-read works by familiar Irish writers in the light of their wartime experiences. To this end, Ute Anna Mittermaier repositions Kate O'Brien's writings of the 1930s and 40s in a newly politicized context, examining the historical novel *That Lady* (1946) alongside journalistic writings and unpublished lectures and letters to chart O'Brien's growing disquiet at the parallels between the quasi-theocratic regime of General Franco in Spain and the unhealthily close alliance between the Catholic Church and the emergent Irish state. Dorothea Depner likewise draws on the wartime diary notes and post-war novels of Francis Stuart to reveal Stuart's concerted efforts 'to filter his experience through acceptable narrative models of victimhood and survival.' Simon Workman's essay on the wartime poetry of Patrick Kavanagh and Louis MacNeice argues that the context of European war 'presented a profound

14 Ibid. 15 See Donal Ó Drisceoil, *Censorship in Ireland 1939–1945: Neutrality, Politics and Society* (Cork, 1996); Brian Girvin and Geoffrey Roberts (eds), *Ireland and the Second World War: Politics, Society and Remembrance* (Dublin, 2000); Dermot Keogh and Mervyn O'Driscoll (eds), *Ireland in World War Two: Neutrality and Survival* (Cork, 2004); Brian Girvin, *The Emergency: Neutral Ireland 1939–45* (Dublin, 2006).

challenge to the core of both writers' poetic faculty' and resulted in a closer align-ment between two poets whose pre-war writings displayed contrasting relationships with the place and society in which they lived and wrote. And Kathryn White reads beyond John Hewitt's poetry to his role as a gallery man and curator, showing how contemporaneous Northern Irish painting had a profound effect on the development of his poetic aesthetics.

White identifies a distinct 'northern rhythm' that permeates both the landscape paintings of Belfast artist John Luke and Hewitt's poetry, and this book too considers the northern dimension so often missing from narratives of neutral Ireland, beyond the familiar tales of cross-border smuggling. Guy Woodward's study of Stephen Gilbert's Dunkirk novel *Bombardier* suggests that Gilbert's status as a Northern Irishman serving in the British Army contributed to his ability to make the subtle challenges to official and mythical versions of events depicted in this fictionalized historical account. Exploring the activities of the English artist Nevill Johnson in Northern Ireland during the war, Conor Linnie describes how a beleaguered but resolute group of artists, disparate in their artistic sensibilities and endeavours, were joined by a mutual determination to counter the isolated and conservative cultural atmosphere of Belfast at this time.

This collection also unpacks the significance of some overlooked connections between mid-century English literature and culture and Ireland, through the Irish hinterlands of some resolutely canonical English writers. Exploring verse by John Betjeman, who served as British press attaché in Dublin from 1941 to 1943, Alex Runchman traces intersections between an emergent Irish realist tradition in the 1940s with a discordant and enduring English tendency to perceive Ireland in romantic terms. Anne Thompson examines the notebooks and personal papers of T.H. White and finds that the English novelist's experiences in Ireland during the war strongly influenced the writing of his Arthurian epic *The Once and Future King*. Eve Patten's consideration of the effect of time spent in Ireland on the novels of Graham Greene and Evelyn Waugh, meanwhile, shows how English writers invested 'figuratively and literally' in neutral Ireland 'as a reaction to a disturbed domestic landscape and, by extension, to the horizon of social devastation and post-imperial fall-out across the continent.'

By contrast Julie Bates, quoting Samuel Beckett's assertion that he preferred 'France at war to Ireland at peace', suggests that Beckett's double exile during the war, from Ireland and then from Paris, inspired a form of 'fugitive literature', whose thematic and formal identification with homelessness is directly compa-rable to the writings of the German author W.G. Sebald some half a century later. And concluding this volume, Gerald Dawe's deeply personal essay 'The war came down on us here', the title of which quotes from MacNeice's poem 'The Coming of War', registers the impact of the war on post-war poets in

Ireland and Europe. Growing up in Belfast in the 1950s and 60s, for Dawe the legacy of the Second World War 'was dominated by a constructed sense of our Britishness', but by the time his second collection of poetry appeared in 1985 he had 'a more coherent understanding that Europe was a way of life and writing, and of understanding history and identity'. Now, he argues, 'the cultural, social and economic interconnectedness of Ireland with neighbouring Britain and Europe, and the fluidity of those relationships when placed in the aftermath of the Second World War [...] are at the very heart of Irish writing.'

All of these essays confirm that the arts, capturing, questioning and particularizing different experiences of the past, should be central to any examination of how the Second World War has been interpreted, translated and transformed. The explorations in this book of various Irish artists' responses to the war, as well as the responses of foreign artists living in Ireland during the war, show that the negotiation of the present's relationship to the past is an ongoing process and suggest that attempts to understand this period in Irish and European history require dialogic exchange and personal, critical investment rather than the creation of new master narratives. The encounters between home and abroad, self and other, which these artists experienced and creatively reimagined, play a crucial role both in allowing us alternative views of the past that complicate established narratives of Irish neutrality and isolation and in helping us to see Ireland's position from an extraneous perspective. In this way, they all participate in shaping the 'imagination' of Europe, even long after their death, contributing towards the process which French philosopher Paul Ricœur considers the key to the future: 'It is no extravagance to formulate the problem of the future of Europe in terms of imagination'.[16]

16 Richard Kearney (ed.), *Paul Ricœur: The Hermeneutics of Action* (London, 1996), p. 3.

'Poised on the edge of absence': Kavanagh and MacNeice in the shadow of war

SIMON WORKMAN

Patrick Kavanagh and Louis MacNeice were both in Dublin on 3 September 1939 when Chamberlain announced, via radio broadcast from the Cabinet room in Downing Street, that Britain had declared war on Germany. MacNeice was holidaying in Ireland and had spent the previous evening drinking with the 'Dublin Literati'; a set which may have included Brian O'Nolan, F.R. Higgins, Austin Clarke, Donagh MacDonagh and Robert M. Smyllie. No doubt the drinking party frequented the Palace Bar at some stage in the evening, the site of a later row over MacNeice between Clarke, Higgins and Padraic Fallon; a literary fracas which Kavanagh witnessed and went on to record in his satirical 'The Ballad of the Palace Bar'. The night must have been jovial, for MacNeice recalls hearing the sobering news of war in a sluggish, half-inebriated haze: 'Sunday morning the hotel man woke me (I was sleeping late and sodden), said, "England has declared war". Chamberlain's speech on a record was broadcast over and over again during the day.'[1] According to Antoinette Quinn, on the same morning Kavanagh was ambling 'fresh and foolish' down Drumcondra Road when he 'came upon a boy holding a Stop Press before him like an apron. It consisted of only one word.'[2] One immediate consequence of war for Kavanagh was that the incipient, if one-sided, relationship with Maeve Mulcahy, a friend of Frank O'Connor, came to an end; Mulcahy had felt obliged to return home to her widowed father in Sligo. The war would also have a dampening effect on MacNeice's prospective romance with the American writer Eleanor Clark, whom he had met during a lecture tour of the US earlier in the year. On his second visit to America in 1940, MacNeice, like Kavanagh, played the role of frustrated troubadour. Clark's affections towards MacNeice seem to have cooled markedly during this period, exacerbated in part by their differing perspectives on the political and moral implications of war.

1 Louis MacNeice, *The Strings Are False: An Unfinished Autobiography*, ed. E.R. Dodds (London, 1965), p. 221. 2 Antoinette Quinn, *Patrick Kavanagh: A Biography* (2nd ed. Dublin, 2001).

The European conflagration, of course, not only played upon the romantic sphere of these poets' lives but induced a heightened consciousness of their connections to home, re-focusing their attitudes towards Irish culture and society. The problem of home in relation to identity is one which is writ large in the work of both poets, though critics have tended to view Kavanagh and MacNeice as inhabiting decidedly different, even inverse, positions in terms of their connection to, and valorization of, home ground. Elmer Kennedy-Andrews argues:

> In the unresolved dialectic between the sense of displacement and the longing for home, there are [...] at one end of the spectrum [...] Hewitt's regionalism and Kavanagh's parochialism as versions of a territorial option which construes place as the unifying ground of identity; at the other, is the example of MacNeice's de-territorialised dwelling in in-between worlds, a position which, rejecting both Kavanagh's monocular vision of place and Hewitt's demand for rootedness, embraces otherness, migrancy and plurality in the struggle for identity and meaning.[3]

The dichotomy underpinning Andrews' formulation suggests a somewhat misleading binary in the sense that, on the one hand, it fails to acknowledge the degree of evolution in Kavanagh's concept of the parochial, and on the other, it overemphasizes MacNeice's accession to an extirpated form of identity. In what follows, it will be argued that the effects of writing in the context of Europe at war (and after) presented a profound challenge to the core of both writers' poetic faculty, contributing to a reformulation of aesthetic approach which drew them into closer alignment than might have been expected, based on the evidence of their pre-war writing.

It is not difficult to understand why MacNeice and Kavanagh have often been seen as occupying opposite ends of a poetic spectrum. The biographical facts reveal that that the poetic sensibilities of both poets were forged and calibrated in very different socio-cultural contexts. MacNeice spent his early years in an upper-middle-class Anglican household (his father was a Protestant bishop) in the north of Ireland, before entering an elite (and elitist) English educational system in which his dazzling intellect allowed him to flourish. After preparatory school at Sherborne, MacNeice won a scholarship to Marlborough College from which he won a scholarship to Merton College, Oxford, eventually gaining a double first in Classics. His peers during this period included Anthony Blunt, W.H. Auden and Stephen Spender, all of whom played an

3 Elmer Kennedy-Andrews, *Writing Home: Poetry and Place in Northern Ireland, 1968–2008* (Woodbridge, 2008), p. 52.

important part in his poetic and artistic education. After leaving Oxford he pursued a career as a lecturer at the University of Birmingham, Bedford College London and Cornell University, before entering the BBC in 1941, where he wrote, produced and directed radio programmes for over twenty years until his death. Kavanagh, on the other hand, grew up on the margins of academic and literary culture, working as a subsistence farmer in Mucker, Co. Monaghan, within a rural, Catholic community for whom his poetic ambitions were largely an anathema. An autodidact, Kavanagh drew what poetic sustenance he could from sources such as Palgrave's *Golden Treasury* and Russell's *Irish Homestead*, though these early encounters with poetry were as much hindrance as help to his achievement of a poetic voice commensurate with his lived experience in rural Ireland. He spent most of his life in Dublin, working variously as a journalist, reviewer and writer, though ultimately failing to gain either the financial security or the national recognition he felt his talent should have garnered. Cognisant of these facts, Alan Peacock has argued that 'Patrick Kavanagh is in many ways the antithesis of MacNeice: largely self-educated, of small-farmer stock, rough in his habits, anti-academic and socially abrasive'.[4] These obvious social and biographical differences, however, can occlude less explicit resonances in attitude and sensibility – a point well made by Alan Gillis, who observes that '[b]oth were vituperative critics of Irish culture. Both were lifelong enemies of cant, dogma, and inauthenticity. Both had the experience of negotiating modernism.'[5] These affinities, however, manifest themselves most readily when the totality of both poets' oeuvre is considered, and are less explicit in their work in the years immediately preceding the war; it is in this period, indeed, when their modes of writing seem most antithetical.

In 1938, the year of 'the Munich bother' as Kavanagh subsequently termed it, MacNeice was domiciled in London working at Bedford College teaching Greek. The year began well for him with T.S. Eliot, his editor at Faber, confirming that his latest collection of poems, *The Earth Compels*, would be published in the coming months. This was a particularly productive period for the poet, for he would go on to publish another three books that year, including: *Zoo*, a commissioned, rather impressionistic guide to London Zoo; *I Crossed the Minch*, a travelogue of the Hebrides; and *Modern Poetry*, an autobiographically inflected critical guide to contemporary poetry, drawing on the work Auden, Spender and Day-Lewis as examples of the modern. *Modern Poetry* was to become an important statement of MacNeice's poetics at the end of the 1930s, containing his well-known plea for '*impure* poetry' and his definition of the ideal

4 Alan Peacock, 'Received Religion and Secular Vision: MacNeice and Kavanagh' in Robert Welsh (ed.), *Irish Writers and Religion* (Gerrards Cross, 1992), p. 160. 5 Alan Gillis, '"Ireland Is Small Enough": Louis MacNeice and Patrick Kavanagh' in Julia M. Wright (ed.), *A Companion to Irish Literature*, 2 vols (Oxford, 2010), ii, p. 160.

poet as one whose world is not 'too esoteric', and who functions within the community as 'its conscience, its critical faculty, its generous instinct'.[6] The poetic attitudes expounded in *Modern Poetry* underlie MacNeice's celebrated long poem *Autumn Journal* (1939) which offers a depiction of pre-war England in the shadow of European crisis. The narrative is largely set in London, but veers between Marlborough, Birmingham, Oxford and memories of Spain just before the Civil War. The poem repeatedly bears witness to the increasing incursion of the political and historical into the personal realm, tracking how 'The bloody frontier / Converges on our beds', or how the 'latest' news of 'Hodza, Henlein, Hitler and the Maginot Line' 'cramps the lungs and presses / The collar down the spine'.[7] The Sudeten Crisis and the increasing threat to European stability caused by Nazi Germany's aggression exerts a constant pressure in the first half of the poem and is most explicit in sections V, VII and VIII. It is no accident that section VI, covering MacNeice's memories of his 1936 journey to Spain, is placed portentously at the heart of this part of the poem. Section VIII finishes with MacNeice's darkly ironic response to Chamberlain's strategy of appeasement at Munich, a policy which the poet now equates with the fairy tale:

> And negotiation wins,
> If you call it winning,
> And here we are – just as before – safe in our skins;
> Glory to God for Munich.
> And stocks go up and wrecks
> Are salved and politicians' reputations
> Go up like Jack-on-the-Beanstalk; only the Czechs
> Go down and without fighting.[8]

Throughout *Autumn Journal* MacNeice evinces a core of liberal humanist values, while also projecting a quasi-utopian hope for progressive future social re-organization; yet the poem is everywhere haunted by the inexorable rise of totalizing politics and fanaticism within Europe. In section XVI, MacNeice turns his attention to Ireland and offers some of his most abrasive commentary on his home country, excoriating, among other things: religious sectarianism, self-deceiving egoism, political intransigence, state censorship, the failing language movement, architectural vandalism and a fatal tendency towards fantasy and nostalgia. This withering philippic, however, is too often understood as existing in isolation from the rest of the poem, negating its connections to the larger European context and MacNeice's response to it. As Edna Longley argues,

6 Louis MacNeice, *Modern Poetry: A Personal Essay* (Oxford, 1938), p. 1. 7 Louis MacNeice, *Collected Poems*, ed. Peter McDonald (London, 2007), p. 109. 8 Ibid., p. 120.

this section emerges from the 'subconscious of *Autumn Journal* to interpret its whole political and moral stance.'[9] MacNeice's critique of Ireland's cultural introspection and rancorous, involute politics is thus in key with the poet's diagnosis of ethical failure and moral timorousness within a British political and cultural establishment facing ideological extremism in Europe. It should also be remembered that in the introductory note to *Autumn Journal* MacNeice acknowledged that the commentary on Ireland was one of the poem's 'over-statements' and part of a poetic approach that demurs from 'a final verdict or balanced judgement.' According to MacNeice, his central aim was 'to be honest before anything else', and he reiterated this point a year later stating that '"Autumn Journal" remains a journal – topical, personal, rambling, but, failing other things, honest'.[10] The poem's emotional and intellectual candour in the context of a rapidly changing local and European scene is one of its central attractions; a point made by Eliot (in his response on first reading the poem) who noted that he 'read it through without my interest flagging at any point' due in part to 'the fact that the imagery is all imagery of things lived through, and not merely chosen for poetic suggestiveness.'[11] The poem proved one of MacNeice's most popular publications, not least because it brilliantly captures the full range of his poetic personality and voice, while also offering one of the most vivid depictions of England on the brink of war.

In the same year that MacNeice began writing his most self-consciously 'honest' poem, Kavanagh's semi-fictional memoir *The Green Fool* (1938) was published – a work he would later decry as partly dishonest. This was Kavanagh's second significant publication following on from his first collection of poetry, *Ploughman and Other Poems*, which was published by Macmillan in 1936. At times in this collection Kavanagh slips into a neo-romantic pose in such poems as 'Ploughman', which verges on the overly trite and sentimental. At other moments, the verse is more complex and substantial, such as the remarkable 'Inniskeen Road: July Evening' which relates the poet's somewhat uncertain relationship to his local community. In this poem, the speaker is partly bereft of the life of the parish and the 'half-talk code of mysteries / and the wink-and-elbow language of delight.' His status as a poet causes a solitariness of perspective which leaves him 'king / Of banks and stones and every blooming thing.'[12] The punned word 'blooming' is redolent of the poet's ambivalence towards his artistic materials, suggesting both praise and disaffection. This dialectical movement between ironic dislocation from chosen subject matter and affective intimacy with the exterior world would become one of the central tensions in Kavanagh's work in the following decades.

9 Edna Longley, 'Autumn Journal', *The Honest Ulsterman*, 73 (Sept. 1983), 71. **10** MacNeice, *Collected Poems*, pp 791f. **11** Quoted in John Stallworthy, *Louis MacNeice* (London, 1995), p. 237. **12** Patrick Kavanagh, *Selected Poems*, ed. Antoinette Quinn (London, 2000), p. 6.

The Green Fool plays less upon the poet's distance from his local parish, although initially suggesting he is a figure on the margins of his community. Rural Inniskeen is depicted in warm tones and hues in the book, as Kavanagh offers a relatively sanitized, colourful and benevolent version of life in rural Ulster. The poet would later condemn the book as 'provincial', arguing, as Quinn states, that it 'was directed towards metropolitan audiences: a London publisher and readership which expected Irish fictional characters to be buffoons with the gift of the gab, and a Dublin literary set which romanticized the peasant as an *echt*-Irish figure.'[13] Kavanagh was perhaps overly harsh on the work which, at the very least, served an anthropological and cultural function in that it opened a window onto a way of life and culture that had been lesser spotted during this period. It is also worth noting that the positive critical response to the book may have been crucial in Kavanagh's fraught decision, in August 1939, to leave his nominal profession as cobbler and farmer in Monaghan and take his chances as a full-time writer in Dublin.

Like Kavanagh, MacNeice had also considered living out the war in Dublin, having applied for the chair in English Literature at Trinity College Dublin in 1939. However, as with Yeats before him, MacNeice was unsuccessful in his application for the post at the university and decided to leave Ireland for America, taking up a teaching post at Cornell in early 1940. Still conflicted in his response to war, MacNeice achieved a greater clarity regarding his role as a writer in wartime while on this second visit to America in 1940. His new attitude was summed up in a letter to E.R. Dodds in which he states: 'Freedom [...] means Getting Into things & not Getting Out of them'.[14] Acting under this new rubric, MacNeice returned to England at the end of 1940, explaining his decision in an article titled 'Traveller's Return' for *Horizon*:

> You cannot forget the War in America (it is the chief subject of conversation), but you cannot visualize it [...] From June on I wished to return, not because I thought I could be more *useful* in England than in America, but I wanted to see things for myself. My chief motive thus being vulgar curiosity, my second motive was no less egotistical: I thought that if I stayed another year out of England I should have to stay out for good, having missed so much history, lost touch.[15]

Kavanagh had also spent the first months of the war worrying over his destiny as a writer, though for the Monaghan poet the possible paths seemed fewer. He was torn between the secure, familiar round of a rural farmer in

13 Ibid., p. xv. 14 Quoted in Heather Clark, 'Revising MacNeice', *Cambridge Quarterly*, 31:1 (2002), 85. 15 Louis MacNeice, 'Travellers Return', *Horizon*, 3 (Feb. 1941), 110.

Inniskeen and the stimulating though frequently impecunious profession of a working writer in Dublin, which involved relying on his brother's financial support. Kavanagh's consequent ambivalence towards his adopted city informs his first public pronouncements about the war which appeared in the *Irish Press* on 25 October 1939. The article entitled 'Europe Is at War' opens: 'Midnight in Dublin [...] The radio in the flat above me has stopped forwarding to this address the mixture of blather and jazz which is called propaganda and which is supposed to influence the masses [...] Being an Irishman I should be abnormal if I didn't dream, think and write of far-past peace and quiet in pastoral fields when everyone else is thinking of war.'[16] Kavanagh then cross-fades into a rural scene of three men pitting potatoes and reveals, wryly perhaps, how the most important question for these farmers is whether their 'Ma' 'wets the tay' in a timely fashion. He finishes the article in deflationary mode in reference to the war: 'I remember some wild talk of Europe. Who is this referred to it? Oh, yes, that radio commentator. But I know that beyond the headlines, beneath the contemporary froth and flurry the tide of humanity flows calm.'[17]

Neither Kavanagh nor MacNeice were active combatants in the war, although MacNeice did unsuccessfully volunteer for the Royal Navy (failing to be admitted due to bad eyesight) and worked as a fire-watcher in London. However, Kavanagh's and MacNeice's responses to the war, as revealed in the two passages quoted above, are suggestive of significantly different forms of historicizing. In MacNeice's conception, the European conflagration can be understood as a centrifugal core of historic consequence and moment. For MacNeice, as suggested in later poems such as 'Brother Fire' (and we may note the influence of Yeats here), Europe is a now a terrifying, fertile zone where history is quite literally being made. Kavanagh, on the other hand, conceives of the pith of human history and life as potentially grounded elsewhere. This perspective is apparent, though not consistently, in his long poem *Lough Derg*, written in 1942 after Kavanagh's pilgrimage there. In one of the central sections of the poem, he states:

> Then there was the war, the slang, the contemporary touch,
> The ideologies of the daily papers.
> They must seem realer, Churchill, Stalin, Hitler,
> Than ideas in the contemplative cloister.
> The battles where ten thousand men die
> Are more significant than a peasant's emotional problem.
> But wars will be merely dry bones in histories

16 Patrick Kavanagh, *A Poet's Country: Selected Prose*, ed. Antoinette Quinn (Dublin, 2002), p. 39.
17 Ibid., p. 43.

> And these common people real living creatures in it
> On the unwritten spaces between the lines.[18]

Towards the end of the poem Kavanagh draws a meaningful parallel with the undocumented activities of the pilgrims at Lough Derg and the events on the Eastern front that would have been making headline news: 'All happened on Lough Derg as it is written / In June nineteen forty-two / When Germans were fighting outside Rostov'.[19] Kavanagh's witnessing of the quotidian lives of peasants in these lines, his role as the bard of unwritten spaces, can be seen as projecting a socially minded revisionism into the prospective historiography of war. Kavanagh deconstructs orthodox historical discourses by drawing attention to the places and people that the spotlight of history usually passes over. Reflecting on the rural existence he has left behind, Kavanagh remarks in 'Europe Is at War': 'Stark and lonely it might seem at times, grey and forlorn as the night poplars of late autumn, but it was real. I was among real folk without false conventions'.[20] Such ontological analysis suggests that Kavanagh's faith in the authenticity of life beyond the urban centres of culture has been unaffected by the larger European context. Kavanagh remains deeply rooted in an intimately known rural community, which he presents as possessing an unaffected vitality and social verity.

A different attitude can be noted in MacNeice's writing of the early war period. At the beginning of his critical study *The Poetry of W.B. Yeats* (1941) he states: 'I had only written a little of this book when Germany invaded Poland. On that day I was in Galway. As soon as I heard on the wireless of the outbreak of war, Galway became unreal.'[21] This sense of how the settled realities of peace-time Ireland become alarmingly destabilized by the European conflict is conveyed powerfully in MacNeice's poem sequence 'The Coming of War', written in August and September 1939. In the section entitled 'Cushendun' about MacNeice's time spent in his father's rented cottage in Cushendun Bay, the poet initially describes a sensuous, soporific landscape of 'Forgetfulness [...] home-made bread and the smell of turf or flax / And the air a glove and the water lathering easy'. This lotus world, however, is troubled in the last stanza by outside perspectives:

> Only in the dark green room beside the fire
> With curtains drawn against the winds and waves
> There is a little box with a well-bred voice:
> What a place to talk of War.[22]

18 Kavanagh, *Selected Poems*, p. 57. 19 Ibid., p. 65. 20 Kavanagh, *A Poet's Country*, p. 43. 21 Louis MacNeice, *The Poetry of W.B. Yeats* (Oxford, 1941), p. 1. 22 MacNeice, *Collected Poems*, p. 180.

The last word reverberates forcefully through the previous fifteen lines of the poem as the genteel, though alien, voice from the 'little box' invokes the barbarism and bloodshed now prevalent on the Continent. MacNeice is unable to blithely dismiss the radio headlines as 'froth and flurry' or to rest easy that 'the tide of humanity flows calm' beneath. Indeed, the image of the dark green room with curtains drawn against the wind and waves offers a microcosm of Ireland's new position, figuratively expressing the precariousness of a nation facing the looming storms from Europe. In a later section of the sequence entitled 'Galway', MacNeice lyrically evokes different aspects of the western city, before the coming war undercuts these tranquil vistas. Each seven-line stanza in the poem ends with the drumming refrain: 'The war came down on us here'.[23] Throughout the poem Ireland is conveyed as a potentially attractive place for refuge, but this escapist impulse is frequently punctured by an awareness of larger European contingencies suddenly encroaching.

Despite the complicating factor of his nationality, the seductive pull of Irish refuge, and initial uncertainty as to the merits of war, MacNeice felt that on balance the Allied cause was a 'lesser Evil'. On his return to England in 1941, he fully committed himself to the fight against fascism and began to write propaganda for the BBC after securing employment there as a features writer. The first series that MacNeice worked on was aimed at America and was called 'The Stones Cry Out'. It took as its theme old buildings under threat from bombardment, such as Westminster Abbey and St Paul's Cathedral, which could be used as symbols to stress shared values of an Anglo-American heritage. As the war progressed, MacNeice was tasked with bolstering support for various other Allied countries at pertinent moments in the war. When Hitler declared war on Russia, MacNeice was asked to adapt Sergei Eisenstein's filmic masterpiece *Alexander Nevsky* for radio. The play was broadcast on 8 December 1941 and the production went out live on the Home Service. Before the play, a recorded announcement, written by MacNeice and spoken by the Soviet Ambassador Maisky, was to be played. Yet, just as the broadcast was about to begin, an indefinite delay was ordered for an incoming news bulletin: it announced the attack on Pearl Harbor. Thus, in a remarkable night for BBC radio, listeners would have heard Roosevelt and Churchill in quick succession, and then Maisky announcing his tribute to Russia. The subsequent entry of America into the war prompted the BBC to commission MacNeice to write *Christopher Columbus*, a play based on the life of Columbus and broadcast on the Home Service on 12 October 1942, the 450th anniversary of Columbus' entry into the new world.

MacNeice also wrote plays and features centred on European countries and regions under Nazi occupation such as Greece, Austria and Sicily. One of the

23 Ibid., p. 182.

more interesting dramas he wrote during this period was the play 'The Story of My Death', a satire on Italian Fascism. The narrative is centred on the real-life story of the Italian poet Lauro de Bosis who, in 1931, had piloted a plane in a daring suicide mission over Rome, distributing anti-Fascist leaflets in a last gesture in a campaign against the Fascist Italian government. It was the first feature MacNeice had suggested himself and he commented later that 'I have always thought of it as *technically* one of my more interesting programmes'.[24] The play is a study on the nature of freedom, and towards the end de Bosis makes clear to his Marxist collaborator 'Shorty' that his goal is to spark political transformation which will permit a society of free-thinking individuals: 'We can't deal in Utopias. There are thousands of People in Italy who've got minds and hearts. Knock down the Fascist regime and all those people, Shorty – for the first time for years – will be able to think and feel. Once they can think, they will act.' Like the hero of his play 'Icaro', De Bosis' goal is the sweeping 'away of all barriers from the earth' and bringing 'the blue freedom of birds' to the 'human race divided and blind with hate'.[25] The play ends as De Bosis dies in his plane in pursuit of his dream of a better future for humanity.

MacNeice's composition of 'The Story of My Death' suggests a sense of optimism as to the possible future for Europe after the war and also reveals how importantly he was now taking his job at the BBC. At this time the poet was increasingly enamoured of the sense of collegiality in his working life, while also admiring the atmosphere of combined effort within the wider community in which he lived. This greater social cohesion, of course, was partly induced by the conditions of war, but it was during this time that MacNeice felt a stronger sense of social integration and belonging than perhaps at any other period in his life. As Robyn Marsack argues, 'MacNeice found in the atmosphere of wartime London exactly that sense of community whose passing from more primitive regions he had regretted.'[26] Yet the war was not without tragedy for MacNeice, and the death of his father in April 1942 and of his friend Graham Shepard on board a corvette in the mid-Atlantic in 1943 were particularly difficult for the poet. MacNeice elegized his father as a 'generous puritan' in 'The Kingdom', while in the radio play *The Dark Tower* (1946) and the poem 'The Strand' (both written in Ireland at war's end) MacNeice attempts to get his relationship to his father and his home into better perspective. The radio play *He Had a Date* (1944) is informed by Shepard's tragic death and the poem 'The Casualty' is a more direct elegy to a friend MacNeice praised as understanding the 'integrity of

24 Quoted in Barbara Coulton, *Louis MacNeice in the BBC* (London, 1980), pp 63f. **25** 'The Story of my Death', written and produced by Louis MacNeice (8 Oct. 1943), pp 20, 32. Page numbers indicate original page number on the script. All MacNeice's unpublished radio scripts can be accessed in the BBC Written Archives Centre, Caversham, Reading, United Kingdom. **26** Robyn Marsack, *The Cave of Making: The Poetry of Louis MacNeice* (Oxford, 1982), p. 69.

differences'.[27] It has been suggested that the bitterness MacNeice felt at losing Shepard fed into 'Neutrality', a strident attack on Ireland's foreign policy and insularity. The poem, however, was completed before Shepard's death, though it does register a general bitterness at Ireland's seeming indifference to those, like Shepard, who were risking their lives to defeat Nazism. In the poem MacNeice upbraids Ireland's isolationism, which cannot shield it from the political realities close at hand:

> Look into your heart, you will find fermenting rivers,
> Intricacies of gloom of glint,
> You will find such ducats of dream and great doubloons of ceremony
> As nobody to-day would mint.
>
> But then look eastward from your heart, there bulks
> A continent, close, dark as archetypal sin,
> While to the west off your own shores the mackerel
> Are fat – on the flesh of your kin.[28]

The intoxicating draw of fermenting rivers with their chiaroscuro surface echoes a Yeatsian invocation of mythic or Twilight Ireland as does the reference to the properties of 'dream' and 'ceremony'. The anachronistic currencies – 'ducats' and 'doubloons' – spell out the moral bankruptcy at the core of Ireland's neutral stance. As Clair Wills has suggested, the final stanza may be based on the stories of 'fishermen in the West selling their catches to U-boat commanders' and that '[i]n a macabre parody of self-sufficiency, MacNeice indicted Ireland for feeding off the harvest of corpses produced by neutrality.'[29]

To be sure, 'Neutrality' represents something of a low point in MacNeice's relation to his home country, but it should be remembered that a year before the poem was written the poet had acknowledged the 'agonizingly difficult' predicament facing de Valera in charting Ireland's route through the war.[30] Furthermore, the poem can also be read as indicting a more timeless human frailty towards escapist introspection and moral egocentricity – 'the neutral island in the heart of man' – which transcends the Irish context. The use of the second person pronoun is significant in this regard, for it tacitly implicates both reader and speaker in the 'archetypal' betrayal of their human 'kin'. These allegorical procedures point to certain aesthetic developments in MacNeice's verse which the poet increasingly deployed during and after the war. As Terence Brown notes, the poems of the war years display a 'predilection for dreams,

27 MacNeice, *Collected Poems*, p. 247. **28** Ibid., p. 224. **29** Clair Wills, *That Neutral Island: A Cultural History of Ireland during the Second World War* (London, 2007), p. 129. **30** Louis MacNeice, *Selected Prose of Louis MacNeice*, ed. Alan Heuser (Oxford, 1990), p. 116.

fantasy, and myth [...] as they become more and more involved in the technical problems of double level writing – that is writing where an appearance of surface realism belies the mythic and symbolic depths.'[31] Particularly in the poems MacNeice wrote directly after the war, these 'mythic and symbolic depths' often become synonymous with Ireland and with layers of memory connected to MacNeice's native place.

The war had tested MacNeice's allegiances to Ireland, but it had not broken his identification with the country or left him exiled. Indeed, the poet was happy to return to Ireland in the weeks following Churchill's announcement of Allied victory in May 1945. He spent the summer on Achill Island with his family writing *The Dark Tower* and developing a series of poems on Irish locales that would be placed at the centre of his next book of poems, *Holes in the Sky* (1948). In such poems as 'Last before America', 'Carrick Revisited', 'The Strand', 'Slum Song' and 'Western Landscape', Irish vistas are treated in a less polemical fashion than previously as MacNeice's tone and attitude towards Ireland became more measured and more dispassionate. Such was MacNeice's contentment in Ireland at this time that he was prepared to lose a month's salary in order to extend his stay. Writing to Laurence Gilliam, his boss and head of the Features Department at the BBC, MacNeice asked for his leave to be extended because he was: '(1) Irish – and have not been in my own country for three years and not for long then – and (2) an (for want of a better word) artist – which means that I can do some hack work all of the time [...] but not all hackwork all of the time'.[32] During this period, MacNeice not only reacquainted himself with familiar Irish landscapes and territories, but also made contact with the cultural and literary life in the north of the country. He spent time with writers such as W.R. Rodgers and Sam Hanna Bell and involved himself in the Northern periodical *Lagan*, which had been established a couple of years earlier by Bell, John Hewitt and John Boyd. In 1946 MacNeice contributed the poem 'The Godfather' to the periodical's final number to which Rodgers also contributed sections from his radio feature on Armagh, 'The City Set on a Hill', which MacNeice had produced in Belfast the previous year. In the same year MacNeice also became involved with the Dublin-based periodical *The Bell* as poetry editor. Though MacNeice's brief editorship was relatively low key, with few poems of real quality published under his watch, the poet did publish Kavanagh's 'Elegy for Jim Larkin', a tribute to the socialist activist who had died early in 1947. A decade earlier, in *Letters from Iceland* (1937), MacNeice had paid tribute to James Connolly, with whom Larkin had founded the Irish Labour Party in 1912, so he may have felt a special resonance on encountering Kavanagh's commemoration of one of Ireland's most notable socialist figures.

31 Terence Brown, 'Louis MacNeice's Ireland' in Terence Brown and Nicholas Grene (eds), *Tradition and Influence in Anglo-Irish Poetry* (London, 1989), pp 90f. **32** Quoted in Stallworthy, *MacNeice*, p. 336.

Kavanagh, of course, had been contributing to *The Bell* since its inception in 1940, and his writing had responded to the journal's critique of Irish romantic nationalism, clericalism and revivalist stereotyping of rural Ireland. Through his association with its founders, Seán Ó Faoláin, Peadar O'Donnell and Frank O'Connor, Kavanagh was emboldened to write *The Great Hunger* (1942), an eviscerating account of life in rural Ireland during the 'Emergency'. Despite Kavanagh's sanguinity at the beginning of the war, like MacNeice, he came to express bitter frustration at the state of Ireland in wartime, although Kavanagh was writing of the reality of life from the inside. Maguire, the focal character of *The Great Hunger* is part of a deadened rural community existing in a devastated landscape devoid of spiritual, artistic, social and economic nourishment. When Kavanagh began to write the poem in autumn 1941, the war was beginning to exacerbate already perilous living conditions for the rural poor as food shortages and depopulation through emigration linked to the British war economy increased. This was also the period in which the Russian front became the main theatre of war, and Kavanagh may have been alert to this context. Wills suggests that Kavanagh intimates a resonance between the Irish and Russian peasantry, in that 'Maguire is described as a soldier fighting a long war for survival. "A wind from Siberia" blows across Monaghan and connects the farmer's battle with that of the Soviet conscripts. But Maguire's existence, and his potency, has contracted to the futility of "no target fired". This is a neutral war – a war without target – and war of the powerless.'[33]

This powerlessness seems to pervade all aspects of *The Great Hunger*, in which a rural society is portrayed as politically disenfranchised, emotionally and sexually hamstrung by the church, and creatively neutered. A similar point of view is also put forward, though less stridently, in *Lough Derg* where Kavanagh satirizes a family-centred community of pilgrims concerned only with comically quotidian contingencies. This mindset is emphasized in their prayers:

> That my daughter Eileen may do well at her music
>> We beseech thee hear us.
> That her aunt may be remembered in her will
>> We beseech thee hear us
> That there may be good weather for the hay
>> We beseech thee hear us
> That my digestion may be cured
>> We beseech thee hear us.[34]

In this scene, the banal, small-minded prayers of the pilgrims are a symptom of the theocratic, solipsistic and largely static society in which they exist. The sense

33 Wills, *That Neutral Island*, p. 253. 34 Kavanagh, *Selected Poems*, p. 61.

of the enclosed horizons of this community is reiterated later in the poem when
the speaker comments that 'All Ireland' 'froze for want of Europe', inferring the
socially deadened, economically crippled and culturally stymied state of Ireland
during the war. The line also reveals Kavanagh's pained awareness of a European
context which the pilgrims, unlike the speaker, patently ignore. In an article
about his pilgrimage, which Kavanagh was writing for the *Irish Independent*
(subsequently rejected by the newspaper's editor), the poet makes Lough Derg a
negative symbol for a deeply conservative and introspective Irish mentality. In
polemical prose, resonant of MacNeice's criticisms of Ireland at this time,
Kavanagh argues that 'Lough Derg is typical of what might be called the Irish
mind. No contemplation, no adventure, the narrow primitive piety of the small
huxter with the large family.'[35]

It would not be until the mid-1950s that Kavanagh's poetry would fully digest
his experience of writing in Ireland during the 'Emergency' and a key poem in
this regard is 'Epic'. The sonnet's mock heroism, suggested by the title, is also
expressed in the recurrent use of half-rhymes and the ironically inflated language
as exhibited in the opening quatrain:

> I have lived in important places, times
> When great events were decided: who owned
> That half a rood of rock, a no-man's land
> Surrounded by our pitchfork-armed claims.[36]

The second quatrain of the sonnet's octave offers a comic portrait of territorial
skirmish between local farmers, while the opening line of the sestet nonchalantly
renders the scene in a global context of war: 'That was the year of the Munich
bother. Which / Was more important?' Despite a wavering of faith in 'Ballyrush
and Gortin', Kavanagh responds by summoning the ghost of Homer to justify
the poem's focus on these obscure rural happenings: 'I made the *Iliad* from such
/ A local row. Gods make their own importance.'[37] This poem is often read as
valorizing the local as legitimate poetic material and as an expression of
'parochial' writing as defined by Kavanagh in his essay 'Mao Tse-tung Unrolls
His Mat', which appeared in *Kavanagh's Weekly* the following year.[38] However, in
many respects, it is more in keeping with Kavanagh's later definition of the
parochial which is rooted more in the poet's 'angle of vision' than the depth of

35 Quoted in Quinn, *Patrick Kavanagh*, p. 196. **36** Kavanagh, *Selected Poems*, p. 101. **37** Ibid., p. 102.
38 In this essay Kavanagh famously recast the term parochial in positive terms, arguing that the parochial
writer is 'never in any doubt about the social and artistic validity of his parish'. This is in contrast with
the provincial writer who has 'no mind of his own; he does not trust what his eyes see until he has heard
what the metropolis – towards which his eyes are turned – has to say on the subject.' See Kavanagh, 'Mao
Tse-tung Unrolls His Mat', *Kavanagh's Weekly*, 1:7 (24 May 1952), 1.

his knowledge of a local society and topography.[39] Writing of the poem, Quinn has observed astutely that it is the 'poet who confers significance, not the place' and that '[Kavanagh's] ultimate insight into the relationship between poetry and the material world was that creativity depended on love rather than on long acquaintance. Poets may appropriate whatever endears itself to them: "a canal bank seat", "a cut away bog", "Steps up to houses."'[40] In this form of parochial poetry, as Kavanagh states, the 'material itself has no special value; it is what our imagination and our love does to it.'[41] These ideas echo statements made by MacNeice as part of his now famous discussion with F.R. Higgins in a radio programme for the BBC which aired in July 1939:

> Compared with you, I take a rather common-sense view of poetry. I think that the poet is a sensitive instrument designed to record anything which interests his mind or affects his emotions. If a gasometer, for instance, affects his emotions, or if the Marxian dialectic, let us say, interests his mind, then let them come into his poetry. He will be fulfilling his function as a poet if he records these things with integrity and with as much music as he can compass or as is appropriate to the subject.[42]

Interestingly, Kavanagh may well have heard a reprise of this debate, having taken part in a Radio Éireann discussion with Higgins and MacNeice some months after.[43] Given Kavanagh's consistent disparagement of Higgins' aesthetic agenda, it is more than likely that on this occasion he would have been both antipathetic to Higgins' arguments and perhaps amenable to MacNeice's poetics. Indeed, Kavanagh's late conception of the parochial writer could well be viewed as an endorsement of MacNeice's belief that it is the poet's *relation* to his material which is more fundamentally important than the material itself.

In terms of the religious and spiritual aspects of Kavanagh's late poetry, there are further points of contact between the two poets. During the war MacNeice felt that a returning religious sense was increasingly prevalent within England, in part because of the constant and tangible presence of death which he conceived now not as a terminus, but as 'a stimulus, a necessary horizon'.[44] This mode of thought is connected to conceptualizations of death associated with the poetry of Rilke, which MacNeice mentions in his book on Yeats. He quotes from the *Ninth Elegy*, lines which chime with his wartime convictions about death, 'your

39 Peacock, 'Received Religion and Secular Vision', p. 165. 40 Quinn, *Selected Poems*, p. xxiv. 41 Patrick Kavanagh, 'From Monaghan to The Grand Canal', *Studies* (Spring, 1959), 30. 42 Broadcast on the BBC on 11 July 1939, printed as: F.R. Higgins and Louis MacNeice, 'Tendencies in Modern Poetry', *Listener*, 22:550 (July 1939), 185–6. 43 'Literary Conversation: F.R. Higgins, Patrick Kavanagh and Louis MacNeice', *Radio Éireann*, 12 Oct. 1939. 44 Louis MacNeice, 'Broken Windows or Thinking Aloud' in Alan Heuser (ed.), *Selected Prose* (Oxford, 1990), p. 142.

holiest inspiration's / Death, that friendly Death'. MacNeice was interested, too, in Rilke's concept of *Verwandlung*, or 'transformation', and observed approvingly that 'Man's gift of seeing is, paradoxically for Rilke, a bridge to the inner invisible world. Sense experience can surmount the senses. Articulation in speech instead of pinning things down can release them from the slavery of the moment.'[45] This comes very close to the artistic attitudes and perspectives underpinning Kavanagh's later sonnets, written after Kavanagh's own close encounter with death, having been diagnosed with lung cancer in 1955. His condition required the removal of a lung which was performed in Rialto Hospital in Dublin. In the post-operative (and quasi-operatic) poem 'The Hospital', Kavanagh projects the extraordinary into the most creatively inert settings: 'the functional ward of a chest hospital' with its 'square cubicles in a row' and its 'Plain concrete, wash basins'. It ends:

> Naming these things is a love act and its pledge
> For we must record love's mystery without claptrap
> Snatch out of time the passionate transitory.[46]

In the poem, 'naming' enacts a sacred, loving embrace of the phenomenal world, as the poet's speech releases the transient objects of the physical into the ideal realm of the transforming mind. The final line of the poem is perhaps Kavanagh's most MacNeicean moment of verse, while also channelling a Rilkean poetics in which the poet acts as an immortalizing agent within (and of) a fleeting, contingent reality.

In the late work of both poets, the poem's universe emerges not from the precise depiction of reality but from the reconstitution of reality within the tremulous kingdoms of consciousness and memory. For Kavanagh this imaginative journeying frequently bathes the exterior world in a beguiling beauty and grace, while for MacNeice it is often the beginning of a descent into nightmare. MacNeice was not able to draw on religious or mystical forms of experience as readily or as simply as Kavanagh; however, in precious moments, he too could achieve what might be termed a Kavanaghesque integration of reality into the self. MacNeice relates one such occasion in 'Selva Oscura', a poem which depicts an elliptical, anfractuous quest through the psychic labyrinths of a haunted imagination:

> A life can be haunted by what it never was
> If that were merely glimpsed. Lost in the maze
> That means yourself and never out of the wood

45 MacNeice, *The Poetry of W.B. Yeats*, pp 161, 127f. 46 Kavanagh, *Selected Poetry*, p. 119.

These days, though lost, will be all your days;
Life if you leave it must be left for good.

And yet for good can be also where I am
Stumbling among dark treetrunks, should I meet
One sudden shaft of light from the hidden sky
Or, finding bluebells bathe my feet,
Know that the world, though more, is also I.[47]

These two middle stanzas of the poem might serve as parable for the artistic lives of both poets; their uncertain journey from an Ulster childhood through war, love, heartbreak, uncertainty and disappointment before a late and surprising blossoming of verse and voice. The last recorded meeting between MacNeice and Kavanagh occurred in 1960 as both poets collaborated on a BBC Third programme production of Kavanagh's *The Great Hunger*. MacNeice had organized the programme, which included an introduction by Kavanagh who was delighted his verse was being performed for the BBC. Three years later, MacNeice died of pneumonia as a result of an expedition to caves in Yorkshire to record sound effects for his last play, *Persons from Porlock* (1963). Kavanagh, perhaps feeling again the shock of his own mortality, was deeply troubled by the news of his death and talked of MacNeice in warm tones in the months after his passing.

Though from artistic and ethical perspectives MacNeice and Kavanagh responded to the war in very different ways, it did have a profound effect on the writing of both poets. For MacNeice the war enlarged and enriched the spaces of his artistic imagination, involving him in thinking and writing in more depth and in different ways about European countries and cultures which he had previously given little thought to. It also instigated a reformulation of his poetics towards a parabolic mode of verse, commensurate with the new metaphysical perspectives which he had forged in wartime London. For Kavanagh, the war was a threatening if more peripheral phenomenon, sublimated through his poetry in an oblique manner and provoking difficult questions about home and allegiance which he was not always able to respond to directly. In post-war poems such as 'Epic' Kavanagh achieves a more circumspect and controlled perspective on the war, while signalling a reorientation of his parochial aesthetic towards a greater valorization of the perceiving artist. Ultimately, the war functioned to draw Kavanagh and MacNeice into greater proximity, both poetically and in their perception of Irish society; if MacNeice's position towards Ireland softened by the war's end, Kavanagh's became more astringent. This

47 MacNeice, *Collected Poems*, p. 572.

increased similitude is intimated in Kavanagh's late description of MacNeice in conversation with Eavan Boland, which has more than a little of his own self-fashioning woven through it. Boland recalls meeting Kavanagh in 1965, in Roberts cafe at the top of Grafton street; Kavanagh's talk, she tells us, was a 'catalogue of dismissals' of poets of his own generation. One exception was MacNeice, who Kavanagh described as a king. MacNeice was, he told her, 'like an eagle with a retinue – *and he pronounced the word with a rolling "r"* – of little birds after him'.[48] Kavanagh's gentle mimicry of MacNeice's distinctively trilled pronunciation of 'r's is crucial to the poet's estimation of his peer. It is both a reflection of the cultural and social divide which originally separated them as well as a typically idiosyncratic act of homage to a poet whose integrity and restlessness of voice was reckoned on a par with his own.

48 Quoted in Quinn, *Patrick Kavanagh*, p. 437.

John Hewitt and the art of writing

KATHRYN WHITE

In December 1949 John Hewitt wrote a long and detailed letter to Belfast-born artist John Luke, proffering his opinion and critical judgment on Luke's unfinished painting of circus performers entitled *The Rehearsal*, which represented for Hewitt a critical point in Luke's development.[1] Claiming that the work spoke nothing to his emotions and had no relevance to life, Hewitt thought the circus people possessed a frozen attitude and that the panel therefore lacked human content, observing that 'Durability is much, permanence is an ideal, but content is more.'[2] Hewitt continues:

> Permanence is not in itself good. We must always ask ourselves 'Good for what?' Good to recover a lost tradition of craftsmanship, certainly, but not just to clarify and hand on methods or recipes. Good emphatically in providing men who have something compelling to say to us, or to people a hundred years hence, that life has had and will have certain significances, certain basic meanings and in providing these men with the best methods of expressing and communicating their response to these meanings and significances [...] You must grapple with reality, exterior or interior [...] making some utterance, some comment on being [...] For in my own way, in another field I am also an artist.[3]

John Hewitt, poet, critic, and bibliophile, is often simply described as a 'father figure' to a generation of poets that includes Seamus Heaney and Michael Longley: an accolade that posits the notion that he was the seed from which accredited Northern Irish poetry would grow. To view Hewitt in this context is to do him a disservice and indeed to overlook the importance of the contribution he made to the cultural scene prior to the 1960s, as he endeavoured to develop a voice that would articulate a sense of place, becoming a curator, in the

1 John Hewitt, *John Luke, 1906–1975* (Antrim, 1978), p. 73. 2 Ibid., p. 72. 3 Ibid., pp 73f.

traditional Latin meaning of '*curare*' (that is, 'taking care'), of cultural heritage on many levels. Hewitt's poetry has of course received considerable critical attention, often from other poets, like John Montague and Frank Ormsby, who recognize his integral position in the development of a Northern Irish oeuvre. In their 'Introduction' to his *Selected Poems*, Longley and Ormsby describe Hewitt as 'a local hero and an exceptional poet'.[4] Hewitt was also a consummate bibliophile, an area of his life which has, over the past four years, garnered increasing interest from academics, most notably from researchers at the University of Ulster, where the Hewitt archive is housed.[5] The Hewitt Collection at the Coleraine Campus of the University of Ulster contains over 5,000 books and journals, and is testament to Hewitt's obsession with books and book collecting. The desire to preserve the written word and thus ensure preservation of a literary tradition and culture is manifest in the texts, manuscripts and journals that line the shelves of the archive. This collection has facilitated research carried out by the Ulster Poetry Project, which endeavours not only to examine the debts and legacies of Hewitt's work but also to interrogate the importance of Hewitt in the context of the evolution of Northern Irish aesthetics. Hewitt's significance as poet or as book collector is not in question. However, what many people fail to realize is that Hewitt was also instrumental in the development of contemporary art in Ulster, working from 1930 to 1957 as an art assistant in the Belfast Museum and Art Gallery where he became deputy director and keeper of art in 1950. There is no doubt that his appreciation of aesthetics was fluid and that his opinions on art changed over time. It is therefore important to examine the significance of the dual roles, poet and gallery man, that Hewitt adhered to, and to question whether there is, in fact, a correlation between them. Specifically, does art itself influence Hewitt's poetics, shaping *his* comment on being? And what impact, if any, do the years of the Second World War have on Hewitt's artistic and poetic vision?

In his autobiography *A North Light*[6] Hewitt recalls that he gravitated towards the visual arts at an early age, describing how he learned much from the books on his father's shelves: books and articles which provided diagrams of curves or parallels, skeletal images of famous paintings, masterpieces, reduced to simple lines so that one might comprehend the composition. Hewitt affirms that 'the principles underlying these analyses are still the spine and bone of my aesthetics'[7]

4 'Introduction' in John Hewitt, *Selected Poems*, ed. Michael Longley and Frank Ormsby (Belfast, 2007), p. xvi. 5 For information on the collection, see the website of the University of Ulster Library, http://library.ulster.ac.uk/craine/hewitt/index.html#home, accessed 27 May 2014. 6 *A North Light: Twenty-five Years in a Municipal Art Gallery* was written after Hewitt had left Belfast in 1957 to take up his role as Director of Art at the Herbert Art Gallery in Coventry. The manuscript was written between 1961 and 1963, a period often characterized by critics as one of stagnation and lack of agency for Hewitt. The typed and bound manuscripts of the autobiography remained unpublished until 2013, when they were published by Four Courts Press. 7 John Hewitt, *A North Light*, ed. Frank Ferguson and Kathryn

and captured these early influences many years later in his poem 'I Learn about Art' (1979). Rhythm, which Hewitt identified at a young age as imperative to the creation of the painted image, due to its correlation with the rhythms of life and hence existence itself, would hold the same significance in later years for the poet as he negotiated the art of writing home, striving for words that would articulate space and identify place. Affirming that '*this*' [emphasis added] is his home and country, he declares in *Conacre*: 'Later on perhaps I'll find this nation is my own'.[8] Gerald Dawe in his essay, 'Beyond *Across a Roaring Hill: The Protestant Imagination in Modern Ireland*', argues that 'writers from such a Protestant background in Ireland are, *ipso facto*, more alert to the various undercurrents of meaning that one associates with terms like "region" and "nation" since they are never sure of their place in this scheme of things.'[9]

Descended from Planter stock,[10] Hewitt assumed the position of 'other' and endeavoured to reconcile his feelings of alienation within a land that was his home, famously affirming in 'Once Alien Here' that he was as native in his thought as any here. This approach reflects Richard Kearney's assertion that, '[t]o be true to ourselves, as Joyce put it, is to be "othered"'[11] – a condition pertinent perhaps not only to the Irish consciousness but also to the Irish narrative. To provide some comment on being, as Hewitt urges Luke to do through art, would remain his own *modus operandi*. The term 'alienation', often credited to the German philosopher Georg Wilhelm Friedrich Hegel, is identified by Gavin Rae as key to Hegel's phenomenological development of consciousness; Rae suggests that 'it is the experience of alienation that drives consciousness to alter its understanding of itself and its object until it overcomes its alienation in Absolute Knowing.'[12] An understanding of self or an attempt to understand self, comprehension of place and a full appreciation of the relationship between man and his environment are intrinsic to the craft of many Irish writers and certainly pervade Hewitt's oeuvre. T.S. Eliot also poignantly expressed this interdependence in his essay 'Tradition and the Individual Talent', which can be found in his *Selected Essays*, a copy of which Hewitt owned and undoubtedly read.[13] Eliot claims:

White (Dublin, 2013), p. 6. **8** John Hewitt, *Collected Poems* (Belfast, 1991), p. 9. **9** Gerald Dawe, 'Beyond *Across a Roaring Hill: The Protestant Imagination in Modern Ireland*', *The Canadian Journal of Irish Studies*, 13:2, (1987), 55–62 at 56. **10** In an interview with Timothy Kearney and John Montague, Hewitt explained: 'By calling myself a planter I make the admission that my people began to colonize. But when I make that recognition I am more acceptable to the Gael because I let him know where I stand.' T. Kearney and J. Montague, 'Beyond the Planter and the Gael: Interview with John Hewitt and John Montague on Northern Poetry and the Troubles', *The Crane Bag*, 4:2 (1980/1), 85–92 at 85. **11** Richard Kearney, 'Postmodernity and Nationalism: A European Perspective', *Modern Fiction Studies*, 38:3 (1992), 581–93 at 584. **12** Gavin Rae, 'Hegel, Alienation, and the Phenomenological Development of Consciousness', *International Journal of Philosophical Studies*, 20:1 (2012), 23–42 at 24. **13** Hewitt's copy of T.S. Eliot, *Selected Essays, 1917–1932* is in the Hewitt Collection, University of Ulster.

> No poet, no artist on any art, has his complete meaning alone. His signif-
> icance, his appreciation is the appreciation of his relation to the dead poets
> and artists. You cannot value him alone; you must set him, for contrast
> and comparison, among the dead.[14]

Herbert Read, an English poet, art critic and supporter of modern British artists
who had an influence on Hewitt,[15] similarly argued that 'both art and society in
any concrete sense of the terms have their origin in man's relation to his natural
environment'.[16] However, what is the effect on the art when man's relationship
to his natural environment is questionable or indeed fractured, when he is of the
land but perhaps feels displaced from the nation? It is, of course, no coincidence
that *Conacre* and 'Once Alien Here' were written during the war years. These
poems attempt to negotiate identity and its implications at a time when the issue
of national identity dominated Europe. Yet if, as Read suggests, man's identity is
located in his relationship to the natural environment, in the art and literature
of the land, perhaps it is here where our cultural identity abides; not in the polit-
ical discourse of those who are elected to 'speak' for us, but in the rhythms of the
local artist's brush and writer's discourse.

 The influence of home and landscape permeates Hewitt's poetry as he artic-
ulates a sense of being in place, but it is interesting that the significance of place
was conveyed to him through art itself. Paul Henry, the Belfast-born artist
renowned for his depictions of the West of Ireland landscape, was the first name
Hewitt learned in Irish landscape painting; he later claimed that Henry
'impressed, almost imposed, his personal vision upon us'.[17] Hewitt recognized
the power of the visual image to articulate meaning and provoke emotion. In the
Belfast Museum and Art Gallery he looked after portraits and relics of notable
men of Planter stock, visual manifestations of the themes that weaved
throughout his poetics. To provide some comment on being, art must articulate
life itself and maintain relevance for future generations. Indeed, Hewitt, in his
letter to Luke, claims that the artist's first responsibility is to further the ends of
life.[18] Likewise, Read, in *The Meaning of Art*, quotes Leo Tolstoy's assertions that
'art is a human activity consisting in this, that one man consciously, by means of
certain external signs, hands on to others feelings he has lived through, and that
others are infected by these feelings and also experience them'.[19] This under-
standing reflects Hewitt's, who elsewhere stresses that 'the tone and style of a
society can only be grasped from the experience of a wide sample of its

14 T.S Eliot, 'Tradition and the Individual Talent' in *Selected Essays, 1917–1932* (London, 1932), pp 13–22
at p. 15. 15 Hewitt heard Read lecture at the Adelphi Centre in August 1936 and read his various publi-
cations on art, 'but considered him incomparably more important as a literary critic.' *A North Light*, pp
53f, 106. 16 Herbert Read, *Art and Alienation* (London, 1967), p. 16. 17 Hewitt, *A North Light*, p. 71.
18 Hewitt, *John Luke*, p. 73. 19 Herbert Read, *The Meaning of Art* (London, 1931), p. 154.

artefacts'.[20] Hence, what we choose to place in museums, galleries and archives represents a shared cultural memory, and these collections must serve as instruments of transparency and indeed accountability if they are effectively to denote the tone and style of society.

Hewitt's appointment to the Art Gallery in 1930 afforded him the opportunity to meet and work with local artists. In 1932 his friend and local painter William J. McClughin introduced him to John Luke, who had just returned from the Slade School of Fine Art in London. Hewitt writes that 'out of that first memorable meeting developed one of the most fructifying of the earlier phases in my thought, for we three, during the next ten years, maintained a rich and complicated conversation on art, its theory, its practice, its origins, its future'.[21] He immortalized these men, along with other local artists, in his poem 'Freehold',[22] composed on 13 September 1942; the subsection entitled 'Roll Call', written in March of that year, is reminiscent of Yeats' 'Easter 1916', as Hewitt names his 'comrades', including Luke, who have played their part in the construction of the culture of Ulster. Hewitt articulates his view of the artist as teacher with reference to Luke, proclaiming that although Luke's mind was initially dominated by art, it evolved to include an appreciation of mankind, a blending of internal and external worlds: to achieve the durable in art, the artist must, Hewitt suggests, 'perceive that art's the colour on the lips of life.'[23] In January 1945, almost five years before his comments on Luke's circus performers, Hewitt received a long and detailed letter from Luke, who at the outbreak of war had moved with his mother from Belfast to a farm at Knappagh, Co. Armagh – not far from Kilmore, where Hewitt's ancestors first settled – where he remained until 1950. This letter, Hewitt claims, gave him the deepest and most lasting delight and in many ways served as the catalyst for developing his 'vision'. Describing the frosty landscapes and its trees, Luke proceeds to engage with the problem of defining the colour of the sky:

> I carried out a small experiment here with the aid of a small mirror and coloured papers, by putting the mirror on to the middle of each sheet of paper, with the so-called blue sky reflected in it. The reflected sky was compared with middle grey, bright blue, blue green, violet, green, yellow green, yellow, orange, red and scarlet; and, believe it or not, the so-called blue sky was neutral to *all* colours except grey [...] it is the earthly contrast with the ethereal background that makes the grey sky (grey light) appear

20 Hewitt, *A North Light*, p. 99. 21 Ibid., p. 50. 22 A freehold is a permanent and absolute tenure of land or property, which makes this an interesting poem for Hewitt to pen during the war years when the question of land ownership was pertinent. Land ownership is, of course, fundamental in the context of Irish history, recalling the plantation and eventual partition of Ireland. 23 Hewitt, *Collected Poems*, pp 486f.

blue. Summed up simply, the sky is part of the white light from the sun caught by our atmosphere, beyond which is black space.[24]

Luke draws Hewitt's attention not only to colour but to cognition, forcing him to re-evaluate his vision and understanding of space and place. The painter's tutelage honed Hewitt's perception of landscape and colour, enabling him to envision his sense of place with fresh eyes, thus facilitating new perspectives which infiltrate Hewitt's verse. Luke's unique perspective on the Irish landscape, seen in paintings such as *The Road to the West* (1944) and *The Old Callan Bridge* (1945), can be seen to influence Hewitt's own perception of home. In his poem 'Overture for an Ulster Literature', Hewitt calls for obedience to the shape of the land, suggesting that the bare tongue can serve a purpose if it connects with the contours of place. Significantly, Hewitt highlights this correlation between tongue and topography, illustrating the intrinsic link with speech and situation, literature and landscape. Perhaps the writer has no alternative but to write *home*, for the fabric of the land weaves into the textures of the literature, recalling the concept of *terroir*, which can be loosely translated as a 'sense of place', and emphasizes the way in which the local environment is intrinsic in developing production which is specific to that location. Two years after Luke's letter, Hewitt composed the poem 'Colour' in which he describes colour as a blessing, using it effectively to illustrate an Ulster landscape.[25] Here we clearly see Hewitt's two worlds merge as he paints the Ulster landscape with words. Geraldine Watts concurs, pointing out that 'colour, the shape of a leaf, the felicitous matching of form with feeling, these were what appealed to Hewitt all his life.'[26] The imperative to express oneself through the rhythm of contours or the rhythm of words was intrinsic to the artistic development of both Luke and Hewitt.[27]

Sensations and perceptions are central to the development of Hewitt's aesthetics and were discernibly honed by the impact of the Second World War. Europe played a fundamental role in Hewitt's life, contrary to any perceptions of him as an insular Belfast man. He embarked on his first foreign trip in 1927, when he was 20 years old, travelling to Belgium with his father. This would be the first trip of many and Europe would provide the inspiration for much of his poetry, while his visits to numerous European art galleries would shape his appreciation of art. Hewitt travelled widely before and after the war, visiting Holland, Poland, Austria, Germany, Italy, Hungary, Czechoslovakia, Sicily, Greece, Turkey and Spain, and his poems reflect his interest in other countries and cultures. In poems such as 'Mykonos', 'Delos' and 'Mycenae and Epidaurus'

24 Hewitt, *A North Light*, p. 135. 25 Hewitt, *Collected Poems*, p. 65. 26 Geraldine Watts, Book Review *The Collected Poems of John Hewitt*, ed. Frank Ormsby, *Irish Arts Review Yearbook*, 9 (1993), 265f. 27 For further information about John Luke's artwork and his sense of rhythm, see Joseph McBrinn, *Northern Rhythm: The Art of John Luke, 1906–1975* (Belfast, 2012).

he engages with topography and its effects on the people who live there, demonstrating his interest in landscape *per se* and in how it shaped the lives of its inhabitants. However, with wartime restrictions preventing travel, Hewitt was forced to remain in Ireland, where even a trip to the southern State required a special permit. Referring to the war years, Hewitt noted in a letter to John Montague in 1964 that he 'felt very enclosed and segregated, and then my thinking turned inwards'.[28] The significance of this statement is evident, as it was this turning 'inwards' that would enable Hewitt to formulate and consolidate his ideas on identity, ecology, heritage and culture, eventually determining his concept of regionalism and aesthetics of place. European travel had encouraged an appreciation of other cultures, landscapes and gallery collections but the war forced homeland contemplation. While Europe's influence did not wane, the war years enabled the Belfast man whose mind had been broadened by European culture to now look at his own land with renewed vision.

Although Hewitt endeavoured to enlist in the British Army, he was turned down, due, he claimed, to the fact that he was a Local Government Officer, a reserved occupation.[29] His wife Roberta and he did take part in Civil Defence activities and Hewitt also worked for the Department of Extra Mural Studies at Queen's University Belfast, travelling to army camps across Northern Ireland where he lectured on art and Marxism. Hewitt writes, 'I was not able to take part in what I realized must have been the greatest imaginative experience of my generation',[30] and yet, as Read declares, 'the artist is stimulated by great events even though he takes no part in them and does not even celebrate them directly in his works',[31] as affirmed in the work of many modernist poets and writers. Hewitt's experience of marginalization during the war years was a further symptom of his negotiation of identity itself. In his 1972 essay 'No Rootless Colonist' he states that 'people of Planter stock often suffer from some crisis of identity, of not knowing where they belong',[32] and perhaps the war years intensified this sentiment. The museum in which he worked remained itself on the fringes of the war effort: 'Being at some distance from the city centre, it was not, like museums in many other towns, made headquarters for the Ministry of Food, or of Civil Defence. So, apart from the siren on the roof, it remained outside the war machine.'[33] In 1949 Hewitt penned the poignant verse 'Raindrop', in which he relates being accused of indifference to Europe's grief because he wrote about raindrops upon a leaf; the implication being that a poet who had time to notice the droplet of water resting on the foliage was not consumed with war and its devastation – a poet, as Hewitt says, considered to exist in a land set apart from war-torn Europe, a marginalized man.[34]

28 See *Quarto*, 7 (1980–1), quoted here from Hewitt, *Collected Poems*, p. xlix. **29** Hewitt, *A North Light*, pp 127–41. **30** Ibid., p. 127. **31** Read, *Art and Alienation*, p. 27. **32** Hewitt, *Ancestral Voices: The Selected Prose of John Hewitt*, ed. Tom Clyde (Belfast, 1987), p. 146. **33** Ibid. **34** This resonates

In *Art and Alienation* Herbert Read claims that 'war and revolution destroy the constructive works of the artist',[35] yet ironically the North of Ireland made some inroads culturally precisely during the war years. The influence of Europe and European artists continued to seep through to Ireland during the Second World War, but as Hewitt points out 'the changes in aesthetic horizons of local artists were not all due to their having gone out of the island',[36] highlighting the fact that aesthetics were being influenced by external factors but also by internal developments.[37] 1943 saw the establishment of Northern Ireland Committee for the Encouragement of Music and the Arts (CEMA), with Hewitt one of the founder members.[38] Belfast entered an unusually energetic period in the creative arts, with new writers emerging who were supported by the Ulster Group Theatre, established in 1940.[39] Hewitt admits that 'the war time isolation of N. Ireland was certainly a factor, compelling us to till our own gardens.'[40] 1943 also saw the first one-man exhibition of work by a local artist – Colin Middleton – the first in a series of showcases which would continue until Hewitt left the gallery in 1957. During these years, Hewitt also curated exhibitions from the Arts Council of Great Britain and exhibited Zoltan Frankl's collection of paintings, which included paintings by Jack B. Yeats.[41] Unsurprisingly, he would write of the period that 'never before in my life time has the Arts seemed so lively and exciting'.[42] Such developments contradict notions that Ireland, during the war years, was culturally stagnant.

In 1947 the magazine *The Studio* demanded that the Belfast Art Gallery 'must become an instrument of general culture, a lively and efficient agent acting upon the total community, and participating in the emotional and imaginative experiences of that area'.[43] Hewitt was centrally involved in realizing these ambitions, ensuring that the gallery was not only exhibiting international artwork but also championing local artists, thereby participating in the emotional and imaginative experiences of both the area and the epoch. The war years, which had forced Hewitt to turn geographically and personally inwards, gave him a new perspective. He supported numerous artists, not solely because some were personal

with Patrick Kavanagh's poem 'Epic'. **35** Read, *Art and Alienation*, p. 27. **36** See John Hewitt, *Colin Middleton* (Belfast, 1976), p. 9. **37** Recognizing, as Richard Kearney suggests, the necessity for 'regional fidelities to remain open to a universal dimension' ('Postmodernity and Nationalism', 591). **38** Hewitt continued to be associated with CEMA until 1957 when he left Belfast for Coventry – he was chairman of the art committee for six years. CEMA became the Arts Council of Northern Ireland in 1963. **39** The Ulster Group Theatre welcomed classic and international drama but was the major company that premiered new writing in Northern Ireland. See www.culturenorthernireland.org/article/823/the-ulster-group-theatre, accessed 27 May 2014. **40** John Hewitt, *Colin Middleton*, p. 19. **41** Zoltan Lewinter-Frankl was Northern Ireland's significant private patron of fine art throughout the 1940s and early 1950s. **42** John Hewitt, 'Contribution to "The War Years in Ulster 1939–45"', *The Honest Ulsterman*, 64 (Sept. 1979 – Jan. 1980), 24–7 at 27; quoted here from Ríann Coulter, 'John Hewitt: Creating a Canon of Ulster Art', *Journal of Art Historiography*, 8 (2013), 1–18 at 1. **43** 'Belfast's Art Gallery', *The Studio*, (Jan. 1947); cited in Terence Brown, *Northern Voices: Poets from Ulster* (Michigan, 1975), p. 92.

friends, but because he had begun to recognize the importance of celebrating the aesthetics of place and home – a passion that would eventually lead him to write his MA thesis on the Rhyming Weaver poets of nineteenth-century Ulster,[44] play an integral role in the recovery of a lost tradition of craftsmanship and continue to inspire his own poetics. By looking inwards and by exploring new perspectives, honed by artists such as John Luke, Colin Middleton and William J. McClughin and consolidated during the war years, Hewitt was able to see outwards and 'grapple with reality, exterior or interior [...] making some utterance, some comment on being'.[45] In his manifesto poem 'I Write For', written in 1945, Hewitt declares that he 'writes for his own kind', and yet these words transcend nationality, religion and politics, encompassing humanity itself as Hewitt strives to articulate what he would urge Luke to do four years later in the letter quoted at the beginning of this essay. Returning full circle, we recognize how, in Seamus Heaney's words, 'the local idiom extends beyond the locale itself'.[46]

Describing his painting *Northern Rhythm* (1946) John Luke notes the contrasting elements contained within the picture – 'strength and delicacy; linear rhythms, complex but unified'[47] – and these elements succinctly epitomize Hewitt's poetry. Luke states that 'no painting has so much or so deeply expressed my own particular type or state of mind and spirit'.[48] It is a painting that illustrates northern place, and the rhythms employed in Luke's work at this time convey landscapes which Hewitt found more naturalistic, capturing the rhythms of life and spirit of place. This sets it apart from the later painting *The Rehearsal* and explains why Hewitt was so scathing of what he believed was intrinsically a technical painting, lacking the content and emotion evident in Luke's earlier work. Yet this is exactly what Hewitt championed in art – works that would provide some comment on life itself – and this was what he continually strove for in his verse. As poet and gallery man, the influence of war and contact with art and various artists challenged Hewitt, forcing him to rethink his relationship with his environment as tongue began to resonate with topography. We see these influences manifest themselves in his poetry: poems that capture the landscape of the glens of Antrim; the cityscape of Belfast; the roots and rootlessness of man; the poetics and aesthetics of place: in essence, the northern rhythm.

44 Hewitt completed his MA thesis 'Ulster Poets 1800–1870' at Queen's University Belfast in 1951; the thesis was published by Blackstaff Press in 1974 as *Rhyming Weavers and Other Country Poets of Antrim and Down*. 45 Hewitt, *John Luke*, p. 73f. 46 Heaney uses these words with reference to Patrick Kavanagh's poem 'Epic'; see R. Kearney, 'Postmodernity and Nationalism', 591. 47 Hewitt, *John Luke*, p. 51. 48 Ibid., p. 67.

An anxious seaward gaze: Nevill Johnson, surrealism and the Second World War in Northern Ireland

CONOR LINNIE

Nevill Johnson, the English artist, writer and photographer who lived in Belfast and Dublin from 1934 to 1958, is one of the forgotten figures of Irish cultural life. The decline of his once-formidable reputation into relative obscurity is surprising when we consider his diverse body of work and the critical acclaim he received both locally and internationally during that period. By the late 1940s Johnson had joined the prominent group of Ulster artists under contract with the Dublin art dealer Victor Waddington, featuring in a number of important solo and group shows in Waddington's gallery on South Anne Street. Johnson's work was shown alongside artists such as Colin Middleton, Gerard Dillon and Daniel O'Neill who, as S.B. Kennedy observes, came to dominate the annual Irish Exhibition of Living Art and 'largely determined the development of Irish painting throughout the 1950s'.[1] Johnson's success in Dublin fostered international recognition leading to exhibitions in London and the US, so that by the early 1950s he was 'numbered among the first half-dozen important modern painters in Ireland'.[2] This essay examines Johnson's life in Northern Ireland in the 1930s and 40s, beginning with his arrival in Belfast where he developed a formative relationship with the painter John Luke. In the summer of 1936 they visited Paris and London together, where they experienced for the first time many of the major works associated with the surrealist and cubist movements. The trip was inspiring for Johnson, whose art and ideology would become deeply influenced by surrealism while living in Northern Ireland. Following Johnson's peripatetic movements through the Ulster countryside in the late 1930s, I explore the profound artistic divergence that emerged between himself

1 S.B. Kennedy, *Irish Art and Modernism, 1880–1950* (Dublin, 1991), p. 130. 2 Edward Sheehy, 'Art Notes', *The Dublin Magazine: A Quarterly Review of Literature, Science and Art* (April–June, 1952), 35–7 at 37.

and Luke in their contrasting responses to the Second World War. The work which best epitomizes Johnson's unique angle is his early painting *Kilkeel Shipyard*. Completed in 1943, it is a powerful expression of the feelings of anxiety and isolation he felt while living in various rural retreats during the war. The painting represents Johnson's disquiet at the events of the war, but it can also be contextualized in relation to the art commissioned by the War Artist's Advisory Committee in Britain and Northern Ireland during the Second World War.

In 1934, Johnson was posted to Belfast to work as a businessman for Ferodo Ltd, a company that manufactured brake friction materials. A restless 23-year-old whose burgeoning artistic aspirations had yet to find any real outlet, Johnson had by this stage already grown frustrated with the 'humourless round of business'[3] that saw him drift through a number of jobs from his native town of Buxton in Derbyshire to the industrial city of Newcastle. The short time that he spent living there before moving to Belfast appears to have been a particularly bleak period in his life. 'The depression in Newcastle was acute and few men had sufficient for their families', he recalls in his autobiography *The Other Side of Six*.[4] Though he was glad to leave England, Johnson's first impressions of Belfast were characterized by ambiguity: 'Belfast 1934. Institutional green and pew brown paint on those Presbyterian facades; few signs of style or culture.'[5] The social privations and inequalities that he had experienced in Newcastle were even more acute in this city devastated by the massive decline of its three major manufacturing trades of linen, shipbuilding and engineering. According to Jonathan Bardon, 'perhaps no city in the United Kingdom was hit harder than Belfast by [the] severe contraction in trade' caused by the Great Depression, and by the time of Johnson's arrival more than a quarter of the general workforce were unemployed.[6] Widespread poverty in densely populated working class districts reignited sectarian tensions, leading to scenes of disorder and rioting on a scale not witnessed since the Civil War period. The Twelfth of July marches in 1935 provoked an outbreak of rioting that lasted until the end of August, causing a number of fatalities and destruction to inner city areas.[7]

Despite the extreme hardships caused by economic depression and the limited opportunities afforded to young artists who had yet to establish themselves, the early 1930s were marked by a flurry of exciting independent artistic activity in the city. Though Belfast may have shown few outward signs of style or culture to Johnson upon first impression, he had arrived at an important cultural moment in which the city's disparate groups of emerging artists attempted to form a cohesive unit bound by their shared interests in modern continental trends. The recent return to Belfast of a number of talented young

3 Nevill Johnson, *The Other Side of Six* (Dublin, 1983), p. 32. 4 Ibid. 5 Ibid., p. 37. 6 Jonathan Bardon, *Belfast: A Century* (Belfast, 1999), p. 65. 7 Ibid., p. 73.

Ulster artists from the Slade School of Fine Art and the Royal College of Art in London, such as John Luke, George MacCann and Mercy Hunter, provided the important impetus for a variety of short-lived but influential cultural ventures that were to follow. John Hewitt, who was appointed as an art assistant in the Belfast Museum and Art Gallery in 1930 and would become a central figure in the cultural life of the city, describes the importance of the return of these 'young men and women' who 'stepped down the gangway at Queens Quay, their portfolios and heads full of new ideas.'[8] The formation of the Northern Guild of Artists in 1933, which involved a brief banding together of young artists including Luke along with older established figures such as William Conor and the English sculptor Morris Harding, reflected a new urgency to create an alternative platform for progressive art in the city.[9] Although the group broke up shortly after their first exhibition in the State Buildings in Arthur Square, a number of its members would join together again to form the Ulster Unit in 1934. Influenced by the Unit One group founded by Paul Nash in London in 1933, the members of the Ulster Unit aspired to align their art with contemporary continental developments, as Hewitt stated in the preface to their first and only exhibition in Locksley Hall in December 1934: 'In this Unit, Ulster has for the first time a body of artists alert to continental influence while that influence is still real and vital.'[10] John Luke and George MacCann both featured in the exhibition and were joined by other emerging local artists such as Colin Middleton. As with the Northern Guild of Artists, the Ulster Unit disbanded soon after its first exhibition. However, their brief grouping together in support of modernist artistic values was nonetheless significant, as S.B. Kennedy writes: 'The Ulster Unit was the first group of artists in Ireland to share, in effect if not by intent, a common aspiration of the role and purpose of art. For them Modernism symbolized the spirit of the age.'[11]

It seems likely that Johnson would have attended the Ulster Unit exhibition, given his own nascent artistic ambitions upon arriving to the city. Most importantly, he soon befriended John Luke, who ranked as one of the group's most accomplished members. Although Johnson does not recall in his autobiography when he first met Luke, it is certain that they became friendly within the first two years of his arrival in Belfast, as they were close enough by the summer of 1936 to embark on a trip to Paris together, along with the artist Charles Harvey. Their friendship was to prove crucial to the development of Johnson's art, for Luke generously invited him to work in his studio and seems to have taken on the role of an informal teacher to the aspiring artist. 'Suffice to say that he set about to teach me and set me spinning on my courses', Johnson recalled, adding:

8 John Hewitt, *A North Light: Twenty-five Years in a Municipal Art Gallery* (Dublin, 2013), p. 78.
9 Kennedy, *Irish Art and Modernism*, p. 73. 10 John Hewitt, 'Preface', *Ulster Unit*, unpaginated exhibition catalogue (Belfast, 1934). 11 Kennedy, *Irish Art and Modernism*, p. 73.

'For two years we worked together, patient John a good teacher. So, rising before dawn, painting early and late while earning my keep by day I worked without stint, fuelled by the distant hope of one day escaping from business.'[12] The nights spent painting with Luke in his studio over the course of two years must have been an exciting time for Johnson. Luke was only five years his senior, but the Belfast and Slade schools of art had furnished the older man with a vast knowledge of artistic ideas, styles and techniques, ranging from the early Renaissance to contemporary progressive art, that would have been greatly nourishing for the younger, less experienced artist. The late 1930s were a period of fervent experimentation for Luke, as he enthusiastically immersed himself in a variety of different art forms that included printmaking, carving, mural painting, sculpture, woodcuts and ceramics. Johnson certainly shared Luke's diverse interests. That his first recorded exhibited piece in 1939 was a sculpture entitled *Mother and Child* suggests the influence of Luke, who himself began to focus on sculpture at this time. Luke's growing desire to achieve greater luminosity in his painting saw him begin to work in tempera, an exacting method dating back to the early Renaissance period which involved the mixing of ground powdered colour pigments with egg yolk, before applying this to a canvas that had been carefully prepared with a fine layer of white gesso. Although Johnson does not explicitly refer to Luke's influence on his own art in *The Other Side of Six*, there remain echoes of the older artist in his work as late as the 1950s. The high key colour scheme favoured by Luke in his great tempera works of the 1940s, for example, is similarly a feature of Johnson's work during the period, most notably in the powerful *Kilkeel Shipyard*. The linear precision achieved in this work is a striking example of Luke's own insistence on the controlled expression of form in painting. One of the most important elements of Johnson's formal rigorousness was his obsession with perspective. Dickon Hall notes how he 'spent years studying perspective and also used a scientific prism to view his paintings, an exacting and ambitious apprenticeship that indicates why he and Luke held each other in such high mutual regard.'[13]

During their 1936 visit to Paris Johnson and Luke were able to experience first-hand many of the major works of the impressionist and post-impressionist movements on display at the Musée d'Orsay. Given their knowledge of contemporary continental art prior to the trip would have largely depended upon reproductions of varying quality in magazines and journals, the impact of being able to view paintings by artists such as Paul Cézanne, Pablo Picasso and Georges Braque must have been considerable. Hewitt's detailed descriptions of his own first visits to the art galleries of Paris in 1929 evoke the sense of excitement

12 Johnson, *The Other Side of Six*, p. 39. 13 Eoin O'Brien and Dickon Hall (eds), *Nevill Johnson, 1911–1999: Paint the Smell of Grass* (Bangor, 2008), p. 12.

Johnson and Luke likely would have shared. Remembering how the vivid luminosity of the paintings surpassed his expectations, he wrote: 'The Impressionists, particularly Monet, seemed far brighter and more immediate than the reproductions and the coloured slides had fortold [*sic*]'.[14] For Johnson, the exposure to surrealist and cubist art was a revelation:

> We stayed for a time in Paris exploring and tasting rare fruits. Braque and Picasso held sway and the Surréalists were on stage; Ernst, Magritte and Tanguy, Lipschitz and Gargallo, splendid straight-faced progenitors of the fur-lined teacup and the spiked flatiron, tripping my pulse. And round the corner fresh young faces – Vivin, Peyronnet, Bombois, children of le Douanier, maître de la réalité. Life-enhancing stuff it was.[15]

Thanks to a stopover in London on their way home from the Continent, Johnson and Luke were also able to visit the International Surrealist Exhibition in the New Burlington Galleries. The sense of excitement surrounding this seminal exhibition was captured by the art critic and influential British exponent of the surrealist movement, Herbert Read, who wrote how it 'broke over London, electrifying the dry intellectual atmosphere, stirring our sluggish minds to wonder, enchantment and derision'.[16] One of the most important exhibitors was the Greek-born Italian artist Giorgio de Chirico, whose early metaphysical paintings of the squares of Florence, Turin and Munich had profoundly influenced André Breton and the surrealist aesthetic. Johnson was similarly affected by the art of de Chirico. In an early painting dating from the mid-1940s entitled *Byrne's Pub*, the sense of emptiness that haunts de Chirico's piazzas pervades the narrow cobbled streets sprawling from the eponymous public house. *Byrne's Pub* is a striking early example of how Johnson had begun to assimilate the techniques of surrealism into his own unique artistic vision. The painting's desolate urban setting is realized through a dynamic use of perspective and a complex geometrical arrangement of pictorial space that suggest the influence of de Chirico's early metaphysical paintings, while at the same time evoking the labyrinthine conditions of Belfast's inner city districts. Shadows cast their severe shapes over the streets in a stylized play of light and dark that resembles a contorted chessboard, and a complex array of rectangles and triangles rigidly segment the pictorial space to create an altogether hostile atmosphere.

Luke shared his friend's excitement in experiencing surrealism at first hand, but the trip did not have the kind of transforming effect on his artistic sensibility as it did for Johnson. It seems his time in the Slade School had already furnished

14 Hewitt, *A North Light*, p. 20. 15 Johnson, *The Other Side of Six*, pp 39–41. 16 Herbert Read (ed.), *Surrealism* (London, 1936), p. 19.

him with the styles and theories that would most influence his art. His great tempera works of the 1940s drew largely from classical ideas of craftsmanship and formal technique, while the art of old masters such as Piero della Francesca and Luca Signorelli seem to have ultimately moved him more than the progressive experimentalism of the surrealist and cubist movements. As Hall notes: 'A surrealist element has been detected in the extreme formal stylization and the arcane subject matter of Luke's later work, but in reality this seems to derive from his own private mythology and interest in art of the renaissance.'[17] The thrill of surrealism for Johnson and the impact it would have on his art suggests that he shared a closer affinity with the Belfast painter Colin Middleton. The vivid imagery and technique of artists such as Salvador Dalí and de Chirico were a 'liberating force' for Middleton and greatly influenced the work he produced at this time.[18] However, the theatricality and obscure psychological symbolism evident in much of Middleton's early surrealistic painting contrasts with the more restrained, austere style that would come to define Johnson's art in the 1940s. Unlike Middleton, who proclaimed himself 'the only surrealist painter working in Ireland', Johnson never publically associated himself with the movement.[19] This was ultimately a reflection of his self-confessed need to 'walk against the wind'[20] which manifested itself in a steadfast individualism and determined the nature of his engagement with society as a detached observer rather than an involved activist. Despite Johnson's refusal to define himself in terms of any particular movement, he was clearly inspired by the creative freedom and invention of surrealism and was also drawn to its political urgency. The ethic of revolt so integral to surrealism, combining a liberating experimentalism in art with the moral imperative to challenge social, economic and political superstructures, resonated with the young artist who had himself been deeply affected by the glaring social inequalities that he experienced while living in Newcastle and Belfast. Following the onset of the Second World War, a stark feeling of spiritual dissolution and alienation would increasingly come to dominate the landscapes of his paintings. The visual intensity of some of his most important works, such as *The Year of Grace 1945*, *Europe 1945* and *Crucifixion*, is realized through the jarring juxtaposition of religious imagery set in a godless, post-apocalyptic world.

In the late 1930s and 40s Johnson travelled widely throughout the Ulster countryside. While the variety of rural retreats in which he stayed may have provided a brief respite from the social inequalities and 'surrounding bigotry and menace'[21] of Belfast, he found himself unable to distance his thoughts from the war spreading across the Continent. During his rural sojourns he visited writers

17 O'Brien & Hall, *Nevill Johnson*, p. 12. 18 Dickon Hall, *Colin Middleton: A Study* (Bangor, 2001), p. 7. 19 Carlo Eastwood (ed.), *Colin Middleton: A Millennium Appreciation* (Belfast, 2000), p. 74. 20 Johnson, *The Other Side of Six*, p. 22. 21 Ibid., p. 41.

and artists such as George MacCann and Mercy Hunter who shared his social and political concerns. Having both graduated from the Royal College of Art in London in the early 30s, MacCann and Hunter married and settled together in Vinecash, Co. Armagh, in 1935. Their small, white-washed cottage located 'deep in the apple orchards of County Armagh',[22] appears to have become a cultural haven for artists and intellectuals during the period. Johnson was just one of the many 'deracinated individuals' who were made welcome at Vinecash. Louis MacNeice, who was a close friend of MacCann and who subsequently became friendly with Johnson, was a regular visitor. Johnson was deeply affected by MacNeice's long poem *Autumn Journal*, first published in May 1939, admitting that 'many of those poems cut straight home to me'.[23] Hunter remembers the vigorous cultural and political debates that typically ensued between the groups of artists, writers and poets that gathered in her cottage: 'Those were the days of the Spanish Civil War – we would sit around reading Lorca – we were very anti-Franco.'[24] In 1939, MacCann enlisted with the Royal Inniskilling Fusiliers, where he held the rank of captain and served in India and Burma until 1946.[25]

Johnson's own political concerns and anxieties became increasingly acute after the outbreak of the Second World War. It is during this time that we can begin to trace a decisive ideological and artistic divergence between himself and Luke. While staying in the small coastal village of Ballintoy in Co. Antrim during the summer of 1939 with his wife and new-born son, Johnson suffered a crisis of conscience over his proper role in the escalating conflict:

> As darkness settled over the sea and the wind moaned in the chimney I sat thinking, suffering all manners of doubts and self questioning. Primitive defence of hearth and home I understood; I would rebut fascism from any quarter – but fight now for whom? For what? For King George, Mr. Chamberlain, the 'B' Specials, the old school tie, the bums and bobby-dazzlers?[26]

Assailed by anxiety and doubt, his recollection of the period echoes MacNeice's own frustrations in *Autumn Journal*: 'We envy men of action / Who sleep and wake, murder and intrigue / Without being doubtful, without being haunted.'[27] After much deliberation he decided to offer his services to the Royal Air Force and attempted to enlist in a recruiting office on the Antrim Road in Belfast. However, his application was rejected due to the fact that his job with Ferodo had been listed as a reserved occupation. As the war progressed, Johnson's disquiet over his own role in the conflict was superseded by an overwhelming

22 Ibid. **23** Ibid., p. 43. **24** 'Nicky Hall talks to Mercy Hunter', *News Letter*, 24 Feb. 1978. **25** Theo Snoddy, *Dictionary of Irish Artists: 20th Century* (Dublin, 2002), p. 364. **26** Johnson, *The Other Side of Six*, p. 42. **27** Louis MacNeice, *Collected Poems*, ed. Peter McDonald (London, 2007), p. 137.

sense of anguish at the widespread devastation and human suffering consuming the Continent. Then, on the nights of 15 April and 4 May 1941, Belfast was heavily bombed by the Luftwaffe. Johnson, who was living there again by this time, shared the communal horror of its citizens at the sweeping destruction and the great number of fatalities caused by the attacks. Desperate to escape the disaster, he abruptly sought refuge in Knappagh Farm in Killylea, Co. Armagh, where his friend and former French cavalry officer, Captain Paul Terris, lived with his family. He was soon joined by Luke, who was invited along with his ageing mother to stay in a gate lodge at the farm.[28]

Time spent in rural wartime retreats affected Johnson's and Luke's work in contrasting ways. Luke's move to Knappagh Farm, where he would remain for over a decade before eventually returning to Belfast, initiated a sustained period of isolation during which his interest in the war and global developments became superseded by his growing obsession with craftsmanship and the mastery of formal technique. Joseph McBrinn is correct in observing that Luke's life in Knappagh was not as cut off from the outside world as has been suggested by earlier critics. Through his frequent correspondence with John Hewitt, for example, he maintained an important connection with life in Belfast and Europe. However, it was nonetheless very much a period of withdrawal in which he strove 'to make a cell of good living in the chaos of the world'.[29] Luke's letters to Hewitt during this time reveal an artist preoccupied with the desire to achieve a greater luminosity and sense of rhythm in his painting. At times, he writes of his exacting painting process with an almost religious fervour, extensively detailing his various experiments with tempera mixtures and glazes. In some of his most effusive passages, Luke describes the controlled formal expression of his art as an attempt to create an alternate, harmonious world, governed by 'a pattern of another order' in contrast to the chaos engulfing the Continent where

> [a]ll is clear, clean and day-bright and dark black night is left to slumber in. All over rhythms meaningfully speed on their way, like bent sunbeams spiral back again. Curving, and then to curve, swerving and the swing, pausing begin again that dance of harmony which knows no end.[30]

The world represented in a number of his paintings that date from this period, such as *The Locks at Edenderry* (1944), *The Old Callan Bridge* (1945) and *The Three Dancers* (1945), seems untroubled by war or suffering: it is a world where courting couples meet by the canal locks at evening or enjoy a boat ride through

28 Johnson, *The Other Side of Six*, p. 44. **29** Joseph McBrinn, *Northern Rhythm: The Art of John Luke, 1906–1975* (Belfast, 2012), p. 50. **30** Letter from John Luke to John Hewitt, 24 Sept. 1946, John Hewitt Papers, Public Records Office of Northern Ireland, D/3838/3/8 ACC 17015.

an idyllic landscape resplendent with light; where families pass leisurely after-
noons strolling through lush parkland and children sprawl on grassy banks with
their beloved pets; where ethereal dancers pirouette beneath swirling, boundless
horizons. As Luke became engrossed in developing his technique, he began to
alienate some of those who had been the most ardent supporters of his work.
Hewitt, in particular, became frustrated with his friend's formal obsession,
arguing that his paintings lacked an essential living quality or meaningful
content. He most forcefully expressed his concerns in reaction to Luke's elabo-
rate tempera work *The Rehearsal* in 1949. 'It said nothing to my emotions', he
wrote, observing that the painting 'offered me no extension of imaginative
experience, somehow had no relevance to life.'[31] Hewitt urged Luke to restore a
sense of tangibility and a contemporary conscience to his art: 'I know of no
painter in our time so well equipped as you. But the equipment is of little use if
there's no horse to harness, no charge to lead, no burden to carry.'[32]

Johnson's art, in contrast, became increasingly burdened by the escalating
events of the Second World War. Unlike Luke, who could admit to being
'happier alone in a cell' while living in Knappagh Farm, Johnson was harried by
a sense of 'hopeless isolation' and struggled to control his feelings of 'fear and
desolation in a land of war, lies and violent rhetoric'.[33] By 1942 he had left
Knappagh and resumed his peripatetic movements about Ulster, returning to
live in Belfast for a brief period before moving to the small fishing village of
Kilkeel, Co. Down. The oil painting *Kilkeel Shipyard* (1943), one of Johnson's
earliest surviving works, is a powerful expression of the anxiety he was feeling at
this time (Fig. 1).

Johnson's recollection of Kilkeel in his autobiography exudes a sensuality that
is typical of his effusive writing style. He evokes a scene bustling with activity as
the sounds echoing from the tools of the shipyard workers blend with the tide
and raucous sea birds with choral intensity:

> The harbour rang with sweet sounds, on one side the thump and flash of
> an adze against the pale resinous ribs of a new built boat, its keel resting
> on grassy cobbles; and across the slow surging tide a band of men dressing
> granite, making curbstones for the streets of London. The unsynchronized
> ring of their chisels made water music, enhanced by the piping of
> sandmartens nesting in the crumbling bluff which sheltered their simple
> forges from the wind.[34]

The image presented in *Kilkeel Shipyard* is strikingly different to this written
evocation. We do see the 'pale resinous ribs' of an unfinished boat with its keel

31 McBrinn, *Northern Rhythm*, p. 67. 32 Hewitt, *John Luke, 1906–1975* (Antrim, 1978), p. 72.
33 O'Brien & Hall, *Nevill Johnson*, p. 28. 34 Johnson, *The Other Side of Six*, p. 46.

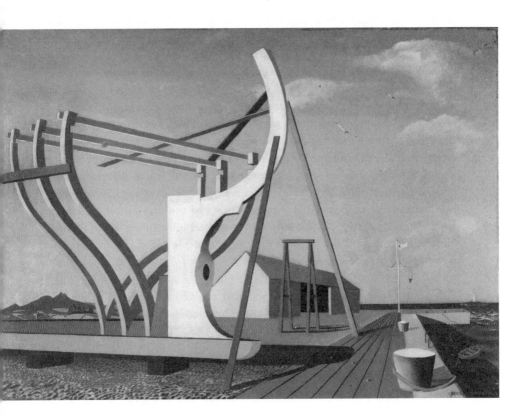

Fig. 1: Nevill Johnson, *Kilkeel Shipyard* (1943)

resting on wooden planks above the cobbles, but the unnerving emptiness of the painting contrasts sharply with the ringing sounds and industrious activity that fill Johnson's autobiographical account. An unusual stillness pervades the harbour and disturbs its idyllic setting. The unfinished frame of the ship and the moored skiff in the harbour suggest the recent presence of human beings, but the gulls flying overhead are the only signs of life. Stylistically, the influence of Luke is discernible in the painting's luminosity and the fine draughtsmanship, yet the scene is rigid with a tension that is altogether different from the idealized landscapes of Luke's great tempera works. The feelings of isolation and moral anxiety that Johnson wrestled with on his rural retreats during the war are palpable. Though he cherished the Ulster countryside and its people, the horrific realities of the war raging on the Continent were never far from his mind, and as the 1940s progressed, his landscape paintings turned increasingly nightmarish. His beloved Mourne Mountains and the Lough Neagh shoreline are gradually transformed into desolate, post-apocalyptic wastelands. A series of diary entries recorded at the time of the dropping of the first atomic bomb on Hiroshima, while Johnson holidayed with his family and Luke at Lough Neagh, represent perhaps his most explicit juxtaposition between the solace of the Ulster country-side and the tumultuous events of the war that had consumed most of the wider world. 'I and my wife prepared a picnic for an afternoon on the shores of Lough Neagh', he writes, as 'the ruins and the people of Hiroshima lay steaming and screaming in the evening sun'.[35]

Whereas *Kilkeel Shipyard* can be understood as an expression of Johnson's own personal wartime anxieties, the painting takes on a more public dimension when considered in the context of art commissioned by the War Artist's Advisory Committee (WAAC) during the period. The WAAC was a British government agency established within the Ministry of Information in 1939, in order to compile a comprehensive pictorial record of Britain during the war. Local artists were commissioned to depict the variegated experiences of British citizens and soldiers in their contributions to the war effort. The scope of the WAAC was enormous, detailing everything from the evacuation of Dunkirk to the mundane realities of rationing and austerity that characterized the everyday experiences of citizens on the Home Front. In this way, it successfully assembled 'a mosaic of life in wartime Britain'.[36] An important aim of the WAAC was to record the huge expansion in merchant shipbuilding following the losses suffered in the Battle of the Atlantic. Accordingly, the English artist Stanley Spencer was commissioned to visit the shipbuilding yards of Port Glasgow in 1940 in order to depict the merchant navy ships that were built there and the workers who

35 Ibid., p. 48. **36** Meirion and Susie Harries, *The War Artists, British Official War Art of the Twentieth Century* (London, 1983), p. 194.

were building them. A project that would span six years, Spencer's 'Shipbuilding on the Clyde' series of paintings vividly evoke the gruelling atmosphere of the shipyards. Focusing on the specific trades of the workers, such as welding, riveting and burning, he presents scenes clamouring with activity where the bent, contorted bodies of the workers are garishly illuminated by the white lights of their torches. For Timothy Hyman, 'Spencer makes us share his wonder at the infernal glare and dazzle of these industrial processes, bringing his "mechanical" landscape eye to bear on all the detail of metal.'[37]

The period Spencer spent making preliminary drawings in the Lithgow shipyard saw him develop a close affinity with the workers and the complexities of their various trades. As Maurice Collis notes, the artist's inclusion of himself among the burners and welders in his Clyde paintings was a device used to achieve a 'closer psychological fusion'[38] with the men, reflecting his strong identification with them. The closeness he felt towards the shipyard workers was coupled with his interest in the abstract qualities of their materials. The triptychs *Burners* and *Welders* were the first two paintings he completed in the Clyde series and demonstrate his fascination with the formal possibilities presented by the shipyard. As Hyman observes, in *Burners* 'the men are shown viewed from above, isolated by the geometric shapes of the steel plates they are working on', while the decorative element of the painting is enhanced 'by the way the steel plates are laid out as if petals'.[39] The geometric stylization of the workers' materials inflects the realism of the paintings with a cubist resonance that deepens their visual intensity.

Johnson was similarly fascinated by the abstract qualities presented by mundane materials and objects. *Kilkeel Shipyard* clearly illustrates this preoccupation in its decorative stylizing of the ship under construction in the foreground. The slender wooden ribs that curve upwards from the keel are mirrored by the beautifully curling frame of the stern, providing a welcome contrast to the otherwise rigid linear rendering of the pier and the warehouse in the background. Just as Spencer's decorative presentation of the steel plates in *Burners* encourages us to think of the skill and artistry of the workers in the way they cut the steel into complex shapes with their oxy-acetylene torches, Johnson's precise and elegant stylization of the exposed ribs of the ship recalls the elaborate steaming process involved in curving the timbers to fit the required shape of the hull. The curvature and alignment of each individual rib was critical, as it ensured that the planks could be joined tightly together so as to leave no warps or gaps where water could leak into the hull.

Another artist commissioned by the WAAC was William Conor in Belfast.

37 Timothy Hyman and Patrick Wright (eds), *Stanley Spencer* (London, 2001), p. 206. 38 Maurice Collis, *Stanley Spencer: A Biography* (London, 1962), p. 42. 39 Hyman & Wright, *Stanley Spencer*, p. 209.

He was asked in 1939 to make a series of sketches of the war effort, including the work in the shipyards and the training of troops. It has been suggested that Conor, who had previously been commissioned as a war artist during the First World War, did not enjoy working for the WAAC in the 1940s and considered it a frustrating distraction from his proper work.[40] However, a draft letter he wrote to the Secretary of the Cabinet in Stormont, Robert Gransden, in 1941 reveals that he nonetheless felt a sense of pride in detailing the contributions made by his fellow citizens in the war effort: 'It has been a gratification to me that I have been permitted by the War Artists Committee to show a wide audience the great deeds that have been performed by my fellow countrymen in the cause of Freedom.'[41]

The affectionate portrayal of urban life that characterized Conor's work for the WAAC was largely a thematic continuation of the sketches of Belfast and its people that he had become renowned for during the 1920s and 30s. *Men of the Home Front*, sketched in 1940, depicts a crowd of shipyard workers crossing Queen's Bridge in the evening on their way home. A warm, relaxed atmosphere suffuses the scene as the men saunter across the bridge in groups, their hands in their pockets, casually conversing with each other after a day's work. Conor's watercolour *Riveting* (1940), though very different to Spencer in terms of style, recalls the focus in the 'Shipbuilding on the Clyde' series on the specific trades of the shipyard workers. Here, we see the three hunched riveters working closely together beneath the enormous hull of a ship. These images were very much in line with the primary aim of the WAAC, which was to promote the communal values and joint endeavour integral to the war effort on the Home Front. They proved to be very popular with the public, and a special exhibition of Conor's work commissioned by the WAAC was one of the highlights of Belfast's hugely successful War Weapons Week in December 1940.

When viewed in relation to Conor's wartime shipyard scenes, the significance of Johnson's *Kilkeel Shipyard* takes on a subversive dimension. The loose, impressionistic strokes of Conor's shipyard scenes that are so integral to their relaxed atmosphere sharply contrast with the cold linear precision of *Kilkeel Shipyard* that conversely grips the painting with a sense of tension. Although Kilkeel harbour's shipbuilding heritage saw it command one of the largest fishing fleets on the entire island of Ireland, both the nature and the scale of its industry were obviously not comparable to the great shipbuilding yards of Belfast that were so important to the British war effort. However, Johnson's stylization and dramatic use of perspective in *Kilkeel Shipyard* imbues the unfinished vessel that dominates the foreground with an unnaturally imposing presence that belies the

40 Judith Wilson, *Conor, 1881–1968: The Life and Work of an Ulster Artist* (Dundonald, 1981), p. 71.
41 Ibid., p. 67.

otherwise relatively unassuming harbour setting. By the time of the painting's completion in 1943, the public popularity of both Spencer's 'Shipbuilding on the Clyde' series and Conor's shipbuilding scenes would have established the shipyard as an emblematic image of British wartime art. It seems plausible, therefore, that Johnson would have been aware of the politically charged nature of his chosen subject and title, particularly given that it is a painting which seems to express his own wartime anxieties. With this in mind, the unnerving emptiness of the scene suggests not only Johnson's personal sense of isolation during the war, but also challenges the communal, lively images of shipyard life fundamental to the ideals of the WAAC, reflected most directly in the commissioned art of William Conor. Johnson, by nature, would certainly have recoiled from the idea of accepting a propagandist commission and submitting to such strict censorship rules. Although he attempted to enlist in the Royal Air Force in 1939, Johnson's fiercely independent nature soon reasserted itself as he recalled that 'political and ecclesiastical societies were anathema to me; I disavowed all cults, clans and brotherhoods.'[42] As the war progressed, his feelings towards both sides in the conflict became increasingly ambivalent. The Allied atomic bombing of Hiroshima and Nagasaki affected him more deeply than any other event in the war: 'For myself and thousands more, these events demanded a total reassessment, a check time, a time to measure the burden of guilt, to reconsider the credit of being human.'[43] It is Johnson's fraught sensitivity to contemporary global events and the profound way in which they impacted upon his art that perhaps most distinguishes him as a painter in Ireland during the 1930s and 40s. The anxious seaward gaze in *Kilkeel Shipyard* is emblematic of the international conscience that compelled his most striking paintings during the period. With this in mind, Johnson should be regarded as an important and dynamic figure in our reconsideration of the relationship between Irish culture and wartime Europe. As Dickon Hall observes:

> It seems important that work was created in Ireland which communicates beyond its immediate surroundings and that this should encourage Ireland to claim at least part of Nevill Johnson's legacy. Otherwise the painting produced here over that period begins to look rather thin and limited in scope and ambition. He remains one of the few artists of this period working in Ireland who can be described as a painter and not just an Irish painter.[44]

42 Johnson, *The Other Side of Six*, p. 42. **43** Ibid., p. 48. **44** O'Brien & Hall, *Nevill Johnson*, p. 59.

A bombardier writes home: Stephen Gilbert

GUY WOODWARD

Stephen Gilbert's autobiographical novel *Bombardier* (1944) is a rare example of Irish (and specifically Northern Irish) war fiction both written and published during the Second World War. Notwithstanding this novelty, its significance lies in the singular way it engages with one of the dominant episodes in British wartime mythology, the evacuation of Dunkirk in 1940. The novel quietly but insistently dissents from officially promoted depictions of British Army life and the Dunkirk evacuation in particular, and unusually focuses on the experiences of Irish soldiers in the army at this time. As a historical document, *Bombardier* asks questions both of British wartime mythology and of dominant currents in twentieth-century Irish history.

Gilbert was born in Newcastle, Co. Down, in 1912. The son of a Belfast seed and tea merchant, he had a middle-class upbringing and was sent to boarding schools in England and Scotland. He left school without passing any exams or gaining any certificate of education. Between 1931 and 1934 he worked as a reporter on the *Northern Whig*, after which he joined his father in the agricultural firm Samuel McCausland Ltd (his Soldier's Service and Pay Book lists his occupation as 'seed merchant' on 19 May 1939, the day he enlisted in Belfast).[1] In her obituary published after Gilbert's death at the age of 97 in 2010, Patricia Craig claimed that reading *Mein Kampf* in the spring of 1939 alerted Gilbert to the necessity of taking a stand against Nazi Germany, after which he joined the Supplementary Reserve.[2] He was at camp in Portstewart when war broke out, whereupon he served as a gunner in the 3rd Ulster Searchlight Regiment. Gilbert's experiences in the British Expeditionary Force (BEF) in France and during the Dunkirk evacuation form the basis of *Bombardier*, his second novel. After Dunkirk, Gilbert was awarded the Military Medal for bravery for his role in blowing up a bridge as the German army advanced and the BEF retreated. He

1 Military Documentation, Soldier's Service and Pay Book, Stephen Gilbert Collection, Queen's University Belfast, MS45/8/1/1.　2 Patricia Craig, 'Stephen Gilbert: Writer who was lauded by Forster but is best known for a lurid novel about rats', *The Independent*, 2 July 2010.

was commissioned as an officer and remained in England, before returning to McCausland's where he later succeeded his father as managing director. During the 1960s Gilbert was active in the Northern Ireland branch of the Campaign for Nuclear Disarmament, where he worked as secretary, organizing marches and demonstrations.

Gilbert was not a prolific novelist – he wrote only five works of fiction, and published no more novels after *Ratman's Notebooks* in 1968. Within this truncated oeuvre *Bombardier* is something of an oddity, since his other novels are an eccentric mixture of fantasy, horror and science fiction. *The Landslide* (1943) describes the appearance of a jungle, complete with dragons and dinosaurs, in the west or north-west of Ireland, while *Ratman's Notebooks* is a horror story featuring an unnamed character who trains rats to attack his enemies. Aside from these works, Gilbert is perhaps best known for his complex and troubled relationship with the much older Ulster novelist Forrest Reid, for whom he acted as literary executor. There are extensive files of correspondence between the two men in the Stephen Gilbert Collection at Queen's University Belfast, which also holds four letters from E.M. Forster to Gilbert.

Bombardier describes the experiences of Gilbert's fictional analogue Peter Rendell in France in the BEF, from Christmas 1939 until the evacuation of Dunkirk at the end of May 1940. Like Gilbert, Rendell is from a middle-class Protestant background and is a Lance-Bombardier serving in the Ulster Searchlight Regiment. It has been widely observed that due to the changing nature of warfare, the Second World War saw a collapse in the distinctions between the battlefield and the Home Front, with profound consequences for cultural representations of war. *Bombardier* is very much a battlefield novel, however: its principal characters are all service personnel, and French civilians make only brief cameo appearances in scenes defined largely by difficulties in communication.

The Searchlight Regiment depicted in the novel is made up of soldiers from both sides of the border, but Irish neutrality does not appear to be of abiding concern, beyond a rumour circulated early on in which all 'Free staters' [*sic*] are to be sent home 'them bein' neutrals in a manner of speakin'.[3] The exportation of sectarian fault-lines to war-torn France has some curious repercussions, however. Billeted in a dance-hall in a dirty mining town, there is uproar one night at the raucous singing of 'The Sash My Father Wore': 'The singer told the troop at large that they were a pack of papish bastards, and a chorus of voices replied that they were better Orangemen than he.'[4] Later, out of curiosity, Rendell and another soldier, Farren, attend Mass in the village of Noyelles but are under-

3 Stephen Gilbert, *Bombardier* (London, 1944), p. 11; afterwards *Bombardier*. The novel was reissued by Valancourt Books in 2014. **4** Ibid., p. 44.

whelmed by the experience: 'The service [...] turned out to be a disappoint-
ment. [...] They were surrounded by a creaking, crinkling mass of black-clad
females, and the air was heavy with the smell of country people in their Sunday
clothes.'[5] In conversation afterwards Peter describes Catholicism as 'a synthetic
religion', is surprised by the unfriendly attitude of local worshippers towards the
soldiers and is unimpressed with the replacement of candles by electric light.[6]
Farren observes disappointedly that '[i]t wasn't as Roman Catholic as I expected',
encouraging Rendell to think of the genesis of his illusions in 'The Troubles', as
he terms the period during his youth, defined by 'the sound of machine guns at
night, the constant talk of murders and rioting – of Catholic and Protestant.'[7]
Between the ages of eight and ten, he had gained the belief that Catholics were
'wicked people', and discussed with other small boys the 'mysterious and imagi-
nary rites of the Roman Catholic Church'.[8] Passing through Ballyhackamore as
a small boy, he describes how he felt a 'thrill of superstitious awe' at the Catholic
'chapel – for no good Ulster Protestant ever called any Roman Catholic building
a church.'[9] However, his disappointment at the French Mass also derives from a
later impression of Catholicism as 'a religion of form and beauty, a religion
where grave priests ministered to the sickness of the soul'.[10]

From Catholicism, then, to Dunkirk, which has itself elicited a degree of
veneration and unquestioning celebration not unlike a religious rite. Following
the completion of Operation Dynamo in early June 1940, the evacuation was
very quickly recruited as the subject of a diverse body of cultural representations,
often celebratory but often also dependent on personal testimony. Writing in the
literary magazine *Horizon* in December 1941, Tom Harrisson listed 'Dunkirk
books' as the third of seven categories of war literature that had appeared since
the outbreak of the conflict over two years previously:

> Dunkirk at last gave people something to write about, and they wrote.
> Novels and reportage books are still coming out about escape through
> France after the Vichy peace. These books are distinctly above the general
> average, largely because written by people who had never before written a
> book, but had had such an interesting experience that there was
> something automatically interesting and easy to write about.[11]

Addressing British fiction of the Second World War, the critic Holger Klein has
argued that 'the most fundamental aspect of structure is the positioning of the
action in war fiction within the overall action of the war.'[12] In realist war fiction,
the narrative must correspond with documented events with which readers are

5 Ibid., p. 53. 6 Ibid., p. 54. 7 Ibid. 8 Ibid. 9 Ibid. 10 Ibid., p. 55. 11 Tom Harrisson, 'War
Books', *Horizon*, 4:24 (Dec. 1941), 416–36 at 419. 12 Holger Klein, 'Britain' in Holger Klein with John
Flower and Eric Homburger (eds), *The Second World War in Fiction* (London, 1984), pp 1–46 at p. 25.

often familiar. Given the magnitude of the Second World War and the extent to which its events were documented, recorded and mythologized even as they happened, writers producing war fiction during the war itself faced considerable pressures to orient their work in this way. That Gilbert was conscious of these pressures is evident from a note addressed to himself regarding an unpublished wartime story in which he stresses that '[t]he thing to remember is I don't have to describe it all. There can be gaps.'[13]

Bombardier itself encourages consideration of the practice of writing during war. At one point, some lines of poetry written by Rendell interrupt the prose; later he takes a *Golden Treasury*, an anthology of nineteenth-century poetry, to the gun-pit each time he goes on duty:

> When he was not firing, or making out reports on the actions, he was reading poetry, or trying to write it. He wrote on the fly-leaf and end pages of the *Golden Treasury*. As soon as he began to write he was in Donegal, on the sea coast – right on the very edge of the sea. He scrambled over rocks, and looked down at the rise and fall of the waves. He bathed; he ran along sandy beaches in his bare feet. That had been part of his childhood – the part he had liked best. Then the planes would come and he would fire and make out his reports in triplicate.
>
> What he wrote reflected this in part. There were descriptive verses about the sea, sea-gulls and cormorants, and the wet, black rocks: in between these came vituperative verses about bombing, the army, and aeroplanes.[14]

The subject matter sketched here is reflected by material in the Gilbert collection at Queen's, where poems written during his army service often address the sea and seashore of Donegal. One untitled handwritten poem with a footnote, 'Written at Lille Aerodrome, in the back of a "Golden Treasury", in intervals of firing a Lewis Gun, chiefly at Messerschmidt fighters. 19/5/40', does indeed describe a cormorant 'flying low' and the 'lonely cry' of a seagull.[15] Comparison of the notebooks with the published novel enable an important insight into the creative decisions taken by the writer during the war, and indicates a perception that poetry was insufficient to the task of responding to events of such magnitude. Gilbert's poems remained unpublished, and the way in which their composition is incorporated into the autobiographical novel underlines the dominance of prose and of personal testimony at this time. This was not an approach favoured by all, of course, and *Bombardier* was characterized by a

13 Stephen Gilbert, 'They Have Their Reward', Gilbert Collection, MS45/2/13. 14 *Bombardier*, p. 147.
15 Stephen Gilbert, untitled handwritten manuscript, Gilbert Collection, MS45/3/4.

reviewer for the *Times Literary Supplement* as 'all well observed, no doubt, but somewhat bleak and restricted as fiction'.[16]

The preamble to *Bombardier* is illustrative of one way in which the pressures outlined by Klein could be navigated. The main text of the novel is preceded by a contents page which divides the book into nine sections, all but one of which is given the name of a French town or area in north-eastern France around which the action takes place (a note at the foot of the page concedes that two of these names are fictional). This culminates in the penultimate 'Dunkirk' and final section 'England'.[17] The following page carries two headings: 'Scene', under which the locations: 'Parts of Northern France', 'The English Channel' and 'The South of England' are listed, and 'Time', with corresponding seasons and years.[18] There is also a 'List of Principal Persons in Order of Mention' on the page after that. The various components to this preamble suggest that Gilbert is self-consciously operating under the constraints of readers' expectations, arising from their knowledge of recent known historical episodes. *Bombardier* was published in October 1944, when the ultimate outcome of the war in Europe was all but assured: by providing readers with the chapter titles 'Dunkirk' and 'England' before the main body of prose, Gilbert signals in advance that the novel will engage with one of the pre-eminent known episodes of that ongoing war, and also indicates that it is likely that at least some of the cast of characters will successfully emerge from these events.

Some of Rendell's thoughts on the possible progress of the war appear at an early stage of the novel:

> He wondered how long the war would last. If people asked him he always said ten years – and everyone laughed. They said there'd be starvation in Germany before that. The Germans couldn't win – yet obviously they had only gone into the war because they thought they *would* win, but how. The Maginot line was impregnable and the Belgians had a similar line.[19]

The dramatic irony in these lines is clear: by 1944 the futility of the fortifications was legendary. There is an echo here of the running joke in Evelyn Waugh's *Put Out More Flags* (1942), in which Sir Joseph Mainwaring continually mispredicts the course of the war, on one occasion with reference to the Maginot line. *Bombardier*'s narrative depends in part on how the importance of these defences is disproved in the novel, how Peter is personally affected by these known historical episodes, and how this personal experience corresponds to, or diverges from, familiar accounts.

16 R.D. Charques, 'Other New Novels', *Times Literary Supplement*, 28 Oct. 1944. **17** *Bombardier*, p. 5.
18 Ibid., p. 6. **19** Ibid., p. 23.

The biographer and journalist John Henry Robertson, an army major in the Directorate of Public Relations during the war who wrote under the pseudonym John Connell, bought *Bombardier* in a bookshop in Cairo in January 1945. He wrote to Gilbert:

> I found it enormously refreshing, after too many over emotionalised + strident 'I was there's' + 'I was a Fighter Pilot' books; your quiet, unassertive, unaccented narrative is astonishingly attractive. Here is a grave, tranquil, young innocence too about it, which is difficult to describe (for me, anyway) without being clumsy. You write as a boy of seventeen *ought* to write, but never does; I imply that you have somewhere in you the spirit of being a boy, with all a boy's mawkish puppydom scoured out. Remarkable.[20]

As Tom Harrisson implies in his magazine article, given the speed at which fiction about the war appeared as the conflict was in progress, and the short forms in which this was often published, it was inevitable that the boundaries between fiction and journalism would be permeable and invite transgression. The 'unassertive, unaccented' register of *Bombardier*, Gilbert's only realist novel, in which description and dialogue are offered with minimal commentary, encourages its reading as reportage (and Gilbert of course had previous experience as a journalist on the *Northern Whig*). The novel's form also contributes to this impression. Chapters are divided into short episodic subsections, and its documentary authenticity is enhanced by elements separated from the main text, such as a bilingual card advertising a brothel, a printed message alerting troops to the possible seizure of an aerodrome by German parachutists, and a written order given by a captain in the General Staff.[21]

The list of principal persons in the preamble to *Bombardier* adds to the sense of generic instability, and aligns the novel with some non-fictional wartime publications. Peter Hadley's *Third Class to Dunkirk: A Worm's Eye View of the B.E.F. 1940*, like *Bombardier* published in 1944 and ostensibly 'a plain statement of an ordinary subaltern's reactions to war', similarly carries a 'Dramatis Personae' before the main text. The influential polemic *Guilty Men*, published in 1940 shortly after the Dunkirk evacuation, and in which the myth of Dunkirk is central to the indictment of appeasement, features a 'Cast' of Neville Chamberlain, Lord Halifax and others at its outset, and follows this up by listing relevant cast members at the beginning of each short chapter. *Bombardier* is clearly not a polemic in the mould of *Guilty Men*, but the novel can be read as

20 Letter from John Henry Robertson to Stephen Gilbert, 22 Jan. 1945, Gilbert Collection, MS45/1/15/2.
21 *Bombardier*, pp 48, 148, 161.

a contribution to a discourse of dissent regarding the British conduct of the early years of the war and also raises questions about how dissent may be expressed in wartime. *Bombardier* is less satirically emphatic than Waugh's *Put Out More Flags* and post-war *Sword of Honour* trilogy, but similarly describes the bureaucratic idiocies of the army. Under cover of restrained and unemotional reportage, the novel insistently challenges the hierarchical power structures of the British Army, suggesting that in some cases these have proved a hindrance to the success of military operations. Waiting for a senior officer to return, Peter muses that 'even after a further hour Guthrie might not return. Things happened like that in the army. People said they would do things: then they received different orders from some superior person, and they were unable to fulfil their promises.'[22]

In his study of Britain and the memory of the Second World War, *We Can Take It!*, Mark Connelly has observed that although the British public received most of their information about the war's progress from sources such as newspapers and wireless broadcasts which were subject to governmental scrutiny and control, they also talked to each other about the war news, and through their own scrutiny 'created an alternative history of the war even as it was happening'.[23] Connelly continues to argue that the Second World War is 'a visual war above all else', citing the importance of war films in 'inform[ing] the development of the myths' while the war 'is not regarded as a genuinely literary war [...] in the way that the Great War was and is.'[24] It is hard to disagree with the contention that the mass appeal of film, and subsequently television, has eclipsed literary treatments of the Second World War. In this essay I want to build on Connelly's arguments and suggest that the medium of fiction during the war years was an important space for discussion and dissent, in which those 'alternative histories' could be discussed as the war was in progress. Given that war fiction was so often social and dealt with the relations between members of a community or organization, the dialogue between these characters and the depiction of these relations offered significant opportunities for expressing dissent indirectly.

Connelly's apprehension that the Second World War was insufficiently literary was certainly felt at the time (the most famous example probably being the appeal made 'To the Poets of 1940' by the *Times Literary Supplement* in December 1939) and is reflected in the way that *Bombardier* looks back to the conflict a quarter of a century previously – the action unfolds across the landscape of north-eastern France, in which the repetitive patterns of advance and retreat and the repeated digging of defensive trenches have an unavoidable resonance.[25] In one village the wife of the local baker turns out to be half-

22 Ibid., pp 159f. 23 Mark Connelly, *We Can Take It!: Britain and the Memory of the Second World War* (Harlow, 2004), p. 6. 24 Ibid., p. 7. 25 Philip Tomlinson, 'To the Poets of 1940', *Times Literary Supplement*, 30 Dec. 1939. Tomlinson wrote that '[c]onsciousness has been struggling vainly to free itself

English, the daughter of an officer in the British Army. As the Germans advance and Rendell's troop becomes engaged in battle, the references to the previous war proliferate. During an operation to sabotage a bridge across a canal, a seriously wounded soldier, a veteran of the First World War, observes:

> 'Ye'd some chanst in thon other war [...] Ye've none in this.'
>
> Peter disagreed, but he didn't want to argue with a wounded man. From what he heard he imagined that compared with the last war this was almost a game.[26]

Later, amid the ruins of Dunkirk, Rendell feels that '[j]udging by the standards of the last war this running-away was surely a terrible disgrace. There was something wrong all through.'[27]

In a letter to Gilbert written in the second month of the war, Forrest Reid advised him 'to keep a diary as Siegfried Sassoon + others did in the last war. Then, if you ever wish to use the material, you can put it into shape later.'[28] The way in which the mythology of the First World War is shown to weigh upon those fighting the Second invites interrogation of the contemporaneous mythologizing of the ongoing conflict. Early in the novel, a description of Christmas Day 1939 articulates a biting awareness of the distance between myth and experience:

> Peter ate his dinner standing in the snow. It consisted of cold bully-beef and dry bread, with a drink of water if you were thirsty.
>
> After dinner he went back to the estaminet: there was nowhere else to go. Madame had turned on the news in English as an additional attraction. The announcer told of how the British soldiers in France were enjoying a wonderful dinner of turkey, roast beef and plum pudding. Hundreds of turkeys, thousands of plum puddings had been specially sent out.
>
> The troops commented on this news in various ways.[29]

Later a sergeant tells Peter that at one point during a spell of duty on the Maginot Line they had been quite close to an exposed enemy working party but had been ordered not to fire on the German soldiers.

> Peter was interested in this. Had the order come from *very* high up? Did the Prime Minister hope to win the war without bloodshed? He felt that

from the mark of the last calamity, but our poetry continued to be permeated, in varying forms and degrees, with the memory and often with the mood of 1914–18. A quarter of a century of moral disquietude and revolt has not been accompanied by any clear conception of what new order should replace the old.' **26** *Bombardier*, p. 191. **27** Ibid., p. 226. **28** Letter from Forrest Reid to Stephen Gilbert, 27 Oct. 1939, Gilbert Collection, MS45/1/14/47. **29** *Bombardier*, p. 19.

> Mr. Chamberlain must be an extremely kind man, with such a desperate
> responsibility, to still have the flickering hope that he could save the youth
> of the world from the slaughter – such a slaughter as he had seen once
> before.
> Peter expressed this opinion to the sergeant. The sergeant didn't know
> what to think; he only wished, he said, that the old bastard would let them
> shoot a few of the ―― ――.[30]

Much later, during the retreat from the border with Belgium, Rendell observes
that a defensive line could be more easily held at a river bank and suggests this
to a superior, offering to return and organize this himself. The officer nods
sympathetically but ignores this offer, and Peter watches as a line of trucks is
loaded with '[t]ypewriters, a duplicating machine, trestle-tables, stationery and
chairs' to be taken back to Dunkirk, a compelling illustration of the ways in
which the BEF was hampered by poor organization and bureaucracy.[31] There are
many other such instances of indecision and waste, but perhaps the most pitiless
image of military incompetence and paralysis is provided by an elderly Brigadier
encountered by Rendell during the confusion of the retreat: 'His mouth was
slightly open: he looked weak and uncertain. Peter felt a complete lack of confi-
dence in him. Probably he was the man who had ordered the withdrawal. He
was far too old to face a crisis.'[32]

These episodes show how the novel may be used to articulate dissent and to
challenge the mythology of the war, even as it was in the process of being estab-
lished. The precarious contingency of the Dunkirk myth is underlined by
Rendell's apprehension on the steamer heading towards England of crowds
gathering on the quays 'who would boo them as a beaten army.'[33] His fear is
quickly shown to be unfounded – following disembarkation, tea and buns await
the troops on an unidentified railway platform, where a clergyman distributes
postcards so the men can inform their families of their safety.

In conclusion, I would like to identify another means by which Gilbert's
novel debunks the official narrative of the war. *Bombardier* is an important
counter to the almost overwhelming Englishness of the Dunkirk myth; Rendell,
his troop and by extension his regiment are outsiders – when it is suggested that
Rendell has been passed over for promotion because he is not English, Farren is
loudly critical:

> 'Englishmen, Englishmen, Englishmen,' he complained. 'They get every-
> thing. Sure, it's the same in the shops in Belfast. They bring in English
> managers to modernize them; and in about three years they go bang! –
> chromium plate, lifts and all.'[34]

30 Ibid., p. 108. 31 Ibid., p. 212. 32 Ibid., p. 209. 33 Ibid., p. 260. 34 Ibid., p. 83.

In his broadcast talk on the Dunkirk evacuation, published the same year in his collected *Postscripts* (1940), J.B. Priestley writes: 'What strikes me about it is how typically English it is. Nothing, I feel could be more English than the Battle of Dunkirk, both in its beginning and its end, its folly and its grandeur.'[35] He then clarifies that 'when I say "English" I really mean British'.[36] As Rendell's ship nears the English coast in the closing pages of the novel, Gilbert evokes one of the pre-eminent mythical images of the British Home Front, familiar by 1944 from Vera Lynn's popular 1942 version of the song, with the curious studied naivety which characterizes the novel. It is worth bearing in mind that this mythical homeland is not, of course, Rendell's home:

> He saw the white cliffs of England. Before, he had always despised those white cliffs, because he didn't like England and preferred the sad, grey cliffs of his own country. Now, in the mid afternoon sunshine, they looked very kind. He thought of Drake, and of how differently the warriors England had sent out in olden times had returned.[37]

Deflating English maritime mythology without resorting to satire, *Bombardier* offers restrained dissent from official and unofficial mythical treatments of the British Expeditionary Force and the Dunkirk evacuation. I propose that Gilbert's status as a Northern Irishman serving in the British Army contributed to his ability to make the subtle challenges to official and mythical versions of events that we see in this fictionalized historical account. The novel illustrates how the meaning of 'home' for the many soldiers of the British Army from outside England was more complex than official and often Anglocentric wartime cultural representations could describe. However muted, the Northern Irish contextual hinterland in the novel, sketched through the Orange songs and the 'sad grey cliffs', clearly complicates more familiar and simplistic wartime narratives.

35 J.B. Priestley, 'Wednesday, 5th June 1940' in *Postscripts* (London, 1940), pp 1–4 at p. 1. 36 Ibid., p. 2. 37 *Bombardier*, p. 261.

T.H. White, Ireland and the Second World War: writing and re-writing *The Once and Future King*

ANNE THOMPSON

The British author Terence Hanbury White wrote the majority of his Arthurian epic *The Once and Future King* while he was living in Ireland and attempting to avoid the Second World War. Ireland had a significant impact on the book that he wrote – an impact that has remained largely unacknowledged by White scholars. Although White was initially enthusiastic about Ireland, about two years into his stay his attitude changed and became distinctly anti-Irish, and these impressions are reflected in *The Once and Future King*. Similarly, guilt over his avoidance of the war seems to have significantly contributed to White's development of his Arthurian narrative, which became more decidedly anti-war in tone and theme than he had originally conceived. Drawing on archival research, in this essay I will explore White's experiences in Ireland in greater detail, showing how they influenced the writing of *The Once and Future King*, both in terms of its representations of the Irish people and its representations of war.

T.H. White arrived in Ireland in February 1939. He was 32 years old, the author of a collection of poetry, seven novels, an autobiographical diary and a satirical manual on hunting and fishing, and his most recent book, *The Sword in the Stone* (1938), had become a runaway success. The American Book of the Month Club selected the novel in July of 1938, changing White's financial situation overnight and bestowing on him what he called in his diary 'the probability of wealth and fame'.[1] On the day he received the news, he wrote that he found himself 'faced with two paths, in the one of which I may remain a sort of philosopher without money, in the other of which I may lose philosophy and all occasion for it'.[2] This sudden financial security gave him the freedom to live

1 White, Diary 1938–1939, 6 July 1938, Box 8, Folder 1 (T.H. White Collection, 1899–1997, undated, MS-4494, Harry Ransom Center, University of Texas at Austin). All subsequent references to White's diaries and notebooks refer to MS-4494 at the Harry Ransom Center. 2 Ibid.

wherever he wished; it gave him the money, he realized, to do what he had been contemplating in his diary for over five months and '[run] away from war'.[3]

Towards the end of 1938, White heard that his friends David Garnett – the Bloomsbury writer and critic – and Rachel 'Ray' Garnett would be travelling to Ireland on a fishing trip, and, as White's biographer Sylvia Townsend Warner describes it, '[he] was fired to go too'.[4] White and the Garnetts arrived in Ireland on 22 February 1939, and while his friends returned to England after a period of about ten days, White remained behind, staying in Doolistown, Co. Meath, as a paying guest of Paddy and Lena McDonagh.[5] Warner implies that White's decision to spend the war in Ireland was accidental. She explains that after 'White failed to get a fish', he was 'mettled' and 'decided to stay on till he had caught a great many fish [...] He supposed it would be a matter of a fortnight or so'.[6] However, although White did suggest this scenario in letters to friends, other evidence indicates that he made the move to Ireland in a calculated attempt to get away from the war. He had been debating leaving England in his diary since March 1938, and he told David Garnett on 20 January 1939, a month before their trip: 'If only I can get out of this doomed country before the crash, I shall be happy. Two years of worry on this subject have convinced me that I had better run for my life'.[7] White did avoid the 'crash' (as he referred to the Second World War) geographically, if not psychologically, by living in Ireland, and, in spite of the occasional attempt to return to England, he remained in Ireland until September 1945.

Unlike other English authors who spent portions of the war in Ireland, White was not in the country in any official or covert capacity. In *That Neutral Island* Clair Wills speculates that White may have been working as a spy for the British, but further evidence suggests that he did not take any active role in the war effort. Wills hypothesizes that since 'on the outbreak of war he had volunteered his services to the Ministry of Information, it is quite likely that his several sojourns on the uninhabited island of Inishkea [...] did have an undercover aspect'.[8] It is true that White volunteered his services to the Ministry of Information at the start of the war, but his journals and letters from the time show that the Ministry did not accept his offer. White mentions the Ministry for the first time on 21 September 1939, writing: 'I have volunteered vaguely for the Ministry of Information, with the mental reservation that I wont [*sic*] do anything till Arthur is over'.[9] Already ambiguous about participating in such work, White grew incensed when he failed to get any response from the

3 White, Diary 1938–1939, 1 Apr. 1938, Box 8, Folder 1. 4 Sylvia Townsend Warner, *T.H. White: A Biography* (New York, 1967), p. 118. 5 Ibid. 6 Ibid. 7 David Garnett, *The White/Garnett Letters* (New York, 1968), p. 39. 8 Clair Wills, *That Neutral Island: A Cultural History of Ireland during the Second World War* (Cambridge, CT, 2007), pp 169f. 9 White, Diary 1939–1941, 21 Sept. 1939, Box 27, Folder 1.

Ministry. A month later, on 20 October 1939, he had received no reply and noted in his diary: 'I have offered my services to such specialised offices as might be advanced by my help – the Ministry of Information and the British Council. But they don't even answer. No doubt they find their purposes served by a collection of journalists and professional adventurers and criminal lawyers. They dont [*sic*] want me'.[10] White continued to lament the fact that no one had responded to his approaches. He expressed what appears to be genuine frustration in a diary entry from 16 December 1941, where he lists his six failed attempts to join in the war effort as a 'record of [his] war service':[11]

> (1) As an author chosen by the American Book Club, I offered my services to the British Council, to lecture in America, a year before the war started. They were positively refused.
>
> (2) On the day war broke out I offered them to the Ministry of Information through Sir Sydney Cockerell, who, I thought [...] might have had a pull. I was politely told to wait.
>
> (3) On the collapse of France I joined the Local Defense Force in Belmullet, but, after a couple of parades, I was politely asked, not to resign, but to absent myself from parade. They were afraid I was a Fifth Column.
>
> (4) All this time I was writing a book about the non-fascist ideal (my Arthur book) for publishing which I shall certainly have my head chopped off, if Hitler wins the war.
>
> (5) On finishing the book I immediately sent my papers to a man called Air Commodore Peake, on Bunny[12] Garnett's recommendation, for a commission in the R.A.F.Y.R. special duties branch. Peake, in this case I think almost impolitely, has not ~~even~~ deigned to reply, although I posted the application more than a month ago.
>
> (6) There are no recruiting offices in Ireland, and I cannot get a visa [...] to visit a recruiting office in England [...] So now I cannot even win through to the latrine squad, as a private soldier with First Class Honours at Cambridge and his name in Who's Who.
> ~~This is freedom.~~[13]

In light of his apparent failure to join the war effort in any capacity, there is little reason to believe that he was passing on information or otherwise engaged in espionage at this time.

This detailed information about the author's wartime activity in Ireland can

10 White, Diary 1939–1941, 20 Oct. 1939, Box 27, Folder 1. 11 White, Diary 1941–1942, 16 Dec. 1941, Box 8, Folder 2. 12 'Bunny' was David Garnett's nickname. 13 White, Diary 1941–1942, 16 Dec. 1941, Box 8, Folder 2.

be found in the extensive T.H. White archive at the Harry Ransom Center (HRC) in Austin, Texas, which offers valuable insight into White's life. The author recorded his experiences of his first three years in Ireland meticulously, and files in the archive contain records of his impressions of people, his experiments on ant colonies (he became a passionate amateur biologist for several months), writings on Irish folklore, reflections on the war and more. The resources available at the HRC include over 400 annotated books from White's library, hundreds of unpublished letters, and White's drafts, notebooks and journals. This unpublished information enables critics to partially reconstruct White's experience in Ireland, and, rather than engaging in espionage, it appears that White's wartime occupation was building his 'book about the non-fascist ideal'.[14] During his first three years in Ireland he was busy turning *The Sword in the Stone*, a cheerful tale of King Arthur's boyhood, into *The Once and Future King*, and incorporating a great deal of his initial interest in Ireland, his subsequent frustrations, and his deep distress about the war into the book.

White's initial attitude towards Ireland appears to have been one of intense curiosity and delight; even the physical appearance of his 1939–41 diary illustrates his enthusiasm. There are entire pages written in Irish (which the author had begun learning in March 1939, shortly after his arrival), postcards from the National Museum showing famous artefacts, dozens of photographs of people and the landscape, and White's own skilled drawings of stylized animals rendered into Celtic designs and patterns.[15] At the time, he was reading widely about Ireland and Irish history. On 29 May 1939, having been in the country for only three months, he wrote to Ray Garnett reporting that he had already finished 'two enormous histories of Ireland – one of them Father D'Alton in 8 volumes'.[16] He also records that he bought 'Finnegan's [*sic*] Wake' but decided that '[l]ife's too short. I cannot learn Irish and read Joyce both at the same time'.[17] He was still reading Irish history enthusiastically a year into his stay. A list in his diary, drawn up after a shopping trip to the Dublin bookshop Hodges Figgis, contains almost a dozen titles, including:

> Ireland in Pre-Celtic Times – Macalister
> Ancient Ireland – Macalister
> The Way That I Went – Praeger
> Pagan Ireland – Wood Martin
> Irish Mythological Cycle – de Joubainville
> 2 volumes of proceedings R.S. of A. of Ireland
> Early Gaelic Literature – Hyde

14 Ibid. **15** White, Diary 1939–1941, Box 27, Folder 1. **16** Garnett, *The White/Garnett Letters*, p. 44. The first six volumes of *History of Ireland* by Edward Alfred D'Alton are still in White's library at the HRC. **17** Garnett, *The White/Garnett Letters*, p. 45.

Volume of Antiquarian Handbook Series on W. islands
Islands of Ireland – Mason
History of Co. Mayo – Knox[18]

In addition to this heavy reading load, White began to collect folklore from the Iniskea islands about a carved statue called the 'neamhóg'. He wrote to the folklorist Seán Ó Súilleabháin to discover what other researchers had found and used local schoolchildren to collect first-hand accounts – some in Irish – from ageing former residents of the island.[19] He would later publish an account of this research as the autobiographical book *The Godstone and the Blackymor* (1959). Like his contemporary John Betjeman, early in his stay he signed his letters to friends in Irish, using the Irish translation of his name. He began to tell his friends, half-jokingly, that he was an Irish bard, and therefore excused from fighting in the war: 'I am going to claim the immunity of the Irish bard, confirmed in A.D. 500 or so at the convention of Drum Cuit', he wrote to Ray Garnett.[20] White probably did not expect his friends to believe this statement, but on some level it seems that he was in earnest, for even in his own diary he began to refer to himself as an Irish bard. On 11 December 1939, after winning the first prize in a poetry competition open to winners of the New Verse Competition on Radio Éireann, he wrote: 'So I am now the chief bard of Erin, and prouder of this than of almost anything else I can think of'.[21]

Despite this enthusiasm, White's early infatuation began to fade after about two years. In 1941, White's occasional complaints about Ireland in his diary intensify into a steady stream of anti-Irish invective. He felt that he was being watched: 'Everywhere I go in this bloody country, in village or town, I am pursued by hundreds of pairs of lurking, over-reaching, ignorant, calculating, crafty, cannibal eyes – the Zulus are far more civilised than the Irish'.[22] At the same time, he became convinced that the Irish understood 'no motive that [was] not mercenary, over-reaching or wicked',[23] telling himself and his friends that even the well-educated and cultured Irish were primitives. In the end pages of a book of short stories by Frank O'Connor, the pre-eminent Irish writer and translator, White, objecting to the humorous treatment of a murder in one of O'Connor's stories, argued: 'The trouble is that the Irish, like all ancient races of savages, have a genuine contempt for human life'.[24] These sentiments are at odds with White's observation in his diary in January 1940 that the Irish had 'a very much more sensitive appreciation of death than there is to be found in

18 White, Diary 1939–1941, 1 Apr. 1940, Box 27, Folder 1. 19 Ó Súilleabháin's reply with suggestions on White's research is in White's diary 1939–1941, 16 Feb. 1940, Box 27, Folder 1. 20 Garnett. *White/Garnett Letters*, p. 45. 21 White, Diary 1939–1941, 11 Dec. 1939, Box 27, Folder 1. 22 White, Diary 1941–1942, 7 July 1942, Box 8, Folder 2. 23 Ibid. 24 White, Works, n.d., Box 11, Folder 4.

England'.[25] In a manuscript draft of *The Elephant and the Kangaroo* (1947) – a novel in which the author imagines Noah's flood recurring in Ireland with an English paying guest called 'Mr White' instructed to build the ark – White described the Irish character 'Mikey'. He based Mikey so closely on his opinion of his host Paddy McDonagh that at one point he confused the names, and wrote 'Paddy' by mistake:

> [Mikey] was nearly always in Mr. White's bad books. This was partly because of his timidity, partly because of his laziness, and partly because he was physically speaking a kind of pre-Chellean[26] idiot. Mr. White was always finding out, with indignation, some new thing which poor Mikey could not do [...] ~~Paddy~~ Mikey could not wind up his watch, could not tell the time by the minute hand, or recognise photographs – he used to hold them upside down. He did not know his age, nor his own second name.[27]

White wrote almost the same words in a December 1943 letter to Mary Potts – wife of his Cambridge mentor L.J. Potts – in which he described Paddy and Lena, the hosts who had fed and housed him for four years. In Mary's letter he added, 'Don't think that these people are naturals. They are slightly more incompetent than their neighbours, but it is mainly just that they are Irish'.[28] It is not clear what precipitated White's violent and sudden turn towards these negative sentiments, and no single trigger event appears in his diaries. We do know that Ray Garnett died of cancer in the spring of 1940. We also know that as his friends in England joined the war effort, White was increasingly bothered by his conscience and that continuing arguments with his publisher, Collins, delayed the publication of *The Once and Future King*. It is possible that these pressures combined to intensify his antipathy towards Ireland and the Irish.

Whatever the trigger was, White's experiences in Ireland had a major impact on *The Once and Future King*. The HRC manuscripts show that in 1941 White began to view the Irish as the antagonists of the Arthurian drama. In one notebook, he concluded that the villains in the Arthur myth were Gaelic, and that the Gaels of Arthur's time were equivalent to the Irish of the 1940s. White wrote: '[The Gaels] were always waiting and scheming to stab some of their accumulated conquerors in the back, as their descendants still wait in Ireland.' He continued: 'Almost all Arthur's enemies, throughout his life, were of Gaelic stock – were these Old Ones taking their subtle chances of revenge'.[29] White cut

25 White, Diary 1939–1941, 30 Jan. 1940, Box 27, Folder 1. 26 White refers to an archaeological find at Chelles, France. 27 White, Notebook 6, Box 12, Folder 1. 28 François Gallix (ed.), *Letters to a Friend: The Correspondence Between T.H. White and L.J. Potts* (New York, 1982), p. 138. 29 White, Works: Notebook 3, n.d., Box 11, Folder 7.

this explicit statement about the Irish from subsequent drafts, but a close reading shows that the central causes of the fall of the Round Table are still attributable to 'Gaelic' characters in his final version. In a letter to L.J. Potts dated 28 June 1939, White defined 'the three tragic themes' of *The Once and Future King* as, '1 The Cornwall Feud, existing ever since Arthur's father killed Gawaine's grandfather, 2 The Nemesis of Incest […] and 3 The Guenever-Lancelot romance'.[30] In *The Once and Future King*, characters from the Orkney Islands are held responsible for these 'three tragic themes'. It could be argued that these 'Gaels' are Scottish and therefore not connected to White's stay in Ireland. Significantly, however, White not only uses Irish references in the novel, but also conflates the Scottish and the Irish in his diary. On 3 May 1939 he wrote some remarks about a character from *Le Morte d'Arthur*, noting 'Anguish, variously mentioned by Malory as of Scotland and of Ireland'.[31] This inconsistency in his source text is confusing, and White resolved the problem by deciding that 'Ireland may have been the original Scotland'.[32] From this statement, it seems clear that White equated the two places as he wrote, so that the characters from Orkney were, at least to some extent, Irish in his mind.

The original root of the Cornwall feud is King Uther, Arthur's father, but the feud is problematic for the Round Table because it is perpetuated by Morgause – whom White described in his diary as, 'the worst west-of-Ireland type: the one with cunning bred in the bone'.[33] From their infancy, Morgause teaches her sons the story of her mother's abduction and rape, and in the novel White introduces the feud through the boys telling one another 'their mother's favourite story'.[34] In the final version of the book, the story is always told through the boys, and through dialogue which reflects Irish-language word order. For example, one boy, Agravaine, says, '[t]here was a beautiful grandmother at us', using the Irish system of describing ownership or affinity with the particle *ag*, translated 'at'. Their storytelling also recalls Irish-language epics. The eldest brother Gawaine says, 'They saddled their prancing, fire-eyed, swift-footed, symmetrical, large-lipped, small-headed, vehement steeds'.[35] This echoes the strings of synonymous adjectives used in Old Irish texts for dramatic and descriptive effect, and White seems to have borrowed this method of composition from similarly alliterative descriptive passages in the *Táin Bó Cúailnge*.[36] The feud is thus revealed to the audience in a distinctly Irish manner, supported by White's own recent reading in Irish history and literature. It is because Irish characters and especially Morgause perpetuate a cycle of violence and reprisal that the first part of Arthur's tragedy is created.

30 Elizabeth Brewer, *T.H. White's* The Once and Future King (Cambridge, 1993), p. 49. 31 White, Diary 1939–1941, 3 May 1939, Box 27, Folder 1. 32 Ibid. 33 White Diary 1939–1941, 25 Oct. 1940, Box 27, Folder 1. 34 White, *The Once and Future King* [1958] (New York, 2011), p. 210. 35 Ibid., p. 209. 36 See Cecile O'Rahilly (ed.), *Táin Bó Cúlainge: Recension I* (Dublin, 1976), ll. 2279ff.

Likewise, it is Morgause who causes the second tragic theme, the 'Nemesis of Incest', by using Irish magic to manipulate her half-brother Arthur. White implies that Morgause entraps Arthur into committing incest by using a 'spancel', a love charm that White describes as 'a piseog'.[37] Using the Irish word *piseog* – charm or superstition – ties the magic to Ireland from the moment it is mentioned. The spancel is 'a tape of human skin, cut from the silhouette of [a] dead man' and to use it, White explains, it must be tied around the object of one's desire while he is asleep.[38] White appears to have found the information for the spancel in Lady Wilde's *Ancient Cures, Charms and Usages of Ireland.* This book can be found in White's library, and the margin next to the passage on 'Love charms' is marked with an X. In this marked section, Wilde describes a love charm that she calls 'the dead strip': 'Girls have been known to [...] exhume a corpse that had been nine days buried, and tear down a strip of the skin from head to foot; this they manage to tie round the leg or arm of the man they love while he sleeps, taking care to remove it before his waking.'[39] As Morgause thinks about Arthur – 'about his strength, charm, innocence and generosity' – and plans to travel to Camelot, White depicts her 'drawing the Spancel through her fingers'.[40] The moment when Arthur sees his half-sister for the first time, just before he sleeps with her, she is 'folding up a tape'.[41] The implication is that Morgause used the Irish magic of the spancel on Arthur, forcing him to have sex with her. In this way, White suggests that a Gaelic character and Irish magic are the cause of the tragic theme of incest in the story.

Even Guenever and Lancelot's affair, although problematic, does not pose an overt threat to Arthur's society until it is manipulated into a weapon by the Gaelic characters Agravaine and Mordred – two sons of Morgause. Arthur is, on some level, already aware of the sexual relationship between his wife and his best friend and allows it to continue because of his own generosity and kindness. Their transgression becomes a problem when the 'Gaels' look for a way to destroy Arthur and avenge the Cornwall feud: 'The earlier wrongs of their family [...] the long-gone feud of Gael and Gall'.[42] Agravaine and Mordred first trick Guenever and Lancelot in order to catch them in a compromising position and then force Arthur's hand, using his own theory of justice to compel him to prosecute his wife for adultery and start a war with his best friend. Guenever and Lancelot, though not blameless, are victims of the Gaelic characters' personal resentments and political manoeuvrings.

Although White omitted his earlier statement that 'all Arthur's enemies' were Irish from the final version of the book, the Gaels remain the difficult characters in the story, and White imagined them at the root of Arthur's three major

37 White, *The Once and Future King*, p. 301. 38 Ibid., p. 302. 39 Lady Jane Wilde, *Ancient Cures, Charms and Usages of Ireland: Contributions to Irish Lore* (London, 1890), p. 32. 40 White, *The Once and Future King*, pp 301f. 41 Ibid., p. 306. 42 Ibid., p. 526.

problems: they perpetuate the Cornwall feud, entrap Arthur into committing incest and use Guenever and Lancelot in their struggle for personal gain and revenge.[43] However, it would be incorrect to imply that White's reading of Irish history was without nuance. The Gaels are rarely wholly evil – Morgause is perhaps the only exception – and White's extensive immersion in Irish history and culture aided his creation of the complex and textured medieval context against which his narratives unfolded.

White's experiences in neutral Ireland provided material for the Irish elements in his version of the Arthurian tale but also inflected the politics of *The Once and Future King*. It became an anti-war text because of elements introduced during the author's Irish sojourn, and it seems that White may have made these changes as a response to his sense of guilt over living in Ireland, away from the conflict. Repeatedly, White justified remaining out of the war because of his ability to write, and after war was declared, he noted in his diary: 'If I fought in the war, what would I be fighting for? Civilisation. [...] But I can do much better than fight for civilisation: I can make it. So at any rate until Arthur is safely through the press, I have ceased to bother about the war'.[44] In spite of this resolution, he continued to dwell on the war and a month later asked himself the rhetorical question, 'How can I help, in any way comparable with my ability to write about Arthur?'[45] Many writers before and during the war shared the sense that literature served to shore up a civilization under threat.[46] Early on, White may have felt he was joining a community of writers in opposing war. During the Munich crisis he wrote to fellow writers Siegfried Sassoon, David Garnett and Sir Sydney Cockerell asking what he should do. His friends told him that he must not enlist and that he could be more useful in other ways. Sassoon, for example, responded on 27 September 1938, writing: 'The only way to be helpful in this emergency is to remain as calm as a rock and to *keep still*'.[47] White's idea of writing for civilization may have originated in a conversation with David and Ray Garnett that occurred in October 1938, shortly after he received this response from Sassoon. The first time he articulates the idea of writing for peace he describes how he, Ray and David

> talked a great deal about the crisis which had just passed over Europe, and what we were to do about it. Ray [...] said that we must spend our time

43 White, Works: Notebook 3, n.d., Box 11, Folder 7. 44 White, Diary 1939–1941, 21 Sept. 1939, Box 27, Folder 1. 45 White, Diary 1939–1941, 20 Oct. 1939, Box 27, Folder 1. 46 Eve Patten's essay, 'Why not War Writers?', discusses a 1941 article in the journal *Horizon* which 'expressed a view that the creative writer should be recognized in an official capacity as a reserved occupation in wartime', and which was signed by many prominent writers of the day, including Cyril Connolly, Arthur Koestler, Alun Lewis, George Orwell and Stephen Spender (in Eve Patten and Richard Pine (eds), *Literatures of War* (Newcastle on Tyne, 2008), pp 17–29 at p. 18). 47 Siegfried Loraine Sassoon to White, 27 Sept. 1938, Box 22, Folder 8.

writing [...] She said almost anybody could be taught to stick bayonets into people, but it took much longer to teach the rules of grammar. So we decided that we would try to help with our pens, while there was time.[48]

By 1941, however, Ray was dead, David had been working in the Air Ministry since the start of the war, and one of their sons had enlisted. The War Office had requisitioned Sassoon's beloved estate at Heytesbury to house refugees and, later, American troops. As sincerely as White may have believed in the validity of writing for the good of the world, the friends who had inspired this stance were contributing in other ways, and the sheer frequency of his comments in his diary seems to indicate a level of self-doubt.

As the war worsened and White remained in Ireland with writing as his only contribution, the pressure placed on the book to be an agent for real change became more dramatic, and White seems to have felt a growing need to write a pacifist text. On 14 November 1940, he rushed to his journal with an inspiration: 'Pendragon can still be saved, and elevated into a superb success [...] His effort has been to abolish war, and war has abolished him'.[49] At this point, White began to imagine King Arthur as a hero who had been trying to find a means of making pacifism viable. Prior to this, in *The Sword in the Stone* (1938) and *The Witch in the Wood* (1939), Arthur fought for justice, but after his revelation, White discovered that 'the central theme of Morte d'Arthur [was] to find an antidote for war'.[50] From this point on, White began to articulate the hope that his book would have a political impact. On 28 August 1941, he wrote to Garnett: 'The epic is really a book on war, and how to prevent it. Also it is a book on the next peace. I think I shall have to send presentation copies to Roosevelt, Churchill, Ghandi and Chiang-Kai-Shek. I would, if I thought there was the least hope that they would read it. Also Stalin. But I suppose they are illiterate'.[51] White's tone is jocular, but on a deeper level he was serious in the hope that his book could help humanity, as he made clear in an undated letter to Garnett from September or October 1941: 'I am hoping desperately that when you have read my last two books you will think that I have helped in the war effort almost as much as you have with the Air War. Or at any rate in the next peace effort.'[52] The pacifist ideas that he developed in *The Once and Future King* and *The Book of Merlyn* – the fifth book in the series, which was not published until 1977 – would, he hoped, constitute a contribution to humanity.

The different versions of each of the component books of *The Once and Future King* show the development of the message about the prevention of war. This message is non-existent in the 1938 version of the first book in the series,

48 White, Diary 1938–1939, 9 Oct. 1938, Box 8, Folder 1. 49 White, Diary 1939–1941, 14 Nov. 1940, Box 27, Folder 1. 50 Letter to L.J. Potts in Gallix, *Letters to a Friend*, p. 120. 51 Garnett, *White/Garnett Letters*, p. 93. 52 Ibid., p. 100.

The Sword in the Stone, but is the sole concern of the final book, *The Book of Merlyn*, which White completed in 1942. The first edition of *The Sword in the Stone* had no pacifist message attached to it, and, indeed, represented war in a positive light in an episode where Arthur and his foster-brother Kay go to war with humanoid creatures called the Anthropophagi and succeed in exterminating them.[53] After White's time in Ireland, however, he wrote *The Book of Merlyn*, which can be read as an attempt to prove the validity and importance of pacifism.

The final instalment in the *Once and Future King* series should be read as a response to Aldous Huxley's anti-war pamphlet *What Are You Going to Do About It? The Case for Constructive Peace* (1936). Huxley's argument takes the form of a series of imagined objections to pacifism, to which the author then presents his counter-arguments. The 'first objection', Huxley tells us, 'is that "war is a law of nature"', but although he agrees that 'conflict is certainly common in the animal kingdom', he argues that this conflict is not the same as war. Huxley continues:

> Conflict is between isolated individuals. 'War' in the sense of conflict between armies exists among certain species of social insects. But it is significant that these insects do not make war on members of their own species, only on those of other species. [...] An animal can be bloodthirsty without being warlike [...] Conflicts between individual animals of the same species are common enough [...] But they do not make war. War is quite definitely not a 'law of nature'.[54]

White draws heavily on Huxley's argument in *The Book of Merlyn*. This fifth and final book, which was not included in the 1958 publication of *The Once and Future King*, tells the story of a sad and ageing King Arthur. On the verge of his final battle, Arthur is transported into a badger's den, where Merlyn and several animals discuss war and humanity. To illustrate his points, Merlyn transforms the king into an ant – one of the warlike 'social insects' – and then into a goose, whose fellow geese cannot understand the concept of war. If we set the rhetoric from *The Book of Merlyn* alongside Huxley's text, the ideas appear to be almost identical. In White's novel, Merlyn lectures Arthur:

> What is War? War, I take it, may be defined as an aggressive use of might between collections of the same species. It must be between collections for otherwise it is mere assault and battery. An attack of one mad wolf upon a pack of wolves would not be war. And then again, it must be between

53 White, *The Sword in the Stone* [1938] (London, 1976), p. 142. 54 Aldous Huxley, *What Are You Going to Do About It? The Case for Constructive Peace* (New York, 1936), p. 4.

members of the same species. Birds preying on locusts, cats preying on mice, or even tunny preying on herrings [...] none of these are true examples of war.[55]

Merlyn continues to ask Arthur which species make 'true' war, and when Arthur does not answer, says, 'You were about to mention a few insects, man, various microbes or blood corpuscles [...] and then you would have been at a loss. The gross immorality of warfare is, as I mentioned before, an oddity in nature'.[56] White's passage not only borrows Huxley's formulations, but the entire *Book of Merlyn* can be seen as a reflection of Huxley's ideas.

There are several reasons why White may have chosen to espouse Huxley's views. Firstly, White believed that the study of animals was a means to inform and improve human behaviour, and *The Sword in the Stone* already used animals to educate the young king. In addition, White was interested in Huxley's work well before the war, and, according to Warner, he referred to his early novel, *They Winter Abroad* (1932), as 'my Huxley novel'.[57] In the months leading up to the war, White – who was himself contemplating leaving England – heard from Hester Sassoon, Siegfried Sassoon's wife, that Huxley had moved to the United States. This news, he wrote, 'affected [him] disagreably [*sic*]', for, he argued 'one cant [*sic*] entirely run away' in a war.[58] The title of Huxley's book may also be reflected in White's 1938 conversation with Ray during which, White tells us, they discussed the Munich crisis and 'what [they] were to do about it'.[59] The connection between Huxley and White continued after the start of the war. While conducting biological experiments on aggressiveness in ants in 1941, White corresponded with the biologist Julian Huxley, Aldous' brother, and several letters about ants survive in the HRC archive. Aldous Huxley was prominent in the formation of White's early writing and influenced his decision about what to do during the war, and the Huxley family continued to occupy his thoughts in 1941 as he wrote *The Book of Merlyn*. From this evidence as well as the similarities in the texts, it seems clear that White deliberately chose to incorporate Aldous Huxley's pacifist thesis into his own book.

Aside from his own personal interest in Huxley, White may also have selected *What Are You Going to Do About It?* because it was central to the public debate about how writers and ordinary citizens should address the threat of war. Samuel Hynes identifies *What Are You Going to Do About It?* as the beginning of a print controversy on pacifism, which included authors Stephen Spender and Cecil Day-Lewis, each of whom published responses to Huxley in 1936. These writers were imagining the proper place of a creative person in a global conflict, and

55 White, *The Book of Merlyn* (Austin, 1977), p. 134. 56 Ibid. 57 Warner, *T.H. White*, p. 59. 58 White, Diary 1938–1939, 10 Sept. 1938, Box 8, Folder 1. 59 White, Diary 1938–1939, 9 Oct. 1938, Box 8, Folder 1.

they took the problem so seriously that Valentine Cunningham describes Huxley's pamphlet as 'one of the '30s' most persistently denigrated texts'.[60] Hynes felt that the Huxley controversy demonstrated 'the way in which war had become a part of the general consciousness, including literary consciousness'.[61] White was building on a pacifist debate that would have been well-known by his contemporaries, using a text that justified his own position of distance from the war and writing in a language recognizable to literary contemporaries.

Reading T.H. White's private writings alongside the published novel, we can see that he altered the tone and the objective of the book as a result of his time in Ireland. Although he was physically safe, the destruction in Europe preyed on his mind, and using Huxley's pacifist pamphlet allowed White to recast *The Once and Future King* as a political text and an engagement with the literary community and the European conflict. As a writer, White's experience of Emergency-era Ireland was unusual. He did not work for any government, lived in rural rather than urban Ireland, spent little time associating with the Dublin literary crowd, and stayed for the duration of the war, in spite of his growing disenchantment with the country. His experience was rich, and his accounts, both in meticulous unpublished diaries and published books like *The Elephant and the Kangaroo* and *The Godstone and the Blackymor* offer a unique perspective on the position of British citizens in Ireland during the war. A study of this period of his life suggests a context of intense psychological and political pressure for the writer. The war itself could not be left behind, but instead stretched across the Irish Sea, extending far into the quiet rural backwater of the country in which White had attempted to find refuge, and emerging again in the refashioned, anti-Irish and anti-war version of *The Once and Future King*. As he rewrote the Arthurian myth – one of the shared myths of the British Isles and Europe – T.H. White was participating in both the Irish world around him and the war abroad. Surrounded by Irish culture but emotionally occupied with the catastrophe in Europe, his story about King Arthur evolved into a different text from the one he first imagined as he wrote *The Sword in the Stone* in 1937, and became a fantasy epic about England, Ireland, Europe and war.

60 Valentine Cunningham, *British Writers of the Thirties* (Oxford, 1988), p. 70. 61 Samuel Hynes, *The Auden Generation: Literature and Politics in England in the 1930s* (New York, 1977), pp 195f.

English perceptions of Irish culture, 1941–3: John Betjeman, *Horizon* and *The Bell*

ALEX RUNCHMAN

The English poet John Betjeman served as press attaché to Sir John Maffey, the senior British diplomat in Dublin, between January 1941 and August 1943. While some accounts speculate about Betjeman's possible involvement in espionage, citing cryptic messages about the 'fishing' on the west coast and a surreptitious visit to an Oldcastle farmer to ask about pews in a local church, Betjeman himself avowed that he knew nothing of politics.[1] His role, he insisted, was exclusively to enhance cultural relations between the United Kingdom and Ireland at a time when Ireland's wartime neutrality was viewed unfavourably by much of the British public. Nonetheless, he was required to be a propagandist of sorts, insisting that 'Britain will win in the end'.[2] And, for a poet whose poems so often value safety, the posting came with risks: the IRA initially marked Betjeman for assassination, identifying him as '"dangerous" and a *person of menace* to all of us'.[3] The poet's advocacy of Irish art, literature and architecture perhaps played its part in convincing the IRA that he was really no threat at all; certainly the general impression he left was one of friendship. Reporting, on its front page, the news of Betjeman's planned return to England, the *Irish Times* of 14 June 1943 praised him for seeing it as his duty not only 'to interpret England

1 Robert Fisk contests the possibility of Betjeman doing intelligence work, insisting that Maffey, unlike his German counterpart Eduard Hempel, was never associated with espionage (R. Fisk, *In Time of War: Ireland, Ulster and the Price of Neutrality, 1939–1945* (London, 1983), p. 381). Bevis Hillier finds this too dogmatic, citing examples given by Robert Cole and David O'Donoghue to suggest that Betjeman may, on a few occasions, have become loosely involved with intelligence work, but conceding that this could only have been subordinate to his principal role. See R. Cole, '"Good Relations": Irish Neutrality and the Propaganda of John Betjeman, 1941–1943', *Éire-Ireland: A Journal of Irish Studies*, 30:4 (Winter, 1996), 33–46 at 40; B. Hillier, *John Betjeman: New Fame, New Love* (London, 2002), pp 230–6; and D. O'Donoghue, *Hitler's Irish Voices: The Story of German Radio's Wartime Irish Service* (Belfast, 1998), p. 94.
2 John Betjeman, *Letters: vol. 1, 1926–1951*, ed. Candida Lycett Green (London, 1995), p. 285. See also Clair Wills, *That Neutral Island: A History of Ireland during the Second World War* (London, 2007), p. 186.
3 Hillier, *John Betjeman*, p. 231. See Andrew Motion's 'Introduction' in John Betjeman, *Collected Poems* (London, 2006), pp xv–xxiv, for a discussion of safety in Betjeman's poetry.

to the Irish, but also to interpret Ireland sympathetically to the English', celebrating, in particular, his discovery of papers by Francis Johnston, whom he re-established as 'the greatest Irish architect'. Such was the extent of Betjeman's involvement in Irish cultural life that the *Times* story concludes by comparing his departure to 'the recall of Earl Fitzwilliam one hundred and fifty years ago'.[4]

Publicly charming, and already long attracted to the aristocratic culture of the Big House – particularly at a time when that Anglo-Irish inheritance was beginning to be superseded – Betjeman was nonetheless unsympathetic to much of the society he encountered. 'I begin to hate Ireland', he complained to his friend John Piper on St Patrick's Day 1941, 'and feel it is all playing at being a country'.[5] Meanwhile, his habit of signing letters 'Sean O'Betjeman', on one hand an affectionate pretence at native identity, is, on the other, not far short of a sneer. The nature of his job, along with nostalgia for his own country, precluded the opportunity of fully Hibernicizing himself. 'I find myself very pro-British', he confided to another friend, Oliver Stonor, 'and absolutely longing for the darn old blitzes.'[6] Even from a poet who, four years earlier, had been able to imagine bombs as 'friendly' (albeit before any of them had actually fallen on Britain), and who had remarked in a 1940 radio piece entitled 'Some Comments in Wartime' that the English 'country[side] seems to have gone back to the peace of the last century', this refusal to accept the air raids as more than a much-missed nuisance reads like a gesture of forced stoicism.[7] It does, however, underline the irony that for Betjeman it was harder to ignore the war in Dublin than it had been at the Senate House in London, where he had previously worked for the Ministry of Information. Living through the Blitz, one knew who one's enemies were; in neutral territory, allegiances were not always so clear. The US spy Martin Quigley Jnr., advising Betjeman on how to get cinematic newsreels past the Irish wartime censor, pointed out that in the commentary 'it might be necessary to avoid stressing which side is which.'[8] In other words, in order to get information to the uninformed public, it might be necessary to further exploit their ignorance. Such a course of action, making him partly complicit with the censor, could only have made Betjeman uneasy.

No matter how frustrated he was by neutral Ireland's politics, Betjeman's belief in a burgeoning Irish culture was sincere, and he worked tirelessly to intro-duce it to British audiences. He sent copies of *The Bell*, founded by Seán Ó Faoláin in October 1940, to John Lehmann, editor of *New Writing*, suggesting that Lehmann contact Ó Faoláin directly if interested in publishing any of the

4 *Irish Times*, 14 June 1943. See also Betjeman, 'Francis Johnston' [1946] in John Betjeman, *Coming Home: An Anthology of His Prose, 1920–1977*, ed. Candida Lycett Green (London, 1997), pp 115–20. 5 Betjeman, *Letters*, p. 283. 6 Betjeman, *Letters*, p. 285. 7 Betjeman, 'Slough' (1937) in Betjeman, *Collected Poems* (London, 2006), p. 20; 'Some Comments in Wartime' (1940) in Betjeman, *Coming Home*, p. 107. 8 Wills, *That Neutral Island*, p. 273.

Irish journal's contributors in his own. He endorsed the painters Jack B. Yeats and Nano Reid, encouraging his friend Sir Kenneth Clark to curate a Yeats exhibition at the National Gallery in London. He also set up a number of features on Ireland in *Picture Post* that challenged British notions of Ireland's backwardness and championed the young nation's cultural life. In May 1943, meanwhile, he oversaw Laurence Olivier's visit to Ireland to film the battle scenes for *Henry V* – a potentially provocative move given the political climate; but Betjeman also arranged for Éamon de Valera to be hosted on set and made a point of taking Olivier to see some repertory theatre in Dublin, handling the situation so as to bring Ireland favourable publicity. Of all his activities, however, it is his involvement in putting together the Irish number of Cyril Connolly's *Horizon: A Review of Literature and Art*, which appeared in January 1942, that most testifies to Betjeman's efforts of promoting Irish literature and art. The number included, under the title 'The Old Peasant', the first four sections of Patrick Kavanagh's *The Great Hunger*, as well as discussions of Irish neutrality by M.J. McManus and L.T. Murray; stories by T.H. White and Edward Sheehy; an appraisal of Jack B. Yeats by Clark; and critical essays by Ó Faoláin and Frank O'Connor on '[W.B.] Yeats and the Younger Generation' and 'The Future of Irish Literature' respectively. Although none of Betjeman's own writing appears, he was largely responsible for soliciting contributions, and the debates under-taken in the magazine reflect many of his own attitudes toward the wartime relationship between Britain and Ireland.

Betjeman's ambivalence toward his temporary home, for example, is charac-teristic of difficulties that many purportedly sympathetic English commentators had in trying to understand an only recently independent Irish culture from their own Anglocentric perspectives. This is nowhere more apparent than in the intersection, within the pages of *Horizon*, of a newly emergent Irish realist tradi-tion with an English propensity for continuing to perceive of Ireland romantically (except in political matters). What reconciliation, if any, was possible between these tendencies? How did the forum of an English journal inflect the debates about Irish national culture that take place inside it? And how did Betjeman's own occasional verse about Ireland participate in, and reflect, these wartime discussions of affiliations and identity?

One of the chief interests of the Irish number of *Horizon* is its continuation, before an English audience, of a discussion about the status of post-Revival Irish culture, politics, and religion that had already been started in *The Bell*. In the inaugural editorial to that journal, Ó Faoláin made clear that the editors were interested only in realism – writing based upon lived experience – and not in the complex symbolism of would-be Yeatses. The title *The Bell* was chosen, Ó Faoláin explains, because it had 'a minimum of associations' and had the poten-tial 'to be created afresh' as a symbol, clothed 'with new life, new association, new

meaning, with all the vigour of the life we live in the Here and Now.'[9] Those who have died for Ireland, Ó Faoláin insists, have died 'for some old gateway, some old thistle lag-field in which their hearts have been stuck since they were children [...] These are the true symbols.'[10] The journal's purpose, rather than perpetuating a specific ideology, was to discover what creative life actually existed in 1940s Ireland.

For O'Connor, the fact that even *The Bell* 'steadily refused to recognize the war' was a point of dispute between himself and Ó Faoláin.[11] The journal's editorials and articles do, however, return time and again to the inhibiting pinch of the wartime censor – a topic that is also examined in the Irish number of *Horizon*. 'A natural urge to keep out the alien supported the Censorship', Ó Faoláin explains in an editorial of April 1941. 'World Radio replies night after night. On the other hand, a world-war has assaulted our isolation, and we have replied by armed neutrality.'[12] While they never directly advocate Irish allegiance to the Allies, both Ó Faoláin here, and O'Connor in his *Horizon* article, see Irish neutrality as consistent with de Valera's policy of isolation and fear the implications of such a stance for Ireland's own people and culture. Ó Faoláin and O'Connor agree that censorship, quite aside from blocking propaganda and indecent subject matter from overseas, in fact serves to inhibit the best native writers, meaning, of necessity, that they are reliant upon English and US readerships. The point could hardly be more emphatically underlined than it was by the controversy surrounding the publication of *Horizon* itself. In May 1942 Connolly reported that the Irish number had been banned in Dublin on account of 'passages in Patrick Kavanagh's poem' that were 'considered to be grossly obscene.' Antoinette Quinn has argued that this was mere hearsay and would have been inconsistent with the principles of the Censorship of Publications Act 1929; the journal does, however, appear to have been investigated under the Emergency Powers Act, with O'Connor's contribution being regarded as far more dangerously subversive than Kavanagh's.[13] Though never actually banned in Ireland, the fact that the publication was treated with such suspicion demonstrates precisely why writers who were prepared to critique their government's policies were more likely to find sympathetic readers overseas.

The Bell's principle of inclusivity, though not incompatible with national pride, was itself a critique of the provinciality that the censorship epitomized and that its contributors insisted had to be satirized. The crux of the problem, for O'Connor, is that for a regional literature (which is how he perceived Irish literature) to survive, it 'must have its inspirations from without and within [...] it

9 Seán Ó Faoláin, 'Editorial', *The Bell*, 1:1 (Oct. 1940), 5–6. 10 Ibid., 6. 11 Frank O'Connor, 'The Future of Irish Literature', *Horizon*, 5:25 (Jan. 1942), 55–63 at 61. 12 O'Faolain, 'Editorial', *The Bell*, 2:1 (Apr. 1941), 7. 13 Antoinette Quinn, *Patrick Kavanagh: A Biography* (Dublin, 2001), pp 184–6.

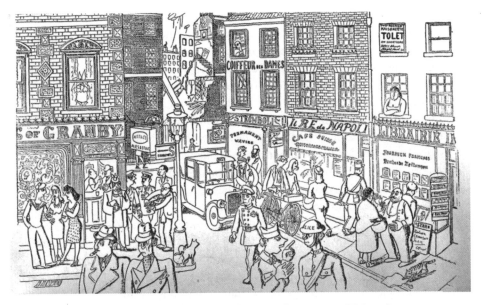

Fig. 2: Osbert Lancaster, *Landscape with Figures – III* (1942)

must be a part of the European system, not a mere folk survival.'[14] But the writer who has been abroad discovers that he can no longer 'translate back' into the idiom of 'Holy Ireland [...] what he has found outside it.'[15] One of the real struggles addressed, and not quite resolved, in the pages of *The Bell* is how to make contemporary Irish writing relevant to an international as well as a national audience, and how to respond to ideas from abroad, without losing the authenticity of particularity – especially at a time when Ireland as an independent nation was still so young.

This difficulty is set in further relief on encountering the English perspectives that appear alongside the Irish in *Horizon*. The issue opens with an illustration by Osbert Lancaster entitled *Landscape with Figures – III* (Fig. 2). Given the international crisis, this depicts a strangely harmonized cosmopolitan street scene. Soldiers and policemen go about their business alongside recognizably French, English, Italian, black and even German figures, all of which mingle without any apparent friction beneath shop, pub and restaurant signs written in various languages. But there is no obviously Irish representative among them. The locale is the intersection of Rathbone Street and Percy Street in Fitzrovia, London – where a Marquis of Granby pub still stands – and the piece might seem ill-placed within this special edition were it not for a pervasive sense of Ireland's relation to the international throughout the issue. Connolly, in his

14 O'Connor, 'The Future of Irish Literature', 56. 15 Ibid.

editorial 'Comment', is sensitive to the Irish cause: he expresses a hope that *Horizon*'s Irish number might be a kind of propaganda against anti-Irish prejudice, and he frankly states that '[n]obody can read any Anglo-Irish history without being convinced by the Irish case [...] From Strongbow to the Black and Tans our record in Ireland is one of seven centuries of cruelty, injustice, intolerance, and exploitation, with a few vacillating intervals of weakness and appeasement.'[16] Connolly is tolerant, too, of Ireland's neutrality – although he turns this to British advantage by declaring the 'tact' and 'gentility' shown toward a neutral Ireland as 'proof of the fundamental democracy of the empire, a spirit utterly different and superior to that of Fascism'.[17] He is nonetheless presumptuous in the claims he makes about Ireland's future. 'Ireland is essentially agricultural', he remarks, describing it as

> the dairy farm and horse pasture of Europe, with a position on the great Anglo-American air-routes of the future which should bring to it the material benefits, the political system, and the language of the Atlantic peoples of the great post-war State – The Anglo-American-Sino-Soviet Union. Against this destiny Mr. de Valera rebels in the name of Nationalistic, Racial, Religious and Spiritual values, and he is so far able to resist it because he has three-quarters of the opinion, and all the prejudice of the country behind him.[18]

In Connolly's vision, Lancaster's small-scale, Western-European-only street scene swells into an international, multicultural conglomeration right in the heart of Ireland. This projection, however, wilfully ignores not only how untenable such a post-war state would be – Connolly was no prophesier of the Cold War – but also the expressed desire of his magazine's Irish contributors that Ireland should count for something more than the convenience of its geographical location.

How can Connolly's characterization of Ireland as 'the dairy farm and horse pasture of Europe' be reconciled with Kavanagh's anti-pastoral exposition, a few pages later, of the price that such an agricultural mentality exacts? Kavanagh's Donaghmoyne farmer, Paddy Maguire, 'lives that his little fields may stay fertile when his own body / Is spread in the bottom of a ditch under two coulters crossed in Christ's Name.'[19] If *that* is Ireland's destiny, why shouldn't the nation's people resist it? And, although Connolly celebrates Ireland as 'the last stronghold of the minor personality', it is hard to imagine how such an individual would fare in his projected post-war state, one in which Irishness is simply subsumed by the joining of greater powers.[20] In celebrating Ireland's minor personalities,

16 Cyril Connolly, 'Comment', *Horizon*, 5:25 (Jan. 1942), 3–11 at 3. 17 Ibid., 4. 18 Ibid., 5.
19 Patrick Kavanagh, 'The Old Peasant', *Horizon*, 5:25 (Jan. 1942), 12–17 at 13. 20 Connolly, 'Comment', 9.

Connolly perpetuates what Clair Wills calls 'the old colonial fantasy: Ireland as the only country in Europe where the world of make-believe and enchantment was still possible.'[21] He exoticizes it, describing the view over Killiney as 'like a coloured print of a plantation in the West Indies'.[22] Kenneth Clark finds similar currency in Ireland's foreignness to the Englishman when he speculates that the 'improbable effects in Jack Yeats' painting [...] exist in that strange saturated atmosphere, where [...] the word "improbable" has little meaning' and when he talks of the 'remoteness' of Ireland from the rest of Europe – something which he believes helps Yeats to preserve 'the native flavour which is so much a part of his strength.'[23] Ireland's wartime neutrality exacerbated such a sense of remoteness, even while the complexity of the political situation might be expected to have dispelled any notion of interpreting such remoteness romantically. Connolly, for one, seems reluctant to recognize that Ireland's much-prized 'native flavour' would be threatened were the country to become a mere stop-off point in a project of post-war globalization.

Like Connolly and Clark, Betjeman also regarded Ireland as 'the breeding ground of eccentrics', similarly investing in ideas of both the country's geographical and temporal removal from modern civilization.[24] He begins a radio broadcast on 'Cooke of Cookesborough' (one of the impoverished Anglo-Irish squires he so admired) by asking his listeners to transport themselves

> to that green island of white cottages, peat smoke, mountains, lakes, little fields, quiet lanes unspoiled by the motor car, wide skies uninvaded by the aeroplane; to those peaceful counties with their crumbling Georgian houses, the tall beech plantations around them, the mouldering garden walls, the grass grown avenues.[25]

Although this was aired in 1937, Betjeman's propensity for celebrating the pastoral idyll over those aspects of Irish society that were modernizing was unchanged by his wartime experience. Though he was more at home in Ireland than he was anywhere else 'abroad', Terence de Vere White's observation, in his *Irish Times* obituary, that the Ireland Betjeman celebrates in many of his poems 'is outside [his] Dublin experience' suggests that Big Houses and rural communities attracted him more than the 'gombeen' men of the nation's capital.[26] The only poem about Dublin that Betjeman wrote was a 70th anniversary piece called 'Prologue' for the Gaiety Theatre in November 1941, published in the *Irish Times* but uncollected thereafter. Even this inclines to dwell in the past rather than the present:

21 Wills, *That Neutral Island*, p. 176. 22 Connolly, 'Comment', 8. 23 Kenneth Clark, 'Jack Yeats', *Horizon*, 5:25 (Jan. 1942), 41, 43. 24 Betjeman, 'Cooke of Cookesborough' in Betjeman, *Coming Home*, p. 121. 25 Ibid. 26 Terence de Vere White, 'The Quintessential Englishman and his Irish Connections', *Irish Times*, 24 May 1984.

> Ah, dear old Gaiety! How many a play
> Like Martin Harvey's goes *The Only Way*.
> Lost in the lumber of the past to-day.[27]

This poem aside, it is 'The Small Towns of Ireland', rather than the capital, that inspired him.

Strange as it is to think of a poet as drawn to the aristocracy as Betjeman sharing pints in the Palace Bar with Kavanagh, the real poetic affinity between the two lies in their writing about place. According to Harold Acton, Betjeman was 'the genius of the *genius loci*', an epithet suggesting not just that he depicted places accurately, but also that his descriptions managed to invest them with some kind of protective spirit.[28] Kavanagh, meanwhile, defended the parochial, stating that the parochial writer 'is never in any doubt about the social and artistic validity of his parish' – in contrast to the provincial writer, who betrays his parish in trying to be metropolitan.[29] Although he would later revise this position, arguing that love for one's subject rather than any specifics of locality was all that mattered in poetry, this is its own kind of *genius loci*: his commitment to naming and to the honest setting forth of realist details remained relatively unchanged. As if to illustrate the proximity of his own subject matter to Betjeman's, Kavanagh remarks, in a review of Betjeman's *English Cities and Small Towns* for the *Irish Times* on 15 May 1943, that '[i]t is interesting to note how little difference in essentials is to be found between a small town in England and Irish towns like Drogheda, Sligo and Limerick. The social structure is largely the same.'[30] Few poets are as topographical as Betjeman; few include so many real place names in their titles. With Geoffrey Taylor, his closest friend while in Ireland and, for a time, poetry editor of *The Bell*, Betjeman edited an anthology of English, Scottish and Welsh landscape poetry.[31] One of the principles of selection was that the poems had to describe real, not fantastical, landscapes: Betjeman conformed entirely to Ó Faoláin's doctrine of writing only about what one knows. This is not to suggest, however, that his poems should be read only as literal descriptions: the pieces set in Ireland in Betjeman's 1945 collection *New Bats in Old Belfries*, even if they are not directly war poems, are nonetheless infiltrated by the context of the war, and to read them only for their topography is to miss this.

The best known of them, 'Ireland with Emily', appears within the collection

27 Betjeman, 'Prologue', *Irish Times*, 22 Nov. 1941. John Martin-Harvey's *The Only Way* was an adaptation of Charles Dickens' *A Tale of Two Cities*, first produced in 1899. **28** Cited by Hillier in 'Foreword' to Betjeman, *Uncollected Poems* (London, 1982), p. 5. **29** Cited by Quinn in 'Patrick Kavanagh: Poetry and Independence' in Kavanagh, *Selected Poems*, ed. Antoinette Quinn (London, 1996), xxii. **30** Kavanagh, 'The English Scene', *Irish Times*, 15 May 1943. **31** John Betjeman and Geoffrey Taylor (eds), *English, Scottish and Welsh Landscape* (London, 1944).

among a number of scenic English poems that, no matter how breezy in tone, cannot help but register a ubiquitous military presence. The collection's opening poem, 'Henley-on-Thames', for example, depicts a boating idyll in which members of the Auxiliary Territorial Service (the women's branch of the British Army) enjoy time off duty: 'the beefy ATS / Without their hats / Come shooting through the bridge'.[32] The scene is couched, however, in a sense of foreboding, expressed through a kind of anticipatory nostalgia. 'When shall I see the Thames again?', Betjeman asks, perhaps conscious of his imminent posting to Ireland, but perhaps also afraid of the then real possibility of a German invasion of Britain.[33] The dread is more overt in 'Before Invasion, 1940', in which the poet asks: 'Are you still taller than sycamores, gallant Victorian spire?', a gesture through which Betjeman shows his habitual concern for architecture but also for the historical English ethos that it represents.[34] 'Margate, 1940' concludes 'And I think, as the fairy-lit sights I recall, / It is those we are fighting for, foremost of all.'[35] Even 'A Subaltern's Love-song', seemingly the collection's lightest poem, bears anxious overtones. The speaker, also off-duty, can make light of losing at tennis to Miss Joan Hunter Dunn, but the couple sip their lime-juice and gins to the six-o'clock news and the poem ends by admitting 'the words never said, / And the ominous, ominous, dancing ahead' – lines that suggest more than just romantic awkwardness and the potential embarrassment of putting a foot wrong at the Golf Club, and also intimate the unspoken understanding that their marital engagement is likely to give way to a military engagement.[36]

'Ireland with Emily' is placed between 'Before Invasion, 1940' and 'Margate, 1940'. It begins as follows:

> Bells are booming down the bohreens,
> White the mist along the grass.
> Now the Julias, Maeves and Maureens
> Move between the fields to Mass.[37]

Bells might have been devoid of association for Ó Faoláin, but they are the dominant symbol of Betjeman's entire oeuvre. He finds them both 'birth and death-reminding'.[38] Though they may sometimes be 'too many and too strong', they at once connote wartime defiance – ringing 'clear, / Loud under 'planes and over changing gear' – and evoke love and mortality.[39] Bells had been silenced in England between June 1940 and May 1943, to be rung only as warnings of air raids; this might account, in part, for Betjeman's tendency to juxtapose the sound of bells against the sound of bombers. 'I have never disliked the sound of

32 Betjeman, *Collected Poems*, p. 84. 33 Ibid. 34 Ibid., p. 97. 35 Ibid., p. 101. 36 Ibid., p. 88.
37 Betjeman, *Collected Poems*, p. 98. 38 In 'On Hearing the Full Peal of Ten Bells from Christ Church, Swindon, Wilts', *Collected Poems*, p. 109. 39 Ibid.

aeroplanes – not even of enemy ones', he writes in 'Some Comments in Wartime', 'because at least they do not change gear in the air and except for a few types of machine, the roar is rather heartening. One sound alone we will miss in the country – the church bells.'[40] This immediately leads into a piece of advice: 'If any country air raid warden thinks he is going to be able to ring the church bells as a warning of a raid, let him be sure he knows how to handle a bell'.[41] It is characteristic of Betjeman to imagine a macabre death by accidental hanging, or by falling from the belfry, ahead of death by bombing. When he does, untypically, imagine the more probable wartime death – in an initially uncollected poem, '1940', which envisages his wife and son killed by bombs as he gets out of the bath – bells first ring out as a warning, but are then terrifyingly absent. 'As I lay in the bath the air was filling with bells', the poem begins, until, halfway through, 'a shuddering thud drove all the bells from the air, / And a shuddering thud drove ev'rything else to silence.'[42] In 'Before the Anaesthetic, Or a Real Fright' the invalid speaker hears both hope and fear in the ringing of bells: 'Swing up! and give me hope of life, / Swing down! and plunge the surgeon's knife'.[43] They challenge his inadequate faith in God, but so long as he can hear them, he is not yet dead. No matter how ambivalent the connotations of ringing bells may be, nothing is more unsettling for Betjeman than their silence.

The 'booming' bells of 'Ireland with Emily' are life-affirming, then, retaining their original function as a call to Mass rather than being used as a warning system. This sense of innocence remains even though they are menacingly – if also ironically – echoed two poems later in *New Bats in Old Belfries* in 'Invasion Exercise on the Poultry Farm', in which the word 'boom' is applied to 'the bombers overhead'.[44] (The echoing is ironic because the latter poem is far more concerned with a tryst between a 'paratroop' and a farm girl than it is with any actual military exercise.) The latent threat in 'booming' is more or less nullified by 'Ireland with Emily's' predominant lexicon of protection. Apple trees 'Guard' the chapel; the congregation is 'hill-protected'; and townlands 'screen us / In the Kingdom of the West'.[45] And yet, the Republic had not remained 'uninvaded by the aeroplane': German bombs had hit Dublin on 1 January and 30 May 1941, while the devastating Belfast blitz of April and May 1941 made only too apparent the proximity of the war to neutral Ireland. It is not clear, in the poem, that the 'many-coloured Munich glass'[46] of the opening stanza's chapel windows, though a mere aesthetic feature (one that Betjeman disliked), manages entirely to supress contemporary association with Munich; and in the final stanza the notion of protection is entirely subverted. In the grounds of a ruined Protestant abbey,

40 Betjeman, 'Some Comments in Wartime' in Betjeman, *Coming Home*, p. 107. 41 Ibid.
42 Betjeman, *Collected Poems*, p. 342. 43 Ibid., p. 106. 44 Ibid., p. 102. 45 Ibid., p. 98, p. 99.
46 Ibid., p. 98.

in pinnacled protection,
 One extinguished family waits
A Church of Ireland resurrection
By the broken, rusty gates.[47]

These gates contrast with the 'Gilded' and evidently Catholic gates of the first stanza, and we might further remember what Ó Faoláin said about Ireland's martyrs dying 'for some old gateway': Betjeman is employing the same realist symbolism.

But the poem's movement from 'decent chapel' to stone ruin bespeaks the ultimate futility of trying to preserve, or gate off, anything. This remains the case, despite Betjeman's problematic presentation, in the fourth stanza, of the survival of the Irish as '[t]he last of Europe's stone age race'.[48] Betjeman derived 'a melancholy enjoyment' from the 'crumbling magnificence' of Ireland's country houses and the ruins of its medieval ecclesiastical architecture.[49] He was also at pains to point out in his essay on Francis Johnston that 'Ireland as a nation is older than England and brought Christianity to Britain', stating his gratitude that '[m]uch of that early Christian Ireland survives'.[50] This, though, cannot altogether explain away what – however affectionately meant – reads as a slur more damning than Clark's suggestion that Ireland is remote or Connolly's that it is exotic. Betjeman resists seeing Ireland as a civilized nation; but rather than launching into the invective of an Ó Faoláin or an O'Connor against the provincial aspects of Irish rural life, he is nostalgic for what he perceives to be a pre-civilized world, one at a temporal as well as a geographical remove from the rest of Europe

There might be a further way of reading this poem. Coupled with its progression towards ruin, describing the Irish as a 'stone age race' could also be interpreted as a critique of Ireland's wartime neutrality, a suggestion of the nation's irrelevance to the international crisis, enclosing itself in a state of isolation from the world beyond – an act of boundary-defining that is further suggested here in the poem's formally enclosed nine-line stanzas. Such latent criticism is softened, but not dismissed, by the recognition that Betjeman himself seems to long to be spared the intrusions of the wider world. He is nostalgically aware that bicycling with the Emily of the title – Lady Hemphill, as she then was, the American wife of a Dublin lawyer – belongs, like the extinguished Church of Ireland family, to a past that is no longer retrievable.

The two other Ireland-related poems in *New Bats in Old Belfries* also regret the passing of an old order. Though Betjeman's elegy for his Northern Irish friend, Basil, Marquess of Dufferin and Ava, killed in Burma on 25 March 1945,

47 Ibid., p. 99. **48** Ibid. **49** Betjeman, 'Francis Johnston', p. 115. **50** Ibid., p. 116.

makes no direct mention of Ireland, its first stanza, in which Dufferin anticipates war, is presumably set on Dufferin's estate at Clandeboye, while the poem as a whole tries to come to terms with the encroachment of international events upon individuals' lives. Not even the bells, in this instance, are consolatory:

> Stop, oh many bells, stop
> pouring on roses and creeper
> Your unremembering peal
> this hollow unhallowed V. E. day, —
> I am deaf to your notes and dead
> by a soldier's body in Burma.[51]

The elegy is largely personal, but the poem that precedes it, 'The Irish Unionist's Farewell to Greta Hellstrom in 1922' is something more than a straightforward valedictory love poem, its speaker seeming to regret, in the fourth stanza, the departure of a Big House eccentric quite as much as that of his beloved. There is also the complication of the title. Greta Hellstrom has never been identified, and it is unusual for Betjeman not to give his subjects their real names. However, that it is a unionist speaking, in 1922 – the year in which the Irish Free State was created and in which Unionist Ulster elected not to belong to it – invites us to seek more than just personal reference in the poem. 'You were right to keep us parted: / Bound and parted we remain': these lines, near the end, seem to be saying something about Ireland's relation to Britain, or the North's relation to the South, as much as about two separated would-be lovers.[52] It is typical of Betjeman to muffle the political resonances; but that they are there at all reveals him to have been more politically conscious than his frequent disavowals to friends would have us believe. And, given how ardently he set about befriending and promoting a generation of Irish writers, it is something of a contradiction that Betjeman's own Irish poems should ache – with the same nostalgia that he elsewhere feels for a bygone England – for the Protestant Anglo-Irish, whom he describes in his essay on Johnston as 'that twice-betrayed race',[53] and whom he once told Elizabeth Bowen he believed to be 'the greatest race of western civilisation'.[54]

51 Betjeman, *Collected Poems*, p. 121. 52 Ibid., p. 119. 53 Betjeman, 'Francis Johnston', p. 118.
54 Betjeman, *Letters* (29 Oct. 1938), p. 216.

Evelyn Waugh, Graham Greene and 1940s Ireland

EVE PATTEN

In the summer of 1943, English theatrical doyen Laurence Olivier travelled to Ireland to direct the cinema version of Shakespeare's *Henry V*, in which he also starred as the English king. The pivotal fifteen-minute scene featuring the Battle of Agincourt was shot on location at Powerscourt Estate in Co. Wicklow, with Irish farm labourers and members of the Local Defence Forces (who were paid an extra pound if they could supply their own horse) recruited to play French and English soldiers. Distributed across cinemas the following year and prefaced by a dedication to serving British military, Olivier's *Henry V* was a major victory for the British government's propaganda mission. Any irony in the fact that England's most resonant historical victory was staged and filmed using Irish civilians in an Irish setting (Wicklow's landmark Sugarloaf mountain is clearly visible at one point in the background to the battle scenes) is usually obscured by what was – indeed, still is – regarded as Olivier's triumphant and suitably jingoistic portrait of the heroic English monarch.[1]

That irony might be recruited, however, to preface a reconsideration of Irish-English relations during the war years, and an acknowledgment of the close and multiple cultural interactions persisting between the two countries, against the grain of Irish neutrality, censorship and apparent disengagement. These interactions can be traced beyond the various closeted military operations and subterranean diplomatic agreements marking the period, into the terrain of literary connections which – though usually less glamorous than Olivier's passage through Dublin on his special diplomatic travel licence – were arguably

[1] The *Irish Times* reported frequently on progress with the production: see, for example, 'London Letter', *Irish Times*, 24 Apr. 1943, on the initial arrangements for the shoot, and 'Private Showing of Henry V', *Irish Times*, 14 Feb. 1945: 'On the eve of Agincourt the coloured canvas merges with the spacious splendour of the Powerscourt demesne, and then the brilliant beauty of the poetry and the background blend to form the finest sequence in the noblest film ever made by a British company.' It was widely reported that John Betjeman was responsible for securing the Irish location, which avoided the problems of filming in an English landscape disrupted by wartime activities.

enhanced by events in Britain and continental Europe. Indeed, throughout the 1940s, many English writers were notably active in Ireland or in writing about Ireland, and the country's cultural profile was in certain respects heightened rather than diminished as a result of its wartime policy.

In this context, we might further consider how various ideological and literary formations were shaped around the juxtaposition of the two nations in the 1940s, and harnessed to the imaginary resolution – *through* Ireland – of British (and specifically English) pressures and anxieties emerging during and shortly after the 1939–45 conflict itself. The use of Ireland as a canvas for the projection of English concerns at this time was, of course, nothing new: Stefan Collini has reminded us of the regularity with which 'Ireland has figured for some intellectuals in England as the repressed or unconscious of English life'; similarly, R.F. Foster has long emphasized the persistence with which, from an early period, 'disaffected British people [have] used Ireland for dreams or ideas or insecurities too uncomfortable for home'.[2] This process is noticeable during the period of the Second World War at a level of discrete personal encounter, with various English writers investing, figuratively and literally, in neutral Ireland, as a reaction to a disturbed domestic landscape and, by extension, to the horizon of social devastation and post-imperial fall-out across the Continent. In this essay, I consider this idea by tracing the Irish engagements of two leading novelists of the period, Evelyn Waugh and Graham Greene, and their respective attempts to secure 1940s Ireland (or versions of it) as a personal 'safe house' on the western edge of Europe.

EVELYN WAUGH'S IRISH RETREAT

In 1942 the English writer Evelyn Waugh published his comic novel *Put Out More Flags*, a satire on the first two years of the conflict and the experiences of a London-based bohemian elite during the so-called 'phoney war' in England. Much of the novel centres on the activities of Waugh's own thinly-disguised literary acquaintances as they repositioned themselves within various wartime ministries and propaganda units; famously too, it castigates, in the characters of Parsnip and Pimpernel, who flee to safety in the United States at the outbreak of hostilities, the real-life departure of poets W.H. Auden and Christopher Isherwood for New York in January 1939.

But there is another flight too: in the novel, the Jewish aesthete and writer Ambrose Silk, outmanoeuvred by the manipulative Basil Seal and labelled as a political undesirable, is obliged to flee undercover from London, disguised as a

2 Stefan Collini, *Absent Minds: Intellectuals in Britain* (Oxford, 2006), p. 191; R.F. Foster, *Paddy and Mr Punch: Connections in English and Irish History* (London, 1993), p. 282.

Catholic priest, and to take refuge in a remote area of Ireland. Waugh's description of the neighbouring nation, deliquescing in neutrality while the conflict escalates (a lengthy passage quoted in truncated form below), is an indulgent prose poem, a panegyric to a nation taken out of time, as it were, and depicted metonymically through its rural western landscape:

> In a soft, green valley where a stream ran through close-cropped, spongy pasture and the grass grew down below the stream's edge and merged there with the water-weeds; where a road ran between grass verges and tumbled walls, and the grass merged into moss which spread upwards and over the tumbled stones of the walls; where the smoke of burned turf drifted down from the cabin chimneys and joined the mist that rose from the damp, green earth; where the soft, resentful voices rose and fell in the smoky cabins merging with the music of the stream and the treading and shifting and munching of the beasts at pasture; where the mist and smoke never lifted and the sun never fell direct; and evening came slowly in infinite gradations of shadow; where the priest came seldom because of the rough road and the long climb to the head of the valley, there stood an inn which was frequented in by-gone days by fishermen. Here in the summer nights when their sport was over they had sat long over their whisky and their pipes – professional gentlemen from Dublin and retired military men from England. No-one fished the stream now. No-one came to stay.[3]

In its imagery the passage echoes the seductive post-impressionist mode through which the Irish countryside had been familiarized to outsiders in the 1930s, not least by the commercial landscapes of the painter Paul Henry. The artificiality of the scene, depicted in the language of Ireland's own counter-revival satirists, is reinforced by the fact that such prose is deeply uncharacteristic of Waugh, a writer who rarely engages in lengthy landscape description free of either dialogue or a narrating consciousness. In this respect the passage marks neutral Ireland as a *caesura* or interruption in the 'story' of the war, but also suggests that this is itself already figurative, an artistic conceit rather than a literal, political reality.

Ambrose Silk's predicament as one of Waugh's Jewish intellectual outsiders (a forerunner to Anthony Blanche in Waugh's subsequent 1945 novel, *Brideshead Revisited*) allows *Put Out More Flags* to stand as a critique of British provincialism and insularity, traits accentuated by the closing of national borders at the beginning of the war. The novel contextualizes, therefore, the author's personal turn away from England to Ireland in the late 1940s. Waugh knew the neighbouring country relatively well, having visited first in 1924, on a walking tour

3 Evelyn Waugh, *Put Out More Flags* [1942] (London, 2000), pp 202f.

while he was at university. He travelled back again to Ireland in rather less relaxed circumstances in 1930 in an attempt to avoid the flak that followed the issuing of divorce proceedings from his then wife, Evelyn Gardner (known disparagingly in their extended circle as 'she Evelyn'). Waugh's conversion to Catholicism might be regarded as a parallel attempt to elude certain pressures at this time, his spiritual release from the Anglican Church of his upbringing into a high Catholic liturgical tradition a parallel to his geographical diversion from England itself. He went to watch the motor races in Belfast, then spent several weeks at the respective homes of his Irish friends, Bryan and Diana Guinness, outside Dublin, and the Pakenham family in Co. Westmeath – acquaintances who may well have lent elements to the creation of the Marchmains, the doomed aristocrats of *Brideshead Revisited*.[4]

In *Brideshead*, Waugh portrays a failing English elite struggling to maintain its ascendancy against the waywardness of its own members and, ultimately, the advance of a version of progress sustained by wartime mass administration and social levelling. The novel reverberates with its author's panic at what he claimed to be a threat to England on a par with Nazi destruction: the encroachment of a middle-class democratic consensus, driven by petty bureaucracy and managerialism. 'German bombs have made but a negligible addition to the sum of our own destructiveness', Waugh wrote in 1945, in the wake of the election that ushered in what he sardonically referred to as the 'Cripps-Attlee terror'.[5] Having absorbed the homogenizing effects of mass mobilization during the war, England, he feared, would slide towards the kind of crippling officialdom depicted in his 1947 work, *Scott-King's Modern Europe*. This novella can be read as a post-lapsarian sequel to *Brideshead*, its portrait of a dystopian but archetypal European country – a version of Spain conflated with elements of Tito's 'modern state' of Yugoslavia – paradigmatic of the entire continent's contemporary degeneration into a hidebound, functionalist mediocrity.

It was in this climate that Waugh announced his intention to move permanently to Ireland. His deep disillusionment with Europe in general and England in particular was a common reflex of the period, and similar sentiments were voiced regularly by fellow metropolitan literary socialites ranging from Harold Nicholson to Elizabeth Bowen.[6] During the immediate aftermath of the war his

4 See a full account of Waugh's travels in this period in Selina Hastings, *Evelyn Waugh: A Biography* (London, 2002). Waugh's fellow novelist Anthony Powell, who was briefly stationed in the north of Ireland during the war, married Lady Violet Pakenham in 1934. 5 'What to Do with the Upper Classes: A Modest Proposal', *Town and Country*, Sept. 1946 in Donat Gallagher (ed.), *Essays, Articles and Reviews of Evelyn Waugh* (London, 1983), p. 312; cited in Hastings, *Evelyn Waugh*, p. 496. 6 On this response more generally see Alan Sinfield, *Literature, Politics and Culture in Postwar Britain* (Oxford, 1989), pp 43–7. Bowen was less than enthusiastic about the post-war government. 'I have adored England since 1940 because of the stylishness Mr Churchill gave it', she wrote to a friend in 1945, 'but I've always felt "when Mr Churchill goes, I go". I can't stick all these little middle-class Labour wets with their old London School of Economics ties'. Cited in Victoria Glendinning, *Elizabeth Bowen: Portrait of a Writer* (London,

mood intensified however. At the cessation of hostilities, Waugh confided to his diary his fears that in the wake of the conflict, England would have no aristocracy left; only a proletariat and a bureaucracy would remain, while in Europe, 'wherever I turn [there is] the reek of the Displaced Persons Camp'.[7] The statement typifies the author's well-known tendency to hyperbole but it glosses, too, his recourse to Ireland in the post-war years as a self-conscious and contingent move westward, *away* from the Continent, a natural escape route from the grip of England's political left turn in 1945. His ambition towards a geographical dislocation matched the convenient chronological slippage of a country whose clock – as Cyril Connolly had written evocatively in *Horizon*, three years earlier – had stopped in 1939, keeping it in stasis perhaps, but preventing at the same time the kind of forward transition taken by England into what Waugh regarded as the cataclysm of the welfare state.

The cultural and political value of the neighbouring island to Waugh was further reinforced by the writer's claim to a gentrified existence in the Irish countryside, much heralded in his planned acquisition of a large house with estate. His attraction to the idea of an Irish mansion relates to a broader context of Irish-English literary configurations during the Second World War, when novelistic versions of the Irish 'big house' often served a quasi-allegorical function for English writers in the period. One thinks here, for example, of Daphne du Maurier's Irish Civil War saga, *Hungry Hill* (1943), or of Henry Green's Irish-set satire on English degeneration, *Loving* (1945). In their respective reformulations of the Irish aristocratic seat doomed to be destroyed either by fire or conflict, these novels share the instinct of Elizabeth Bowen's wartime family memoir *Bowenscourt* (1942) and faux spy-thriller, *The Heat of the Day* (1949), to confront, through the metaphor of the afflicted *Irish* estate, the potential conflagrations of *English* society and the proximate threat to class, continuity, property and inheritance heralded by the shift of the conflict to the home front. In cohort such literary constructions represent what critic Marina MacKay terms 'an ironic Blitz equivalent', and their close relationship to Waugh's own overblown lament for England's failing aristocratic caste in *Brideshead Revisited* is evident.[8]

Waugh's interest at this time, however, was specifically in the comparative resilience of the Irish house, and perhaps a persuasive template in his mind, inspired by the previous war, came from Siegfried Sassoon. In *Sherston's Progress* (1937), the third and final volume of the Sassoon's autobiographical *Memoirs of a Fox-Hunting Man*, the poet's fictional alter ego George Sherston, temporarily relocated from the Western Front in the final year of the war to the fox-hunting idyll of Co. Limerick, daydreams of settling in the archetypal Irish gentleman's

1993), p. 166. **7** *The Diaries of Evelyn Waugh*, ed. Michael Davies (London, 1976), p. 661; cited in Hastings, *Evelyn Waugh*, p. 510. **8** Marina MacKay, *Modernism and World War II* (Cambridge, 2007), p.

retreat. Calling to mind the attractions of a fireside chat with the Master of the local hunt, Sherston considers the potential charms of an elevated existence in a well-appointed Irish country seat:

> Yes, I imagine myself soaking it all up and taking it all home with me to digest, rejoicing in my good fortune at having acquired such a pleasant period-piece example of an Irish country mansion [...] I should remember a series of dignified seldom-used rooms smelling of the past; and a creaking uneven passage with a window-seat at the end of it and a view of the wild green park beyond straggling spiral yews, and the evening clouds lit with the purplish bloom of rainy weather.[9]

If Sassoon positioned his idealized Irish house to counter, retrospectively, the physical and emotional damage of the Western Front, Waugh imagined *his* Irish mansion as a foil to what he regarded as a similarly grievous assault: the reduction of Europe's social landscape to a bureaucratic problem of mass population administration. Hence his attraction, even as early as 1942 in *Put Out More Flags*, to the figurative social emptiness of his imagined Ireland, from which society itself had retreated ('No-one fished the stream now. No-one came to stay'). His consternation at Europe having become a vast problem of refugee management, a theme upon which he harped repeatedly throughout his later *Sword of Honour* trilogy, found relief in the idea of a country which was, comparatively at least, empty of people.

The reality of trying to live in Ireland was far from straightforward, however, as the author discovered when he put his plan into action immediately after the publication of *Brideshead Revisited* in 1945. Buoyed up by the book's considerable critical and financial success, he began contacting Irish estate agents, venturing across to look at property in Wicklow in 1946. On the announcement of his plans to move, his fellow writer Nancy Mitford wrote to him, with characteristic waspishness, that Ireland was *made* for him: 'The terrible silly politeness of lower classes', she enthused disingenuously, 'the emptiness, the uncompromising Roman Catholicness [...] the neighbours all low brow and armigerous, and all 100 miles away, the cold wetness, the small income tax, really I could go on for ever.' Waugh should not be worried, she continued, about the supernatural features of Irish life: if an 'elemental' appeared, she reassured him, the local priest could be brought in to manage it.[10] Mitford's snide remarks failed to discourage her fellow novelist, however: in December 1946 he viewed Gormanstown Castle in Co. Meath (intrigued partly by the advertisement speci-

108. **9** Siegfried Sassoon, *Complete Memoirs of George Sherston* (London, 1972), p. 577. Sassoon attended an Officer Training Camp in Limerick in January of 1918. **10** Nancy Mitford to Evelyn Waugh, 16 Oct. 1946; cited in Hastings, *Evelyn Waugh*, p. 510.

fying 'Ballroom, unfinished') and instructed his solicitors, the Irish firm of de Vere White, to put in a bid, only to withdraw in horror on learning that a Butlins holiday camp was scheduled to be built nearby.

For most of 1947 Waugh was preoccupied with his attempts to convert his friend, the poet John Betjeman (recently returned from his own Irish wartime sojourn), to Catholicism, but he kept up his search for an Irish house, writing to Betjeman – in between lengthy doctrinal discussions – of his decision to purchase Lisnavagh, a mansion in Co. Carlow. Detached and relatively isolated, it was close to his ideal. 'Obscure peers – Rathdonnell', he wrote to Penelope Betjeman enthusiastically of its former inhabitants. But the Carlow plan also failed to work out and gradually Waugh's enthusiasm for an Irish property waned. By 1952, his project to secure an Irish retreat was concluded. Disillusioned with the effort, he wrote again to Nancy Mitford: 'Among the countless blessings I thank God for, my failure to find a house in Ireland comes first.' Unless one were mad or keen on fox hunting, he continued archly in the same vein, there was nothing to appeal: 'the peasants are all malevolent, their smiles false as Hell. Their priests are very suitable for them but not for foreigners. No coal at all. Awful incompetence everywhere.'[11]

These sentiments are typically theatrical, shaped and penned for the benefit of his correspondent. The self-dramatizing aspect of the Irish venture is telling, as is the fact that the English author advertised his Irish plans so widely and vocally to his many acquaintances. Waugh was less concerned with opposing transitions in English society than with being *seen* as oppositional. Ireland was easily recruited to this cause, and one wonders if he ever really intended to move permanently across the Irish Sea. The facts of the situation give way to the gesture: in the face of the war and what it appeared to have done to England, Waugh mobilized a repository of Irish imagery, including the imagery of the solid and enduring Irish aristocratic mansion, as a protest vote, a register of complaint against England's decline and the diminished authority of a post-war English elite. His strategy engaged a belated Celtic Twilightery, merged with a vaguely congratulatory appraisal of neutrality. In *Put Out More Flags*, Ambrose Silk reflects, in his temporary Irish sanctuary, on a markedly similar projection:

> This is the country of Swift, Burke, Sheridan, Wellington, Wilde, T.E. Lawrence, he thought; this is the people that once lent fire to an imperial race, whose genius flashed through two stupendous centuries of culture and success, who are now quietly receding into their own mists, turning their backs on the world of effort and action. Fortunate islanders, thought

11 Evelyn Waugh to Nancy Mitford, 1 May 1952; see Hastings, *Evelyn Waugh*, pp 510f for details of Waugh's activities in Ireland in this period.

Ambrose, happy, drab escapists who have seen the gold lace and the candlelight and left the banquet before dawn revealed stained table linen and a tipsy buffoon![12]

It is tempting to read into these lines a surreptitious channelling of the recently deceased W.B. Yeats and the bombast of 'Under Ben Bulben', from the 1939 volume *Last Poems* – 'Sing the lords and ladies gay / That were beaten into the clay / Through seven heroic centuries'. If so, the allusion is pointed, at once celebratory and mocking of a neighbouring island held in the tension of a characteristic English ambivalence. And tempting, furthermore, to speculate on how exactly Waugh's late career might have developed, had he succeeded in following through with his protest against England, secured his gentleman's mansion, and become in due course one of the 'indomitable Irishry'.

GRAHAM GREENE'S IRISH IDYLL

A similar literary perspective on Ireland in this period is provided by Waugh's friend and fellow novelist, Graham Greene. Like several of his contemporaries (including V.S. Pritchett) Greene's first encounter with Ireland was as a journalist: in 1923, at the age of 19, he was engaged by the *Weekly Westminster Gazette* to report on the condition of the country in the immediate aftermath of the Civil War. 'It is like that most nightmarish of dreams', he wrote of a shattered but uncannily familiar Dublin, 'when one finds oneself in some ordinary and accustomed place, yet with the constant fear at the heart that something terrible, unknown and unpreventable is about to happen'.[13] In a later interview, he recalled his journey from Dublin to Waterford on that occasion only vaguely – 'an impression of broken bridges all along the route' – but the potential correspondence between Ireland's fractured landscape and the development of Greene's imaginative hinterland is inviting.[14] At least one commentator has mooted that the writer's brief experience of the country in its ravaged condition provided him with a domestic template for portraits, in his later fiction, of foreign environments in various stages of colonial and post-colonial transition or mobilization, including French Indochina (Vietnam), in *The Quiet American* (1955) or *The Comedians* (1966), set in Haiti. 'It was on this brief trip to Ireland', the critic Charles Duffy writes of Greene's career, 'that he first sketched the topography of the better known foreign "Greeneland" which was to summon him so strongly during the next seven decades'.[15]

12 Waugh, *Put Out More Flags*, pp 218f. 13 'Impressions of Dublin' in Graham Greene, *Reflections* (London, 1991), pp 3f. 14 See Pierre Joannon, 'Graham Greene's Other Island: An interview with P. Joannon', *Études Irlandaises*, 6 (Dec. 1981), 157–69. 15 Charles Duffy, 'Ireland and Greeneland', *Éire-Ireland*, 31:3 (Fall, 1995), 14–27 at 17.

Certainly, it might be seen that fragments of Irish Republican history – carefully distinguished by Greene himself in the late 1970s from its post-1969 counterpart – feature occasionally in writing (in his 1980 novel *Dr Fischer of Geneva or The Bomb Factory*, for example, a suicidal character briefly considers starving himself to death, recalling the fate of hunger-striker Terence MacSwiney in Cork in 1920).[16] But such allusions are little more than incidental and hardly support a case for Ireland as the *ur*-text of Greene's distinctive novelistic landscapes. What we might call a 'cinematic' Irish Republicanism was probably more influential: Greene admired John Ford's 1935 film version of Liam O'Flaherty's *The Informer* and was in close touch with director Carol Reed at the time of the filming of *Odd Man Out* – F.L. Green's story of a wounded IRA man on the run in Belfast – in 1947.[17] Both political and filmic associations are outweighed, however, by the very significant personal connection developed between Greene and Ireland in the late 1940s, a connection shaped, as it had been with Waugh, by the context of the post-war and apprehensions about England's vulnerability in the flux of broader European changes and transitions.

During the war itself, Greene was recruited into the British Secret Service where, under the supervision of Kim Philby, he was dispatched to Africa to take up a military information posting, first in Lagos and then in Freetown, Sierra Leone. By coincidence his convoy to Africa sailed from Belfast where he went ashore to take confession at one of the inner city churches.[18] Once settled in Africa, he completed the final draft of his London-set war novel *The Ministry of Fear* (in which Hilfe, a Nazi infiltrator, tries in vain to escape by the boat-train from London to Dublin), and after its publication in 1943 began work on what would become the masterpiece of his mid-career writings, *The Heart of the Matter* (1948). This novel's emotionally charged account of Major Henry Scobie, a high-ranking colonial policeman, and the sordid circumstances of his wartime posting to a West African coastal capital, is one of Greene's most autobiographical. Largely based on the author's own experience in Sierra Leone, it contains further distinct echoes of Greene's personal life in its heady dramatization of Scobie's bungling spiritual, financial and sexual transactions as he attempts to distance himself from his moribund job and sterile marriage.

16 Greene later alluded to this event to distinguish it from the 1981 IRA hunger strike: 'Terence MacSwiney was fighting a good fight, Bobby Sands wasn't. For a young English boy of that period the sacrifice of the Lord Mayor of Cork was part of a very romantic revolution against imperialist England'. See Joannon, 'Graham Greene's Other Island', 164f. **17** On a trip to Belfast in 1977, Greene visited the Crown Bar to see, first-hand, one of the key locations of the film. See Joannon, 'Graham Greene's Other Island', 158f. **18** Greene converted to Catholicism in 1926. His journey, including descriptions of wartime Belfast ('so dull a place'), is described in his journal, *Convoy to West Africa*, held with his papers at the Harry Ransom Center, University of Texas (Graham Greene Collection, Box 11: 8). Charles Duffy suggests that his experience in the city inspired elements of his 1957 play *The Potting Shed* ('Ireland and Greeneland', 22).

At a thematic level the novel foregrounds through its archetypal protagonist – one of Greene's 'white men going to seed in outlandish places' – the exhaustion of petty colonial officialdom struggling under the pressures of the war to manage an overseas administration fast becoming an operational millstone. Scobie's moral disintegration and suicidal trajectory pick up a common thread in the 'British novel abroad' tradition of the 1940s and 1950s: that of a desiccated, increasingly neurotic imperial authority which dreams of unburdening itself of its overseas responsibilities. Greene had often written of the shabbiness and inadequacy of Freetown's European expatriate community; notably, to his brother Raymond, in 1943: 'their contribution has been confined to cowardice, complacency, inefficiency, illiteracy and thirst [...] how tired one is of little plump men in shorts with hairless legs'.[19] Against this enervated imperial landscape Scobie invests in a private ideal of the 'real' Africa, a place true to an elemental, undisguised human nature, and indulges in a fantasy of walking alone in the interior, shedding home, family, possessions, responsibilities, to return to the simplicity of a primitive landscape, emptied of colonial machinery.

On one level, the fact that Greene completed the later drafts of this Africa-set narrative in Co. Mayo, on Achill Island off the west coast of Ireland, is purely circumstantial.[20] The connection between the themes of *The Heart of the Matter* and the writer's Irish context in the late 1940s deserves some attention nonetheless. Africa lent itself to this intensely realized novel, but how much did the novel itself, complete with its suggestive bristling at an English imperial mission, translate into Greene's post-war investment in an alternative version of primitivist escapism in Ireland? In short, what kind of emotional re-mapping took place in the exchange of one west-coastal landscape for another? Ireland was in Greene's sights throughout the latter half of the 1940s, after the end of the war and his return from service overseas. Early in 1947 he wrote to Evelyn Waugh of his strong desire to find somewhere to live outside England: 'I should like to go to Ireland because I like the Irish and approve so strongly of their recent neutrality', he ventured, explaining however that Vivien, his wife, 'has an anti-Irish phobia so I can never do that'.[21] The letter was deliberately misleading, however, as within a few months Greene was spending a considerable amount of time in Ireland, pursuing a love affair with Catherine Walston, the American wife of a wealthy British politician, in her holiday home on the western side of Achill.

The relationship with Walston has long been cited by critics as the source material for Greene's 1951 novel *The End of the Affair*, a London-set tale of

19 Richard Greene (ed.), *Graham Greene: A Life in Letters* (London, 2008), p. 123. **20** Greene's letters to Catherine Walston indicate that he completed and submitted a final draft during September of 1947; a telegram to her in November of that year notes that the book is now finished (Georgetown University Library Special Collections: Catherine Walston/Graham Greene Collection, Box 1; Fold: 18, Correspondence 1947). **21** R. Greene, *Graham Greene*, p. 139.

wartime adultery contorted by Catholicism, but this identification jumps ahead of the Irish interlude without sufficiently accounting for the impact of Greene's compositional geography.[22] As much as Waugh's mansion, Walston's cottage provided an idealized version of Irish life – an isolated, peasant picturesque – and Greene's writing and correspondence from this short period suggest that, at some level, he sought to secure, in Achill, a displaced fulfilment of Scobie's pre-colonial fantasy; a place where the Englishman might shed the burden of international leadership and retreat to an unspoiled, unregulated Eden. Frequent references in his letters to Catherine Walston (his 'human Africa', as he described her) emphasize his desire to be in Achill and his love for the simplicity of the cottage with its associated routines of fire-building and fishing, or of the appeal of a place where, as he wrote to her, 'there are no telephones'. [23] During this period, as far as Ireland was concerned, Greene seems to have been unashamedly and self-consciously primitivist. In between visits to Achill he read J.M. Synge's *The Aran Islands*; in between reading Synge he wrote some (admittedly rather feeble) poems eulogizing his Irish locale and celebrating his newly simplified identity. In his love poem 'After Two Years', for example,

> A mattress was spread on a cottage floor
> And a door closed on a world, but another door
> Opened, and I was far
> From the old world sadly known
> Where the fruitless seeds were sown...[24]

The African-Irish connection is specifically addressed in one particular letter to Catherine Walston, in which Greene writes (in relation to another girlfriend's journey abroad) of how the litany of stations on the railway route down the African coast reminds him of the train line across Ireland to the west. 'I must say when I saw the list of stops my heart missed a beat', he wrote. 'Las Palmas, Dakar, Bathurst, Freetown, Contonou, Lagos – it's like hearing Maynooth, Athlone, Galway, Westport, Newport, The Sound, Dooagh'.[25]

An added layer of interest in Greene's Irish connection lies in the fact that the writer was introduced at this time to the retired Irish Republican Army leader Ernie O'Malley, who was living nearby in Mayo, and who was also closely involved with Catherine Walston. The two men had various common interests (beyond Walston), including their respective sojourns in Mexico before the war, and it seems likely that O'Malley – a keen and eclectic reader – had read Greene's evocative account of the country in his 1938 *Journey Without Maps*. O'Malley had

22 The case is argued definitively by William Cash, *The Third Woman: The Secret Passion that Inspired The End of the Affair* (London, 2000). 23 R. Greene, *Graham Greene*, p. 170. 24 Cited in Cash, *The Third Woman*, p. 131. 25 R. Greene, *Graham Greene*, p. 143.

much to gain from his acquaintance with the English author. He was already writing at this time for the Irish literary and cultural journal *The Bell* and had contributed a major article on Irish artist Louis le Brocquy to *Horizon* in the issue for July 1946, but was ambitious for further and sustained publication in the major English journals and reviews. He hoped that Greene would secure him some access to these through his numerous high-profile contacts and influence, a request he put on at least one occasion through the intermediary of Walston and with which Greene obliged.[26]

Less obvious, but relevant to a full understanding of his 'Irish interlude' in the 1940s, is the question of what Greene, in turn, took from O'Malley's presence in Mayo. He had almost certainly read O'Malley's memoir *On Another Man's Wound*, published in 1936, but the full extent of his interest in, or prior knowledge of, the Irish Republican-turned-litterateur is unclear. In later interviews he referred to him simply as his 'friend', and commended him as representing, along with Erskine Childers, a Republican calling with which he, Greene, had long been in sympathy.[27] But it might also be suggested that Greene wanted to imbue O'Malley, in 1947, with a retrospective political mystique, the aura of a noble activism carried over from 1923. In a 1970s interview Greene talked of his sojourn on Achill and recalled O'Malley as an enigmatic figure, defined by his Civil War role but also transcendent of it:

> There I met Ernie O'Malley, the author of *On Another Man's Wound*, who had been chief of staff of the IRA in 1922. He was an enchanting man. I remember one day in Achill, I asked him at what time the high tide was. He hesitated a long time, a look of caution came into his eyes and his attitude became typical of the old IRA man determined not to give any information to a possible enemy. 'Well Graham, that depends', said he laconically in the end.[28]

If the anecdote (such as it is), reveals anything, it conveys a sense of Greene's desire to secure O'Malley as a figure of 'post-political' autonomy. In his introduction to a volume of Ernie O'Malley's letters, the critic Nicholas Allen suggests that in his west coast bolthole at Burrishoole in Co. Mayo, O'Malley was self-consciously engaging in the lifestyle of the solitary man of letters, reading, reviewing, writing about art and architecture, in retreat from the perceived failings of national politics, hoping, Allen argues, that a 'miniature

26 For an overview of O'Malley's literary activities see Richard English, *Ernie O'Malley, IRA Intellectual* (Oxford, 1998). **27** In interview with Joannon, Greene stated that '[i]t seemed to me that the new Provo IRA was closer to Chicago gangsters than to the idealism of men like Erskine Childers and my friend Ernie O'Malley'; Joannon, 'Graham Greene's Other Island', 160. **28** Joannon, 'Graham Greene's Other Island', 160.

republic of one self might survive the decimation of the republic as a reality or ideal'.[29] To what extent did Greene identify in the former Republican leader a retreat from the pressures of nationalism, and align this with his own sentiments of disillusionment with imperialism? This is crudely put: in more refined terms, one might suggest that O'Malley's carefully managed withdrawal from activism to an individual and isolated literary survivalism – a personal utopianism – held an appeal for the English novelist as he himself recoiled, in the wake of the most bureaucratized war in history, from the political overreach of a flawed and faltering British military and diplomatic project. This instinct was manifest in the convoluted situation of West Africa, and reinvested in the stripped-down environment provided by the isolated and 'primitive' Mayo cottage. The idyll could not endure, however: despite his fantasy of buying the Old Head Hotel near Louisburgh on the Irish mainland and settling there with Walston, Greene's post-war Irish romance, like Waugh's, gradually tailed off, coming to an end, more or less, in tandem with the decade.

In an essay of 1956, collected in *The Vanishing Hero*, Seán Ó Faoláin described Graham Greene as always writing with a sense of grievance, having a 'certain sulkiness in his attitude to life'.[30] But there is a very positive, even joyous version of this 'sulk' in evidence during the Achill Island period. Greene's Irish episode enabled him briefly to step out of a pressurized time, a life compromised by England's weakening military and imperial agenda during and after the war. And while it is important not to over-read the Irish sojourn of the late 1940s as more than the sum of its parts, a geographical and sexual diversion from duty, we can nonetheless identify small points of significance. The fact that *The Heart of the Matter* is book-ended by visits to Ireland does perhaps allow for potential connections between the driving thematic crisis of the novel – the desperate flailing of colonial authority under the pressure of war – and the solitary remove of the western Irish landscape, as an allegorical resolution of that crisis, a futurist vision of a post-imperial release. In this respect, the political facts of Irish neutrality are again less important than the symbolic value of the country, reinvested with primitivism and invoked as a relief or foil for pressing English anxieties.

For Evelyn Waugh, Ireland enabled an interim project of elaborate self-dramatization, a theatrical and theoretical protest vote against an administrative assault on class and elite, but a vision to which the writer never fully committed in practice. For Greene, Ireland immediately after the war provided for a short-term fantasy of a release from England's imperial responsibilities, channelled metaphorically through an adulterous liaison, and perhaps bolstered by the

29 Cormac K.H. O'Malley and Nicholas Allen (eds), *Broken Landscapes: Selected Letters of Ernie O'Malley 1924–57* (Dublin, 2011), p. xxvi. 30 Seán Ó Faoláin, *The Vanishing Hero: Studies in Novelists of the Twenties* (London, 1956), p. 57.

proximity of post-Republican utopianism in the figure of O'Malley. From the perspective of literary biography such connections are worth pursuing, but do they add anything to the critical landscaping of Anglo-Irish political or historical relations during the 1940s? In some respects they work too far beneath the political radar: the references and exchanges are fleeting, idiosyncratic and circumstantial. In other ways, however, the nature of English literary recourse to Ireland in the period tells us a good deal about the complex gradations and differentiations of attitudes to Irish neutrality among a literary (and perhaps also political) intelligentsia. The novel and the novelist give us more pliable resources, in many respects, than either official documents or journalistic material from the period, allowing us to recognize the extent to which English culture, destabilized and compromised by events in war-torn Europe, kept Ireland in its wing-mirror throughout this decade.

Kate O'Brien's subtle critique of Franco's Spain and de Valera's Ireland, 1936–46

UTE ANNA MITTERMAIER

Fatal attraction between persons is an old poets' notion that some of us still like to believe is possible and occasional, though not probable – and Spain seems to me to be the femme fatale among countries [...] My love has been long and slow – lazy and selfish too, but I know that wherever I go henceforward and whatever I see I shall never again be able to love an earthly scene as I have loved the Spanish [...] with Spain I am once and for all infatuated.[1]

Spain held a lifelong fascination for Kate O'Brien, as shown by the elaborate declaration of her love in the quotation above, taken from her 1937 travel book *Farewell Spain*. Although the reissuing of some of O'Brien's novels in the 1980s as well as the publication of Eibhear Walshe's biography of O'Brien in 2006[2] have revived scholarly interest in the author and gradually secured her a place in the literary canon of Irish women writers, the name of Kate O'Brien is not widely associated with literature engaging with public affairs. Rather than a political commentator, O'Brien has often been hailed as a chronicler of bourgeois Irish Catholic family life of the late nineteenth and early twentieth centuries. Therefore, the appearance of an essay on this writer in a book dedicated to Irish cultural responses to wartime Europe might initially surprise. In her book *Kate O'Brien and the Fiction of Identity* the critic Aintzane Legarreta Mentxaka has decried 'O'Brien's contextualization as a Catholic, middle-class author', as it 'turns her into an apolitical, genderless, sexless author'[3] by deflecting critical attention away from the individualist feminism and leftist-libertarian politics suffusing her creative work. While Legarreta has identified a

1 Kate O'Brien, *Farewell Spain* [1937] (London, 2001), p. 155. 2 Eibhear Walshe, *Kate O'Brien: A Writing Life* (Dublin, 2006). 3 Aintzane Legarreta Mentxaka, *Kate O'Brien and the Fiction of Identity: Sex, Art and Politics in* Mary Lavelle *and Other Writings* (Jefferson, NC, 2011), p. 6.

'general determination to de-politicize O'Brien's work'[4] in the past, however, Michael Cronin has taken issue with the recent opposite critical tendency to 'construct her [...] as a radical subversive', since 'to describe O'Brien's politics as radical or subversive is seriously to underestimate the strength of her commitment to bourgeois liberalism'.[5]

This essay examines O'Brien's credentials as a political commentator through a close reading of O'Brien's literary and non-fictional writings on Spain, focusing on her representation of the socio-political troubles which kept the country in turmoil in the mid-twentieth century. After a brief discussion of the author's third novel, *Mary Lavelle* (1936), and her travelogue, *Farewell Spain* (1937), which were written shortly before and during the Spanish Civil War respectively, the essay explores O'Brien's relationship with Franco's Spain as manifested in her historical novel *That Lady* (1946) and in her journalistic writings and unpublished lectures and letters. The literary analysis takes account of the striking political, economic and cultural parallels between Spain and Ireland in the eras of General Franco and Éamon de Valera, which were marked by an unhealthily close alliance between the Catholic Church and the state. I will argue that, being well aware of the ideological similarities between the quasi-theocratic systems of government in place in Ireland and Spain of the mid-twentieth century, O'Brien repeatedly used Spain as a reference point for her indirect critique of socio-political conditions in Ireland, so that when commenting on Spain she was often alluding to Ireland at the same time. Rather than as a political radical of any particular hue, the analysis of her writings on Spain establishes O'Brien as a politically inspired writer celebrating liberal individualism and condemning any form of authoritarian government restricting freedom of speech and conscience.

O'Brien's love affair with Spain began in 1922–3, when she spent almost a year in a village outside the Basque city of Bilbao working as a governess for the influential de Areilza family.[6] The writer drew on her own experience as an 'Irish miss' for her third novel *Mary Lavelle*,[7] in which the eponymous heroine goes to

4 Ibid., p. 39. In the 1980s and early 1990s careful readers, including Lorna Reynolds, Adele Dalsimer and Ailbhe Smyth, recognized O'Brien's novels about the struggle of young Irishwomen for self-fulfilment against family and social constraints as vehicles for socio-political, feminist commentary and critique. However, the political dimension of her work has been more often noted in passing than thoroughly analysed under consideration of the historical contexts of her settings. 5 Michael Cronin, 'Kate O'Brien and the Erotics of Liberal Catholic Dissent', *Field Day Review*, 6 (2010), 28–51 at 32. 6 Lorna Reynolds, *Kate O'Brien: A Literary Portrait* (Gerrards Cross, 1987), p. 36. O'Brien provided accounts of her time as a governess in northern Spain in her unpublished lectures given in Claremorris in the late 1950s and in Canterbury in 1972, as well as in her unpublished essay 'My Spain'. O'Brien, Lecture to the Claremorris Countrywomen's Association, n.d., *c*.1957, Holograph, 5pp, Northwestern University (Chicago) Collection of Kate O'Brien Papers; O'Brien, Lecture to the Association of Professional and Business Women in Canterbury of 10 March 1972, Typescript, 7pp, University of Limerick Collection of Kate O'Brien Papers; O'Brien, 'My Spain', Talk on Spain, Holograph, 22 pp. n.d., *c*.mid-1960s, Northwestern University (Chicago) Collection of Kate O'Brien Papers. 7 O'Brien, *Mary Lavelle* [1936] (London, 1984).

northern Spain for a year to take up a post as governess to a wealthy Spanish family, the Areavagas, in order to widen her horizon before settling down to married life in her native town Mellick. Unlike the author, who married the Dutch journalist Gustave Renier after her return from Spain,[8] Mary Lavelle plans to break up with her fiancé John after her brief adulterous affair with Juanito, the married son of her employer. However, just like her creator, Mary falls in love with her host country Spain and is transformed by this experience. Towards the end of the novel, 'the disciplined Puritan from Mellick'[9] has shed many of her old beliefs and convictions in which she had been indoctrinated back in Ireland. This becomes most obvious from her decision to consummate her love with Juanito, despite being fully aware that she thereby transgresses the laws of her Catholic religion. Over the course of her four-month stay in Spain Mary develops from a self-conscious and naive girl into a self-determined woman who takes fate into her own hands.

Although O'Brien desists from idealizing Spain in her novel and does not allow her protagonist to turn a blind eye to the slums of Bilbao or the puzzling 'inconsistencies in the Spanish character',[10] she makes it clear that Spain acts as catalyst for Mary's maturation, which would not have been possible if she had stayed in Ireland. Through numerous flashback scenes presenting Mary's reminiscences of home, the reader is encouraged to draw comparisons between Mary's dull, restricted existence in Ireland and her free, adventurous life in Spain. Thus, in Altorno she enjoys the freedom to be herself and 'sit unknown, unneeded, in the leafy square of a Spanish town', while at home in Mellick she had always been defined and judged by others as 'a[n] eldest daughter, eldest sister; considered pretty, considered intelligent [...] and loved by John MacCurtain'.[11] Mary's own dysfunctional family contrasts starkly with the harmonious family life of the Areavagas. Her widowed father is described as a lazy, peevish and miserly man who '[knows] nothing and read[s] nothing' and considers investment in a girl's education '[a]bsolute waste [...] unless [she] is downright plain'.[12] By contrast, Don Pablo 'love[s] his children and [is] honourably devoted to his wife'.[13] He attaches great importance to his daughters' education and encourages them to voice their opinions. Just as Don Pablo is represented as the exact opposite of Mary's father, her Irish fiancé John functions as the perfect foil for her lover Juanito, the Spanish 'John'. While John is characterized as an arrogant, conservative and patronizing man who passively waits for the death of his uncle in the hope of inheriting a small fortune before marrying his fiancée, Juanito is not only a passionate lover, but also a revolutionary political activist with the quixotic hope of establishing communism as a transitional system to anarchism in Spain and the courage to 'ride at any old windmill'.[14]

8 Reynolds, *Portrait*, pp 36–8; O'Brien had met Renier in London in 1921 and consented to marry him after her return from Spain in 1923. The marriage lasted just eleven months. 9 O'Brien, *Mary Lavelle*, p. 132. 10 Ibid., p. 108. 11 Ibid., p. 72. 12 Ibid., p. 26. 13 Ibid., p. 52. 14 Ibid., pp 63f.

By contrasting her sympathetic and intellectual male Spanish protagonists with the chauvinistic and narrow-minded male Irish characters in the novel, O'Brien indirectly conveys an image of an arch-conservative, patriarchal Ireland which compares unfavourably with Spain. However, O'Brien does not commend Spain as the only country capable of promoting Mary's psycho-sexual development; rather, we are told that '[l]eft to herself anywhere, bereft of the family setting and the Irish back-cloth, bereft of the dominating authority of John, she might have put out unexpected shoots'.[15] Moreover, she presents Spain not as the exotic, utopian 'Other' of Ireland, but rather 'as a mirror image of Ireland, which, in spite of all its differences, evinces parallels'.[16] O'Brien made no attempt to conceal the fact that, just like Ireland, Spain was a Catholic and patri-archal society in which pre-marital sex – with a married man at that – was considered a grave sin and divorce was not an option. Still, her sympathetic portrayal of Spanish characters taking a more active interest in Mary's individual personality than her own father and fiancé reflects the author's impression that Spanish society left its members more freedom for self-expression, because the Spanish people were 'astoundingly individualistic' and unlikely to be cowed by self-denying, inflexible rules:

> They can be controlled by a broad ideal and by a symbol which appeals to them, but within that ideal the rules must be limber and have all possible room for personality – which is why, taking it broad and large, the Catholic faith has remained so native to the Spaniard.[17]

Meanwhile, in Ireland, Catholic morality was becoming enshrined in the 1937 Constitution masterminded by Taoiseach Éamon de Valera, which granted the Catholic Church a 'special position' on account of its function 'as the guardian of the Faith professed by the great majority of the citizens' and effec-tively confined women to the realms of home and hearth.[18] A system of strict censorship ensured that Irish citizens were 'protected' from immoral, liberal voices from within and outside the country. As her friend and biographer Laura Reynolds stated, O'Brien 'disliked intensely the claustrophobic, complacent, in-grown, Puritanic society that had developed in Ireland in the thirties and forties of the [twentieth] century'.[19] In *Mary Lavelle*, she depicted the protagonist's

15 Ibid., p. 106. 16 Karin Zettl, 'Crossing Borders – Nation and Gender as Interrelated Concepts in Kate O'Brien's Works: A Thematic Analysis' (PhD, University of Vienna, 1999), p. 208. 17 O'Brien, *Farewell Spain*, p. 153. 18 J.J. Lee, *Ireland, 1912–1985: Politics and Society* (Cambridge, 1989), p. 203. Article 41.2.1 of the Constitution states: 'In particular, the State recognises that by her life within the home, woman gives to the State a support without which the common good cannot be achieved.' And in 41.2.2: 'The State shall, therefore, endeavour to ensure that mothers shall not be obliged by economic necessity to engage in labour to the neglect of their duties in the home.' Constitution of Ireland, http://www.irishstatutebook.ie/en/constitution/index.html, accessed 27 May 2014. 19 Reynolds,

dysfunctional family as a microcosm of the patriarchal and priest-ridden post-independence Irish society at large. The novel ends with Mary leaving Spain in a state of confusion, and certain only that she will not stay in Ireland. The unstated but clear message is that the newly independent Irish Free State offers no opportunities for financial independence and personal self-fulfilment to emancipated Irishwomen like Mary.

Reading *Mary Lavelle* not just as a private coming-of-age novel but as a socio-political parable, critical of the heavy interference by church and state in private affairs in de Valera's Ireland, sheds light on the special significance of the temporal gap between the novel's composition in 1935 and its setting in 1922. The civil war that tore the nascent Irish Free State apart in 1922 is hardly mentioned by O'Brien a decade and a half later in *Mary Lavelle*. We are only told that during the Anglo-Irish War Mary used to run dangerous errands for her brother, who was in the IRA. As Karin Zettl argues in her dissertation on Kate O'Brien, the writer's relative silence on the nationalist struggle for independence does not prove her an apolitical writer, but rather reflects her disillusionment with the nationalist revolution in Ireland, above all because it isolated Ireland from the rest of Europe and failed to revolutionize Ireland's patriarchal society.[20]

At the same time, however, *Mary Lavelle* can be read as a political parable with regard to Spain. Setting the novel in 1922 was also an interesting decision with regard to Spanish history, given that just one year later General Primo de Rivera imposed a military dictatorship, which was followed by the establishment of the Second Spanish Republic in 1931. By 1935, when O'Brien wrote *Mary Lavelle*, a coalition of centre- and far-right parties had taken power and reversed most of the social, industrial and agrarian reforms introduced by the previous left-wing government. This had further fuelled the political radicalization of Spanish society, which was roughly divided into liberal and conservative forces including liberal-federalist democrats, regional nationalists, anarchists and communists on the one hand, and conservative-centralist monarchists, Catholic reactionaries and fascists (the Falangists) on the other. Concerned about the advance of both fascism and communism in Spain, O'Brien used Juanito as her mouthpiece to voice her hope that the Spanish people, thanks to their strong respect for individualism, would never succumb to the power of any dictator. While O'Brien stopped short of supporting the anarcho-syndicalist and revolutionary Marxist call for a social revolution to redistribute land and property in Spain, and never professed her allegiance to any particular political party or movement, she considered anarchism as the political system best suited to granting individual citizens a maximum degree of personal liberty. In *Farewell Spain* she would describe 'absolute anarchy' as 'Heaven on earth', but 'an impos-

Portrait, p. 105. **20** Zettl, 'Crossing Borders', pp 79–101.

sible condition of life'.[21] In *Mary Lavelle*, O'Brien similarly presented anarchism as an admirable, though utopian, political ideology through her sympathetic portrayal of Don Pablo and Juanito as cultivated, Christian anarchists looking for the best way to combine social justice with respect for the individual need for personal freedom. Juanito's public commitment to the establishment of anarchism parallels Mary's private battle for self-determination and liberation from societal pressures. While the title of the novel refers unequivocally to its Irish heroine, the democratic, liberal Spain beloved by O'Brien appears as the second, hidden protagonist, whose struggle against hostile conservative-nationalist forces is depicted in Don Pablo's and Juanito's internal monologues on the troubles of their country. In this light, *Mary Lavelle* can be read as O'Brien's political appeal for the respect of every individual's right to freedom of speech and conscience, which at the time the novel was published was just as relevant to Ireland as it was to Spain.

Unfortunately, Juanito's prophecy of a bloody battle over the fate of Spain was to come true. In 1936, the left-wing parties gained a narrow majority in the general elections and formed an unstable Popular Front coalition supported by socialists, communists and anarchists. The following months saw the country spiral into violent chaos with political murders, church burnings and workers' strikes. The assassination of the right-wing opposition leader Calvo Sotelo by the Republican police provided the final trigger for the military insurrection on 17 July 1936. Supported by aircraft and artillery from fascist Germany and Italy, the insurgents hoped for a swift victory. However, the readiness of thousands of civilians from Spain and abroad to fight for the democratically elected Republican government, coupled with the generous arms supplies from the Soviet Union, prolonged the military *coup d'état* into a devastating civil war which would last almost three years.[22]

During the early stages of the Spanish Civil War, between October 1936 and February 1937, O'Brien wrote *Farewell Spain*, a travel book with a hidden political agenda – to defend Spain's democratic left-wing government against its fascist assailants, while promoting anarchism as a desirable utopian alternative to all forms of organized state power.[23] O'Brien's overtly pro-Republican comments in this book were clearly written in response to the one-sided representations of the Spanish Civil War both in Britain, her country of residence, and in her home country Ireland, where public opinion was largely pro-Franco, but the author deliberately distanced herself from other war-commentators by embedding her political statements seemingly in passing in a highly subjective,

21 O'Brien, *Farewell Spain*, p. 23. **22** Antony Beevor, *The Spanish Civil War* (London, 1982), pp 14ff; Paul Preston, *A Concise History of the Spanish Civil War* (London, 1996), pp 10ff. **23** For an extended analysis of the political content of *Farewell Spain*, see U.A. Mittermaier, '*Farewell Spain*: Kate O'Brien's Elegy to Wartorn Spain', *Études Irlandaises*, 38:1 (2013), 155–73.

sentimental travelogue filled with reminiscences of her frequent visits to Spain before the outbreak of war.[24] That *Farewell Spain* is in fact no more an apolitical travelogue-cum-memoir than *Mary Lavelle* is a conformist romantic novel, however, becomes most obvious from her frank declaration of support for the Spanish Republican government in the chapter about Madrid, entitled with the Republican battle-cry 'No pasarán':

> I am not a Communist, but I believe in the Spanish Republic and its constitution, and I believe in that Republic's absolute right to defend itself against military Juntas, the Moors and all interfering doctrinaires and mercenaries [...] it should be clear, as we approach the capital of the 'all-Spains', that the writer is on the side of the Republic, of the Army in Overalls, and of the indomitable *madrileños* who have said of the Republic's enemies: *No pasarán* – they shall not pass.[25]

General Franco entered Madrid in March 1939 and replaced the democratic Spanish Republic with a brutal dictatorship, which drove hundreds of thousands of political opponents into incarceration or exile. Over the next three-and-a-half decades up until his death in 1975, Franco ran an authoritarian right-wing regime with some striking similarities to the democratic Republic of Ireland under the political leadership of Éamon de Valera and his Fianna Fáil party. Both in de Valera's Ireland and in Franco's Spain, the Catholic Church was constitutionally granted a special position in the state[26] and legislation reflected Catholic moral teaching. As a result, legal discrimination against women, the banning of contraception, abortion and divorce were just some of many other aspects in which state ideology and social policies in Franco's Spain and de Valera's Ireland coincided. From the 1930s to the 1970s Irish and Spanish society and culture were marked by the dominant influence of the Catholic Church and its state-supported propagation of a patriarchal family model, the idealization of the nation and the glorification of its history, governmental efforts to promote one language (Irish and Castilian respectively) over another (or several others in the case of Spain),[27] the exaltation of rural life and tradition above urban life and

24 The public reaction to the Spanish Civil War in Ireland and the military involvement of Irish volunteers on both sides in the conflict have been discussed at length in Fearghal McGarry, *Irish Politics and the Spanish Civil War* (Cork, 1999) and Robert Stradling, *The Irish and the Spanish Civil War, 1936–39: Crusades in Conflict* (Manchester, 1999). 25 O'Brien, *Farewell Spain*, pp 83–4. 26 Lee, *Ireland*, p. 203. Spain was actually proclaimed a confessional state with Catholicism as its only officially recognized religion. E.J. Rodgers, 'National Catholicism' in E.J. Rodgers (ed.), *Encyclopedia of Contemporary Spanish Culture* (London, 1999), p. 359. 27 The linguistic situation was, of course, very different in Ireland and Spain. Whereas any political measures to revitalize the endangered Irish language stopped short of seriously threatening the dominant position of English as the most widely spoken language in Ireland, the Franco regime actually banned the Catalan and Basque people from speaking their thriving mother tongues outside their homes and suppressed publications in the minority languages. After the Second World War,

modernity, and the cultural isolation from the modern world by means of rigid censorship. In Ireland, as in Spain, cultural protectionism was accompanied and reinforced by economic isolationism. Rather than promoting self-sufficiency, however, the Irish and Spanish governments' protectionist policies caused economic stagnation and soaring unemployment and emigration rates until the late 1950s.[28]

That the Irish church and state were hardly more appreciative of liberal voices than the Franco regime, though dissenters were neither executed nor jailed as in Franco's Spain, was painfully brought home to O'Brien by the banning of her novel *Mary Lavelle* in December 1936,[29] presumably for its depiction of an adulterous love affair.[30] O'Brien expressed her shock and anger at having been censored in the highly polemical novel *Pray for the Wanderer* (1938), in which she used the protagonist Matt Costello, a banned writer from Mellick (that is, Limerick) living in voluntary British exile, as her mouthpiece to excoriate the puritanical and self-complacent society of post-independence Ireland and to condemn de Valera as a *de facto* dictator:

> [Ireland,] a dictator's country, too. But a more subtle dictator than most – though he also, given time, might have the minds of his people in chains. He did not bring materialism out for public adoration, but materialistic justice controlled by a dangerous moral philosophy, the new Calvinism of the Roman Catholic [...] Subtle but dictatorial and obstinate [...] A clever man, Dev.[31]

The banning of her next novel, *Land of Spices* (1941), for a one-line reference to homosexual love[32] did nothing to improve O'Brien's relationship with de Valera's Ireland. Nor did Ireland's neutrality during the Second World War, which she indirectly criticized as immoral in her book reviews[33] and in her sixth novel, *The*

when Franco was compelled to show a more liberal face to the Allied victors to gain international recognition, the publication of some books and plays in Catalan was allowed. However, it remained hard for writers to find publishers for their works in Catalan. E.J. Rodgers, 'Franco Bahamonde, Francisco' in E.J. Rodgers (ed.), *Encyclopedia*, p. 204. **28** For a more detailed comparison of political and socio-cultural conditions in Ireland and Spain from the 1940s to the 1970s, see chapter 4.2 in U.A. Mittermaier, 'Images of Spain in Irish Literature, 1922–1975' (PhD, Trinity College, Dublin, 2010), pp 275–89. **29** Brad Kent, 'Literary Criticism and the Recovery of Banned Books: The Case of Kate O'Brien's *Mary Lavelle*', *Ariel: A Review of International English Literature*, 41:2 (2011), 47–74 at 47. **30** Although books were not officially censored for their political content in Ireland, Brad Kent has suggested that *Mary Lavelle* might have been banned 'not merely due to the consensual adulterous sex between Mary and Juanito or its portrayal of lesbian love [of the Irish governess Agatha Conlan for Mary]', but rather for 'the many more ways' in which the novel 'functions [...] against the official nationalism of 1930s Ireland'. Thus, the novel's subversive aspects include its 'stance against the marriage of Church and State; the negative portrayal of Catholicism; [...] the appeal of socialism to the intellectual and wealthy patriarchs' (Kent, 'Literary Criticism', p. 66). **31** O'Brien, *Pray for the Wanderer* (New York, 1938), pp 43–4. **32** Reynolds, *Portrait*, p. 75. **33** Zettl, 'Transcending Borders – Limerick, Ireland, Europe: Kate O'Brien as Critic and

Last of Summer (1943).[34] O'Brien spent the war years in London and Oxford and did not return to Ireland until the summer of 1945, when she finished her seventh novel, *That Lady* in Clifden, Co. Connemara.[35]

That Lady,[36] published in 1946, is a historical novel with contemporary relevance for socio-political conditions in 1940s Ireland and Spain. Entirely set in sixteenth-century Spain, it is based on the real-life story of Ana de Mendoza, the Princess of Eboli and Duchess of Pastrana and widow of Ruy Gomez, King Philip II's late secretary of state. The novel opens with the king urging Ana to move from her estate in Pastrana to Madrid to have her near him as his confidante. Philip admires Ana and enjoys the gossip that they had once been lovers. He flatters himself with the idea that he had nobly refrained from taking her as his lover out of friendship and respect for Ruy. Therefore, he is particularly piqued at learning that Ana is having an affair with Antonio Pérez, Ruy's successor as Secretary of State, who is married. In order to simultaneously force the lovers apart and wash his own hands of the assassination of the alleged conspirator Juan Escovedo, which he himself had commissioned, he refuses to open a trial to investigate the murder and instead nourishes the rumour that Ana and Antonio killed Juan to prevent him from exposing their affair. When Ana exhorts Philip to take the Escovedo case to court and refuses to abandon Antonio, the king has her imprisoned and finally immured within her own house in Pastrana, where, deprived of sunlight and fresh air, she dies within a few months.

Ana's pride in her Castilian identity is highlighted throughout the novel. We are told that Ana's family, 'Viscayan in origin and now holding lands all over the peninsula, had nevertheless, at the time of Ana's birth in 1540, been Castilian in root and spirit for over three hundred years'.[37] The 'very Spain of her heart' is central Castile rather than the 'eastward extremity of Castile', whose inhabitants were to her 'only by elastic courtesy Castilian' given the influx of Catalans, Aragonese and *moriscos*.[38] O'Brien's heavy emphasis on Ana's conviction of Castile's superiority to the rest of Spain is somewhat ambiguous. On the one hand, it seems clear that Ana's nationalist pride gets her into trouble. Already at the tender age of 15 she lost her left eye in a duel with an Andalusian page who had dared to question 'Castile's claim of premiership among the kingdoms of Spain'.[39] As a mature woman in her mid-forties, she refuses to obey a 'half-

Novelist' in P.A. Lynch et al. (eds), *Back to the Present. Forward to the Past: Irish Writing and History since 1789* (Amsterdam, 2006), pp 41–9 at p. 44. For example, in her review of Jeffrey Dell's *Nobody Ordered Wolves* (1940), published in the *Spectator* on 5 Jan. 1940, O'Brien wrote: 'All of us have helped to make the situation which Europe now confronts [...] It is our collective responsibility which we must face and examine as well as we can [...] The ivory towers have all been bombed away'. **34** At the end of this novel, O'Brien's French protagonist prefers returning to war-torn Europe to staying in a Jansenistic, patriarchal and isolationist/self-protective Ireland. **35** Walshe, *Kate O'Brien*, pp 98–102. **36** O'Brien, *That Lady* [1946] (London, 1985). **37** Ibid., p. 4. **38** Ibid., p. 128. **39** Ibid., p. 86.

foreign' king,[40] whom she regards as a '*parvenu* in the Peninsula', and ends up a prisoner in her own house.[41] This negative interpretation of Ana's Castilian hauteur as the source of her troubles seems to be supported by the dismissive comments of non-Castilian characters in the book. Thus, Ana's loyal Andalusian servant Bernardina 'had [often] gasped in sheer, vulgar astonishment before the story-book Castilianism of Ana de Mendoza and that great lady's comical unconsciousness of her own absurdity'.[42] She fears that 'innocent and arrogant' Ana's conviction of her superior status as a native Castilian blinds her to the threat emanating from Philip's megalomania.[43]

That O'Brien herself had little sympathy for her heroine's excessive patriotism is suggested by her journalistic writings. In a 1969 essay on de Gaulle she described nationalism as 'a dangerous pride', adding: 'Patriotism is an attribute in people which I, for one, never welcome overmuch. The idea that it is particularly wonderful to be, say, Irish or Spanish or Indonesian or whatever, always tires me'.[44] She also commended the author of *The Golden Century of Spain*, R. Trevor Davies, for aptly explaining Spain's bankruptcy at the end of King Philip II's reign as the result of, among other things, 'the general mania for religious orthodoxy and racial purity, the peculiarities of the Castilian character'.[45] At the same time, O'Brien's great love of Castile and preference for this predominantly Catholic region in central Spain over Moorish-influenced Andalusia and Catalonia (fuelled by her reading of the works of the Spanish nationalist-centralist writers of the 'Generación 1898', including Miguel de Unamuno and Pío Baroja) are well-documented.[46] In this light, Ana's Castilian pride and sense of honour can be seen positively as the source of her moral strength and the central motive for her brave defiance against a tyrannical king. We are certainly not encouraged to read Ana's fall from grace and subsequent incarceration as just punishment for her overweening national pride. Rather, Ana emerges from the battle of will against Philip as a heroine in the most literal sense, a champion of individualism and human rights. On a personal level, she denies the king the right to interfere with her private life and relies on her own unorthodox and 'very Protestant' morality to come to terms with her guilty conscience for committing adultery.[47] On a public level, Ana's plea for fair trials, transparent government and power-sharing show that her national pride is based on an understanding of Castilian traditions as representing respect for individualism and privacy, and the right and obligation to participation in political decision-making. She deeply

40 Ibid., p. 218. **41** Ibid., p. 19. **42** Ibid., p. 64. **43** Ibid., p. 263. **44** O'Brien, 'De Gaulle: And He Was and Remains Incorruptible', *Creation* (June 1969), 47. **45** O'Brien, 'Review of *The Golden Century of Spain* by R. Trevor Davies', *Spectator*, 10 Dec. 1937. **46** Legarreta, *Kate O'Brien*, p. 35. Walshe has observed that O'Brien's 'Spanish intellectual and spiritual heritage is exclusively Catholic. She allows no other landscape or traditions within the Iberian Peninsula to find a place in her Spain' (Walshe, *Kate O'Brien*, p. 62). **47** O'Brien, *That Lady*, p. 215.

resents 'the growing indolence and indifference of the Spanish nobility before the general question of Spanish destiny',[48] which has allowed Philip to gradually turn Spain into an absolutist monarchy, and considers it as her duty to protest against the king's tyranny on behalf of Castile and all of Spain. As she explains to her son-in-law:

> I have done no criminal wrong, and I won't be bullied out of my country by a nothing [...] in this mad issue I have seen a principle, and I shall stay and hold it. Castile is crumbling under the curious, cautious tyranny of this king. I'm a Castilian. I've done nothing useful in all my life, and I've committed many sins. But by chance I can do this one small service for Castilian good sense before I die.[49]

Thus, while Ana's Castilian hauteur appears absurd and self-destructive, it is informed by a sense of responsibility for the fate of her nation and is, therefore, preferable to King Philip's entirely selfish and ignoble vanity, which, when hurt, leads him to commit the most brutal humanitarian crimes. In the end, Ana carries the moral victory over Philip, even though it is at the loss of her freedom, and ultimately, of her life.

O'Brien meticulously researched the historical context for her 'drama of conscience' and interwove the latter with references to the key events in sixteenth-century Spanish history. Still, O'Brien stressed in her foreword to *That Lady* that '[w]hat follows [was] not a historical novel' and that 'everything which [the characters] say or write [...] [was] invented'.[50] Given that all historical novels are inevitably subjective, critics like Anne Dalsimer and Anne Fogarty have found this 'disclaimer of historical fidelity' quite 'puzzling'[51] and 'somewhat perverse'.[52] On the one hand, the cautious note in O'Brien's disclaimer must be seen in the light of her previous brushes with censorship. Aware that her portrayal of Ana de Mendoza differed vastly from descriptions of her character in historical records, according to which the 'real' Ana was a 'difficult and much-disliked intriguer',[53] the author felt the need to defend her right as an artist to tamper with the historical evidence. Most importantly, however, O'Brien's insistence on the ahistorical nature of her story serves to alert the reader to the allegorical function and the contemporary relevance of her novel about a woman's struggle against tyranny. As Lorna Reynolds has pointed out, *That Lady* can be read both in 'a universal light', in which Ana 'typify[ies] the lot of most women in a patriarchal society', and 'in application to the years when it was

48 Ibid., p. 6. **49** Ibid., p. 296. **50** Ibid., p. xiv. **51** Anne Dalsimer, *Kate O'Brien: A Critical Study* (Dublin, 1990), pp 87–9. **52** Anne Fogarty, 'Other Spaces: Postcolonialism and the Politics of Truth in Kate O'Brien's *That Lady*', *European Journal of English Studies*, 3:3 (1999), 34–53 at 345. **53** Walshe, *Kate O'Brien*, p. 103.

being written', that is, at the end of the Second World War – a reading according to which Ana becomes 'an example of the many men and women who, in defence of freedom, defied the assaults and tortures of the Fascist regimes, whether in Spain, or Germany, or Italy'.[54]

That O'Brien conceived of *That Lady* as a political parable is intimated by her commendation in 1938 of historical novels for their 'didactic and topical value' when designed as 'parables for the present political situation'.[55] Apart from the hint in the preface, the author peppered the novel with anachronisms serving as reminders of the contemporary relevance of her novel's message. Two hundred years before the period of Enlightenment, when few people dared to question the 'divine right of kings', it is unlikely that a woman would have criticized her sovereign for having 'carried off some dangerous crimes against human rights'. Similarly, Ana's exhortation to Philip – 'Don't be foreign, don't be German. Go to our common courts and let us hear why Escovedo died' – would have set alarm bells ringing for her readers in 1946, one year after the end of the Second World War, when the novel was published.[56]

It is clear that the writing of *That Lady* was directly inspired by the horrors of the war; indeed, the idea for the novel came to O'Brien during a blackout in London in 1940.[57] Reynolds is certainly right in surmising that the author did not treat the war directly, and instead chose sixteenth-century Spain for her setting to avoid the banning of the novel in Ireland.[58] At the time, any references to the 'Emergency' which seemed to express sympathy with either side in the war, and were thus deemed to violate Ireland's neutral stance, were censored.[59] Furthermore, in view of O'Brien's disapproval of the spirit of censorship and insularity, particularly prevalent in Ireland during the war, her novel set in sixteenth-century Spain about a woman's defiance of a tyrannical regime denying its citizens freedom of speech can just as plausibly be read as a parable of de Valera's Ireland as of Europe's fascist regimes.

Anne Fogarty has pointed out that 'as always in her work, O'Brien uses Spain as a means of making an oblique commentary on Ireland'.[60] More specifically, '*That Lady* acts as a telling critique of the isolationism and falsely conceived self-reliance of de Valera's Ireland'[61] predicated on the belief in Ireland's moral superiority to other nations, which O'Brien only questioned explicitly in her non-fictional writings. Thus, in her lecture on Irish prose delivered at the University of Valladolid in 1971, O'Brien said that 'to be free, to be able to say what you mean' was more important to her than 'the idea of being Irish rather

54 Reynolds, *Portrait*, p. 104. 55 Zettl, 'Crossing Borders', p. 90. 56 O'Brien, *That Lady*, pp 106, 107, 243. 57 Walshe, *Kate O'Brien*, p. 102. 58 Reynolds, *Portrait*, p. 104. 59 For the censorship of Irish literature, films and the press during the Second World War, see Clair Wills, *That Neutral Island: A Cultural History of Ireland during the Second World War* (London, 2007), pp 8–12, 263–76. 60 Fogarty, 'Other Spaces', 350. 61 Ibid., 349.

than of any other breed'.[62] In *That Lady*, by contrast, she used Castile and its proud and apathetic aristocracy to warn that a nation whose members are self-complacent and completely indifferent to political developments at home and abroad is prone to fall into the hands of despotic rulers gradually curtailing freedom of speech and other civil rights.

The possibility that O'Brien's implicit condemnation of Philip II's despotism can be applied not only to de Valera's Ireland but also to Franco's Spain is hinted at in various key scenes of *That Lady*. Ana's complaint that 'court life appeared to […] [be] directed by a few fanatical canons from Sevilla' and that the king's absolutism was 'unnatural to Castile'[63] echoes O'Brien's comments in 1934 that the Irish Catholic Church's 'spoil-sport fanaticism' and 'spirit of censorship', as well as de Valera's insular nationalism, were 'unnatural to Ireland'.[64] This critique of an 'unnatural' and unholy alliance between an oppressive political regime and the church is as relevant to Ireland under de Valera as to Spain under Franco. Similarly, Philip's astonishment that 'a woman' has taken the liberty to advise him on state affairs directs attention to the exclusion of women from political decision-making in both Spain and Ireland of the 1940s. Finally, Philip's harsh punishment of Ana for her persistent refusal to bow to his Catholic moralistic dictates, abandon her lover and confess her sins reflects the tyrant's disrespect for freedom of speech and opinion, and recalls the thousands of political prisoners and state oppression in Franco's Spain. It also serves as an implicit critique of the censorship practiced in de Valera's Ireland, which similarly sought to silence critical voices, including O'Brien's. In the event, *That Lady* was not only passed by the Irish Censorship Board but also turned out to be a bestseller receiving considerable critical acclaim.[65] The success of her novel allowed O'Brien to buy a house in Roundstone, Co. Galway, where she lived from 1950 to 1960. Although her return to Ireland in the 1950s suggests an improved relationship with her home country, O'Brien continued to criticize Ireland's political and cultural estrangement from Europe in her journalistic writing.[66]

Despite the novel's critique of Philip II's brutal authoritarianism and its applicability to the similarly oppressive Franco regime, *That Lady* was not

62 O'Brien, 'Imaginative Prose by the Irish, 1820–1970' in J. Ronsley (ed.), *Myth and Reality in Irish Literature* (Waterloo, 1977), pp 305–15 at p. 307. 63 O'Brien, *That Lady*, pp 2, 218. 64 O'Brien, 'Changing Ireland', *Spectator*, 18 May 1934. 65 Walshe, *Kate O'Brien*, p. 108; O'Brien adapted the novel for the Broadway stage in 1949 and in the 1950s it was dramatized for radio and television and finally filmed in Hollywood. 66 Zettl, 'Transcending', 43–5. In her 1965 article 'Irish Writers and Europe', for example, O'Brien exhorted Irish writers 'to go back into Europe on its best strength' (*Hibernia* (May 1965), reprinted in *The Stony Thursday Book*, 7 (1980), 37). And as Ireland's representative of the European Community of Writers she saw it as imperative that 'Irish writers help establish free and continuous dialogue between […] writers of all the countries of Europe, East and West' (O'Brien, 'Avantgardisme – in Europe and Ireland: Writers Meet in Rome', *Irish Times*, 21 Oct. 1965).

banned in Spain either.[67] The 1955 Hollywood movie version of the novel, directed by Terence Young, was initially banned because 'General Franco object[ed] to the film on the grounds that it shows King Philip the Second in an unfavourable light'.[68] However, after changes had been made to the Spanish script to make Philip II appear more sympathetic, the film was released for screening in Spain and was 'very successful', as O'Brien noted in her Claremorris lecture. The novel itself was actually saved from being censored by O'Brien's emphasis on its invented, ahistorical character in the preface. While the Spanish censors pointed out that the novel could not be relied on for a truthful account of the trial against Antonio Pérez and the death of Juan Escobedo, they recommended the authorization of its publication in Spain to avoid the rights for its translation being ceded to an Argentinian publisher who might have failed to smooth over those concepts to which suspicious Spaniards might take exception.[69]

There is not even any record of *Farewell Spain*, in which O'Brien had openly declared her opposition to Franco, having been censored in Spain.[70] Whereas critics have repeatedly stated that O'Brien's fierce criticism of Franco in *Farewell Spain* led to her being banned from entering Franco's Spain until 1957,[71] no documentary evidence of this claim has been traced so far.[72] Still, it was only from September 1958 that O'Brien revisited Spain frequently *and* officially.[73] Her stays in Spain from 1958 onwards allowed her to observe and evaluate the

67 O'Brien's claim in her Canterbury lecture in March 1972 that she was never 'persona grata with the Franco government' and that 'it [was] the only feather in [her] cap that all [her] works [had] been long ago banned in Spain' was just as inaccurate as Walshe's contention that 'her work was freely available in Spain', and that '[t]he only form of censorship recorded was that permission was refused for the book jacket of *Without My Cloak* on the grounds of immorality' (*Kate O'Brien*, p. 75). In fact, permission to translate *Mary Lavelle* was denied on 7 January 1944 for no specified reasons (Archivo General de Administración de Alcalá de Henares, file no. 8102-43). Furthermore, the translation of *The Last of Summer* (*Final de verano* in Spanish) was only authorized on 15 June 1943 on condition that all 'immoral' as well as all critical statements on Hitler and Nazi Germany were excised or paraphrased (ibid., file no. 3852–43). **68** *Irish Times*, 3 Mar. 1955, 3. **69** The Spanish translation of *That Lady*, entitled *Esa Señora*, was approved on 24 July 1946. Archivo General de Administración de Alcalá de Henares, file no. 3154-46. **70** Walshe's suggestion that 'there would have been no official Nationalist censorship in place to ban [*Farewell Spain*]' (*Kate O'Brien*, p. 75) during the Spanish Civil War seems questionable in light of the censorship foreign correspondents experienced in the territory held by Franco's forces (see, for example, Francis McCullagh, *In Franco's Spain: Being the Experiences of an Irish War-Correspondent during the Great Civil War which Began in 1936* (London, 1937), pp xxi–xxii). Rather, the publication of *Farewell Spain* was probably not even attempted during the civil war, let alone during Franco's dictatorship. **71** E.g. Reynolds, *Portrait*, p. 97; Walshe, *Kate O'Brien*, p. 76; María Isabel Butler de Foley, 'Each Other's Country: Some Twentieth-Century Irish and Spanish Writers' in J. Logan (ed.), *With Warmest Love: Lectures for Kate O'Brien, 1984–1993* (Limerick, 1994), pp 15–31 at p. 24; M. O'Neill, 'Introduction' to *Farewell Spain* by Kate O'Brien (London, 1985), pp ix–xxi at p. xii. **72** M. Morales Ladrón, 'Banned in Spain? Truths, Lies and Censorship in Kate O'Brien's novels', *Atlantis*, 32:1 (June 2010), 55–72. **73** Walshe, *Kate O'Brien*, p. 136; Legarreta notes that a stamp from the Spanish border officials of 2 Sept. 1954 indicates that O'Brien 'had managed at least once to cross the border without adequate documentation' and 'see[s] no reason to doubt that her visa was denied a number of times after 1947, possibly even for a decade until 1957' (*Kate O'Brien*, p. 216).

changes that twenty years of dictatorship had wrought on the country, and formed the basis of several newspaper articles and lectures to various societies. Most of these articles were travel pieces in which O'Brien restated her love for Spain and gave advice to potential visitors to the country. While the author was confident that no government could ever change her beloved Spain beyond recognition – owing to her firm belief in the stereotypical 'eternal, unchanging Spanish character'[74] – she did acknowledge the socio-political ills afflicting Franco's Spain. In her journalistic pieces she repeatedly commented on the appalling poverty of the hard-working rural labourers, the flight from the land and the resultant overpopulation of the big cities,[75] the rigid censorship driving the country's writers into conformity and mediocrity or silence,[76] and the government's 'giantism' and frequent mismanagement of large-scale projects.[77] Still, O'Brien would have liked to have been able to be more outspoken in her criticism of the Franco regime, as her letters to her friend Mary Hanley show,[78] but she had to restrain herself to avoid being put on Franco's watch-list. She preferred this compromise to completely staying away from Spain:

> I know there are those who if they disapprove of a regime won't go to a country. I have friends who say they will never return to Spain under Franco […] I have never been able to feel like that – so renunciatory […] I certainly wouldn't deprive myself of Spain, Spain that has given me so much in my brief life – I certainly wouldn't punish myself by never seeing Spain again – no matter what her rulers seemed to me to be.[79]

Her resumed love-affair with Spain in the 1960s also inspired O'Brien to write the romantic short story 'A View of Toledo' (1963)[80] and the novel *Constancy*, which was partly set in civil war Spain and unfortunately remained

74 O'Brien, Canterbury lecture, p. 11. **75** O'Brien, 'Spanish Contrasts', *Irish Times*, 5 June 1967; 'A Quick Look', p. 1; 'Spain', Article for the *Observer*, n.d., *c.*1959, Holograph and corrected typescript, each 3pp at p. 2, Northwestern University (Chicago) Collection of Kate O'Brien Papers. **76** O'Brien, 'Spain', p. 2; 'New Writing in Spain', *Irish Times*, 31 Jan. 1962; 'Young Novelists and the Spanish Spring', *Irish Times*, 14 Feb. 1962. While condemning censorship in Franco's Spain in all these articles, O'Brien also pointed out that young, non-conformist Spanish writers were finally beginning to make their voices heard in the country. **77** O'Brien, 'I – Spain', p. 3 (a revised version of 'Spain'), n.d., *c.*1959, Corrected typescripts, 4pp each, Northwestern University (Chicago) Collection of Kate O'Brien Papers. **78** See two letters from O'Brien to Mary Hanley dated 27 Jan. 1961 and 24 Nov. 1961, *The Stony Thursday Book*, 5 (1977/8), 6f. O'Brien resented the excessive attention she was given by Franco's literary henchmen who were 'bending over backwards (just like Russia!) in case I'll get any impression of Spain save theirs.' She was also quite cynical about the difficulties she encountered in getting permission for an interview with Franco: 'The Pope sees everyone, President Kennedy and Elizabeth II see a good few – so does poor Dev. But Mr. So-and-So Generalissimo how-are-you Franco! O dear me! […] how good he is, with his prisons full, and his newspapers one long sweet song of lies! (But not a word of that in my article need I say?)'. **79** Canterbury lecture, pp 4f. **80** O'Brien, 'A View of Toledo', *Argosy*, 24:10 (Oct. 1963), 76–98.

unfinished at her death in 1974.[81] The surviving manuscripts and typescripts extend to the second part set in Madrid and Ávila in 1931, the year of Alfonso XIII's abdication. The intervening chapters covering the revolutionary years 1931–6, the Spanish Civil War and the first sixteen years of Franco's dictatorship were left unwritten. Certainly, advanced age and ill health delayed O'Brien's progress with the novel, but it is equally plausible to assume that the effort to write imaginatively *and* honestly about the Spanish Civil War without falling foul of the Spanish authorities presented the writer with insurmountable difficulties.

In conclusion, my analysis of O'Brien's various representations of Spain before, during and after the Spanish Civil War has demonstrated that the writer used Spain not just as a picturesque background for romantic novels, but rather as a reference point for her critique of the alliance between the Catholic Church and the state, which she believed fostered political and cultural insularity and provided the ideological foundation for the legal discrimination against women. O'Brien's condemnation of the curtailment of freedom of speech and conscience, however, went beyond the confines of de Valera's Ireland and Franco's Spain, applying equally to Nazi Germany and its fascist allies. Whereas she reserved her more explicitly critical comments on Franco for her political travelogue *Farewell Spain* and her journalistic writings and lectures, she resorted to more subtle means of conveying her disapproval of censorship and other forms of political oppression in Ireland and Spain, and, by extension, wartime Europe at large, in her novels. In *Mary Lavelle*, set fourteen years before the outbreak of civil war in Spain, O'Brien still presented Spain as a comparatively liberal, enlightened Catholic society and a foil for puritanical post-independence Ireland, which, however, was increasingly coming under threat from radical right- and left-wing agitators. Six years after Franco's establishment of a brutal dictatorship in Spain O'Brien designed her historical novel *That Lady* as a political parable to hint at the analogous suppression of political opponents – albeit with different degrees of ruthlessness – under the absolutist King Philip II in sixteenth-century Spain, and in Franco's Spain, Hitler's Germany and de Valera's Ireland in the mid-twentieth century. Even though the critique in her fiction of the stigmatization and/or violent persecution of political dissenters in Ireland, Spain and all across wartime Europe was subtle enough to have escaped the notice of many readers, it is clear that O'Brien cannot easily be dismissed as an apolitical writer if full consideration is given to inter-textual references and historical as well as biographical background. At the same time, concurring with Cronin's assessment, I have shown that she cannot justifiably be constructed as

81 O'Brien, *Constancy.* Unfinished and unpublished novel. Typescripts and manuscripts at University of Limerick's Kate O'Brien Collection. Sections of the work in progress were published in *Winter's Tales from Ireland*, vol. 2, ed. Kevin Casey (Dublin, 1972).

a (socialist or other) political radical given that her utopian idea of anarchism as the system granting maximum freedom to the individual did not aspire to establish a classless society. O'Brien's main concern was with the defence of liberal individualism and freedom of speech and conscience against authoritarian forces gaining ground not only in Ireland and Spain, but all across Europe in the 1930s and 1940s. She was not to be silenced by Irish wartime censorship. Rather, it spurred her into defying de Valera's isolationist policy by setting her novels abroad and in the past, thus wrapping her topical political commentary in the cloak of history.

'On behalf of suffering foreigners': Francis Stuart in Germany

DOROTHEA DEPNER

In a collection that highlights Irish culture's embeddedness within the larger framework of European memory of the Second World War, Francis Stuart occupies a unique position. As an Irish writer who chose to spend the war and post-war years in Germany, Stuart was well aware of his singularity, and his surviving diaries from the war and the years that followed show that he always considered this decision a felicitous one, both for his career and for his pursuit of personal fulfilment.[1] What changed after the war, however, was Stuart's interpretation of his motives for going to Nazi Germany and of his role and place in wartime and post-war Germany. His continual fine-tuning of his past, until finally achieving with *Black List, Section H* (1971) what W.J. McCormack called a 'synchronisation between his obsessions and [the] needs'[2] of his readers, illustrates Stuart's responsiveness to the modes in which memories of the war and Holocaust were mediated over time. It is also indicative of the degree to which his audience was receptive to a local template of an allegedly 'dissident' artist, witness and survivor[3] of the Second World War, many mistaking the autobiographical fiction rendered in a documentary style as 'the full truth of those war years'.[4] In this essay, I want to focus on Stuart's interpretation of events in Germany not only with hindsight, but also as they were unfolding. By highlighting some of the constants and variables in his accounts – whether in diary notes or fiction – I will examine the interplay between changing attitudes

1 These diaries are part of the Francis Stuart Collection at the University of Ulster, Coleraine, and comprise eighteen notebooks (including a notebook entitled 'Notes on Shakespeare and other subjects, August 1942') covering the period from March 1942 to October 1978. Subsequent references to Stuart's diaries refer to this collection. 2 W.J. McCormack, 'Francis Stuart: The Recent Fiction' in Patrick Rafroidi and Maurice Harmon (eds), *The Irish Novel in Our Time* (Villeneuve-d'Ascq, 1976), pp 175–83 at p. 182. 3 See, for example, Timothy O'Keeffe, 'A Survivor', *The Guardian*, 24 Aug. 1972; Fintan O'Toole, 'Forcing Art to Confront the Reality of Experience', *Irish Times*, 5 Nov. 1996, and 'The Survivor', *Writing Ulster*, 4 (1996), 77–84. 4 Sean McMahon, 'Sacrifice Makes Pure: Review of *The Pillar of Cloud*', *Hibernia* (6 Dec. 1974), 21.

after the war and Stuart's own efforts to filter his experience through acceptable narrative models of victimhood and survival.

Stuart, who had recently returned from a book tour through Germany when war broke out, went to considerable lengths to obtain a visa for Switzerland on feigned medical grounds with a view of travelling on to Berlin, where he had been offered a lecturing post in Friedrich-Wilhelms-University (now Humboldt University).[5] Leaving behind his wife of twenty years, Iseult Gonne, as well as a teenage son and young daughter, he departed in January 1940 and spent the war years not only teaching and writing in the German capital (the two wartime novels *Winter Song* (1941) and *The Cave of Peace* (1943) were never published), but also working for various German propaganda outlets as well as assisting Abwehr (German Military Intelligence) in a number of projects that never came to fruition.[6] Towards the end of the war, Stuart attempted to leave the crumbling Third Reich the same way he had entered it, but was turned back at the German-Swiss border, his passport having long since expired.[7] He and his German lover, Gertrude Meissner, witnessed VE Day in the Austrian village Dornbirn and, a few months later, Stuart managed to travel to Paris. When officials at the Irish Legation refused to issue a visa for Meissner, he returned to her in the French-occupied zone where they were both arrested shortly afterwards by the French Allies. They had spent half a year in prison on suspicion of having recruited agents for Abwehr and broadcast propaganda for the Germans[8]

5 Although the Irish authorities suspected Stuart's real destination, he was not hindered in his departure, as the position held by Secretary Joseph Walshe was to avoid the impression of partiality at a time when many Irish people were travelling to Great Britain in order to engage there in similarly 'unneutral' activities, be it in the war industry or the army (see Walshe's letter to Liam Archer, G2 Branch (Irish Military Intelligence), 8 Nov. 1939, DFA 10/A/72, National Archives of Ireland). **6** In addition to broadcasting regularly from March 1942 onwards for *Irland Redaktion*, the German Foreign Office's radio propaganda unit dedicated to Ireland, Stuart had been carrying out translations and writing scripts for the Foreign Office's British radio division since his arrival (David O'Donoghue, *Hitler's Irish Voices: The Story of German Radio's Wartime Irish Service* (Belfast, 1998), p. 57), and had been involved in translating news items for the news agency *Drahtlose Dienst* (Madeleine Stuart, *Manna in the Morning: A Memoir, 1940–1958* (Dublin, 1984), p. 19). He also appears to have made broadcasts for the *Reichsrundfunkgesellschaft*, overseen by Joseph Goebbels' Ministry for Propaganda (Damien Keane, 'Francis Stuart to America, 9 June 1940', *The Dublin Review* 14 (2004), 53–6), and, according to one source, he contributed occasionally to German black propaganda stations (Horst J.P. Bergmeier and Rainer E. Lotz, *Hitler's Airwaves: The Inside Story of Nazi Radio Broadcasting and Propaganda Swing* (New Haven, 1997), p. 208). Stuart's services to Abwehr included giving the German spy Hermann Görtz his wife's address in Laragh as a safe house and signing up for a later abandoned plan of smuggling provisions for the IRA to Ireland ahead of the arrival of Seán Russell and Frank Ryan (O'Donoghue, *Hitler's Irish Voices*, p. 51). He likewise served as a consultant to Abwehr in its endeavour to recruit prisoners of war with Irish roots for an Irish Brigade (see Carolle J. Carter, *The Shamrock and the Swastika* (Palo Alto, 1977), pp 124f). **7** The Irish government's attitude towards the legitimacy of Stuart's stay in Nazi Germany changed in light of his activities, and all his applications for a passport renewal during the war were refused on the grounds that 'he [was] regarded as having forfeited any claim to [Irish] diplomatic protection by unneutral and disloyal activity' (telegram from Assistant Secretary Frederick Boland to Berlin Legation, 25 May 1944, DFA 10/A/72). **8** See letter from French Foreign Ministry to Irish Legation in Paris after Stuart's release, 18 July 1946, DFA 10/A/72.

by the time Stuart's family and External Affairs became aware of their situation and intervened in May 1946.[9] Shortly after Irish diplomats contacted the French authorities, Stuart and Meissner were released and – in the absence of repatriation offers that included his lover – the couple settled in Freiburg im Breisgau in southern Germany. There, Stuart wrote *The Pillar of Cloud* (1948), *Redemption* (1949) and *The Flowering Cross* (1950).[10]

With growing distance from the time and place, he revisited wartime Germany in his novel *Victors and Vanquished* (1958), which appeared the year he returned to live in Ireland with Meissner, whom he had married after his first wife's death in 1954. He did so again a decade later, and when *Black List, Section H* was eventually published in 1971, it set the terms for discussions of Stuart's works for years to come. Thus, McCormack's *Festschrift for Francis Stuart* the following year reiterated the claim that, financial and marital troubles aside, Stuart went to Germany to bear witness and to develop as a person and writer away from the constrictions that governed his life in Ireland;[11] according to Colm Tóibín, this 'set the tone [...] for the next twenty-five years'.[12] Jerry Natterstad, who likewise played a crucial role in promoting Stuart's works in the 1970s, eventually came to question this view in an essay published in 1991.[13] However, it was the publication of Brendan Barrington's edited *Wartime Broadcasts of Francis Stuart* in 2000 that marked a turning point. Barrington's contextualization of Stuart's broadcasts in a scrupulously researched introduction highlighted the discrepancies between the political persona Stuart who went to Germany in 1940 and the literary construct of the artist that emerged in his post-war works. Barrington suggested that the complacent attitude with which the author's imagined version of his past in novels, in edited diary extracts published in the Irish media, and in interviews with journalists, researchers and biographers was accepted may well have suited both those defending and those dismissing Stuart, in that neither group had to question what they held as self-evident and that the facts surrounding Stuart's sojourn in Germany as well as the Second World War itself could continue to be treated as extraneous to Irish cultural memory.[14]

9 See telegram from Boland, who succeeded Walshe as Secretary of the Department of External Affairs in 1946, instructing the Irish Envoy in Paris to provide the usual degree of diplomatic protection, legal and humanitarian aid (31 May 1946, DFA 10/A/72). 10 *The Flowering Cross* was completed before Stuart left for Paris in July 1949, but Germany and the war are already only feeble echoes in this story which is set in post-war France and London. Another novel written in Freiburg shortly after his release – *The Pillar of Fire* – remained unpublished. 11 W.J. McCormack (ed.), *A Festschrift for Francis Stuart on his Seventieth Birthday, 28 April 1972* (Dublin, 1972). 12 Colm Tóibín, 'Issues of Truth and Invention', *London Review of Books*, 4 Jan. 2001, http://www.lrb.co.uk/v23/n01/toibo1-.html, accessed 25 Jan. 2008. 13 J.H. Natterstad, 'Locke's Swoon: Francis Stuart and the Politics of Despair', *Éire–Ireland*, 26:4 (1991), 58–75. 14 B. Barrington (ed.), *The Wartime Broadcasts of Francis Stuart, 1942–1944* (Dublin, 2000), pp 56, 59. Ulick O'Connor, for example, believed the suggestion even that Stuart had ever made any broadcasts was simply slanderous ('Alienation of a Black Swan', *Sunday Independent*, 13 Nov. 1994), while Anthony Cronin remained under the misapprehension that because Stuart's broadcasts had

Perhaps the ebb in literary evaluations of Stuart's works in the years that followed Barrington's publication represents a wish for closure rather than continued analysis of Stuart's, and his audience's, engagement with this chapter in European history.[15] However, both are, as Mark Rawlinson reminds us, 'part of the cultural process by which apprehensions of the Second World War are reproduced and refocused'.[16] What is needed, then, is a sustained critical approach to Stuart's accounts of the war and its aftermath, addressing these with the necessary degree of historical differentiation and placing them firmly within the context of an ongoing discourse on the interpretation and representation of the past, self, and other in the force field of the Holocaust.

IMMEDIACY AND HINDSIGHT

Stuart's engagement with the years he spent in Germany and the responses he has elicited are affected by 'two complementary issues' which have been diagnosed in German literature about the Second World War: 'that of the valorisation of trauma (i.e., immediacy) and that of historization (i.e., distance [through the use of diaries, photographs, documentary footage]), both of which take recourse to an argument about the purported "authenticity" of experience' in an attempt to restore a '"clean", "uninhibited" image of [...] suffering'.[17] These key elements – the valorization of suffering and experiential perspective,

supported Irish neutrality, they were therefore not Nazi propaganda ('Ghastly and Insubstantial Charges', *Sunday Independent*, 21 Jan. 2001). Inversely, discussions of Stuart's time in Germany in the Irish media in the late 1990s that focused solely on whether or not he had been a Fascist or anti-Semite were equally undifferentiated, failing to critically assess Stuart's implication in other National Socialist policies. **15** The few publications that have appeared – with the exception of Damien Keane's 'Broadcasting Dead: The Radio Voice, the Case of Francis Stuart, and the Question of Pedagogy' (in Fionnuala Dillane and Ronan Kelly (eds), *New Voices in Irish Criticism 4* (Dublin, 2003), pp 29–37) – continue to operate within the terms Stuart set in his post-war works: see Anne McCartney, *Francis Stuart: Face to Face: A Critical Study* (Belfast, 2000); Brendan McNamee, 'The Flowering Cross: Suffering, Reality, and the Christ Motif in Francis Stuart's *The Pillar of Cloud* and *Redemption*', *Christianity and Literature*, 53:1 (2003), 41–58; and Kevin Kiely's biography, *Francis Stuart: Artist and Outcast* (Dublin, 2007). More recently, Hiroyuki Yamasaki has argued that Stuart's broadcasts were an expression of the artist's lifelong dissident stance, because he advocated Irish neutrality in them ('The Relationship between Francis Stuart's Response to Neutral Ireland and his Vision of the Artist as a Dissident', *Journal of Irish Studies*, 27 (2012), 28–35). This interpretation ignores that the advocacy of Irish neutrality was not so much the broadcaster's decision, but was the policy adopted by the German government in relation to Ireland during the war, as reflected the mission statement of *Irland Redaktion* drawn up by Adolf Mahr – former director of the National Gallery in Dublin – in May 1941 (his memorandum is reproduced in Hubert Sturm, *Hakenkreuz und Kleeblatt: Irland, die Alliierten und das 'Dritte Reich', 1933–1945*, 2 vols (Frankfurt a.M., 1984), i, A60). **16** M. Rawlinson, 'On the Losing Side: Francis Stuart, Henry Williamson and the Collaborationist Imagination' in Silvia Bigliazzi and Sharon Wood (eds), *Collaboration in the Arts from the Middle Ages to the Present* (Burlington, VT, 2006), pp 121–37 at p. 135. **17** Helmut Schmitz, 'Historicism, Sentimentality and the Problem of Empathy: Uwe Timm's *Am Beispiel meines Bruders* in the Context of Recent Representations of German Suffering' in Helmut Schmitz (ed.), *A Nation of Victims? Representations of German Wartime Suffering from 1945 to the Present* (Amsterdam, 2007), pp 197–222 at p. 209.

the need for distancing through media or through assuming a detached, purportedly 'neutral' stance, the redefinition of the self-image and blending of boundaries between personal experiences and the suffering of the Nazis' victims – are all discernible in Stuart's post-war novels *The Pillar of Cloud*, *Redemption*, *Victors and Vanquished* and *Black List, Section H*. His portrayal in these novels of foreign couples in Germany brought together by the war is predicated on a mystically sublimated vision of shared suffering which supports an abstract interpretation of concrete historical events, encourages an undifferentiated notion of victimhood, fails to adequately contextualize their stories, and expunges traces of personal implication in National Socialist policies. Indeed, these couples' misguided search for healing or for a foundation myth in the rubble of the destroyed Reich resembles the approach adopted by some of Stuart's German contemporaries of sanitizing the past 'in the interest of re-forming an "imaginative community"'.[18]

At the same time, Stuart's works are part of a process of mnemonic and narra-tive readjustments in the vein of historization, originating in his diaries after the war which he progressively reshaped for an audience at home. Thus, the documentary account 'Extracts from the Journal of an Apatriate', written after he moved to Paris in 1949 and published in the Irish journal *Envoy* in 1950,[19] is not a faithful reproduction of the actual diary notes from his ill-fated trip to the French capital in August 1945, and it is the thrust and atmosphere of the novels he had completed in the intervening years, far more than his original diary entries, which inform this 'Journal'. Stuart later used a slightly varied version of these diary notes to chronicle his protagonist's journey to Paris at the close of *Victors and Vanquished*, and he also backed up the documentary style of *Black List* by including suitably edited quotations from his 1942 diary, in a bid to authenticate the protagonist's sympathies for the Soviet Union during the war.[20]

In the wake of his growing popularity after the publication of this work, Stuart went one step further in moulding his image when he released 'Extracts from a Berlin Diary Kept Intermittently between 1940 and 1944' for the benefit of *Irish Times* readers.[21] This selection included seven 'remembered' diary entries from the first two years of the war for which the source texts no longer exist, Stuart claiming to have destroyed them in late 1942, following the visit of two officers from the Geheime Staatspolizei (Gestapo) to his home after the German resistance group Rote Kapelle was exposed. Stuart's portrayal of the two resisters Libertas and Harro Schulze-Boysen – who he met at a party in 1941 according to

18 H. Schmitz, 'Introduction: The Return of Wartime Suffering in Contemporary German Memory Culture, Literature and Film' in H. Schmitz (ed.), *A Nation of Victims?*, pp 1–30 at p. 13. 19 Stuart, 'Extracts from the Journal of an Apatriate', *Envoy*, 3:12 (1950), 57–66. These extracts were later included in Stuart, *States of Mind: Selected Short Prose, 1936–1983* (Dublin, 1984). 20 Stuart, *Black List, Section H* (Carbondale, 1971), pp 369f. 21 Stuart, *Irish Times*, 29 Jan. 1976.

a 'remembered' diary entry – as his friends did not fail to be misunderstood by some as a form of vindication by acquaintance.[22] Yet his attempt to align himself with these dead German resisters is tainted by his ill-informed claim that his alleged friends were members of a pro-Russian espionage network – a statement that unwittingly perpetuates the convenient allegation fabricated by the Gestapo to destroy what were, in fact, separate groups in different countries, driven by very different political and religious motivations.[23] Moreover, his explanation for the missing diaries covering 1940 and 1941 seems doubtful, not least in light of the fact that he was still in possession of these notes over a month after the Schulze-Boysens had been arrested, as he quotes on 8 October 1942 from an entry he had written on 28 September 1941. After the war, on 19 March 1947, he recorded in his diary that his German agent in Berlin had just returned to him his diaries, which he had left with him for safe-keeping in September 1944, and that he was enjoying reading 'the strange tale of [his] own development'; there is no indication that this tale was missing two full years. However, in 1971 Stuart notified Natterstad of a diary notebook from spring 1942 which he was going to send to Kenneth Duckett – the librarian at the University of Southern Illinois in Carbondale who acquired some of Stuart's papers (though not the diaries) following the publication of *Black List* by the local university press – and mentioned that 'some missing pages contained comments which a little later, when my own situation was somewhat precarious, made me destroy them'.[24] By January 1976, when Stuart published his 'Extracts' in the *Irish Times*, he specified that he destroyed 'some of these notebooks' after the arrest of the Schulze-Boysens, and in June that year, he added in interview with Robert Fisk that the Gestapo found his phone number in a notebook belonging to the German couple. They 'turned up at his flat one morning to question him about the couple but they left satisfied that he knew nothing about the *Rote Kapelle*'.[25] His biographer Geoffrey Elborn likewise writes that Stuart's phone number was found in this manner, but maintains that the Gestapo officers' visit took place 'early in 1942', and that the policemen only spoke to the doorkeeper as Stuart was out.[26] Kevin Kiely, finally, speculates (probably encouraged by his interview partner Stuart) that the Schulze-Boysens may have surrendered Stuart's name

22 A. Cronin, 'Stuart an Innocent Abroad', *Sunday Independent*, 30 Nov. 1997, and 'Healing the Wounds of Francis Stuart', *Sunday Independent*, 27 June 1999. Stuart's actual diary entry for 1 Sept. 1947 suggests he had hardly ever thought of the Schulze-Boysens in the years since meeting them at that party. **23** See Jürgen Danyel, 'Die Rote Kapelle innerhalb der deutschen Widerstandsbewegung' in Hans Coppi et al. (eds), *Die Rote Kapelle im Widerstand gegen den Nationalsozialismus* (Berlin, 1994), pp 12–38. The defamation of this resistance group as 'a Soviet Secret Service group' continued during the Cold War and, in biographies of Stuart, even beyond (Geoffrey Elborn, *Francis Stuart: A Life* (Dublin, 1990), p. 140 and Kiely, *Francis Stuart*, p. 143). **24** Stuart, letter from 10 May 1971, reproduced in J.H. Natterstad, 'A Francis Stuart Number', *Journal of Irish Literature*, 5 (1976), 105f at 106. **25** Robert Fisk, *In Time of War: Ireland, Ulster and the Price of Neutrality, 1939–45* [1983] (Dublin, 1985), p. 405. **26** Elborn, *Francis Stuart*, p. 144.

under torture, and reports that Stuart 'had taken the precaution of removing any diary entries that referred to members of the Rote Kapelle' already prior to the visit by the Gestapo.[27]

Yet how exactly would Stuart have been able to satisfy the Gestapo that he knew nothing about a resistance network whose portmanteau name was invented by the Gestapo itself? If he did not even know of the existence of a resistance group that included people he had met once at a party, how could he have had the foresight to remove diary entries that referred to this group's members? What good would a Gestapo visit in early 1942 have been, given that Harro Schulze-Boysen was arrested on 31 August 1942, and his wife, Libertas, on 8 September, leaving her ample time to destroy records of contact details before her arrest, which she did?[28] Is the author's claim of having destroyed his diaries for the years 1940–41 out of *fear* of the German authorities not called into question by the fact that, in the same 'Extracts', he added several new sentences to his entries for 2 and 4 May 1944 which impress upon his readers his very fearlessness in the face of these same authorities pressuring him.[29] Most importantly, however, why did Stuart make no connection at all to an earlier threatening Gestapo visit when he noted in his diary on 1 September 1947 that he had found out, 'for the first time', about the Schulze-Boysens' arrest and execution in a German magazine the previous day? These contradictions – and the uncanny coincidence with which these new biographical details also enrich the sentimental beginning of his next novel, *The High Consistory* (1981) – went unnoticed, encouraging Stuart to include even more heavily edited and expanded versions of his diary entries in the prose collection *States of Mind* (1984).[30]

This process of shaping documentary evidence of the past to suit his needs in the present is revealing of how Stuart used hindsight expediently to both dramatize his protagonists' stories in his post-war fiction and to add a frisson to his own. That he would peg his emergence from the rubble of defeated Germany to the theme of 'suffering foreigners', however, is no small irony if we consider

27 Kiely, *Francis Stuart*, p. 143. 28 Johannes Tuchel, 'Die Gestapo-Sonderkommission "Rote Kapelle"' in Hans Coppi, *Die Rote Kapelle*, pp 145–59 at pp 148, 150. 29 Later, around the time of Richard von Weizsäcker's presidency in the Federal Republic, Stuart claimed that none other than the latter's father, State Secretary Ernst von Weizsäcker, had helped him retrieve his passport after it was briefly confiscated by police in May 1944 (Elborn, *Francis Stuart*, p. 165; O'Donoghue, *Hitler's Irish Voices*, p. 140). This claim seems doubtful in light of the fact that Ernst von Weizsäcker had left Berlin in June 1943 in order to serve as German Ambassador to the Vatican (Eckart Conze et al., *Das Amt und die Vergangenheit: Deutsche Diplomaten im Dritten Reich und in der Bundesrepublik* (Munich, 2010), p. 272). 30 The unreliability of Stuart's edited and 'remembered' diary entries is highlighted further by the fact that he changed the date of the entry for 'Early Summer, 1940', published in the *Irish Times* in 1976, to 'Late Summer, 1941' in *States of Mind* (p. 34). While he seized the opportunity in this entry to justify his complicity in a plan of smuggling weapons for the IRA to Ireland, he misled readers about the causality of events by misdating Russell's death and his first meeting with Ryan in Berlin by one year.

the view he held before the war, expressed in a letter to the editor of the *Irish Times* from 13 December 1938.[31] Stuart had been roused to write it by an appeal, launched in the same paper on 9 December, to help families and young men from Central Europe to emigrate by making available funds for their agricultural training in Ireland prior to their settlement in more distant parts of the world.[32] The Irish initiative appears to have been a direct response to the pogroms of Reichskristallnacht on 9 November that year, although the wording chosen by the organizing committee referred only to 'Christian' victims 'of whatever race or blood'.[33] Stuart objected to the vested interests he thought were behind this call for aid, berating those involved for shrewdly mounting a 'plan [...] to prove the humanitarianism of the democracies compared with certain countries where such an ideal does not prevail'.[34] Such a campaign 'on behalf of suffering foreigners' seemed hypocritical to him, and he suggested the do-gooders had better attend to problems closer to home. A second statement he wrote in response to other letters his had provoked makes it clear that Stuart was anything but the 'unprejudiced observer' he claimed to be:

> When democracy has found some solution to the pressing problems observable in the countries where it is practiced, which I would define as, among others: Unemployment, slums, the tyrany [sic] of money, and the appallingly low level of general culture, then let it sit in judgment on other forms of government. But, in my belief, our bureaucratic democracies can never of their nature find such a solution, being themselves largely responsible for these evils.[35]

Stuart's cynical suspicion of democracy thus seems to have limited his ability to observe critically its opposing ideology's effects in Germany just before, during, and after the war, leaving him trapped in preconceived ideas and counter-propaganda. 'Who could have suspected in 1939 that things would turn out the way they did?', he asked a *Time* magazine reporter in 1950, and his tone seems self-assured and defiant rather than fully understanding.[36]

Stuart's myopic political perspective was, of course, not unique. It can be

31 Barrington discovered this letter and discusses it in *The Wartime Broadcasts*, pp 26ff. 32 Such skills were a necessary precondition to meet the strict quota that governed eligibility for entry into British-protected Palestine or South American countries if the emigrant did not meet the first and most desirable criterion: being rich (see Arno Herzig, 'Jüdisches Leben in Deutschland, 1933–1945: Verdrängung und Vernichtung', *Informationen zur politischen Bildung*, 307 (2010), 51–61 at 55). 33 Anon., *Irish Times*, 9 Dec. 1938. 34 Stuart, *Irish Times*, 13 Dec. 1938. 35 Stuart, *Irish Times*, 19 Dec. 1938. Stuart renewed his attack on the 'democratic clap-trap' and proposed an ideological reorientation a year later, in an article that appeared in *The Young Observer* on 1 December 1939 ('Ireland a Democracy? The Real State of Affairs', scrapbook of articles and reviews, Francis Stuart Collection, University of Ulster, Coleraine). 36 Anon., 'Down with Duck Ponds', Review of *Redemption*, *Time*, 56:22 (27 Nov. 1950), 108.

traced in the approach the Irish government took to dealing with anti-Semitism and Jewish refugees, or in the boost some of Stuart's Irish compatriots later derived from interpreting neutrality as a superior moral stance of detachment from all war atrocities.[37] It is also discernible in the attitude of members of the 'propagandised intelligentsia', who, Adam Piette has shown in his study of British wartime literature, were prone to exhibit 'an ignorantly knowing "incredulity"' towards the crimes committed by the Nazis that 'deadened the essential "duty to know and to be haunted by your knowledge"'.[38] The effect was the same, rendering the individual immune to the suffering of the other, specifically the Jewish other. Stuart, who had visited German POW camps but refused to believe reports he heard of extermination camps, dismissing them as enemy propaganda,[39] continued throughout the war to slate those who had the clarity of vision to see where National Socialism was leading: Thomas Mann, who had incessantly warned about the danger which the regime Stuart had been flirting with posed to the world,[40] he dismissed as 'too much of a professional democrat'.[41] Even in old age, he insidiously set Samuel Beckett's risky involvement in the Resistance on a par with his own actions, claiming it was 'entirely convenient for the French to give a high decoration to a foreign *collaborator*, but I thought it was farcical'.[42] In the same interview, Stuart would still rage at the Allies' temerity in calling their warfare 'a Christian crusade',[43] in essence reiterating the very thrust of Nazi propaganda that detracted from Germany's crimes by denouncing the Allies for their hypocritical moral pretensions.[44]

37 R.M. Douglas lists several examples of the Office of the Controller of Censorship suppressing stories of anti-Semitic attacks in Ireland and abroad (*Architects of the Resurrection: Ailtirí na hAiséirghe and the Fascist 'New Order' in Ireland* (Manchester, 2009), pp 129f). Also see Clair Wills, *That Neutral Island: A Cultural History of Ireland during the Second World War* (London, 2007), pp 398–418. **38** A. Piette, *Imagination at War: British Fiction and Poetry, 1939–1945* (London, 1995), p. 197. Piette quotes from Arthur Koestler's response to a sceptical reader of *Horizon* who had doubted Koestler's report of the use of mobile gas chambers in Poland, published in the magazine in October 1943. **39** Elborn, *Francis Stuart*, p. 190. **40** Mann's monthly broadcasts for the BBC, recorded in his American exile, were published in 1945 as *Deutsche Hörer!* (*Listen, Germany!*). **41** Stuart, Diary June–Sept. 1944, 8 Aug. 1944. **42** Naim Attallah, *In Conversation with Naim Attallah* (London, 1998), p. 317, emphasis added. **43** Attallah, *In Conversation*, p. 314. Stuart made the same complaint in Bill Lazenbatt, 'A Conversation with Francis Stuart', *Writing Ulster*, 4 (1996), 1–18 at 7. His susceptibility to German propaganda is further evident in his lifelong belief that the former American diplomat John Cudahy was killed by British agents in Switzerland (this conjecture is repeated in *Black List*, p. 373, Elborn, *Francis Stuart*, p. 137, and in interview with Attallah, p. 315). In reality, Cudahy died following a riding accident on his farm near Milwaukee in September 1943 (Anon., *The Manchester Guardian*, 7 Sept. 1943), and not after the war, as Kiely states (*Francis Stuart*, p. 138). **44** Consider, for example, the sarcastically titled article '"Fair play" in Nordirland' in the German illustrated magazine *Die Woche* (3 May 1944), which accuses 'London police, various secret services, military police and [...] US military police and security personnel' (my translation) of a sweeping operation against Irish nationalists in Northern Ireland. Of course, the feigned moral outrage at these arrests flies in the face of the magazine's silence on the arrest and deportation of thousands of German and foreign citizens in the years since Hitler's election in 1933.

THE INABILITY TO MOURN

Stuart's portrayal of the couples who people the *The Pillar of Cloud*, *Redemption*, *Victors and Vanquished* and *Black List, Section H* as victims of the war was mirrored in his and Meissner's attempts after 1945 to dissociate themselves from their past and to position themselves at the right end of the perpetrator-victim binary. Both in his biography and in his fiction, the conflation of his subject position as self-styled outcast artist with the experiences of the historical other resulted in an insensitive interpretation of events that valorized the suffering inflicted by the war as an evolutionary step forward for a chosen few. Holocaust memory, by contrast, resists such harmonizing and spiritually uplifting interpretations, precisely because, as Dominick LaCapra warns, the indiscriminate 'desire for redemption and totality' blurs the necessary distinctions between past and present, self and other, and risks investing the catastrophe of the war with a 'displaced sacralization' and 'negative sublimity'.[45] The result – an arrested development, fixed in its facile foundation myth – can be seen in Stuart's post-war works, which remain trapped in a repetitive creative loop, recycling ideas the author conceived in relative peace during the war over and over.

After Stuart completed *Winter Song* in late 1941, following a period of emotional and creative stagnation, he believed that he had 'suffered through love sometimes all that [he] could bear'.[46] Suffering and stagnation both ended when Stuart accepted as his guiding 'truth' that 'passion is the touchstone for art (or emotion)',[47] a revelation that simultaneously served as his licence to discard one lover, Nora O'Mara (now Róisín Ní Mheara), and begin a new relationship with his German student and assistant, Gertrude Meissner.[48] From then on until the end of the war, Stuart had to content himself with studying suffering in theory, in the books he read and wrote, for, by his own admission, he led a 'strange life of ease and plenty'.[49] Repeatedly in his diaries, he congratulated himself on his good fortune during the war, expressing gratitude for having the time and means to attend to his 'own life and its needs', feeling that '[t]here will never have been a better time for a writer than after this war – for a writer with a new way of life

45 Dominick LaCapra, *Writing History, Writing Trauma* (Baltimore, 2001), pp 47, 23. 46 Stuart, Diary July – Oct. 1942, 11 Oct. 1942. Natterstad claims that Stuart later used parts of this novel, as well as elements of its sequel, *The Cave of Peace*, in *Redemption* (Natterstad, 'A Francis Stuart Number', 95, n.1). 47 Stuart, Diary July – Oct. 1942, 25 Sept. 1942. 48 Meissner appealed to Stuart because of her ability to act freely from the heart rather than the head, a quality he attributed to her being German (Stuart, Diary March – June 1942, 13 Apr. 1942). Her Kashubian father had opted for German nationality after the First World War (Elborn, *Francis Stuart*, p. 139), and her family seems to have undergone a process of complete acculturation, including adopting a German-sounding surname – her father's surname, as State Secretary Boland learned through a Polish priest in 1947, was originally Niedzialkowski, her mother's maiden name Majewska (see letter and additional notes from 2 Apr. 1947, DFA 10/A/72). Meissner changed her first name to Madeleine after she and Stuart moved to Paris (Elborn, *Francis Stuart*, p. 140). 49 Stuart, 'Berlin in the Rare 'Oul Times', *Irish Press*, 1 Sept. 1989.

to reveal [...] – after will be the time when there will be a few people eager to read something about eternal truth.'[50] Such 'eternal truth' was to be revealed in the works he planned to write about the 'new life', 'new woman', and 'new love', all based on his own experiences with Meissner.[51] It had little to do with his later claims that his presence in Germany was motivated by a desire to 'be at the heart of where things are most intense [to] report it [...] primarily for my own people'.[52] In fact, his self-centredness made him exceedingly reluctant to carry out the risky business of bearing witness. During the Allies' invasion of Normandy, for example, Stuart found it 'much much better' to stay at his desk in Berlin rather than report on events, as had had heard Hemingway and Saroyan were doing. Two months later, he specified his preferred subject and technique, neither of which relied on reality: 'Propaganda. Propaganda for one's own soul. That is what I write.'[53]

Such zeal was a powerful source of creative energy: Stuart recorded notes for several book projects in autumn 1944, and while imprisoned by the French authorities after the war, he sought help from the British military historian Sir Basil Liddell-Hart, explaining that his imprisonment was unjust not only because he had been 'deeply opposed to Nazism and State tyranny', but also because it meant an intolerable 'hold up in that work which I believe I could now do'.[54] At the same time, his zeal circumscribed the extent to which his works after the war were self-involved without being self-reflective, preventing him from engaging critically with the events he had lived through and from imagining the suffering other – female, foreign, Jewish or otherwise – outside stereotypical taxonomies. It ultimately explains Stuart's inability to realize his avowed ambition and unique opportunity to write about the war – in particular, '[w]ar as revealed in raids'[55] – as no other writer in English could, by virtue of having lived in the bombed-out German Reich.

Stuart's letter to Liddell-Hart shows that, in common with many Germans, he was eager to distance himself from National Socialism in every way possible. Silence on his own implication in the policies of the Nazi state, coupled with a tendency to attribute blame solely to the (mostly dead) political leaders and to resent the victors out of shame, were all common responses in post-war Germany, according to Alexander and Margarete Mitscherlich's landmark study of 1967, *Die Unfähigkeit zu trauern*.[56] The 'inability to mourn' affected an entire

50 Stuart, Diary June 1943 – May 1944, 15 May 1944. 51 See Stuart, Diary Aug. 1944 – June 1945, which contains plans for several works. 52 Carol Coulter, 'Stuart Rejects Charges of Anti-Semitism and Support for Hitler', *Irish Times*, 12 Jan. 1998. 53 Stuart, Diary June – Sept. 1944, 9 June, 11 Aug. 1944. Stuart crossed out the last sentence while editing his notes on 11 May 1945 and replaced it with 'After all the other propaganda.' 54 Quoted in Elborn, *Francis Stuart*, p. 189. 55 Stuart, Diary Aug. 1944 – June 1945, n.d. Dec. 1944. 56 Alexander and Margarete Mitscherlich, *Die Unfähigkeit zu trauern: Grundlagen kollektiven Verhaltens* [1967], (Munich, 2007), p. 36. Their work appeared in English as *The Inability to Mourn: Principles of Collective Behavior*, trans. Beverley R. Placzek (New York, 1975).

generation which resisted working through the past and admitting personal responsibility, having numbed their empathy with the other before the war and systematically ignored, denied or misrepresented to themselves reality in Nazi Germany. The resulting deadlock can be traced in post-war German literature, as W.G. Sebald highlighted in his 1997 Zurich lectures. In these, Sebald tried to understand how those who witnessed the large-scale destruction of German cities could remain so blind to the horrors around them. He especially condemned writers who sought to derive meaning from the war by proclaiming a new beginning for those survivors willing to accept the respective author's brand of 'truth':

> If this idea of an elite operating outside and above the state as the guardian of secret knowledge reemerges, even though it had so utterly discredited itself in social practice, and if it does so in order to enlighten those who barely escaped total destruction with their lives about the presumed metaphysical meaning of their experience, we are looking at evidence of a profound ideological inflexibility for which only a steadfast gaze bent on reality can compensate.[57]

Stuart's inability to mourn what he could not admit as well as his subordination of the war and its victims to his cult of spiritual renewal spell out his own 'ideological inflexibility'. If he escaped a similar verdict and scrutiny as his German contemporaries in his lifetime, this may be due to the fact that he was trying to 'enlighten' an audience at a safe remove from the war; an audience which, Tóibín concluded in a review of his own attitude towards Stuart, was 'part of the legacy of Irish neutrality, and [...] [was] living in a sort of backwater, protected from the terrible pain and anger suffered by the families of those killed by the Nazis'.[58]

Stuart's failure to find a publisher for his first post-war novel, *The Pillar of Fire*, showed him how to adjust his account of his time in Nazi Germany in order to make it palatable to his target audience.[59] Although the manuscript does not survive, we can gauge from his diary notes that the book centred on his and Meissner's 'new life' of 'inner peace', enriched by 'all the incredible adventure that happened after' (that is, their imprisonment).[60] While this brief outline does not differ much from the premise on which *The Pillar of Cloud*,

57 W.G. Sebald, 'Air War and Literature: Zurich Lectures' in Sebald, *On the Natural History of Destruction: With Essays on Alfred Andersch, Jean Améry and Peter Weiss*, trans. Anthea Bell (New York, 2003), pp 50f. **58** Tóibín, 'Issues of Truth and Invention'. **59** See Stuart's comments on receiving rejection letters in Diary 1947, 29 June, 15 July, 6 Sept. 1947. **60** See Stuart, Diary Aug. 1944 – June 1945, [n.d.] Dec. 1944, where the author sketched out future plots and added successive annotations after the war.

Redemption, Victors and Vanquished or even parts of *Black List, Section H* are based, it seems to have been oblivious to its setting and time. As literary agent Curtis Brown complained, the problem was that 'the hero, although being in Germany during the war [...] had little feeling about the war and [was] on the contrary concerned with his own personal life!'[61] Stuart's reaction was defiant – 'If that is the main fault they can find then I am really glad to know it. My God, what incredible people!' – yet he would not only avoid setting another novel in Nazi Germany until *Victors and Vanquished*, but would also take care to propagate his concerns with inner growth through characters cast as clear victims of the war. This strategy ensured that his next books were all published, but the author's heavy-handed use of exterior markers to legitimize his hero and heroine as 'suffering foreigners' confirms the racialist and gender tenets of the regime in whose shadow they were conceived.

At the same time as Meissner was applying for Displaced Person status as a Polish refugee[62] and Stuart stopped calling her by her German nickname in his diaries, switching to the Slavonic 'Gruscha', he changed the name of his heroine in the manuscript of *The Pillar of Cloud* from the German-sounding 'Klara' to the French 'Céline'[63] to 'Halka Mayersky', half Polish, half French, endowed with a surname that closely resembles Meissner's mother's maiden name. And at the same time as Stuart was dismissing the legitimacy of the victors' justice in post-war Germany in his reaction to the trials of German war criminals – implicitly casting the vanquished supporters of the Nazi regime as victims[64] – he was creating a hero with Irish poet Dominic Malone whose collaboration during the war he imbued with subversive meaning. Dominic, although eager to be scapegoated on the general principle of suffering, insists that he had never, 'in any

61 Quoted in Stuart, Diary 1947, 7 Oct. 1947. **62** According to German law, a woman's nationality was based on 'derivative citizenship' and depended on her father's nationality or, if she was married, on her husband's (Miriam Rürup, 'Lives in Limbo: Statelessness after Two World Wars', *Bulletin of the German Historical Institute*, 49 (2011), 113–34 at 119). This law was revoked by the Allies following Germany's defeat, leaving Meissner, who had been born in Danzig, free to claim Displaced Person status in order to be able to leave Germany with Stuart. According to Gerard D. Cohen, Polish refugees were subject to a less rigorous investigation by UNRRA to achieve DP status, which in turn was tantamount to 'an international recognition of victimization' (*In War's Wake: Europe's Displaced Persons in the Postwar Order* (Oxford, 2011), p. 37). **63** These changes are noted in Stuart, Diary 1947, 26 June 1947. **64** Stuart, Diary 1947, 16 Aug. 1947. Stuart's comments about war criminals were probably a reaction to the release that month of the list of defendants who were to be prosecuted for war crimes in November. The list included senior staff of the German Foreign Office, Stuart's former employer, among them Secretary of State Ernst von Weizsäcker and the Head of the Political Department, Under Secretary of State Ernst Woermann. Both were found guilty of crimes against peace (starting a war of aggression) and crimes against humanity (see Conze et al., *Das Amt*, pp 389, 392). In interviews years later, Stuart claimed a chummy affiliation with von Weizsäcker (Carter, *The Shamrock*, p. 108; Kiely, *Francis Stuart*, p. 130), but official records of the German Foreign Office indicate that Stuart actually only met Woermann on arrival in Germany (Horst Dickel, *Die deutsche Außenpolitik und die irische Frage von 1932–1944* (Wiesbaden, 1983), p. 106, Andreas Roth, 'Francis Stuart's Broadcasts from Germany, 1942–4: Some New Evidence', *Irish Historical Studies*, 32:127 (2001), 408–22 at 411).

way, in thought or deed, sided with the captors against the captives, with the executioners against the victims'.[65] He was even imprisoned briefly in a German camp, thereby fulfilling the wishful thinking expressed by Irish diplomats when Stuart arrived at the Irish Legation in Paris in August 1945. The latter's unhindered travel had raised hopes that he had possibly 'rehabilitated himself' in the eyes of the Allies by having been interned towards the end of the war by the Germans,[66] and although the author could not oblige with such a 'happy ending', he added this detail to the biographies of his Irish heroes in *The Pillar of Cloud*, *Redemption* and *Victors and Vanquished*. Halka Mayersky's war experience is painted in equally broad brush strokes: she prostitutes herself when her parents die in order to obtain food for herself and her sickly little sister, Lisette; she hides a Jew during the war, but, somewhat improbably, spends only a few months in a concentration camp when found out; in a needless plot intensification that establishes an incongruous hierarchy of suffering, she is later committed to an asylum and subjected to electroshock therapy. And yet despite these experiences, Halka rejects the idea that one of her former tormentors – a concentration camp warder whose whip left scars between her breasts which Dominic reveres like stigmata – should be duly prosecuted by the French Allies. The perverse eroticization of her pain in Stuart's novel reaches its nadir when Halka has sex with Dominic in the same prison cell in which the accused warder awaits trial. Her engagement with her war trauma is diminished to an act of purported sexual liberation, after which she proclaims she will forgive the Nazi rather than testify against him.[67] What makes the undifferentiated forgiveness advocated in the novel doubly problematic is the insidious way in which it competes with, and displaces, the trauma of Jewish victims. Prior to finding out that the witness summoned against the ex-concentration camp warder was Halka, Dominic assumed that the witness was a Jew and reassured his cell mate that '[t]hey won't condemn you on the evidence of the Jew alone.'[68] His reaction shows not only suspicion of, and disrespect towards, specifically Jewish suffering, but also its subordination within Stuart's Christian-inspired code of suffering.

Margareta, the heroine of *Redemption*, is a less glowing incarnation of Halka: a frumpy Eastern European washed up in Berlin during the war, she is buried under the rubble of a building that collapsed in an air raid and presumed dead by her Irish lover, Ezra Arrigho. He returns to Ireland unscathed where he nevertheless lectures to a gullible small-town audience that he 'hadn't completely escaped it', having spent 'some months locked away with the others'[69] – 'it' and 'the others' standing in for the unspecified violence perpetrated against an unspecified group by an impersonal 'great machine'[70] of war. His time in

65 Stuart, *The Pillar of Cloud* [1948] (Dublin, 1994), p. 46. **66** See letter from Boland to Paris Legation, 16 Aug. 1945, and transcript of negative reply, 28 Aug. 1945, DFA 10/A/72. **67** Stuart, *The Pillar of Cloud*, p. 222. **68** Ibid., p. 214. **69** Stuart, *Redemption* (London, 1949), p. 52. **70** Ibid., p. 53.

Germany seems to qualify Ezra to sneer at the sheltered lives of others and, rather than having come to appreciate the vulnerability of life and precious integrity of the other, to welcome their wanton destruction. Thus, he condones the murder of the servant Annie Lee by the fishmonger Kavanagh as an act of passion, and he justifies his own loveless defloration of the priest's young sister, Romilly, as her necessary rite of passage out of complacency. However, the very fact that her degradation and rape – and Annie's rape and murder – are plot twists needed purely to generate a small following for Ezra's spurious spiritual fraternity is symptomatic of the instrumentalization of the female as 'other' in Stuart's novels.

The ideal Stuart upheld in these post-war works is 'communion' between his male and female characters, a state of oneness that at once redeems the male and fades out the specificities of history and victimhood in the glare of woman's 'unfathomable innocence that was on the earth to set over against the monstrous evil'.[71] With that, her pain is absorbed by the protagonist, and questions of causality and guilt become obstacles in the way of spiritual healing. Historical experience is cancelled out by unreal aspirations to innocence, and love is transmuted into a shield against the outside world by egoistic, rather than inspirational, couples. The heroine's ability to forgive anything glosses over the rift between victims and perpetrators and implicitly absolves the hero from any complicity or responsibility for his actions or inaction. In *Redemption*, for example, the specifics of the war and its aftermath are figuratively committed to oblivion in the cleansing Margareta undergoes at the hands of Ezra. In the act of first washing his lover's feet, then carefully 'laving' her entire body, he absorbs not only her traumatic experiences, but also puts an end to the need to remember them. 'All that is over', Ezra tells Margareta as she tries to share with him the details of the price she had to pay to join him in Ireland.[72] While there is tenderness in this act, allowing the couple to overcome their social isolation, the blind insistence on forgiving and forgetting all (including what is not for them to forgive) overwrites the need to engage with the more important issue of 'moral isolation' which Stuart experienced so strongly in post-war Germany, once the atrocities of the Nazis were revealed to the world.[73]

A look at the one story Stuart dedicated to the experience of air raids, 'The Destroying Angel', published in *Envoy* in 1950,[74] shows that here, too, he proved chiefly concerned with moulding his audience's perceptions to suit his needs. As a result, it becomes more important for the narrator Louis to invite the cleansing 'wind of destruction' to reign freely 'as long as we and a few others are at the same time being kindled to intenser life'[75] than to write about the bombard-

71 Stuart, *The Pillar of Cloud*, p. 223. 72 Stuart, *Redemption*, pp 206f. 73 Stuart, Diary Feb. – Sept. 1950, 18 May 1950. 74 Stuart, 'The Destroying Angel', *Envoy*, 2:1 (1950), 12–20. This story was reprinted in *States of Mind*, pp 46–52. 75 Stuart, *States of Mind*, p. 51.

ments and the war outside pre-established biblical references or empty formulations such as 'the explosive fury of the machine outside them'.[76] Lingering on the sight of the dead in the street after the raid is declared 'shameless', a violation of the bodies, and so seems to be the act of writing about death.[77] The actual trauma of large-scale destruction – of homelessness, decay, stench, horrifying images and sounds, madness and irrational behaviour among civilians in the wake of such attacks – is neatly contained in an equivocal narrative of passive, stoic survival. In effect, Stuart proves as incapable of spelling out and bearing witness to the experience of these air raids as his English[78] or German contemporaries, who, Sebald argues, 'did not try to provide a clearer understanding of the extraordinary faculty for self-anaesthesia shown by a community that seemed to have emerged from a war of annihilation without any signs of psychological impairment'.[79] What remains suppressed in this story, as well as in novels like *The Pillar of Cloud* and *Redemption*, then, is the suffering of the same other that stood at the threshold of Stuart's departure for Germany.

CONCLUSION

Stuart's preconceptions were not overhauled by his experiences during the war; his reliance on limiting taxonomies in his representations of the other, on one hand, was matched, on the other, by the continued self-conscious shaping of his own image. His return to the setting of wartime Germany in *Victors and Vanquished* and *Black List, Section H* only spawned new variations on the theme of 'suffering foreigners', albeit this time emphasizing the protagonist's role as witness to important historical events. Started in November 1955, *Victors and Vanquished* is more than a redrafted version of *The Pillar of Fire*, as Anne McCartney maintains.[80] In contrast to the earlier novel, Stuart responded to the need to adjust his representation of his experiences and actions by acknowledging the persecution of Jews and dissidents in Nazi Germany. However, *Victors and Vanquished* is suffused with what Piette calls 'Jew-consciousness'[81] – the attempt to rise above the racialist thrust of anti-Semitic ideology only to nurture the anti-Semitic lie of difference by confirming every stereotype in reverse. Myra Kaminski, the German-Jewish nurse whom Irish writer Luke Cassidy falls in love with and rescues from Berlin, is hence as much a victim of the war as she is a victim of Stuart's nauseatingly philo-Semitic racial kitsch. Although Luke cannot

76 Ibid., p. 47. 77 Ibid., p. 50. 78 As Piette explains, the blitz myth in Britain promoted 'a generalised story of fire-fighting, underground existence and communal effort', effectively dispelling any description of how individuals actually experienced the air raids, providing them instead with a convenient way of expressing the inexpressible (*Imagination at War*, pp 71ff). 79 Sebald, 'Air War', p. 11. 80 McCartney, *Francis Stuart*, pp 10, 153. 81 Piette, *Imagination at War*, p. 195. Piette bases this formulation on Raymond Postgate's *Verdict of Twelve*, published in 1940.

save Myra's father Isaak, Stuart makes sure that, long before the old professor is deported to Auschwitz, he absolves the perpetrators and bystanders of the Holocaust, declaring the Nazi persecution a chastisement wrought by 'a jealous God' on his chosen people that will allow him to 'melt them again and remould them into receptacles of His Word'.[82] Attributing such an interpretation of the war to a Jewish victim allows the author to present Luke as guileless Gentile, submitting to a higher wisdom in considering these extreme events the foundation of a new beginning for himself and Myra. This strategy is particularly disturbing when Stuart buttresses Luke's cynical suspicion of the Allies and their motives (essentially his own suspicion, as has been shown in the above) by having Isaak condemn 'the moral indignation over the persecution of the Jews' in the British papers as 'the most dangerous frame of mind'.[83]

Whereas *Victors and Vanquished* fell short of Stuart's hopes that this book would be the best he had yet written – he took great care to cross out all statements to this effect in his diary after the novel's publication – the sober documentary style of *Black List, Section H* better matched the expectations of an audience receptive to witness accounts of the war. Affecting a suitable, dispassionate tone in this work cost Stuart considerable effort, but his third, successful draft convinced Timothy O'Keeffe, who had rejected an earlier version, that the narrative 'ha[d] been progressively demythologised over the years so that it now reads much more like straightforward autobiography'.[84] Stuart deliberately conceived this work between two genres, autobiography and fiction, which encouraged many to see in it a '[w]itness-novel or thinly fictionalised memoir'.[85] Crucially, however, the witness wants to be believed, and Stuart's regular quoting from *Black List* as if it were his catechism whenever asked about his time in Germany suggests that he himself believed and no longer intended to leave it up to the reader to decide into which category his work fell. Once again, however, his conflation of H's search for meaning and individuation, which leads him to Nazi Germany, with the historical losses suffered by the victims of the Nazi regime proves incapable of a self-critical assessment of events and blind to the suffering other.

How little the annihilation of millions during the war lends itself to Stuart's portrayal of it as foundational is epitomized in Denis Johnston's diary entry on his arrival at Buchenwald concentration camp near Weimar, two days after its liberation. The extract was published in *The Bell* in 1950, a few issues after Stuart's accounts of his friendship with Frank Ryan appeared.[86] Johnston's break-

82 Stuart, *Victors and Vanquished* (London, 1958), pp 192ff. **83** Ibid., p. 272. **84** O'Keeffe, 'A Survivor'. **85** Eileen Battersby, 'Entering the Lists', *Irish Times*, 3 June 1995. **86** Stuart, 'Frank Ryan in Germany', *The Bell*, 16:2 (1950), 37–42 and 'Frank Ryan in Germany: Part II', *The Bell*, 16:3 (1950), 38–40. Despite having written these fond recollections, Stuart denied he and Ryan had been friends when interviewed by O'Donoghue decades later, on 17 November 1989, reporting Ryan's alleged faith in Nazi

down at the end, after realizing where his 'thirst for fairness and justice' as a 'neutral' reporter for the BBC had led him, does not end with his rise from the scene of horror to hail the new life that will come from it. Rather, he lets the indelible consequences, the limits of the experience, sink ever deeper into him:

> Oh Christ! We are betrayed. I have done my best to keep sane, but there is no answer to this, except bloody destruction [...] we must break the double gates in pieces and fling down the walls, and whoever tries to stop us, be he guilty or innocent, must be swept aside. And if nothing remains but the stench of evil in ourselves, that cannot be helped![87]

The hands on the dial of the clock above the gates at Buchenwald may be stopped permanently at 3.15 p.m., the time the camp was liberated by the US Army on 11 April 1945, but Johnston's reaction reminds us that there is only one way to fight a complacent engagement with the Second World War and Holocaust: it is that of 'democratic pedagogy',[88] or enlightenment of the individual, which rejects forgetfulness, formulaic accounts, or harmonizing tendencies in our approach to these events. Stuart's own stance was diametrically opposed and, no doubt, he would have baulked at the very term. Resisting the notion that his works should be subjected to critical analysis,[89] he tried to impose his own definitive word on the silence he had thrown in the balance between past and present at the end of *The Pillar of Cloud*, *Redemption*, *Victors and Vanquished* and *Black List, Section H*. These works, however, are part of an ongoing dialogue on the interpretation of the past and its relation to Irish cultural memory, a dialogue that requires the participation of informed readers and critics.

victory and pitting against it his own rejection of such an outcome (*Hitler's Irish Voices*, p. 51). In fact, Stuart had still placed his trust in rumours of the German *Wunderwaffe* ('wonder-weapon') in a diary entry written three days after Ryan's funeral, on 18 July 1944. In the same entry, he expressed gratification at the news of German air raids on the south of England. **87** Denis Johnston, 'Buchenwald', *The Bell*, 16:6 (1950), 30–41 at 41. **88** Theodor W. Adorno, *Critical Models: Interventions and Catchwords*, trans. Henry W. Pickford (New York, 2005), p. 99. **89** Stuart complained in a letter to Natterstad that a 'purely literary (academic) critical approach [...] for such a writer as I am isn't much good' (letter from 7 Aug. 1973, reprinted in Natterstad, 'A Francis Stuart Number', 108).

Nine Rivers from Jordan: a lost masterpiece of reportage

MAURICE WALSH

Long after the publication of his book about his experiences as a BBC war correspondent, *Nine Rivers from Jordan,* Denis Johnston remained bitter about its critical reception. 'There were eccentrics who professed to like it very much, but the general attitude of the Intellectual Establishment was a significant, half-smiling silence. I was a playwright – not a book-writer, so the less said about it – at any rate in my presence – the better.'[1] Although his reaction was understandable, given that a book he spent eight years writing did not sell well and was the subject of perplexed and asinine commentary, this account of its failure is nonetheless an exaggeration. *Nine Rivers* was hardly treated with indulgent silence. In London, after it appeared in November 1953, it was reviewed in the *Observer*, the *Daily Telegraph* and by Elizabeth Bowen in *Tatler*.[2] Two years later, the American edition, published by Atlantic/Little Brown, attracted two separate notices in the *New York Times*.[3] And contrary to Johnston's recollection, reviewers did not advise that Johnston stick to plays instead of books. Many praised the writing: 'imaginative', 'muscular' and 'sensual' were some of the epithets applied to Johnston's prose. In the *New York Times Sunday Book Review*, Herbert Mitgang (who had served as an intelligence officer and journalist with American forces in Europe) hailed it as 'one of the best *written* war books.'[4]

So how do we explain Johnston's pique? The problem was not that some eccentrics liked it very much, but that even those who liked it found it eccentric. In the *Telegraph*, Guy Ramsey suggested it was 'almost – a major work', but felt that it had been weakened by overweening Joycean influences and 'its

1 Bernard Adams, *Denis Johnston: A Life* (Dublin, 2002), p. 309. 2 Robert Kee, 'What War Is Like', *The Observer*, 29 Nov. 1953; Guy Ramsey, 'Quest Without Conclusion', Review of *Nine Rivers from Jordan* by Denis Johnston, *The Golden Echo* by David Garnett and *Hatred, Ridicule and Contempt*, by Joseph Dean, *Daily Telegraph*, 20 Nov. 1953; Elizabeth Bowen, 'One Man's Verdict on War', *Tatler*, 20 Jan. 1954, 108. 3 Herbert Mitgang, 'The Long and the Short and the Tall', *New York Times Sunday Book Review*, 21 Aug. 1955; Orville Prescott, 'Books of The Times', *New York Times*, 17 Aug. 1955. 4 Mitgang, 'The Long and the Short and the Tall'.

pretentious and formless form'. In the *Observer*, Robert Kee, another war veteran and journalist, complained that Johnston's philosophizing 'is particularly irritating [...] because the straightforward part of the book is extremely good.' And in the second review in the *New York Times*, Orville Prescott despaired that 'so much prolix verbal self-dramatisation and so much nonsense' had swamped what was good in *Nine Rivers*. Johnston's 'sharp, sensual humorous reporting' was obscured in 'a fog of pretentious neo-Joycean, neo-Eliotan, neo-Biblical rhetoric'.[5] Even more telling than the reviews is a letter Johnston received from a man called Joe Dine, a partner in a New York public relations firm who recalled meeting the BBC correspondent during the war, probably when he was an American military press briefing officer: 'I've just finished your book and I must say I enjoyed it tremendously. Not being a philosopher, I wasn't as shocked as you were to find out the Germans were rotten bastards. Some time maybe we can talk about it.'[6]

Much of this reaction had been foreseen by those who read the book in manuscript, when it consisted of over 900 pages crafted from the diaries, notebooks, letters and radio scripts Johnston wrote between 1942 and 1945, incorporating extracts from military promulgations, cable dispatches and newspaper headlines. Harry Craig, who edited the draft for Johnston's British publisher Verschoyle, admired its 'integrity, vitality, scope [and] enterprise', but he 'combed' 40,000 words from the text, commenting:

> In general, the philosophising passages are weak. Denis, as he says himself, is not a thinker, and anyone with the meanest knowledge of philosophy would surely find them boring and a bit schoolboy. One must make a distinction, however, between the philosophising and the wonderful – the wonderful – statements of feeling and impression.[7]

Editors at Atlantic agreed, suggesting that it would be a good idea to 'cut or prune the musings on God and theology'.[8] This kind of advice was not welcomed by the author. Johnston saw no reason, as he told an agent in New York trying to place it with an American publisher, that people who did not want to read his book 'should be invited to say that they can't make head or tail of it.'[9] In order that it might find readers prepared to brave its complexity, unhindered by the commercial judgments of publishers, he deposited the original manuscript, a mass of typescript sheets entitled 'Dionysia', at the British Museum.

5 Orville Prescott, 'Books of The Times'. 6 Joe Dine to Denis Johnston, 16 Sept. 1955, Denis Johnston Papers, Trinity College Dublin, MS 10066/28–29. Subsequent references to 'Johnston Papers' are to the collection held in Trinity College. 7 Harry Craig to Derek Verschoyle, 16 June 1952, Johnston Papers, MS 10066/28–29. 8 Johnston Papers, MS 10066/28–29. 9 Denis Johnston to American agent, 16 Apr. 1954, Johnston Papers, MS 10066/28–29.

We can admire the author's stubborn devotion to the integrity of his work and his determination that it be read on its own terms and, at the same time, lament that it has exacted an unfair cost to the long-term reputation of an exemplary memoir. It is precisely those elements of the book which contemporary reviewers identified as flawed or baffling which have claimed centre stage in critical reappraisals over the past fifty years, with *Nine Rivers* often read as an interlude in Johnston's career as a playwright. The structure of the book as a quest, in which the actual crossing of nine rivers during Johnston's pursuit of the Allied campaign is cast as stages in a spiritual autobiography, its Homeric and Joycean mythic overtones, classical allusions and the treatment of religious and philosophical themes through allegory, liturgy and dramatic dialogue are what makes *Nine Rivers* worthy of attention. And perhaps, in addition, it is useful to explore the text as a source for a play and a libretto written long afterwards. In his book-length study of Johnston's work, Gene A. Barnett explicitly sets out this rationale for including a chapter on *Nine Rivers* and other critics have, more or less, concurred.[10] Terry Boyle, who concludes that Johnston's sentimental attachment to 'man's innate sense of goodness' and his trivial fantasy of war as a chivalrous sport leads him to a wilful evasion of the implications of the Nazi concentration camps, reads *Nine Rivers* almost as a philosophical treatise untethered from its context.[11] The problem is not whether these arguments have merit in themselves, but that the terms of the critical discussion of Johnston's war memoir have obscured its enduring literary value by neglecting its portrayal of the war.

Once again, Johnston's own gloomy assessment of the book's lack of success is an unreliable guide to the full spectrum of contemporary opinion, for the reviewers who were unimpressed by the philosophizing were unanimous in their praise of the depth of Johnston's achievement as a reporter. Robert Kee contrasted *Nine Rivers* favourably to the poor standard of narration and observation in other books about the Second World War. 'Anyone who was under eighteen when the war ended, who wanted to get the real flavour of what the war was like for the fighting man, could hardly do better than browse – with some skipping – through *Nine Rivers from Jordan*.'[12] In an unlikely American review in the *Army Combat Forces Journal*, pasted in a scrapbook among Johnston's papers in Trinity College, Major Orville C. Shirey wrote that 'Mr Johnston has written a book that shows more of war and goes deeper toward the root of it than a lot of the punditry you'll find around these days [...] Any soldier will recognize that

10 Gene A. Barnett, *Denis Johnston* (Boston, 1978), p. 106. See also Shirley Neuman, 'Autobiography, Epistemology and the Irish Tradition: The Example of Denis Johnston', *Prose Studies: History, Theory, Criticism*, 8:2 (1985), 118–38. 11 Terry Boyle, 'Denis Johnston: Neutrality and Buchenwald' in Kathleen Devine (ed.), *Modern Irish Writers and the Wars* (Gerrard's Cross, 1999), p. 218. 12 Kee, 'What War Is Like'.

this is a book about War with a capital W and not about any particular war, even though its battles are those of World War II.'[13] And it was this dimension of *Nine Rivers* that Bowen recognized in her review in the *Tatler*. Praising Johnston's 'brilliant *reportage*', she suggested the book had achieved the status of literature because 'the author has put what was contemporary material to what is a contemporary use – he is writing not about a war (however worldwide) but about War, and his treatment is at once imaginative and philosophic.'[14]

Very little effort has been made to investigate what these reviewers found so compelling about Johnston's unwieldy book. One reason why *Nine Rivers* is something of a lost text is that later critics have been reluctant to regard it as a work of literature, or have written off its more literary effects as flawed or unsuccessful. At the beginning of the twentieth century the boundaries between literature and journalism were less clear-cut, but gradually the novel was elevated as an aesthetic form and journalism reduced to a secondary status, valued only as timely information.[15] Although Johnston's reportage delivers aesthetic pleasure as well as insight and writing that plays with tone as much as it conveys information, it is often deemed unworthy of analysis. Even Barnett, who acknowledges the 'reporting of a high order' and believes that the book succeeds in describing the war, repeatedly refers to its narrative strategy as 'simple' or 'straightforward.'[16] And, perhaps unintentionally, he does Johnston's work even more disservice when he suggests that, compared to conventional histories and military memoirs, *Nine Rivers* may have little value.[17]

When Johnston complained about not being recognized as a 'book writer', it was significant that he avoided specifying what kind of a book he had written. Works of reportage that achieve the status of literature are often unclassifiable, and Bowen's judgment on *Nine Rivers* presaged John le Carré's verdict on *Dispatches*, Michael Herr's account of his experience as a reporter in the Vietnam War: 'The best book I have ever read on men and war in our time.'[18] The two books have much in common. Like Johnston, Herr reworked his notes and drafts for many years after his war experience to create a fragmented narrative of an autobiographical journey from naivety to knowledge. The war as an experience rather than a political or moral crusade is central to both treatments, as are questions of form and style. 'If somebody were to ask me what it was about', Herr told an interviewer, 'I would say that the secret subject of *Dispatches* was not Vietnam, but that it was a book about writing a book.'[19] More specifically,

13 Major Orville C. Shirey, 'Memorable Book on War', *The Army Combat Forces Journal*, November 1955, p. 68. **14** Bowen, 'One Man's Verdict', 108. **15** For an extended argument on the exclusion of journalism from 'literature' see Phyllis Frus, *The Politics and Poetics of Journalistic Narrative* (Cambridge, 1994). **16** Barnett, *Denis Johnston*, pp 109f, 116, 124. **17** Ibid., p. 124. **18** Blurb on cover of Michael Herr, *Dispatches* (London, 1978). **19** Eric James Schroeder, *Vietnam: We've All Been There: Interviews with American Writers* (Westport, CT, 1992), p 34.

Nine Rivers and *Dispatches* are attempts to write an account that will fill the appalling gap between propaganda and reality. Far from offering a solution, journalism is itself implicated so that Herr's somewhat disingenuous protest, 'I don't have a journalist's instincts and have absolutely no training or discipline as a journalist', becomes his strength rather than a weakness.[20]

Like Herr, Johnston set himself at an angle to the job he was sent to do. 'I have really no idea why the BBC ever made me a war correspondent', he would say later. Much attention has been devoted to his protestation that 'I was technically a neutral', so that the source both of his sense of detachment from the BBC and his resistance to taking sides in the war has been attributed to his Irish nationality. His position has thus been implicated in debates about the morality of de Valera's determination to keep Ireland at a remove from the conflict. Of equal – if not more – significance, but scarcely noticed, is his emphatic declaration: 'I had nothing to do with the news division [...] I was not a journalist.'[21] His unfamiliarity with the skills and routines of journalism is often rendered in *Nine Rivers* as a self-deprecating lack of confidence in his own professional competence in the field, but is expressed more often as distrust or disdain for the conventions of what he discovered to be 'a centrifugal profession', defined by intense competition between colleagues rather than the collegiality he found when he practised law or worked in the theatre. Individual journalists were amusing – an important trait in Johnston's estimation – but as a herd their shop talk was 'spoilt by an unusually high percentage of what the Army knows as Bullshit [...] that mixture of Idle Boast, of Empty Promise, and of Windy Talk that forms the greater part of our conversation.'[22] He steered clear of this myth-making, refusing to pay tributes to correspondents killed in the press and on air 'because it draws distinction between the death of a Correspondent and the death of any other poor blighter who gets killed in this dirty business [...] when the sounding-board of publicity is made use of in such a way, what is really meant is: Look at the hazards that we are going through. It might have been Us!'[23] Towards the end of the war, Johnston is presented with an opportunity to be the first correspondent travelling with the Allied forces to cross the Rhine, when he happens upon a bridge built by American troops. Given the opportunity to walk across, put a foot on the other side and come back with a 'pompous by-line', he rejects this 'dubious piece of self-gratification' on the grounds that 'Christ, isn't it better to be grown-up than to be the first.'[24]

Choosing not to behave like a character from Evelyn Waugh's novel *Scoop* is not the solution to his difficulties of being a war correspondent. *Nine Rivers* is

20 Eric James Schroeder, *Vietnam*, p. 33. **21** Quoted in Rory Johnston (ed.), *Orders and Desecrations: The Life of the Playwright Denis Johnston* (Dublin, 1992), p. 119. For discussions of Johnston's neutrality see Boyle, 'Neutrality and Buchenwald' and Barnett, *Denis Johnston*. **22** Johnston, *Nine Rivers*, pp 72f. **23** Ibid., p. 227. **24** Ibid., p. 364.

the story of how Johnston wrestled with the demands of being a writer and an eyewitness, in which neutrality is often synonymous with objectivity, or at least with the desire to give a faithful account of the war. Unlike the British press, where reporters working for politically partisan proprietors could still proclaim their attachment to ideas of independence, fair play and truth, the BBC's journalism was constrained by law to a much more rigid notion of objectivity after the proclamation of its charter in 1927. The corporation was forbidden from commenting on controversial affairs, so its journalists worked under a stifling regime prescribing even-handedness, balance, impartiality and an exaggerated reverence for the idea that news reporting was merely the assembling of facts.[25] By necessity, Johnston had to adhere to this credo when he became a war correspondent: 'I am going to report this War soberly and objectively. All that I have to do is to give the world the Facts.' The sardonic tone with which he defined the simplicity of his task signalled how such a simple faith would dissolve upon contact with the battlefield. 'But the trouble is', he concluded after covering the Battle of El Alamein, 'there are no Facts. Or perhaps more truly, there are far too many of them, and none of them strictly true'.[26]

Making sense of the shifting sands of objectivity was further complicated by the unique position of Johnston's employer. As soon as the British government realized that the continuously expanding audience for radio offered an invaluable conduit for maintaining morale on the Home Front, the BBC was co-opted to the war effort.[27] Even as early as the phoney war of autumn 1939, Johnston was recording in his diary the heavy influence of the Ministry of Information on the BBC; the only 'real news' was coming from stations in America, Paris or Berlin. He was in a unique position to know: he had been redeployed from his job as a television producer to monitor and censor the despatches of American correspondents using BBC facilities to broadcast from London.[28] Arriving in Cairo to begin his tour as a correspondent, he was under instructions to concentrate on British troops fighting the campaign in North Africa, in order to counter German propaganda that Britain was relying on troops from India and the Dominions to fight its battles. He discovered that reality did not entirely confound the German claims: 'In this mass of South Africans and Australians and Free French, it seems at first sight that there is a good deal to support Dr Goebbels' contention.'[29] He could hardly be shocked by the demonstration that propaganda did not rely on lies, only the careful selection of facts to make a plausible story which might or might not be the truth; for many in the 1920s and

25 Mark Hampton, 'The "Objectivity" Ideal and its Limitations in 20th-Century British Journalism', *Journalism Studies*, 9:4 (2008), 481–9. **26** Johnston, *Nine Rivers*, p. 111. **27** Brian P.D. Hannon, 'Creating the Correspondent: How the BBC Reached the Frontline in the Second World War', *Historical Journal of Film, Radio and Television*, 28:2 (2008), 175–194 at 177. **28** Adams, *Denis Johnston*, pp 196ff. **29** Johnston, *Nine Rivers*, p. 30.

30s, this insight was itself the era's most potent truism. During his journey to Italy aboard a cargo boat Johnston leafed through a copy of *Mein Kampf* he found in the mate's cabin. The next day its owner, a Welshman, asked his opinion of Hitler's book. Reading it had convinced him that the author was 'half-crazy', Johnston replied.

> 'Didn't you know that before?' asked the Welshman.
>
> 'No,' said Johnston. 'I only had it on hearsay, and I never believe hearsay – particularly international hearsay.'
>
> 'I know,' the Welshman agreed. 'That's one of the things that too much propaganda has done to us. We've heard it shouting "Wolf" so often that we have become allergic to it altogether.'[30]

The incorporation of successful techniques for manipulating mass audiences, pioneered in Britain and the United States during the First World War, into everyday politics had heightened awareness of publicity stunts, public relations agents and the 'doctoring' of news. 'A word has appeared, which has come to have an ominous clang in many minds – Propaganda', wrote Harold Lasswell in 1927. 'We live among more people than ever, who are puzzled, uneasy, or vexed at the unknown cunning which seems to have duped and degraded them.'[31] This was the context in which the British government issued a White Paper in October 1939, corroborating reports that thousands of political prisoners were being held at concentration camps such as Buchenwald and Dachau in Germany. Although its veracity was scarcely disputed, and it was widely covered in the newspapers, the White Paper induced cynicism about the government's motives rather than anger towards Germany. Why had this been released after war had been declared and not when appeasement was being debated? The public readiness to suspect manipulation made the government particularly wary of propagating stories of atrocities: 'horror stuff', according to a Ministry of Information memo, 'must be used very sparingly and must deal always with treatment of indisputably innocent people. Not with violent opponents. And not with Jews.'[32] Journalists had been particularly implicated in uncritically reproducing atrocity stories in 1914–18 and when the war ended the tainted credibility of the press was widely seen as a threat to public liberty.[33] Walter Lippmann, who had been a fervent propagandist for Woodrow Wilson during that war, later published a series of books arguing that the crisis of journalism

30 Ibid., p. 124. **31** Brett Gary, *The Nervous Liberals: Propaganda Anxieties from World War I to the Cold War* (New York, 1999), p. 2. **32** Quoted in Hannah Caven, 'Horror in Our Time: Images of the Concentration Camps in the British Media, 1945', *Historical Journal of Film, Radio and Television*, 21:3 (2001), 205–253 at 229. **33** For the genesis of this see Maurice Walsh, *The News from Ireland: Foreign Correspondents and the Irish Revolution* (London, 2008), chapter 1.

was a major problem for modern democracy. The correspondents who had reported the war were the worst fakes. 'Most people seem to believe [when meeting] a war correspondent', Lippmann wrote, 'they have seen a man who has seen the things he wrote about. Far from it.' In reality correspondents 'reported day by day [...] what they were told at press headquarters, and of that only what they were allowed to tell.'[34]

Johnston was fully imbued with this zeitgeist as he headed to Cairo, and his time on the desert battlefields of North Africa made him determined to preserve his integrity. He believed he could evade propaganda by identifying with the fighting men; 'a complete picture of what it's really like' would come from reporting 'what the men are saying and feeling, and their attitude towards what they're living through.' The detached and impartial attitude of the troops in North Africa towards the enemy was a revelation, confounding everything he had read about war and its 'phoney heroics'.[35] It also exposed another dimension of propaganda, less instrumental but more insidious: the difference 'between the Myth of our Motives and the Truth of our Intentions, between what we imagine we are doing and what really happens.'[36] Rather than being turned into a cynic by this discovery, Johnston valued it as an achievement of true adulthood and, even more importantly, the source of the sardonic humour which is the leitmotif of his memoir. He even acted it out himself, wandering around Dublin on leave with an 'impudent smile' on his face as he was wined and dined by friends who greet him as a returning war hero. The only voice of scepticism was the architect Michael Scott, who bookended Johnston's grandstanding stories with the query: 'Tell me, did you ever get near the actual fighting?'[37]

As it happens, Johnston's accounts of pushing himself onto the front line despite being paralytic with fear are among the best written scenes in the book; terse, devoid of self-dramatization, unheroic, funny. Nonetheless he came away with his authority and pride enhanced, and lecturing the British Army's 184th brigade on the Desert War he was pleasantly surprised to find himself to be one of the few present 'who had actually seen a battle'.[38] In common with many men, war for Johnston was an experience imagined since boyhood which held 'all the fascination of a terrible thing that one would like to avoid', but which had to be investigated when an opportunity presented itself. '[Y]ou want to find out how you will react to it yourself, and whether the courage and endurance of the ordinary men who manage to come through it without disgracing themselves are so very much greater than your own – as they certainly seem to be.'[39] The real truth about war, in other words, was to be found in the experience, not the

34 Walter Lippmann, *Liberty and the News* (New York, 1920), pp 43f. **35** Denis William Johnston, 'Dionysia: An Account of the Author's Experiences as a BBC War Correspondent, 1942–45', British Library, London, p. 53. **36** Johnston, *Nine Rivers*, pp 110f. **37** Adams, *Denis Johnston*, p. 238. **38** Ibid., p. 242. **39** Johnston, 'Dionysia', p. 13.

cause. Unlike moral and political justifications for conflict, which were suscep-
tible to the taint of cant and self-delusion, the detachment and common sense
of ordinary soldiers rang true. That he found their attitude 'heart-warming and
inspiring' warns us that he was himself prone to sentimentalizing war,[40] but it
did provide him with a lodestar for his conduct as a war correspondent. 'It is the
Goebbels I detest – not the Rommels – and I'm damned if I'm going to be one
of them – on either side.'[41]

This was always going to be a difficult aspiration to fulfil while working for
the BBC. Johnston's letters home were peppered with accounts of the frustra-
tions of dealing with the layers of oversight and bureaucracy. He developed a
particular antipathy for Richard Dimbleby, the senior correspondent in Cairo
(of whom 'a fat Hedonist' was one of Johnston's less libellous descriptions).[42]
Halfway through *Nine Rivers*, the author satirically portrays himself as a figure
whose individuality has been erased, 'a member of Staff, Something on a List, an
Anonymous Filer of expense accounts, a Voice amongst Voices shouting from
the far end of a pipe, a War Correspondent.'[43] But circumstances prevented him
from being entirely crushed by the constraints on his independent judgment.
The propaganda value of the BBC depended on its reputation for accuracy, so
there was an incentive to try to avoid lying outright in its news coverage.[44] It was
also in the interest of the Ministry of Information to have direct reports from the
battlefield aired as soon as possible to maximize the potential broadcasting
offered for connecting the public at home with the troops all over the world.[45]
The demands of war coverage drove transformative stylistic and technical
innovations in radio broadcasting. Internal BBC memos discussed the war as a
singular opportunity to produce 'sound pictures of battle' and 'exploit the quali-
ties of immediacy and reality which make broadcasting unique as a medium for
bringing the war to life.'[46] The vivid and dramatic reports which this new depar-
ture encouraged were a hit with the audience; by comparison, newspaper
accounts appeared 'stilted and overly formal'.[47] Asa Briggs has described how the
news bulletin at 9 p.m. 'became in most households an institution almost as
sacrosanct as family prayers are said once to have been.'[48] The conventions of
radio reporting, as Paul Fussell has pointed out, honoured the 'creative imagina-
tions' of the audience.[49] In rural Derry, neighbours gathered around the wireless
set in a farmhouse kitchen, while in his bed upstairs a small boy (and future
Nobel Laureate) strained with rapt attention to hear 'the names of bombers and

40 Ibid., p. 53. **41** Adams, *Denis Johnston*, p. 243. **42** Denis Johnston to Betty Chancellor, 30 July
1942, Johnston Papers, MS 10066/288/26–51. **43** Johnston, *Nine Rivers*, p. 212. **44** James Curran and
Jean Seaton, *Power Without Responsibility: The Press, Broadcasting and New Media in Britain* (Glasgow,
1981), p. 139. **45** Ibid., pp 136, 153. **46** Hannon, 'Creating the Correspondent', p. 176. **47** Phillip
Knightley, *The First Casualty: The War Correspondent as Hero, Propagandist and Mythmaker* (London,
1982), p. 307. **48** Quoted in Hannon, 'Creating the Correspondent', p. 178. **49** Paul Fussell,
Wartime: Understanding and Behaviour in the Second World War (Oxford, 1989), p. 181.

of cities bombed, of war fronts and army divisions, the numbers of planes lost and of prisoners taken, of casualties suffered and advances made'.[50] For all his complaints about the suffocating diktats from the newsroom in London, Johnston realized that the novelty of radio reporting from the front line opened up huge freedoms which he could exploit and creative possibilities that he would enjoy. 'You have to break the law and disregard your instructions in a job that has never been worked out – a fact that makes it all the more fascinating.'[51] If he strove to 'break entirely new ground in reporting', the effort itself would be an antidote to his despair. 'My stuff is going to be the real thing – like they've never had before on the radio.'[52]

In addition to the freedom that came with being a pioneer, Johnston was sustained by his own cussedness. He had never followed a conventional career path and was not a corporation man by temperament. A self-avowed 'disruptive type', Johnston was delighted to think as he recorded Churchill in the desert of how much the 'Old War Horse' would disapprove of the BBC correspondent who had appeared before him with a microphone if he only knew his background.[53] The source of much of his jealousy of Dimbleby was the knowledge that the younger man was a careerist who enjoyed all the benefits denied to the non-conformist. Johnston conflated Dimbleby with the corruptions of propaganda, writing that he 'was a General's man. According to his training you go to the top for your information. He gave the official view'.[54] In contrast, Johnston saw himself as an outsider. 'An Irishman, of whatever kind, is a born freelance', Bowen remarked in her review of *Nine Rivers*, noting that Johnston, as an Anglo-Irishman, possessed heightened gifts of 'ambivalence and detachment peculiar to that race inside a race.'[55]

It is the tension between the constraints of Johnston's occupation as a war correspondent and the valuable insights this might yield, if he could resolve his uncertainty about his own value as a witness, which gives *Nine Rivers* the narrative drive to override the uneven experiments with form and voice. He achieved the aims he set himself: to deliver a running commentary on an air raid, to get behind enemy lines, to make himself as much as possible an eyewitness. And this gave him the material to write a memoir, not of combat or the war in general, but of his own persona as a war correspondent, 'an entertaining penance for having played the Censors' game so obediently in my despatches.'[56] Beyond the running critique of propaganda and its impact on behaviour, he used the astringent observation preserved in his scripts and notebooks to conjure up the

50 Seamus Heaney, 'Crediting Poetry', Nobel Lecture, Stockholm, 7 Dec. 1995, http://www.nobel-prize.org/nobel_prizes/literature/laureates/1995/heaney-lecture.html, accessed 15 Aug. 2014. 51 R. Johnston (ed.), *Orders and Desecrations*, pp 124f. 52 Johnston, 'Dionysia', pp 31f. 53 Johnston, *Nine Rivers*, p. 124. 54 R. Johnston (ed.), *Orders and Desecrations*, p. 123. 55 Bowen, 'One Man's Verdict', 108. 56 Johnston, 'Dionysia', p. 4.

strange, dislocating world of total war. 'Do you ever open your eyes in the dark and wonder where the hell you are?', he writes of his experience of waking up in a Parisian hospital where he was being treated for a broken arm in December 1944. 'An everlasting experience of my own – for almost every bed is a new one these days, and the faint, white oblong of the window is never in the same place twice. Until I can pick up and examine the brain traces of memory I might be anybody or any age.'[57] Bombs not only obliterated the familiar paths carefully carved into the landscape of Europe by centuries of human settlement, but the only signs of life remaining were the marching armies and their technology. One May night in 1944, a jeep without lights crawled through an 'evil grey mist' covering the Pontine Marshes south-east of Rome. In the passenger seat a young British Army captain; at the wheel 'a person of indeterminate rank, age and nationality, wearing a pair of German boots, a short American belted coat, and a British beret with an Arab cap badge' – Denis Johnston. Most of the bridges in this rectangular network of roads, canals and drains had been blown up, so they had to plot a route over the few left intact and at the same time avoid enemy patrols. An American armoured car appeared through an ethereal light at a cross-roads, while an arc of tracer bullets lit up the sky to the right. 'We peered ahead for craters and obstructions. There was no sound except the purr of the engine and the croaking of the bull frogs. From time to time a shuttered house loomed up out of the murk and vanished behind us, but there was no sign of any inhab-itants.'[58]

Johnston's faith in the value of experience over the ideals proclaimed by Allied propaganda served him well as he sought to discover truths about war. But it could no more protect him from error than it could insulate him from conforming to the designs of propaganda. Simply being there was insufficient to capture the 'complete picture' he aspired to create. The Nazi concentration camps and death camps were, as Samuel Hynes has remarked, 'narratives that were beyond any correspondent's range', out of sight and only accessible through rumours or official accounts that might be self-serving. Besides, mass murder and enslavement were unthinkable in Western Europe, where the Nazi occupa-tion appeared less harsh than in the east.[59] This was a war story that revealed the limitations of the eyewitness. When Denis Johnston was shown around a captured concentration camp in Alsace, formerly used by the Gestapo, he was more concerned about the treatment of French collaborators interned there by the 'grinning sadistic officer' in charge than what might previously have happened during the German occupation. He followed the conducted tour with his usual sceptical, disbelieving eye. '[W]e were shown around the alleged torture

57 Johnston, *Nine Rivers*, p. 317. 58 Ibid., pp 229–32. 59 Samuel Hynes, 'Introduction' in Samuel Hynes et al. (eds), *Reporting World War II: American Journalism 1938–1946* (New York, 2001), p. xxii.

chamber, gassing room and cremation oven, all of which showed no sign whatever of having been used for such purposes.' He only accepted with certainty what he could see with his own eyes, 'the fact that there were two gallows in the centre of the exercise yard, around which the miserable inhabitants were circulating, in an effort to keep a bit of warmth in their bodies.'[60] As he made his way through defeated Germany in 1945, he was engaged in his familiar battle with the censors, accused of fraternization because he accepted apple cake from an old German woman among fifty women and children he discovered living in a mine. His Irish sensibility was stirred to break such an absurd law, which in any case, he observed, was derided by ordinary soldiers; he would be happy to be arrested for talking to Germans.[61] Searching for the girlfriend of a dead German soldier whose letters he had picked up in an abandoned jeep in North Africa, he felt like 'a representative of the new Gestapo' among the wary inhabitants of a small German town.[62] An encounter with a friendly American officer led to a startling change of direction. After they exchanged cigarettes and lit up, the American suggested he explore another road leading out of town. 'I guess you don't know much about this war until you've been down that way.'[63]

The road brought him to Buchenwald camp, recently captured by the Americans. Prepared for 'another recital of uncorroborated horrors' he followed two raggedly dressed internees from the Channel Islands who offered to show him around. As soon as one of them lifted the tarpaulin covering a lorry to reveal a high pile of emaciated corpses, Johnston realized that his scepticism had betrayed him. Here, even propaganda served the truth. Prisoners had put charred bones in one of the furnaces to lend the scene verisimilitude. Johnston could not bear to look, turning his head and remarking that this embellishment was hardly necessary. 'That's what I thought', his guide agreed. 'But some people can't let bad alone. They've got to fix it up for the photographers.'[64] As the tour continued he forced himself to look, in all senses, first at the bodies and then at everything else. '"Here's the block you want to see. Don't come in if you don't want to." I went in.'[65]

Despite its flaws, *Nine Rivers from Jordan* is more powerful than many other accounts of the Second World War because of Johnston's continuous, forensic, but imaginative exploration of his own role as a witness and whether it can lead him to revelation or deception. Chris Morash has highlighted how this questioning of the forms through which we explore what it means to be human is central to all of Johnston's work. 'I always feel that there must be something wrong with the information, rather than with human nature', was how Johnston

60 Johnston, *Nine Rivers*, p. 342. 61 Ibid., p. 347. 62 Ibid., p. 389. 63 Ibid., p. 391. 64 Ibid., pp 393f. 65 Ibid., p. 395.

explained the decades he had spent exploring the biographical enigma of Jonathan Swift through four different media.[66] The 'old newshawks' he met when he started out as a war correspondent were 'hard bitten sceptics', but compared to Johnston's drive to probe the truth behind appearances it is less a method than a fossilized affectation.[67] The objective truth that high-minded journalists insist must be protected from censorship may not, Johnston suggests, be so sacrosanct after all, 'for if the bulk of what one has to say is only a half truth, it does not matter so much if it gets treated roughly.' Rather than an oracle, a war correspondent in pursuit of truth 'has to be something half way between a Judge and a Detective.'[68] In *Dispatches* Michael Herr claimed that most journalism about the Vietnam War obscured rather than revealed reality. 'Conventional journalism could no more reveal this war than conventional firepower could win it, all it could do was [...] turn it into a communications pudding, taking its most obvious, undeniable history and making it into a secret history.'[69] Denis Johnston tried to confront the limitations of journalism to tell a similar secret history which aspired to what W.G. Sebald described as the 'ideal of truth inherent in [...] entirely unpretentious objectivity'.[70] But such 'unpretentious objectivity' was, as *Nine Rivers* shows, far from simple.

66 Chris Morash, 'Denis Johnston's Swift Project: "There Must Be Something Wrong with the Information"', *The Canadian Journal of Irish Studies*, 33:2 (Fall 2007), 56–9 at 56. 67 Johnston, 'Dionysia', p. 31. 68 Johnston, *Nine Rivers*, p. 114. 69 Herr, *Dispatches*, p. 220. 70 W.G. Sebald, *On the Natural History of Destruction*, trans. Anthea Bell (London, 2004), p. 53.

Denis Johnston's European journey
and Irish search

TOM WALKER

Near the end of 1949 Denis Johnston appeared to give up on the possibility of publishing his wartime memoirs. Bound mimeographed copies of an anonymous typescript entitled 'Dionysia', running to over 900 pages, were deposited in 'a few semi-public places'.[1] The volumes are prefaced by an opening 'Introit' (one of many references to the Christian Mass), which concedes that publishing 'a work that one knows to have got out of control is a bad idea'.[2] The Introit also renounces any authority over the text. Its composition up to this point is described as a process of 'editing and cutting' the 'mass of material' that Johnston had acquired while working as a BBC war correspondent from 1942 to 1945. Indeed, 'Dionysia' is to some extent a scrapbook, including pasted in copies of photographs, military documents and propaganda.[3] The deletion of Johnston's name reflects the ambition that the story contained therein be 'that of a generation and of an age'. Signing himself off as the 'first editor', he likens the possibility of others attempting to order his unwieldy text to the palimpsestic composition of the 'great books of antiquity'.[4]

Johnston's sense of a complicated future history for 'Dionysia' was to prove prophetic, even if his own relinquishment was only temporary. In 1950–1, four extracts (selected by the Republican socialist George Gilmore) formed what the *Irish Times* advertised as 'the first major series' in the revivification of *The Bell* after a thirty-month hiatus: the initial excerpt was the star opening turn in the

1 Anon. [Denis Johnston], 'Dionysia' (*c*.1949), p. 5. I have traced copies deposited at the British Library, Trinity College Dublin, Oxford, Cambridge, Harvard and Stanford. An unbound copy of the typescript was also later presented to the University of Ulster in 1985. **2** Johnston, 'Dionysia', p. 4. Johnston neglects to mention that an earlier incarnation had already been rejected by Jonathan Cape: Bernard Adams, *Denis Johnston: A Life* (Dublin, 2002), p. 300. **3** Johnston's papers are held at Trinity College Dublin and the University of Ulster, Coleraine. He was a prodigious self-archivist, collecting, ordering and retrospectively annotating a huge amount of material, as well as keeping extensive notebooks and diaries, on which his later writings drew. There is also much Johnston-related material at the BBC Written Archives. **4** Johnston, 'Dionysia', pp 5f.

return issue.[5] Through the periodical's editor, Peadar O'Donnell, the London-based Irish publisher Derek Verschoyle came to hear of the manuscript, which he employed H.A.L. Craig (a former associate editor of *The Bell*) to prune.[6] It was published in 1953 as a 458-page book under the title *Nine Rivers from Jordan: The Chronicle of a Journey and a Search*. A revised US edition followed in 1955 (although it is unclear if these alterations were Johnston's or the American publisher's doing). Having allowed the text to be cut, however, Johnston at some point assembled a grangerized copy. This involved taking a set of page proofs of the 1953 edition, sticking each A5 page onto the alternate side of one of four A4 scrapbooks, and surrounding them with annotations.[7] Further elaboration of a more public yet abstruse kind later came with *The Brazen Horn*, published privately in 1968 and then in a beautiful Dolmen Press edition in 1976.[8] Calling on an array of scientific and metaphysical theories of time to posit multiple dimensions and alternate realities, this is, as Vivian Mercier identifies, an 'extended commentary on *Nine Rivers*', offering an esoteric attempt to puzzle out Johnston's notion that in one version of the present he had been shot dead at the end of the war.[9] In the late 1960s, Johnston also wrote an opera libretto based on his wartime experiences.[10]

This baroque publication and textual history points to the unfinishable nature of Johnston's response to his wartime experiences. Poised between conventional kinds of literary failure – the struggle to find a suitable form, publisher, audience or much critical understanding – and the vaunting philosophical and theological ambition to speak for an age or somehow create what will become a sacred book, this was an ongoing project that occupied much of the rest of his writing life. Johnston's war and the creative agon it provokes is also a story that sits within that of his increasing inability to leave his past alone, 'to rewrite', as Hilton Edwards noted of his former theatrical collaborator, 'almost as often as he creates'.[11] This made from middle-age on for a textually forbidding series of recastings of his plays, a tending of his extensive archive and a deceleration in his new literary output.

5 Quidnunc, 'An Irishman's Diary', *Irish Times*, 26 Oct. 1950; Denis Johnston, 'Meet a Certain Dan Pienaar', *The Bell*, 16:2 (Nov. 1950), 8–18; Denis Johnston, 'Man Sovereign Man', *The Bell*, 16:3 (Dec. 1950), 19–28; Denis Johnston, 'Detour in Illyrea', *The Bell*, 16:5 (Feb. 1951), 44–52; Denis Johnston, 'Buchenwald', *The Bell*, 16:6 (Mar. 1951), 30–41. 6 'London Letter', *Irish Times*, 14 Nov. 1953. 7 Denis Johnston, 'Nine Rivers from Jordan' (grangerized), Denis Johnston Collection, University of Ulster, Archive Box 3, A.2(b). 8 Denis Johnston, *The Brazen Horn: Lenaea 5: A Non-Book for those who, in Revolt Today, Could be in Command Tomorrow* (Alderney, 1968); Denis Johnston, *The Brazen Horn: A Non-Book for those who, in Revolt Today, Could be in Command Tomorrow* (Dublin, 1976). 9 Vivian Mercier, 'Perfection of the Life, or of the Work?' in Joseph Ronsley (ed.), *Denis Johnston: A Retrospective* (Gerrards Cross, 1981), pp 228–44 at p. 228. 10 Denis Johnston, *Nine Rivers from Jordan* in *The Dramatic Works of Denis Johnston*, 3 vols (Gerrards Cross, 1977–92), ii, pp 277–338. The music was written by Hugo Weisgall and the opera was premiered on 9 October 1968 at the New York City Opera: Harold C. Schonberg, 'Opera: "Nine Rivers from Jordan" Has Premiere', *New York Times*, 10 Oct. 1968. 11 Hilton Edwards, 'An Appreciation' in Ronsley (ed.), *Denis Johnston*, pp 1–3 at p. 2.

Something of the scale of what Johnston was attempting to confront in experiential and conceptual terms is outlined in the different 'Introit' that prefaced *Nine Rivers*. Beginning after the war's end, from the vantage point of Jerusalem in the summer of 1947, its focus is not on victory or peace; conflict is on the verge of renewal, as 'Arab and Jew prepare to come to a decision in the old way'. Yet indignation at this is seen as misplaced: 'in its own fashion, it is not a bad way'. Morality and justice are no less complex affairs further north in Germany where the victors are now 'hanging hangmen to prove that hanging does not pay'. As the book's subtitle suggests, the work is framed not merely as a journey through the war but a search for what Johnston's generation should now do 'with the world', an effort to discover individual and collective 'sanity of behaviour'.[12] His war memoirs are not mere personal reportage but also an everyman's quest to understand the war's implications for humanity as a whole.

Johnston recounts many of his experiences through straightforward first-person narrative, pitched in the present tense and drawing closely on his original diary entries. Yet his search for some kind of ethical and metaphysical understanding of his experiences aligns this documentary core to much stylistic experimentation. This is a journey mediated through an elaborate structure of parallel myths and parodic models, as well as an array of echoes and allusions. The main three sections of the book focus successively on Johnston's time spent covering the Allies' campaigns in North Africa, Southern Italy and Northern Europe. Yet the section's titles, 'The Catechumens', 'The Ordinary' ('The Faithful' in the 1955 edition), and 'The Epiklesis', relate, as Johnston's private annotations explain, to divisions in the Christian Mass: '(1) the Mass of the Catechumens, of Students, when the unbaptised were permitted to be present. After the Lessons and Collects these were supposed to withdraw, and the "Ordinary" would continue with (2) the Mass of the Faithful up to the point where the Holy Spirit is involved (Epiklesis) and (3) the ceremony concludes with the sacrificial banquet of the Eucharist'. These might also, for Johnston, 'profitably be compared with the ploughing, the sowing and the harvest'.[13] The published title refers to a prophecy received from a dragoman while on a sight-seeing trip to the Pyramids: 'in your hand I see nine rivers that you must cross'.[14] These turn out to be the Jordan, Nile, Sangro, Tiber, Seine, Liffey, Rhine, Danube and Inn. But as chapter headings signal, these rivers are coupled with the Greek muses: Polymnia, Terpsichore, Euterpe, Clio, Erato, Thalia, Melpomene, Calliope and Urania. This raises the unacknowledged possibility of some kind of parallel to Herodotus' *Histories*, which also names its chapters after the muses.[15] The most extensive attempt so far made to consider the book's

12 Denis Johnston, *Nine Rivers from Jordan: The Chronicle of a Journey and a Search* (London, 1953), pp 1f. 13 Johnston, 'Nine Rivers' (grangerized). 14 Johnston, *Nine Rivers* (1953), p. 27. 15 Beatriz Kopschitz Bastos, '*Nine Rivers from Jordan*: A Centenary View', *ABEI Journal: A Brazilian Journal of Irish*

intertextual pyrotechnics notes that Johnston's often innocent persona equates not only to a 'forty-year-old Candide', but one who has 'undoubtedly read *Candide*, as well as *Faust* (sometimes quoted in German), the *Odyssey*, and the *Divine Comedy*'.[16] In a preface eccentrically inserted two-thirds of the way through the 1955 edition, Johnston reveals that the text 'frequently takes on the lineaments of whatever standard work the author happened to be carrying in his kit at the time of writing' – a practice that takes in some rather non-standard works too, such as *The Mirror of Perfection*, a thirteenth-century testimony of the life of St Francis of Assisi.[17]

One way of coping with *Nine Rivers*' seemingly endless range of references is by apprehending that Johnston's search for 'sanity of behaviour' is partly being conducted through textual appropriation: 'When I have got something to say, I try to say it in the best way that anybody else can suggest to me'.[18] This patch-work of masks, allegorical or otherwise, are not, as Terry Boyle would have it, an evasive attempt to 'depersonalize the issues'.[19] Rather they are an expansion beyond the self in a search for historical understanding. Like the critique of 'the postures of nationalist revolution' in *The Old Lady Says 'No!'* (1929), conducted in part through the play's opening co-option of 'lines by Mangan, Moore, Ferguson, Kickham, Todhunter, and the romantic school of nineteenth-century Irish poets', they are a means of showing how past modes of thought impinge on the present.[20] In *Nine Rivers*, Johnston is attempting to perform such immanent, intertextual critique on a pan-European scale, incorporating parts of the Middle East and Northern Africa too. The current crisis necessitates a journeying through the history and culture, as well as the terrain, of this broader Europe. Its civilization, or rather whole series of overlapping civilizations, are represented as a kind of palimpsest, offering various modes of perception and behaviour to be judged in relation to present pressures.

The valley of Jordan is not merely experienced as a place but also in relation to a rendering of Psalm 126: 'Going shall one go, and weeping, / Bearing the train of seed: / Coming shall one come with ringing cry / Bearing his sheaves'. The solace of this prayer of restoration and any identification with the Old Testament story of the 'Children of Israel [...] pouring down this very road in the wake of Joshua' is then complicated by a series of associative leaps. The possi-bility of a parallel with the more recent presence of 'Lawrence and his Arabs, coming to harass Johnny Turk' leads to Johnston thinking about T.E. Lawrence's

Studies, 7 (2005), 25–32 at 27. **16** Mercier, 'Perfection of the Life, or of the Work?', p. 230. **17** Denis Johnston, *Nine Rivers from Jordan: The Chronicle of a Journey and a Search* (Boston, 1955), p. 334. **18** Ibid. **19** Terry Boyle, 'Denis Johnston: Neutrality and Buchenwald' in Kathleen Devine (ed.), *Modern Irish Writers and the Wars* (Gerrards Cross, 1999), pp 205–18 at p. 210. **20** Nicholas Grene, *The Politics of Irish Drama: Plays in Context from Boucicault to Friel* (Cambridge, 2000), p. 153; *Dramatic Works of Denis Johnston*, i, p. 17.

and Alexander Pope's unsatisfactory translations of *The Odyssey*: 'I cannot believe that Homer was a bore to those who first heard him. Yet Pope is a bore'. Following a passing mention of Christ's Last Supper and the Via Dolorosa, this section ends with recognition of the dangers of overidentification: 'I think the man in question', by which Johnston seems to mean Odysseus, 'must have been rather like me. But then, aren't we inclined to visualise all public characters in terms of ourselves – from God downwards?'[21] References to other journeys and an acknowledgment of the challenges of translating across language and time interpose through a kind of thought experiment.

Across its whole narrative arc, moreover, *Nine Rivers* relates such seemingly redemptive personae and their narratives (Joshua, Odysseus, Jesus) to the evil discovered further north at the concentration camp at Buchenwald:

> This is no fortuitous by-product of the chaos of war. This is no passing cruelty or wanton act of destruction. This is deliberate. This is the intentional flower of a Race Theory. This is what logic divorced from conscience can bring men to. [...]
>
> How did I ever doubt that there is not an Absolute in Good and Evil? Oh Christ! We are betrayed. I have done my best to keep sane, but there is no answer to this except bloody murder.[22]

In the following chapter, 'The High Court of the Brocken', this present is again experienced as cultural history. Through a pastiche of the *Walpurgisnacht* in Goethe's *Faust*, Johnston thinks through this admission of evil and the discovery of its source among an over-reaching rationality, as well as questioning his initial desire for some kind of vengeful justice. Such mapping opens up comparative ways of thinking that keep recognition and difference in play. Pinpointing the exact terms on which the Holy Land and Germany, and Joshua/Odysseus/Christ and Faust are being interlinked is difficult, but the presence of such acculturated responses to these locations partly offers a sense that although faith in a benevolent deity might no longer be sustainable, Christian morality is not to be wholly discarded either, in its recognition of evil or the limits it sets on humanity's capacity to effect justice.

The journeying through the history, culture and terrain of Europe in *Nine Rivers* includes Ireland too: the Liffey is, after all, one of the rivers crossed. As Clair Wills outlines, Johnston numbers among several Irish writers, including Elizabeth Bowen, Francis Stuart and Louis MacNeice, whose war work seeks 'a solution to the problem of Ireland's status, an overcoming of the dangers of parochialism, and an appropriate sense of "Europeanness", or – at least – of

21 Johnston, *Nine Rivers* (1953), pp 58f. **22** Ibid., pp 396f.

Ireland's relation to Europe'.²³ Much of Johnston's Irish material reckons with
the issue of neutrality. In the framing Introit, among the series of morally
complicating present phenomena, the Allies' 'hanging' of 'hangmen' is aligned
with 'the Vigliacci' [*sic*], Dante's neutrals (as Johnston's annotations note)
gathered 'in Dublin's Pearl Bar'.²⁴ In the journey back towards 1947 that subse-
quently follows, neutrality is tested within Europe through Johnston's own
persona. His initial attitude in the western desert is one of detachment, mixing
by turns innocence, cynicism and exultation. The idealism of being a 'free and
objective' reporter unconcerned with 'propaganda' is undermined by censorship
and, more prosaically, various logistical problems. But it gives way to a celebra-
tion of the honour and vitality of war 'as these men', under Montgomery and
Rommel, 'play it'. Such sentiments are challenged on entering Europe, first
through experiencing the attritional Italian campaign and most conclusively at
Buchenwald, where he finally embraces belligerence, symbolized by his picking
up of a Luger. In 'The High Court of the Brocken', Faustus-as-Johnston then
equivocates on being asked under cross examination if he is 'a neutral in this
war': 'Technically, yes. But I have always advocated ...'.²⁵

Wills views *Nine Rivers* as offering 'a sustained and ironic reflection on
Ireland's neutral stance', in having Johnston's character 'echo and parody de
Valera's persona' in its obsession with correct protocol with the Germans and its
refusal to be swayed by Allied propaganda: '*Nine Rivers* not only questions the
possibilities of an objective stance on the war. It also warns that a belief in the
superior virtue of impartiality can blind people to the real issues at stake.'²⁶
Disentangling an ironic portrayal of the Johnston persona in the text from the
conflicts and contradictions within Johnston's real-life opinions is difficult. His
obsession with both sides' propaganda is attested to by the sizeable collection of
air-dropped leaflets and other such ephemera preserved among his papers.²⁷
After his experience of seeing Buchenwald, he was also, according to his diaries,
still the only reporter to salute Hermann Goering as he left the historic press
conference at Augsburg in May 1945: 'He seemed surprised – looked at me for a
moment, and then saluted me in return'.²⁸ But in addition to the portrayal of
Johnston's growing personal turmoil, Ireland certainly comes to be represented
as an uneasy 'Hy Brasil'. Just before the discovery of the concentration camp,
Johnston journeys home to get married. He finds the country 'just as I left it!'
This is initially a source of thanks, offering him the chance for 'a damn good

23 Clair Wills, 'The Aesthetics of Irish Neutrality during the Second World War', *boundary 2*, 31:3
(Spring 2004), 119–45 at 125. 24 Johnston, *Nine Rivers* (1953), p. 1; Johnston, 'Nine Rivers' (granger-
ized). 25 Johnston, *Nine Rivers* (1953), pp 8, 119, 396, 407. 26 Clair Wills, *That Neutral Island: A
Cultural History of Ireland During the Second World War* (London, 2007), pp 407f. 27 Denis Johnston
Papers, Trinity College Dublin, MS.10066/362/324–402. 28 Denis Johnston, War Field Book 6 (22
Mar. – 21 May 1945), Denis Johnston Collection, University of Ulster, Archive Box 7, B.49(f); Adams,
Denis Johnston, pp 281–3.

break'. However, disquiet starts to emerge at his own displacement, as a Protestant, within a present-day Ireland increasingly dominated by the Catholic Church: 'the day will come when my countrymen will no longer be servile in their faith – the only servility that is really contemptible – and will readmit the Middle Nation. Meanwhile I must confess I am not greatly upset by the jibe that we who have no part in Catholic Ireland are raceless vagrants.'[29] The following chapter, 'The Back Garden of the Hesperides', further satirizes Irish insularity as a parody of 'an Old Irish *echtrae* or adventure in the Celtic Otherworld, translated fairly literally into Victorian English by someone like Kuno Meyer or Whitely Stokes'.[30] Indifference to the conflict is offered by a thinly veiled version of Patrick Kavanagh stating 'I am not impressed by this war'. Others on the 'Fortunate Isle' admit to being: 'aweary of our lives and our happiness has turned to sawdust in our mouths. Teach us privily therefore how we may depart from the Land of Youth and come with thee to where we may learn to weep.'[31]

Johnston had supported neutrality at the start of the war to the extent of joining the Irish Local Security Force to defend Ireland against a British or a German invasion. Whatever neutrality's initial justification, however, the forms it had taken by the war's end had for him become compromised by their association with 'the aggressive nationalism, isolationism, irredentism' of the Irish government.[32] This particular regime of neutrality had placed those who had remained in Ireland outside of European experience, of learning 'to weep' and so understand a supra-national consciousness that had been radically altered by the horrors of war. From the start of his career, with *The Old Lady Says 'No!'* and *The Moon in the Yellow River* (1931), Johnston's work had been preoccupied with the state of post-revolutionary Ireland and, more particularly, with the struggle to reconcile certain strains of Romantic nationalist thought to the realities of the post-independence dispensation and its place within the wider workings of modernity – within the framework of what Harold Ferrar describes as being Johnston's spiritual quest to acknowledge 'the universe as it is'.[33] An example of this is the shooting of Darrell Blake by Commandant Lanigan in *The Moon in the Yellow River*. Johnston described it as an attempt to confront the difficulty of recent history in which 'the recrudescence of murder as a political argument had been brought to a sudden stop by means of the counter-murder of prisoners in the hands of the new native Government. There was no legal or moral justification for such measures on the part of the infant Free State. But the melancholy fact remained that it had worked.'[34] Such unpleasant realities were not to be evaded. Part of *Nine Rivers*' critique of neutrality, therefore, is not just

29 Johnston, *Nine Rivers* (1953), pp 379, 368, 370, 373. **30** Mercier, 'Perfection of the Life, or of the Work?', p. 232. **31** Johnston, *Nine Rivers* (1953), pp 377f. **32** Ibid., pp 140, 409. **33** Harold Ferrar, 'Denis Johnston's Spiritual Quest' in Ronsley (ed.), *Denis Johnston*, pp 189–202 at p. 190. **34** *Dramatic Works of Denis Johnston*, ii, p. 82.

of a growing moral blindness or even superiority, but of a more general state-promoted Irish flight from the world as it has now become.

Returning to Johnston's period in Ireland before he became a war correspondent illuminates the terms on which he initially supported Irish neutrality. At the outbreak of war, he was working for the BBC in London. On 6 June 1940, just two days after the completion of the Dunkirk evacuation, he asked for permission (granted shortly afterwards) 'to be transferred to a job in Belfast which might include a commission for a certain number of long features', so that he might live in Dublin and 'take his share in the struggle against the I.R.A.', reportedly adding that: 'He thinks it will not be long before we are needing an eye-witness on the spot in Ireland'.[35] The complexity of Johnston's private life was such that other reasons for his return to Dublin were also in play, but this discussion with his BBC employers strongly suggests Johnston's concern at this time with preserving Irish independence (equated with neutrality), which he viewed as being under imminent threat from within and without.[36] By the beginning of November 1940, with the prospects of invasion of Britain or Ireland seemingly receding, he admits in correspondence to 'feeling rather a fool playing at soldiers when so much is really going on elsewhere'.[37] His investment in neutrality is based, therefore, on his perception of a genuine challenge to Ireland's sovereignty, yet this does not involve a renunciation either of his ties to Britain or of his engagement with the war.

In Ireland, Johnston's work included attempting to persuade the authorities to allow the BBC to use Radio Éireann's facilities to broadcast news and other material. He reported to London that rather than being a defence of freedom, neutrality was being maintained in a 'hysterical' fashion through an attempt 'to stop all publicity about Ireland of any kind until the crisis is over'. The elephant in the room was the 'wide open' northern border. However, he advised against broadcasting southern news from Belfast 'except for stories of such importance that they warrant running the risk of not getting back again or of being rounded up if one does!'[38] Some of Johnston's early wartime BBC scripts resisted such attempts to isolate Ireland from the experience of war. Reporting on the bombing of Dublin on 31 May 1941, he emphasized that it was 'painfully like what we have recently seen elsewhere'.[39] Later that year, a talk on 'Today in Dublin' highlighted the deprivations of 'everyday life in Ireland today' due to shortages of essentials such as bread, tea, oil and coal.[40] He showed how, in spite

35 BBC Internal Memo, 6 June 1940, BBC Written Archives, L1/225/3. 36 Adams, *Denis Johnston*, pp 195–215. On the rhetorical slippage between independence and neutrality see Thomas E. Hachey, 'The Rhetoric and Reality of Irish Neutrality', *New Hibernia Review*, 6:4 (Geimhreadh/Winter 2002), 26–43 at 30. 37 Denis Johnston to Val Gielgud, 2 Nov. 1940, BBC Written Archives, L1/225/1. 38 Denis Johnston, report on broadcasts from Eire, 12 July 1940, LI/225/1. 39 Denis Johnston, 'Dublin's Air Raid' (broadcast 31 May 1941, BBC Home Service), BBC Written Archives, Radio Talks Scripts Pre-1970, JOA–JON T262. 40 Denis Johnston, 'Today in Dublin' (broadcast 3 Sept. 1941, Home and Forces

of neutrality, the war was affecting Irish life. This kept a sense of common experience alive in broadcasts that, although aimed at British audiences, were also popular in Ireland.

The 'wide open' border was also something to which Johnston's radio work drew attention, to the discomfort of some in Northern Ireland. 'Today in Dublin' provoked 'an extremely irate listener' in having 'referred to Dublin as the capital of Ireland': his superiors in Belfast felt the need to remind him that 'Dublin is now, as you know, the capital of Eire, but not of Northern Ireland. Further, Eire is neutral, while Northern Ireland is not, being part of the United Kingdom'.[41] Undiscouraged, Johnston later offered a more overt joining up of the island in 'The Train to Eire'. A description of a journey on the Belfast to Dublin train, 'one of the few [...] left in Europe that crosses a peacetime polit- ical frontier', it emphasizes the plurality of the passengers, 'people speaking with a variety of accents and going on a variety of errands', yet describes a kind of platonic wartime meal enjoyed as the train passes over the border in which white bread and tea (scarce in the south) and butter and eggs (scarce in the north) are all available.[42] In a minor way, this gentle sketch offers a picture of an Ireland that for all its divides, including now between war and peace, also remains an interconnected space. From a kind of tri-located Southern Irish, Northern Irish and British perspective, and within the restrictive framework of having to produce work that fitted with the propaganda objectives of the British govern- ment, Johnston keeps in view how the broader European story is impinging on Ireland. It is not so much that Johnston's broadcasting involved 'having to compromise his belief in Ireland's right to be neutral', but rather that through his radio work neutrality was not to be made into a denial of Ireland's relations to the rest of the world.[43]

Returning to *Nine Rivers*, in 'The Back Garden of the Hesperides', Johnston's persona, Donnachada, is mocked by some as 'the wily picker of the winning side'. His wrathful reply, referring to the long Irish history of private soldiering, is that it would be 'better had we striven against each other on both sides as our fathers did before us', before he again refers to Dante: 'For there are none so wily as the Vigliacchi who take neither part and shall lie at last in Limbo tormented by gadflies and wasps.'[44] At this point, any kind of engagement with the war is seen as better than the fate of those left in Ireland – shut off from the world by 'rigid press censorship' imposing 'xenophobic isolationism'.[45] Donnachada is

Service), BBC Written Archives, Radio Talks Scripts Pre-1970, JOA–JON T262. **41** BBC Memo from Assistant Northern Ireland Director to Denis Johnston, 5 Sept. 1941, BBC Written Archives, LI/225/2. **42** Denis Johnston, 'The Train to Eire' (broadcast 21 Feb. 1942, Home Service), Denis Johnston Collection, University of Ulster, Archive Box 3, B.2(i)(b). **43** Wills, 'The Aesthetics of Irish Neutrality', 127. **44** Johnston, *Nine Rivers* (1953), p. 377. **45** Hachey, 'The Rhetoric and Reality of Irish Neutrality', 32.

offered sympathy at the pub by 'O'Maille [...] whose face still bore scars of the Saxons' torture chamber. And Mac Gilla-more and O'Donnell of Tir-connail two mighty men of the Fianna'.[46] Johnston's annotations reveal that these figures are Ernie O'Malley, George Gilmore, 'one time Brigadier of the Dublin Brigade', and Peadar O'Donnell.[47] Coupled with the efforts made by Gilmore and O'Donnell to get 'Dionysia' into print, this suggests a point of contact between Johnston's evolving view of neutrality, and the developing thoughts of these three left-wing Republicans – by this point thoroughly alienated from the workings of either the Fianna Fáil government or the IRA. This should be unsurprising for a writer with such complicated and evolving political beliefs, whose first play can be read as offering not just a satire on Romantic nationalism but also 'a renewal of revolutionary purpose'.[48]

Lawrence William White views *The Bell*'s realist and pluralistic agenda, initially outlined and pursued by its first editor Seán Ó'Faoláin, as according with developments in O'Donnell's political thought towards the promotion of an inclusive and inquisitive civic republicanism (in opposition to a more narrowly conceived and inward-looking cultural nationalism).[49] As the war ended and censorship was lifted, under O'Donnell's editorship the periodical's efforts to map Irish life increasingly involved addressing Ireland's place in a new world order. Gilmore's excerpts of 'Dionysia' (presumably selected at O'Donnell's behest), in their original 1950–1 printed context, form part of an attempt to re-examine the war and its relation to Ireland: to see the real Ireland in facing up to the real war. Printed alongside Johnston's first two extracts are pieces by Francis Stuart recounting the strange fate of Frank Ryan, the former associate of O'Donnell and Gilmore in Republican Congress in the mid-1930s, who, having fought in the International Brigades in the Spanish Civil War, was released by the Franco regime at the behest of German Abwehr (German Military Intelligence) in July 1940 and spent the remainder of the war years in Germany until his death in June 1944.[50] The return issue of the magazine also contained a provocative essay by Hubert Butler, querying the excuses made for the Germans in the aftermath of war and speculating as to Ireland's likely behaviour ('easy going collaboration' for many) and fate if it had been invaded by the Nazis: 'In the Nazi hierarchy of races the Irish would not I think have ranked high.'[51] Such pieces undermine notions of Irish insulation from not only the war itself, but the ongoing political and ethical quandaries of the small nation among the machinations of greater international powers.

46 Johnston, *Nine Rivers* (1953), p. 378. **47** Johnston, 'Nine Rivers' (grangerized). **48** Grene, *Politics of Irish Drama*, p. 157. **49** Lawrence William White, 'Peadar O'Donnell, "Real Republicanism" and *The Bell*', *The Republic*, 4 (June 2005), 80–99 at 94. **50** Francis Stuart, 'Frank Ryan in Germany', *The Bell* 16:2 (Nov. 1950), 37–42; Francis Stuart, 'Frank Ryan in Germany: Part II', *The Bell*, 16:3 (Dec. 1950), 38–40. **51** Hubert Butler, 'The Invader Wore Slippers', *The Bell*, 16:2 (Nov. 1950), 43–51 at 44, 50.

Gilmore's selections from 'Dionysia' might be read, therefore, as an attempt to emphasize the complex international and ideological aspects of the war to a post-war Irish readership. He certainly picks out moments that might resonate with recent Irish history. Johnston's encounter with the Afrikaans general Dan Pienaar, for instance, stresses that the Irish are not unique in feeling ambivalent about fighting alongside the British. On the phone to the Air Force, Pienaar quips: 'My father fought the British in the Transvaal, and all I want to know is, which side I'm supposed to be on now? Because if I'm on Rommel's, say so, and I'll turn around and let him have Alexandria within twelve hours.'[52] The Allied forces in the desert are encountered as a new international alliance, made of South Africans, Indians and New Zealanders. In the messy aftermath of victory, travelling across the desert, sovereignty is briefly glimpsed at the anarchic level of the individual, rather than the nation: 'For the first time in our lives we were complete masters both of our conduct and of our destiny, and were utterly beyond and above Police Power.'[53] Later on, inspiring exemplars of radicalism are found on encountering Tito's Yugoslav partisans on the island of Vis off the Dalmatian coast.[54] And part of the horror of Buchenwald is the inscription over the gate of a statement of blindly amoral patriotic allegiance: 'RECHT ODER UNRECHT – MEIN VATERLAND'.[55] In the context of the international mid-century rise of the state, totalitarian and otherwise, these extracts seem to draw out the aspects of Johnston's wartime writing which suggest that questions of liberty and morality must be re-engaged with at the level of the human subject. On the pages of *The Bell*, Johnston's European journey is being brought to the attention of post-war Ireland.

In addition to offering a critique of aspects of Irish neutrality and, in the particular circumstances of its initial publication, bringing recent European experience to bear on contemporary Ireland, *Nine Rivers* reconnects Ireland to Europe by suggesting that Irish experience and knowledge has something to offer those outside of Ireland in search of 'sanity of behaviour'. Encounters in Italy, in the book's second section, amount to a kind of Irish education in conflict, morality and future conduct for the protagonist. Soon after his arrival in Italy, his idealized view of war is rebutted during a press conference with General Alexander, much of whose youth was spent in County Tyrone. He is a soldier who seems to have walked straight out of a play by George Bernard Shaw to be placed 'in a niche between [...] Bluntschli and General Burgoyne'. Asked if he has any idea 'what should be done with Germany after the war', he suggests: 'the only thing to do will be to let the Poles and Czechs loose in Central Europe

52 Johnston, 'Meet a Certain Dan Pienaar', 9. 53 Johnston, 'Man Sovereign Man', 24. 54 Johnston, 'Detour in Illyrea', 44–52 55 Johnston, 'Buchenwald', 30–41. Johnston translates this literally as 'Right or wrong – My Fatherland', although the German inscription chosen by the SS is itself a translation of the patriotic slogan 'My country, right or wrong.'

for a while, and come back ourselves in, say, a year's time to restore order. That's the British way. We don't mind certain things being done that have to be done, provided we don't have to do them ourselves.' Johnston observes that he is 'the very picture of the charming, ruthless, Irishman who has won so many of England's wars for her, and who is so much more ready to speak aloud the unspoken policy of England than any English gentleman'.[56] A kind of Irish (and not coincidentally Shavian) perspective makes clear the Realpolitik masquerading behind British virtue.

Yet as the Introit explains, Johnston comes to see that something more than 'neo-Shavian enlightenment' – the kind of complex deconstruction of present notions of good and bad that Shaw engages with in a play such as *Major Barbara* (1905) – is needed in the face of the war through which he is living. A dialogue with an Irish priest reintroduces the question of personal conscience. The Johnston persona explains that he is 'coming to the belief that Good and Evil haven't any real existence at all'. The priest identifies this as 'Pelagianism', 'the special contribution of our own islands to the list of the early heresies'. Johnston is intricately drawn into seeing that his decision to travel to Italy was based on Britain's decision not 'to try to bully' Ireland, despite the fact that at the time Hitler looked like he would win the war: 'That was foolish of you, but it was good'. Evil though is 'infectious'. In what Johnston's annotations reveal to be a reference to Lord Longford's 1932 adaptation of Sheridan Le Fanu's novella *Carmilla*, the priest explains: 'remember that old play you used to do in the Gate Theatre about the vampire? Well, that's the way of it. An evil man bites you, and the next thing you find is that you are evil too [...] that's just what we are going to find when this war is over – that we have managed to kill Hitler, but that we are doing, ourselves, everything that he has done'.[57] Again, an Irish person and an Irish cultural frame are shown to offer illuminating ways of seeing in relation to Europe's present, sounding a warning as to the possible continuance of evil about to erupt in the aftermath of war.

Exorcizing such evil is *Nine Rivers*' emerging challenge. This is shown to have parallels with recent Irish history, as Johnston, amid the waking nightmare of being shelled, sees that compromise will be necessary: 'I've been shaking hands with murderers all my life and if I'm not allowed to do that now I'll have bloody few left to shake hands with. First of all there were those charming Blacks and Tans with all the quaint tricks who were so busy when I was at college. It was they – not the Gestapo – who reintroduced that good old medieval idea of torturing prisoners [...] then there are all those ex-gunmen now quite respectable who murdered the other side in their beds on Bloody Sunday, and

56 Johnston, *Nine Rivers* (1953), pp 130, 132. **57** Ibid., pp 1, 138–143; Johnston, 'Nine Rivers' (granger-ized).

are now all very civil servants in Dublin'.[58] The Irish lesson is that a European future based on any side's sense of straightforward moral superiority will be problematic. The book is a fascinating failure, amid a larger unfinishable project. As Wills suggests, it struggles to 'resolve' an awesome 'conundrum of neutrality, atrocity, guilt and moral engagement', resulting in 'a fragmented tale, with a nightmare vision of the split self'.[59] Part of its struggle, however, is not just to criticize Irish neutrality but to integrate imaginatively a post-war Ireland into the journey towards, and the search for, a European-wide atonement.

58 Johnston, *Nine Rivers* (1953), pp 153f. **59** Wills, *That Neutral Island*, p. 407.

Writing homelessness: the fugitive literature of Samuel Beckett and W.G. Sebald

JULIE BATES

In 1937, Beckett moved from Dublin to Paris, comparing his 'relief', once the move was complete, to 'coming out of gaol in April'.[1] Beckett was to live in France for the remaining fifty-two years of his life. At 31 years old, he had good reasons for escaping Ireland, one of which was his rather complex and stormy relationship with his family, whose response to Beckett's having no more tangible career plan than becoming a writer – without, however, ever seeming to succeed in getting anything published – ranged from his father's bewildered support to the active, hostile disapproval of his mother. The clique-ish, sneering and self-satisfied qualities of the Dublin social circles in which he moved also provoked contempt from the young Beckett – even though these were all qualities he shared as a young man – and similarly encouraged him to pack his bags.

His departure from Dublin in 1937 was precipitated by a number of small disasters: he was living at home, drinking heavily and behaving chaotically, leading to a series of heated arguments with his mother. He crashed the family car, writing it off, and refused to pay a fine, insisting instead on representing himself in court, a decision that outraged and shamed his mother. Having moved to Paris in October, Beckett returned a month later to appear in court once again, this time as a character witness for his uncle Harry Sinclair in a libel case taken against Oliver St. John Gogarty, who had included an anti-Semitic and defamatory portrait of the Sinclair family in his book *As I Was Going Down Sackville Street*. Beckett's decision to settle for good in Paris was doubtless influenced by his treatment in this case: he was publicly undermined and humiliated by the defence lawyer, and declared a barely credible witness by the judge in a packed courthouse. The case was widely reported, particularly the defence

[1] Letter to Thomas MacGreevy, 10 Dec. 1937, Martha Dow Fehsenfeld and Lois More Overbeck (eds), *The Letters of Samuel Beckett*, vol. 1 (Cambridge, 2009), p. 567. Beckett's archly archaic spelling choice of 'gaol' instead of 'jail' is a piece of mock-pedantry directed at the Revivalists, whose verbose literary nationalism was anathema to Beckett.

lawyer's description of Beckett as a 'bawd and blasphemer from Paris' – all of which horrified Beckett's mother, who did not see him while he was in Dublin. Beckett left Ireland as quickly as possible after his appearance in court.[2]

Paris in 1937 offered Beckett a social and creative environment in which he could try new things without feeling oppressed by expectations. Soon after he moved to Paris, he began to write poetry in French, commenting to friends that he thought any writing in future would also be in this language.[3] Beckett's decision to switch his language of composition was one made partly out of desperation – he had had no substantial success in English, so it made sense to try to find publishers and readers in French – but it transpired to be a profound and formative creative choice: Beckett could write in French with far less self-consciousness about how he was positioning himself in relation to the canon of English literature, and to Joyce in particular. This affiliation with French culture was enormously decisive in Beckett's discovery of his own voice and artistic identity, and for a time contributed to his sense of France as some sort of home.

The degree to which Beckett felt connected, and even indebted, to France, is evident in his actions during the Second World War, and in a comment he made before war broke out: in April 1939 he wrote to a friend from Paris: 'If there is a war, as I fear there must be soon, I shall place myself at the disposition of this country.'[4] Indeed, when war did break out he happened to be visiting his mother in Ireland, and swiftly returned to Paris, arguing with officials in England to secure his place on the ferry to France. In the years 1941–2, Beckett was active in the Resistance in Paris. After the infiltration of his Resistance cell in 1942, he escaped with his girlfriend Suzanne to Roussillon in the south of France, where he seems to have continued to support the Resistance in the period 1942–5. He was decorated after the war for his efforts – something he did not tell his friends. Years later, when asked about his wartime experiences, he played down his contribution. It is clear from his letters and friends' testimony that he was prompted into joining the Resistance in 1941 by the coordinated persecution of Jewish people by the Nazis, with the assistance of the French authorities.

Strictly speaking, Beckett was an émigré rather than exile: his return home was not prevented by an antagonistic regime; rather, home had become untenable for him. That he did not feel banished once and for all from Ireland is evident in his return trips. For as long as his mother and brother lived, Beckett made infrequent journeys back to Ireland to see them. After their deaths, however, there was no longer cause for Beckett to visit Ireland. In April 1945, as at the start of the war, Beckett had returned to Ireland to visit his mother and

2 For accounts of these turbulent months in Beckett's life, see James Knowlson, *Damned to Fame: The Life of Samuel Beckett* (London, 1996), pp 262–81, and Anthony Cronin, *Samuel Beckett: The Last Modernist* (London, 1997), pp 251–75. **3** Fehsenfeld & Overbeck, *The Letters of Samuel Beckett*, vol. 1, p. 614. **4** Letter to Thomas MacGreevy, 18 Apr. 1939, quoted in Knowlson, *Damned to Fame*, p. 297.

was alarmed to discover, when he tried to return to Paris, that the French Government was not permitting 'aliens' to enter the country. Beckett's friend, the doctor Alan Thompson, suggested that Beckett join him as part of a delegation from the Irish Red Cross to the town of Saint-Lô in Normandy, which had been devastated in the war, largely by Allied bombing. Beckett worked as an interpreter and storekeeper, and having gained access to the country in this way, eventually made his way back to Paris.

Beckett infamously insisted that he preferred 'France at war to Ireland at peace'.[5] Comments such as this, that bristle against Ireland's choice of neutrality during the war, or his complaints about the relative wealth of provisions available in Ireland in its aftermath – certainly in comparison with the grim situation in Paris – point to Beckett's rejection of Ireland as home, a refusal of affiliation that had caused his permanent move to France and was confirmed by the war. Letters written in Paris after the war, however, reveal how changed Beckett felt his adopted city to have become, and describe his growing sense of estrangement from France. In January 1948, he wrote to Thomas MacGreevy: 'The news of France is very depressing, depresses me anyhow. All the wrong things, all the wrong way. It is hard sometimes to feel the France that one clung to, that I still cling to. I don't mean material conditions, which are appalling.'[6] It is clear that the sense of cultural 'belonging' Beckett had experienced in Paris in the late 1930s was now deeply conflicted. This was a widespread reaction to the war across Europe. The mass emigration, deportation, and destruction of European Jews, and the profound loss of orientation felt by the survivors of the Second World War, conspired to mark the second half of the twentieth century with a dismantling of Heimat, of the certainties associated with knowing one's place in the world, one's country and nationality. The German concept Heimat is difficult to translate. While its literal meaning is 'homeland', it carries with it a host of associated meanings, including natural habitat, security and identity.[7] Loss of Heimat means social alienation and exile. The extent to which this disorientation was a symptom of the age is suggested by a line written by Elias Canetti in 1943: 'It is only in exile that one realises to what an important degree the world has always been a world of exiles.'[8]

I suggest that this double exile sharpened Beckett's sensitivity to the widespread contemporary experience of displacement, and inspired one of the defining features of his wartime and post-war writing: its thematic and formal identification with homelessness. In this essay, I propose that Beckett's response to the war was to create a form of 'fugitive literature' that evacuated certainty and

5 Israel Shenker, 'Moody Man of Letters,' *New York Times*, 6 May 1956. Quoted by Eoin O'Brien in *The Beckett Country* (Dublin, 1986), p. 383, n.4. 6 George Craig et al. (eds), *The Letters of Samuel Beckett*, vol. 2 (Cambridge, 2011), p. 72 7 *Oxford Language Dictionaries*. 8 Elias Canetti, *The Human Province*, trans. Joachim Neugroschel (London, 1985), p. 29.

stability from itself to become disoriented, ephemeral, impotent, vagabond and centrally preoccupied with exile. Beckett's writing in this respect is directly comparable to that of the German author W.G. Sebald, whose prose and poetry written on the cusp of the twenty-first century engages, obliquely, with some of the worst catastrophes of the twentieth.

Sebald was a lecturer and writer who died in 2001 at the age of 57. Like Beckett, he was something of a late bloomer, and experienced the same sudden fame for writing produced in his forties. Sebald left Germany soon after the Frankfurt Auschwitz trials in 1965, a traumatic experience for many Germans of his generation as they became aware of the complicity of their parents in Nazi policies: Sebald's father had served in the Wehrmacht and came home a stranger to his 3-year-old son in 1947, having been released from a prisoner of war camp in France. He never discussed the war with his family. In an interview for the *New York Times Magazine* in 2001, not long before his death, Sebald described Germany as a society that had 'willed itself into amnesia', and spoke of how he conceived the act of remembering as a 'moral and political act'. In response to the journalist Arthur Lubow's suggestion that Sebald's mother, at that time in her late eighties, 'could probably no longer remember the war years', Sebald 'replied quickly, speaking of his mother's generation: "They could remember if they wanted to."'[9]

Sebald moved to England and lived there, lecturing in the University of East Anglia, for the rest of his life. Again like Beckett, he felt at home in neither the place of his birth nor his adopted country, and found himself between languages: he taught in English, but all his creative writing was in German. Sebald's novels, charged with a melancholic ethical urgency, are difficult to classify – they elude tidy generic categories and are a combination of travel writing, photo-essays and memoir propelled and disrupted by great swells of recollection and lapses of memory. In interviews, Sebald emphasized that although he had lived in England since the mid-1960s, he never came to identify it as home, while what he described as his 'disdain for the failure of Germans to actively confront their own violent past' made it difficult for him to even visit Germany.[10] Sebald considered himself a 'child of the destruction of German cities during the Allied aerial bombings'.[11] Home, in this way, was for him 'a peculiar non-place: the ruins and rubble of post-war German cities'.[12]

One of the most apparent similarities between the forms of fugitive literature created by Beckett and Sebald is their shared reluctance to represent or comment

9 Geoff Dyer, Susan Sontag et al., 'A Symposium on W.G. Sebald', *The Threepenny Review*, 89 (2002), 18–21 at 20. 10 Markus Zisselsberger, 'Introduction: *Fluchtträume / Traumfluchten*, Journeys to the Undiscover'd Country' in Zisselsberger (ed.), *The Undiscover'd Country: W.G. Sebald and the Poetics of Travel* (Columbia, 2010), p. 10. 11 Ibid. 12 Markus Zisselsberger, 'Stories of *Heimat* and Calamity: W.G. Sebald and Austrian Literature', *Modern Austrian Literature*, 40 (2007), 1–27 at 7.

directly upon the war. In his account of translating Beckett's letters, George Craig notes the dramatic switch to a policy of 'understatement' between the first volume of Beckett's letters, covering the years 1929–40, and the second volume (1941–56):

> Beckett's work in the Resistance has been described in some detail; but never by him. The horrors of war and Occupation are vividly present to him: he will not write about them. What we know of his loyalty to his friends will tell us what their death means to him; he will not. What we see is a sort of crack in the surface of his writing; we have ourselves to imagine what lies beneath it. Not far away is a related reticence: the frequent inability or unwillingness of Holocaust survivors to speak of their experience. Beckett talks, unforgettably, of the need to express: but expressing is not turning on a confessional tap.[13]

Sebald was similarly uncomfortable with the idea of writing about the Holocaust directly. In interviews he spoke about his awareness that the subject, particularly for a German like himself, was 'fraught with dangers and difficulties'.[14]

> It was also clear you could not write directly about the horror of persecution in its ultimate forms, because no one could bear to look at these things without losing their sanity. So you would have to approach it from an angle, and by intimating to the reader that these subjects are constant company; their presence shades every inflection of every sentence one writes. If one can make that credible, then one can begin to defend writing about these subjects at all.[15]

Sebald described 'the horror of the Holocaust' as the head of the Medusa: 'you carry it with you in a sack, but if you looked at it you'd be petrified'.[16] He dismissed as 'grotesque' the idea that 'Holocaust literature', a term he loathed, could become a 'sub-genre' and a 'speciality'.[17]

The critic Thomas Trezise has considered the difficulties attendant upon artistic representations of the Holocaust. He has noted the tension between the obligation to speak of the Holocaust, and the perils, for survivors and witnesses of the camps, of adopting the voices of its victims: 'to remain true to those who perished by speaking *for* them, and especially to do so in the first person, was in a sense to betray them, if only because it required availing oneself of the very speech that they themselves had been forever denied.'[18] Such ethical demands

13 George Craig, *Writing Beckett's Letters, the Cahiers Series*: 16 (Paris, 2011), p. 29. 14 Maya Jaggi, 'The Last Word', *Guardian*, 21 Dec. 2001. 15 Ibid. 16 Maya Jaggi, 'Recovered Memories', *Guardian*, 22 Sept. 2001. 17 Ibid. 18 Thomas Trezise, 'Unspeakable', *The Yale Journal of Criticism*, 14 (2001), 36–66

explain why Beckett and Sebald each recoiled from the interpretative imperti-
nence of a literature that might seek to directly and confidently narrate the story
of the Holocaust, even while they both evidently felt obliged to engage with this
catastrophe by voicing the stories of people, places and objects that had hitherto
been overlooked. There are several important similarities between Beckett and
Sebald's writing in this respect: in the first place both refused the privileged
perspective and moral authority of the omniscient narrator.

In his famous comments about his decision to deliberately work against
Joyce's literary example, Beckett contrasts Joyce's omniscience with his own
impoverishment:

> I realised that Joyce had gone as far as one could in the direction of
> knowing more, in control of one's material. He was always *adding* to it;
> you have only to look at the proofs to see that. I realised that my own way
> was in impoverishment, in lack of knowledge and in taking away,
> subtracting rather than adding.[19]

Sebald similarly spoke of his efforts to get rid of omniscient narration in many
interviews, often identifying Thomas Bernhard as an influence in this respect, as
a 'constant presence' by his side.

> What Thomas Bernhard did to post-war fiction-writing in the German
> language was to bring to it a new radicality which didn't exist before,
> which wasn't compromised in any sense. Much of German prose fiction
> writing of the fifties certainly but of the sixties and seventies also is
> severely compromised: morally compromised and because of that aesthet-
> ically frequently insufficient. Thomas Bernhard was in quite a different
> league because he occupied a position which was absolute, which had to
> do with the fact that he was mortally ill since late adolescence and knew
> that any day the knock could come at the door so he took the liberty
> which other writers shied away from taking. And what he achieved I think
> was also to move away from the standard pattern of the standard novel.
> He only tells you in his books what he heard from others, so he invented
> as it were a kind of periscopic form of narrative, so you're always sure that
> what he tells you is related at one remove, at two removes, at two or three,
> and that appealed to me very much, because this notion of the omniscient
> narrator who pushes around the flats on the stage of the novel and cranks
> things up on page three and moves them along on page four and one sees

at 61. **19** James and Elizabeth Knowlson (eds), *Beckett Remembering/Remembering Beckett: Uncollected
Interviews with Samuel Beckett and Memories of Those who Knew Him* (London, 2006), p. 47.

him constantly working behind the scenes is something that I think one can't do very easily any longer, so Bernhard singlehandedly I think invented a new form of narrating, which appealed to me from the start.[20]

In such interviews, Sebald identifies Bernhard as the literary model he followed in attempting to create a new form of prose adequate to the challenging stories he wished to tell.

Indeed, Bernhard's writing might be said to stand between that of Beckett and Sebald, providing a common bond between otherwise markedly different bodies of work. The literary kinship of Bernhard and Beckett is expressed in their compulsive, self-propelling and negative prose, the great rushes and sudden shuddering halts of their tormented monologues, the relentlessness of their excoriating asides about society and other people. In his academic career, Sebald concentrated on Austrian writers, including Bernhard. The critic Ritchie Robertson has suggested that Sebald may have related so well to Austrian literature because it is a 'literature of displacement. Its writers and its literary figures are alienated from their childhood, their places of origin, and their native cultures.'[21] Where Bernhard is furious, however, Sebald is laconically melancholic; and where Bernhard concentrates the white heat of his scorn on his native Austria, Beckett creates works in deliberately obscure settings that contain strong echoes of Ireland, but are clearly intended to be suggestive of almost anywhere.

One of the features shared by Beckett and Sebald's writing that sets them both clearly apart from Bernhard is that the fugitive literature they created takes the form of a restitutive project to recover and articulate marginalized and shunned perspectives that had been written out of more authoritative narratives of history, biography or literature. In *Austerlitz*, Sebald writes of 'how everything is constantly lapsing into oblivion with every extinguished life, how the world is, as it were, draining itself'.[22] The reason for this emptying out is, the narrator continues, that 'the history of countless places and objects which themselves have no power of memory is never heard, never described or passed on'.[23] I propose that Sebald's line in *Austerlitz* eloquently sums up a major preoccupation of both his and Beckett's writing: 'the history of countless places and objects which themselves have no power of memory is never heard, never described or passed on'.[24] To challenge this, Beckett and Sebald devoted themselves to voicing the stories of some of the people, places and objects that had hitherto not taken centre stage: the overlooked stories they each sought to recover and explore. Their writing, in seeking to encompass the boundless disorientation and loss of

20 Michael Silverblatt, 'Interview with W.G. Sebald', *Bookworm* audio recording, 6 Dec. 2001, www.kcrw.com/etc/programs/bw/bw011206w_g_sebald, accessed 21 Apr. 2014. 21 Ritchie Robertson, 'W.G. Sebald as Critic of Austrian Literature,' *Journal of European Studies*, 41 (2011), 305–22 at 310. . 22 W.G. Sebald, *Austerlitz*, trans. Anthea Bell (London, 2002), pp 30f. 23 Ibid, p. 31. 24 Ibid.

faith caused by the widespread, carefully orchestrated savagery of the war, manages to salvage and address this minor history of otherwise ignored things, people and places that Sebald connects with the emptying out of the world in the above passage.

Sebald spoke explicitly of the restitutive nature of his vision of writing in an address he delivered at the opening of the House of Literature in Stuttgart in 2001, which was subsequently translated by Anthea Bell and published in the *New Yorker*. Having shared memories of his childhood and several biographical and historical fragments of Germany's past, all of which he interpreted as pointing almost inevitably towards the destruction of the war, Sebald posed the question, 'So what is literature good for?', and answered it by arguing for its potential: 'There are many forms of writing; only in literature, however, can there be an attempt at restitution over and above the mere recital of facts, and over and above scholarship.'[25]

One of the most obvious thematic characteristics of all Beckett's writing is a skewed realism that rejects the socially valorized categories of family, work, love, sex and health, and focuses instead on indigent, sick and alienated characters. This is a defining feature of his fiction, theatre, poetry and film. It is present even in his first texts, but becomes much more prominent during and after the war, as his focus shifts exclusively to characters on the margins of society with profoundly contingent lives whose time and energies are entirely occupied by their physical and mental ailments. These vagrant characters are haunted by obsessive preoccupations that set them apart, making communication with other characters difficult. Indeed, encounters with others are a dangerous business, for background characters in Beckett's work are typically noxious, bullying and antagonistic, and almost certain to taunt or threaten the lone central character.

Examples of this are legion in Beckett. Even before we get to characters crawling in the mud, assailing each other in the buttocks with tin-openers in the late prose work *How It Is*, we have the breathlessly melancholic and elderly Maddy Rooney who gets stuck halfway up the steps of the train station modelled on Foxrock in the radio play *All That Fall*, and is openly, loudly mocked by the largely genteel crowd waiting on the platform. In the novel *Molloy*, the elderly and lame titular character runs over a dog on the bicycle he is attempting to cycle while on crutches, and is quickly surrounded by 'a bloodthirsty mob' that seems to encompass the entire town, for he describes seeing in it 'white beards and little almost angel-faces'.[26] Other people, as imagined by Beckett, are the sinister 'they' referred to in the opening moments of *Waiting for Godot*, when Estragon replies

25 Sebald, 'An Attempt at Restitution: A Memory of a German City', *New Yorker*, 20 Dec. 2004.
26 Samuel Beckett, *Molloy* in Paul Auster (ed.), *Samuel Beckett: The Grove Centenary Edition*, 4 vols, (New York, 2006), ii, p. 28.

testily to his friend Vladimir's enquiries about where and how he spent the night: 'Beat me? Certainly they beat me.'[27]

The formal identification with homelessness in Beckett and Sebald's writing is most evident in the shape of their works which correspond, in Beckett's case, to rambling walks without beginning or end, purpose or destination, and in Sebald's, to seemingly innocuous strolls, over which pass the shadows of a sudden wrenching dislocation, like a violent summer storm. Walking, restlessness, a sense always of being in the wrong place are vital elements of Beckett and Sebald's writing. In *The Practice of Everyday Life*, the social philosopher Michel de Certeau asserts that '[t]o walk is to lack a place'.[28] The incapacitated narrator of Beckett's novel *Malone Dies*, trying to piece together how he came to be in the strange bed in which he finds himself, muses: 'But what is the last thing I remember, I could start from there, before I came to my senses again here? That too is lost. I was walking certainly, all my life I have been walking, except the first few months and since I have been here.'[29] Similarly, in the bizarre 'birth' that is imagined in the short prose piece *Texts for Nothing 9*, a hunched little old man, shod in heavy boots, tramps out and into a life of walking with the following words:

> [I]t would be the first step on the long travelable road, destination tomb, to be trod without a word, tramp tramp, little heavy irrevocable steps, down the long tunnels at first, then under the mortal skies, through the days and nights, faster and faster, no, slower and slower, for obvious reasons.[30]

The relationship between walking and displacement, and the inherent association of home with certainty, authority, security, and of homelessness with confusion, impotence and uncertainty, runs throughout both Beckett and Sebald's work. After the war, these latter rootless and powerless categories come to dominate Beckett's writing.

This brings us to another feature shared by Beckett and Sebald's fugitive literature: the inscription of a dim, pervasive menace in the landscape of their narratives across which their characters are condemned to wander, without hope of escape to a personal or social refuge. This feature is linked to the restitutive project of both writers: their treatment of landscape suggests that the hitherto ignored stories and perspectives on which they focus had been buried or submerged, and that their fugitive writing is a form of excavation, of exposing

27 Beckett, *Waiting for Godot* in Auster (ed.), *The Grove Centenary Edition*, iii, p. 4. 28 Michel de Certeau, *The Practice of Everyday Life*, trans. Steven Rendall (Berkeley, 1988), p. 103. 29 Beckett, *Malone Dies* in Auster (ed.), *The Grove Centenary Edition*, ii, p. 177. 30 Beckett, *Texts for Nothing 9* in Auster (ed.), *The Grove Centenary Edition*, iv, p. 325.

what had been hidden, by tacit social agreement. In *Landscape and Memory*, the historian Simon Schama articulated the intimate relationship between place and perception: 'Before it can ever be a repose for the senses, landscape is the work of the mind'.[31] This idea informs the work of writers who have been termed 'psychogeographers', including Kathleen Jamie, Robert MacFarlane, Will Self, Iain Sinclair, Rebecca Solnit and a host of similarly minded academics, and it has long been acknowledged as one of the most elemental aspects of Sebald's writing. The critic Christopher Gregory-Guider has identified this role of place in Sebald's writing, describing it as 'a highly unstable variable, a quantity more likely to unsettle than to ground us.'[32]

Mark Anderson has spoken of 'the edge of darkness' against which Sebald's fictions repeatedly bring the reader: 'a place and a time in which the ordinary constraints of history give way to an immense penumbral continuum of human suffering, exile, and "silent" catastrophes that take place "without much ado."'[33] In a review of Sebald's poetry for the *Irish Times*, the poet Gerald Dawe similarly reflected on the loaded quality of place in Sebald's writing: 'Landscape is never innocent; behind the everyday world lies a history capable of disabling the imagination.'[34] This idea of history as a series of calamitous inscriptions in the landscape, to be read and interpreted by a harrowed walking narrator, characterizes Sebald's work, the most obvious thematic preoccupation of which is the gathering of evidence to support the queasy suspicion voiced frequently in his work: that human life expresses itself most naturally and emphatically in acts of destruction. Sebald makes this argument repeatedly, in particular in his Zurich lectures, published in an English translation in the 2003 collection of essays, *On the Natural History of Destruction*, and in his novel *The Rings of Saturn*:

> On every new thing there lies already the shadow of annihilation. For the history of every individual, of every social order, indeed of the whole world, does not describe an ever-widening, more and more wonderful arc, but rather follows a course which, once the meridian is reached, leads without fail down into the dark.[35]

I suggest that landscape and place in Beckett are similarly vexed, that Beckett and Sebald set their halting, blurred, uncertain narratives in landscapes inscribed with the traces and effects of a long European history of orchestrated catastrophes. In both their works, landscape hums with strange, submerged forces that

31 Simon Schama, *Landscape and Memory* (London, 1996), pp 6f. **32** Christopher C. Gregory-Guider, 'The "Sixth Emigrant": Travelling Places in the Works of W.G. Sebald', *Contemporary Literature*, 46:3 (2005), 422–49, at 423. **33** Mark Anderson, 'The Edge of Darkness', *October*, 106 (2003), 102–21 at 121. **34** Gerald Dawe, 'W.G. Sebald the Poet: A Chilly, Elusive Reality', *Irish Times*, 19 Nov. 2011. **35** Sebald, *The Rings of Saturn*, trans. Michael Hulse (London, 2002), pp 23f.

reveal themselves in an obscure menace felt by a narrator or character as he walks an ostensibly innocent terrain. This is one of the most radical aspects of their fugitive literature, and represents to a great degree the means by which both Beckett and Sebald manage to accommodate a sustained queasy uncertainty within their writing, even as they create starkly beautiful works of fiction.

A central aim of such writing is to record those stories that are difficult to accommodate within other literary forms or means of expression. This is an attempt to achieve in literature a feat that the philosopher Wittgenstein identi- fied as being beyond language. Wittgenstein wrote his *Tractatus Logico-Philosophicus* on the front line in the First World War. One of the dominant concerns of the *Tractatus* is to determine the limit points of language, and it ends on the aphorism, 'Whereof one cannot speak, thereof one must be silent.'[36] Self-evidently true of philosophy, this is not necessarily the case in liter- ature. Sebald and Beckett both took issue with Wittgenstein's argument. His dictum comes in for tacit criticism in Sebald's novel *The Emigrants*, published in 1996:

> At home, my parents never talked about the new order in my presence, or only did so obliquely. We all tried desperately to maintain an appearance of normality, even after Father had to hand over the management of his gallery [...], which had opened only the year before, to an Aryan partner. I still did my homework under Mother's supervision; we still went [...] skiing in winter, and [...] [on] our summer holidays; and of those things we could not speak of we simply said nothing. Thus, for instance, all my family and relatives remained largely silent about the reasons why my grandmother Lily Lanzberg took her own life; somehow they seem to have agreed that towards the end she was no longer quite in her right mind.[37]

The strong implication in this paragraph is that dreadful, unspeakable things are allowed to take place and to remain beyond understanding so long as they are not spoken of. Beckett's friend, the lighting engineer Duncan Scott, reported a conversation he had with Beckett in the pub in the late 1970s where Beckett 'fervently disagreed' with the final point of the *Tractatus*. Beckett quoted Wittgenstein's line, then retorted: 'That's the whole point [...] We must speak about it.'[38]

In conclusion, then, I would like to suggest that Beckett and Sebald's writing shows them to be preoccupied with the dismantling of Heimat that occurred as a result of the war. Loss of Heimat means social alienation and exile, phenomena

36 Ludwig Wittgenstein, *Tractatus Logico-Philosophicus* in Anthony Kenny (ed.), *The Wittgenstein Reader*, 2nd ed. (Malden, 2008), p. 30. 37 Sebald, *The Emigrants*, trans. Michael Hulse (London, 1996), pp 182f. 38 Knowlson, *Beckett Remembering*, p. 218.

that Beckett and Sebald harnessed for literary forms that could encompass their sense of alienation, of not being at home in the world. Sebald and Beckett each recover from annihilation marginal stories, accounts of victims, ignored and isolated things that would otherwise never see the light of day. Both writers make of their own personal exile, homelessness and estrangement an imaginative home for themselves, a unique space in and from which to create a mode of writing that would not speak *for* any audience, and not *of* any society, but rather concern itself with the portrayal of dispossession, failure, and confusion. The elusive, powerless genre of fugitive literature developed by both writers as a form of 'writing homelessness' takes as its subject the overlooked, displaced, unremarked and all that had hitherto been deemed unimportant, uninteresting, or unsuitable as a subject for literature. For these reasons, their works quietly, steadily, with unassuming and self-deprecating determination, shatter the silence that Wittgenstein had deemed imperative.

The war came down on us here

GERALD DAWE

> The grass-grown pier,
> And the dredger grumbling
> All night in the harbour:
> The war came down on us here.[1]

It sounds very strange saying so, whatever about thinking about it, but in concluding a book such as this which has been dealing with, among other things, the monumental forces of political conflict and cultural division, I find myself constantly drawn to individual stories, personal voices and coincidences, random, contingent parallels, rather than the all-powering sweep of History. This probably has much to do with the fact that I am a product of the way war casts people together – as civilians in a time of war, as men and women in the armed forces – as much as it hurls people against each other in acts of barbarity, no matter how we weigh the morality of cause.

My late mother was a keen admirer of all kinds of music in performance. As a very young woman she fell in love with my soldier-father. Originally from the Welsh-English borders, he was a musician in the Royal Inniskilling Fusiliers band which toured Northern Ireland for a morale-boosting celebration towards the end of the Second World War. They married in 1945. The marriage lasted until the mid-fifties, whereupon my sister and I and my mother relocated to my grandmother's house in North Belfast. It was during this time – the mid-to-late fifties – that the aftermath of the war registered with me. The Second World War – known simply as 'the war' – was literally everywhere. Barely a decade had gone by since the war's ending, but the city in which I was growing up was still very much marked by the experience of war. The physical landscape bore the scars of the deadly blitz of 1941 in which almost one thousand citizens had perished,[2] and

1 From the poem 'The Closing Album' in Louis MacNeice, *Collected Poems*, ed. Peter McDonald (London, 2007), pp 181f. 2 Stephen Douds, *The Belfast Blitz: The People's Story* (Belfast, 2011).

in the quasi-industrial pop-up camps that had been created to house army instal-
lations, garages, depots and such like, one could still wander. As young boys we
did so, picking up the handed-down habits of bubble-gum, hairstyle and latterly
the dance moves from the long-departed US troops who had been stationed
nearby. The 'prefabs' – as temporary housing was called – remained along North
Belfast's Shore Road.

But the sense of a ceremonial life in honour of those who had lost family
members during the war was very much an accepted and unselfconscious part of
our upbringing in school and in social and civic life. More intimately, the house
in which I spent my early years retained fixtures of the war – blackout blinds to
seal off any light that might benefit Luftwaffe bombers stayed in place on the
bedroom windows upstairs; ration-books were left in a kitchen press, and the
language and customs that were associated with rationing carried over well into
the late 1950s.

Food was not thrown out; clothes were repaired, socks darned and these
practices continued not out of thrift but out of habit; a mind-set of 'making do',
'getting by', that was deeply shaped by war. While the human dimension of this
post-war world retains a very special resonance, bearing in mind what would
descend upon the city of Belfast by the end of the 1960s, the particular context
of *how* that world at war was etched in a generation's idea of 'home' – as a natural
and given 'space' – is relevant here. In my own case, that house we moved to in
the mid-1950s with its random relics of wartime, I took in without actually
knowing it, along with many stories of precisely how war recasts what seems to
be the stabilities and securities of 'home'.

My mother and her brother were evacuated after the first blitz in Belfast to
the County Antrim countryside from their family home, to which they had
returned from Canada in the mid-1930s. It was in this house in North Belfast
that refugees, contacts of friends of my grandmother's, had briefly passed
through on *their* way to Canada. I was fascinated to hear about the 'CID' calling
to that house to interview my grandmother about one such friend, one of the
fleeing émigrés, only to be confronted by her straight-laced and stalwart father
who denied any such knowledge and sent the police on their way. Or so the story
goes.

Around that house and the surrounding avenues and terraces off the Antrim
and Cliftonville roads, the Nazi bombs would fall and create carnage in the blitz
of 1941. It is a scene recalled with such contradictory awe in Brian Moore's
Belfast-set novel of the war, *The Emperor of Ice Cream* (1965):

> To the north, the guns chattered again. A new wave of bombers
> approached. The whole of the city seemed to be on fire. All around the
> night bowl of sky, from Cave Hill to the Lough, from Antrim to Down,

a red glow eddied and sank, the reflected light of hundreds of burning houses, shops, factories, and warehouses. Yet the streets were strangely empty [...] He walked, caught in a cold excitement, feeling himself witness to history, to the destruction of the city he had lived in all his life.[3]

If the aftermath of war had left its mark on the streetscapes of Belfast, one can also see in retrospect how lives had been not so much 'influenced' by the war as determined by it. Men in their regimental blazers heading to the British Legion sporting pencil-thin moustaches, raincoats folded neatly over arm, 'turned-out well' was the phrase. Some of these men had never fully recovered from their experience of war; one of our neighbours, whose merchant-ship had been torpe-doed, cried out at night for his friend and second-in-command lost at sea; the strained understanding of their women stretched, no doubt, to breaking point. A friend's father had been a rear gunner on a Lancaster (a perilous position with high rates of mortality); he never referred to his war experiences and would unaccountably turn morose and barely talk for days on end. Another neighbour who lived next door, a quiet unassuming civil servant who had fought with the British Army through the bitter campaigns liberating Europe, found himself finally in Vienna where he met and married Elsa, with whom he returned to Belfast to live a subdued life before illness struck him down in middle-age. Elsa seemed so foreign in manner and style and custom. One evening my mother, to whom she was close, recounted the truth of Elsa's hounded wartime existence, dressed as a man to avoid rape when the avenging Soviet troops settled their grim score with the Third Reich.

The anecdotes I eagerly listened to when 'soirées' gathered in our house included recollections about the Pathé newsreels that featured the release from the camps of desperate, unbelievable figures. Those who watched laughed at first and thought that what they were seeing on the screen was a horror movie until the reality dawned that this was actual. My mother recounted how people in the Capitol cinema on the Antrim Road fainted or were sick and fled.

When I started at the Lyric Youth Theatre as a young impressionable teenager, our dance instructress was a wonderful woman called Helen Lewis who had been incarcerated in a concentration camp (her camp number was stamped on her arm) – experiences which she recounts in *A Time to Speak*, one of the few Holocaust survivor accounts from Ireland, the ending of which tells its own story of aftermath:

I arrived in Belfast at the end of October [1947] and spent the first two years learning to understand that strange place, its language, customs and

3 Brian Moore, *The Emperor of Ice-Cream* [1965] (London, 1994), pp 220f.

people. Harry [Lewis' husband] guided me along with tact, patience and good humour. Yet in spite of being safe and feeling secure, I was tormented by a recurring nightmare, from which I always awoke screaming in terror. It stopped, never to return again, after the birth of our first child, Michael, in 1949. Robin's arrival five years later marked the end of transition and the beginning of my integration. From then on I was at home.[4]

* * *

As a British city, as Belfast so publicly and officially was, and in a way can no longer be, the airwaves were awash with military ceremonials and commemorations. Victory and the world at war, and the *history* of the war in Europe, were part and parcel of our education, our schoolbooks, our calendar, our church, our scout 'troop'. Despite the abomination of the Holocaust and the oppressions that befell Europe during the war and after, with the cruelty of the Iron Curtain and the displacement of millions of people throughout Europe, the legacy of the Second World War was dominated by a constructed sense of our Britishness – the military tattoos in the summer, the quasi-military role-playing of the Boys' Brigade and in the pervasive expectation of being 'in the right' since 'we' had 'won' after all.

The aftermath of war is really about the psychological reality of everyday life and how people cope with its damaging effects. But as Adam Piette states in *Imagination at War*, we need to acknowledge that 'however many individual stories of courage and endurance there were [war] should never again become the subject of nostalgia, glorification and fond reflection'.[5] Even with the passing of time and the implied timelessness of the term 'aftermath', we need to remind ourselves, as we consider how Irish writers have reflected this deepening consciousness in their own writing, that war is anathema and nothing we say about it can ever redress the terrible things done during the decade between 1938 and 1948.

From a personal position, I am interested to see how these experiences form a rich, complex map of the island of Ireland during the twentieth century and to understand accordingly this unfolding literary, social and cultural history. It is folly to think that in so doing – in seeing both world wars as an essential part of Irish history – we are displacing Easter 1916 or deposing from literary-political priorities internal Irish struggles against British imperialism or issues of post-colonialism. The cultural, social and economic interconnectedness of

4 Helen Lewis, *A Time to Speak* (Belfast, 1992), p. 131. 5 Adam Piette, *Imagination at War: British Fiction and Poetry, 1939–1945* (London, 1995), p. 7.

Ireland with neighbouring Britain and Europe, and the fluidity of those relation-
ships when placed in the aftermath of the Second World War, of the late 1940s
and 1950s, are at the very heart of Irish writing.

Louis MacNeice's 'Galway', section IV of the sequence 'The Closing
Album',[6] which provides both the title and epigraph for this essay, was written
during his trip through Ireland in 1939. Together with other writers of his gener-
ation, including John Hewitt, Robert Greacen,[7] Roy McFadden[8] and Denis
Johnston (whose *Nine Rivers from Jordan*[9] is an amazing study of war and its
personal impact), MacNeice's work provides a challenging view of Ireland at this
time and of the country's relationship with the rest of Europe; relationships
which have only comparatively recently started to be critically examined.

MacNeice was one of the earliest influences on the imaginative development
of poets born in the late 1930s and 40s, such as Derek Mahon and Michael
Longley, both of whom have written about how the Second World War
fashioned their lives growing up in Belfast. It is also true to say that MacNeice's
poetry and critical attitudes[10] shaped how these and other poets of their genera-
tion and later understood 'Ireland' and its place in the wider world. The Second
World War provided Longley and Mahon with a theme through which that
wider world could be accessed. With Longley's Great War soldier-father as a
recurrent figure, 'war' has been at the very forefront of his writing. He addresses
it from an early stage in his writing life in a poem such as 'Bog Cotton' with its
name-checking of both First World War poet Isaac Rosenberg and Second
World War poet Keith Douglas:

> Let me make room for bog cotton, a desert flower –
> Keith Douglas, I nearly repeat what you were saying
> When you apostrophized the poppies of Flanders
> And the death of poetry there: that was in Egypt
> Among the sandy soldiers of another war.[11]

Michael Longley is also one of the very first poets in Ireland to engage with the
appalling legacy of the Holocaust.

In Derek Mahon's poetry it is war-*time* that is pre-eminent, such as the
cultural legacy he associates with retrospection and revelation in
'Autobiographies', his quartet of poems dedicated to fellow northern writer a

6 MacNeice, *Collected Poems*, pp 181f. 7 Robert Greacen, *The Sash my Father Wore: An Autobiography*
(Edinburgh, 1997); *Collected Poems, 1944–1994* (Belfast, 1995); and *Selected & New Poems*, ed. Jack W.
Weaver (Cliffs of Moher, 2006). 8 Roy McFadden, *Collected Poems, 1943–1995* (Belfast, 1996).
9 Denis Johnston, *Nine Rivers from Jordan: The Chronicle of a Journey and a Search* (Boston, 1955).
10 Louis MacNeice, *Modern Poetry: A Personal Essay* (Oxford, 1938). 11 Michael Longley, *Collected
Poems* (London, 2006), pp 136f.

THE WAR CAME DOWN ON US HERE 191

Maurice Leitch, whose novel, *The Smoke King*[12] concerns the American GIs stationed in Northern Ireland in the lead-up to D-Day.

Mahon's 'The Home Front' is quite literally *his* home, on the Antrim Road, where he sleeps in a cot 'with siren and black out'

> under the stairs
> Beside the light meter
> When bombs fell on the city;
> So I never saw the sky
> Ablaze with a fiery glow,
> Searchlights roaming the stars.[13]

There are other poems of Mahon's, such as 'One of these Nights', which are a kind of writing home through time-travels to the lived experience of wartime, while his fascination with Elizabeth Bowen in 'At the Shelbourne'[14] takes its bearings from her war stories as well as her life lived between 'neutral' Dublin and London under fire. As war and its alarms are clearly inflected in much of Mahon's poetry, revisiting the Second World War and memorizing the past are strong and recurring themes in much post-war Northern Irish writing. It features, for instance, in John Montague's poetry, particularly in the sequence 'Time in Armagh', which zooms in on the blitz of Belfast in the prose-poem 'A Bomber's Moon' and in 'Waiting'.[15] The experience of watching the Second World War unfold from a distance, both physical and psychic, underlines, perhaps surprisingly, Seamus Heaney's poems such as 'The Aerodrome',[16] while the significance of the war is recalled in some detail in 'Crediting Poetry', Heaney's Nobel Prize lecture. As 'the eldest child of an ever-growing family in rural County Derry', Heaney recalls:

> We could pick up [...] in the resonant English tones of the newsreader the names of bombers and of cities bombed, of war fronts and army divisions, the number of planes lost and of prisoners taken, of casualties suffered and advances made; and always, of course, we would pick up too those other solemn and oddly bracing words, 'the enemy' and 'the allies'. But even so, none of the news of these world-spasms entered me as terror. If there was something ominous in the newscaster's tones, there was something torpid about our understanding of what was at stake; and if there was something culpable about such political ignorance in that time and place, there was

12 Maurice Leitch, *The Smoke King* (London, 1998). 13 Derek Mahon, *New Collected Poems* (Oldcastle, 2011), p. 83. 14 Derek Mahon, *New Collected Poems*, pp 119f, 199f. 15 John Montague, *New Collected Poems* (Oldcastle, 2012), pp 348, 355. 16 Seamus Heaney, *District and Circle* (London, 2006), pp 11f.

something positive about the security I inhabited as a result of it. The war-time, in other words, was pre-reflective time for me.[17]

One of the most under-recognized poets of the northern generation, Frank Ormsby, published in *A Northern Spring* (1986) an extraordinary sequence of poems which exclusively focus upon the American GIs and their lives, waiting to embark on what would turn out to be the critical turning point of the Second World War – the landings at Normandy on D-Day. In 'The Clearing', the opening poem of the sequence of 'A Northern Spring', Ormsby has one of his soldiers reflect:

> Here is a place I will miss with a sweet pain,
> As I miss you always, perhaps because I was spared
> The colourless drag of its winter. This is an hour
> To dream again the hotel room where we changed
> From the once-worn, uncreased garments,
>
> assured and beside ourselves and lonely-strange.[18]

* * *

Each one of these individual poetic achievements to which I have referred requires their own critical space and attention to fully recognize the poet's imaginative treatment and understanding, but in place of this more extensive consideration I will finish by outlining a personal understanding of how poems of my own emerged out of the early background I sketched at the beginning of this essay.

As I have described elsewhere,[19] I was schooled in British history and to most of my generation the Second World War featured prominently in everyday life, whether we liked it or not. The public figures of that time, the names of the battles, the sense of war and destruction in countries and cities the names of which we heard in school, on television and in the cinema, filled my mind and imagination. Yet it was primarily and fundamentally a *distant* 'Europe', despite its geographical proximity. It started to take on a much more personal meaning as I grew slightly older (like most things). When I saw, for instance, sometime in the late 1960s, a photograph in the *Observer*[20] newspaper, commemorating the

17 Seamus Heaney, *Opened Ground: Poems, 1966–1996* (London, 1998), pp 447f. **18** Frank Ormsby, *A Northern Spring* (Dublin, 1986), p. 4. Many of the poems referred to here are included in Gerald Dawe (ed.), *Earth Voices Whispering: An Anthology of Irish War Poetry, 1914–1945* (Belfast, 2008). **19** See Gerald Dawe, *My Mother-City* (Belfast, 2007) and *The Stoic Man: Poetry Memoirs* (Derry, 2015). **20** See Richard Raskin, *A Child at Gunpoint: A Case Study in the Life of a Photo* (Oxford, 2004). I am indebted

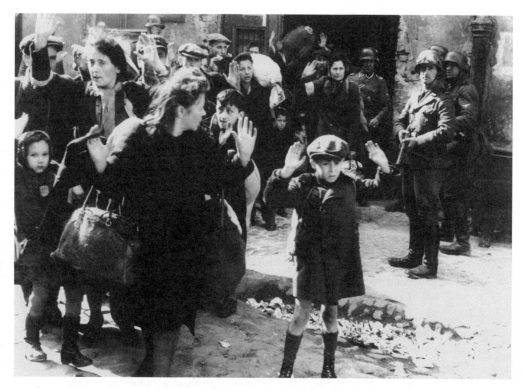

Fig. 3: The original caption in the Stroop Report reads: 'Mit Gewalt aus Bunkern hervorgeholt' ('Forcibly pulled from their dug-outs')

Second World War, the human toll of war on a civilian population was clear and direct. The photograph is one of the most enduring images of the Holocaust, showing a Jewish boy with raised hands in front of German storm troopers forcing surrendering residents of the Warsaw Ghetto to move (Fig. 3).[21] This photograph was used in the Nuremberg Trials as evidence of the forced deportation of Jews from the Warsaw Ghetto in 1943 to extermination camps like Auschwitz. The image of the boy and – presumably – his mother haunted me. His arms raised, his cap seemingly too large for his frightened face, brought up

to Dorothea Depner for this reference. **21** The photograph was included in SS-*Brigadeführer* Jürgen Stroop's report entitled 'Es gibt keinen jüdischen Wohnbezirk – in Warschau mehr!' ('The Warsaw Ghetto Is No More'), written after the suppression of the Warsaw Ghetto Uprising and the ghetto's liquidation in May 1943. A facsimile of the original report (and Polish translation thereof) can be accessed through the website of the Polish Institute of National Remembrance, http://ipn.gov.pl/_data/assets/pdf_file/0007/109735/Raport_STROOPA.pdf, accessed 18 Nov. 2013. The photograph in question can be found on p. 203 (p. 91 of the original document) or at http://en.wikipedia.org/wiki/File:Stroop_Report_-_Warsaw_Ghetto_Uprising_06b.jpg.

close the reality of war on the civilian population in a way the rhetoric of most English war movies of the time did not.

Around the same time, I also started to read through the magnificent Penguin European Poets series that appeared in the mid-to-late 1960s, and which published poets who were not on any 'reading list' at school or college. In particular, the Russian poet Anna Akhmatova, mentioned by Heaney in 'Crediting Poetry'. In the famous prose text, 'Instead of a Foreword', the preface to her stunning sequence 'Requiem 1935–1940', Ahkmatova recounts the following:

> During the terrible years of Yezhovshchina [the purges of the last 1930s] I spent seventeen months in the prison queues in Leningrad. One day someone recognized me. Then a woman with lips blue with cold who was standing behind me, and of course had never heard of my name, came out of the numbness which affected us all and whispered in my ear – (we all spoke in whispers there):
> 'Can you describe this?'
> I said, 'I can!'
> Then something resembling a smile slipped over what had once been her face.[22]

The poem which I recall reading with such shocked fascination is the following second section of 'Requiem's' monumental statement of what the ravages of political warfare were like on the Russian population, and this *before* the devastating war with Hitler's Germany had descended upon it. It begins:

> The hour of remembrance has drawn close again.
> I see you, hear you, feel you.
>
> The one they hardly dragged to the window,
> The one who no longer treads this earth,
>
> The one who shook her beautiful head,
> And said: 'Coming here is like coming home.'
>
> I would like to call them all by name,
> But the list was taken away and I can't remember.[23]

22 Anna Akhmatova, 'Instead of a Foreword: Requiem 1935–1940', *Selected Poems*, trans. Richard McKane (London, 1969), p. 90. The text is dated 1 April 1957, Leningrad. **23** Akhmatova, 'Epilogue II', *Selected Poems*, pp 104f.

Other poets from Eastern European countries, such as Vasko Popa[24] from the former Yugoslavia, became increasingly more read and more available in English translation, bringing with them a much wider sense of the experience of war in Europe. Here, Ted Hughes, one of the most important proponents of this trans-European writing, makes the case for their poetry's centrality:

> I think it was [Czeslaw] Milosz, the Polish poet, who when he lay in a doorway and watched the bullets lifting the cobbles out of the street beside him realised that most poetry is not equipped for life in a world where people actually do die. But some is [...] In a way, their world reminds one of Beckett's world.

The reference to Milosz (not to mention Beckett) is pertinent, because around the same time as the European poets of the post-war period were finding an audience in translation, Milosz was himself being translated, or re-translated, into English. *The Captive Mind*,[25] his classic study of war and its bloody after-math in Soviet totalitarianism, originally published in English in 1953, was reissued by Penguin in 1980 and found a deep echo in literary circles both here and in the US, probably because Milosz was writing out of, and in turn addressing, politically fraught and dangerous immediacies of the Cold War just as the first serious cracks were beginning to show in the structure of the Eastern Bloc. The landscape of war is dramatically revisited in 'Looking to the West', the second chapter of *The Captive Mind*:

> Man tends to regard the order he lives in as natural. The houses he passes on his way to work seem more like rocks rising out of the earth than like products of human hands. He considers the work he does in his office or factory as essential to the harmonious functioning of the world [...] His first stroll along a street littered with glass from bomb-shattered windows shakes his faith in the 'naturalness' of his world [...] Farther down the street, he stops before a house split in half by a bomb, the privacy of people's homes – the family smells, the warmth of the beehive life, the furniture preserving the memory of loves and hatreds – cut open to public view. The house itself, no longer a rock, but a scaffolding of plaster, concrete, and brick.[26]

For the young poet in the late sixties and seventies reading this material about the sense of war, of the Second World War, and of history being made or remem-

24 Ted Hughes, 'Introduction to the Poetry of Vasko Popa', in *Vasko Popa: Selected Poems* (London, 1969), pp 9f. 25 Czeslaw Milosz, *The Captive Mind* (London, 1980). 26 Ibid., pp 25f.

bered, there was a strong complicating identification with the places and poetry of Europe – Prague, Paris, Warsaw, Leningrad; names that had once been only themselves, 'names' on a map, took on an actual life of their own, like London or Belfast; places known, lived in, familiar.

The local world I knew, entering its own crisis of political violence in the late 1960s and early 70s, had common bonds, parallels and comparisons both historically with the aftermath of the Second World War and culturally in the opening up of non-English language poets, whose work was now relatively easy to find in the Belfast bookshops of the time. I wrote poems, I see now, clearly straining to the example of the great European figures. By the time my second collection appeared in 1985, there was a more coherent understanding that Europe was a way of life and writing, and of understanding history and identity. In a literary sense, Longley and Mahon, and before them MacNeice, had shown the way.

But it took me another ten years – discovering, working and travelling through various European and former Eastern Bloc countries – to understand and to see what had happened. In *The Morning Train* (1999), which collected poems from those journeys of the previous decade or so, that experience crystallized around a group of poems – 'The Minos Hotel', 'Europa', 'The Old Jewish Cemetery, Lodz', 'The Night's Takings' and 'In Ron's Place', among others. 'In Ron's Place' starts off in the much-loved, much lived-in home from home of a friend outside Lucca in Tuscany. While recovering from some kind of ailment, I could hear conversations on the little roof garden overhead and drifted off. For some reason a train journey across the middle of Slovakia came to mind. It had been quite a trip overnight, and midway through that journey the thought had struck me about all the other train journeys that had taken place on similar rail networks to those we had been using. It was a scarifying feeling – the ordinary day life of a harmless journey through what had been nightmarish terminals barely thirty or forty years before. 'In Ron's Place'[27] celebrates the respite and pleasures of (that temporary) home in the Tuscan hills, together with the haunted and haunting landscape of another time, the other places of war and war's alarms:

In Ron's Place

I was sitting up in Ron's place
among the mountains,
church bells followed by church bells,
then 'April in Paris',

27 Gerald Dawe, *The Morning Train* (Oldcastle, 1999), pp 41–3. Reprinted in *Selected Poems* (Oldcastle, 2012), pp 66f.

when I realized that a person
can only take so much in.
I'd been lying in my cot
for the guts of a week –

Hong Kong or Singapore flu –
and could hardly lift my head for you,
lover, lady, wife.
I thought this was it –

the end, to simply waste away,
neutral and inert,
without a bit taken,
the brassy taste of stomach juices,

swollen glands, blocked passageways,
the shivers, energy levels
at an all-time low,
when, as I say,

I was listening to Bird, 'April in Paris',
the church bells went counting,
then the tower up here
in the silent hills,

where the only sound
is the postman's moped,
a couple of voices under the window,
before you really see

the mountains beneath us
and the brazen light of day
over all things, great and small –
lizards slipping in and out

of the warming roof tiles,
the logs dissembling into cobwebs
and dust, the table and chair
moved to where you take the sun…

And I fall back to sleep,
this time in a couchette,
listening to the wheels brace and tack
to miles and miles of railway track.

At one station –
its long name in black and white,
the row of lorries parked in
a yellowish light from the waiting room –

the deadpan voice announces
where we are and where we are going next
as we arrive and depart
the all-night factories, the cubist blocks

of flats, the shapes of installations
in the darkness, snowy embankments,
sidings, cranes, sheds,
and then nothing again.

The wheels at my head,
the door double-locked.
The countryside flees
and I wake with a jolt.

Are you still there?
Is the sun still out?

Index